LADIES
AND
GENTLEMEN,
BOYS AND GIRLS

THE **SUNY** SERIES

CULTURAL STUDIES IN CINEMA/VIDEO

WHEELER WINSTON DIXON | EDITOR

LADIES AND GENTLEMEN, BOYS AND GIRLS

*Gender in Film at the
End of the Twentieth Century*

Edited by

MURRAY POMERANCE

STATE UNIVERSITY OF NEW YORK PRESS

Cover photograph by Chris Buck.
Copyright © by Chris Buck, used by kind permission of the photographer.

Published by
State University of New York Press, Albany

© 2001 State University of New York

For information, address State University of New York Press,
90 State Street, Suite 700, Albany, NY 12207

Production by Marilyn P. Semerad
Marketing by Michael Campochiaro

Library of Congress Cataloging-in-Publication Data

Ladies and gentlemen, boys and girls : gender in film at the end of the twentieth century /
edited by Murray Pomerance.
 p. cm. — (The SUNY series, cultural studies in cinema/video)
 Includes bibliographical references and index.
 ISBN 0-7914-4885-1 (alk. paper) — ISBN 0-7914-4886-X (pbk. : alk. paper)
 1. Sex role in motion pictures. 2. Men in motion pictures. 3. Women in motion
pictures. I. Pomerance, Murray, 1946– II. Series.

PN1995.9.S47 L33 2001
791.43'653—dc21

 00-032954

10 9 8 7 6 5 4 3 2 1

to Ariel,
thirteen in the year 2000

Magic is directed almost entirely to men, you know. . . . It has nothing to do with women, who hate it—it irritates them. They don't like to be fooled. And men do.

—Orson Welles, to Peter Bogdanovich,
This Is Orson Welles

CONTENTS

◆

PART III
Paragons and Pariahs

ACKNOWLEDGMENTS

---------------------◆---------------------

This book was born in a dream in 1995 and would never have become a manuscript without the genuinely warm support of Mr Andrew Lockett (London). David Kerr has worked tirelessly as my editorial and research assistant and in preparing the index, very often tempering my zeal with the gift of his grace and gentility. I am also grateful for exceptional generosity and help to Chris Buck (New York), Bryan Dale (Toronto), David Desser (Champaign), Wheeler Winston Dixon (Lincoln), Frances Gateward (Champaign), Steve Gray (Toronto), Mark Harrison (Toronto), Paul Kelly (Toronto), Kristen and Robin MacDonald (Toronto), Hrire Mikaelian (Toronto), Jerry Ohlinger's Movie Material Store, Inc. (New York), and Alan Schoepp (Toronto), as well as to the Office of Research Services (particularly Michael Owen) and the Dean of Arts and the Vice-President Academic of Ryerson Polytechnic University.

Krin Gabbard has been a good chum with a very good tune. My friendly collaborators at the State University of New York Press have been a pleasure to work with at every stage of the strange and captivating process through which books are made; I want to thank particularly James Peltz, Katy Leonard, Dale Cotton, Michael Campochiaro, Marilyn Semerad, and freelance cover designer, Amy Stirnkorb. Hamid Naficy and I are grateful to I. B. Tauris.

Ariel Pomerance has provided kind and extremely adept assistance with many ideas and much of the imagery. Nellie Perret has seen every nuance of this book at my side.

ILLUSTRATIONS

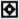

CHAPTER ONE

◈

Introduction:
Gender in Film at the
End of the Twentieth Century

MURRAY POMERANCE

If the past one hundred years have been the Age of the Electron (computers, microphones, telephones, film projectors and cameras, the chemistry of film processing, the elimination of night) and of the Fracture (Joyce, Godard, the news story, the bureaucracy, the advertisement, corporate diversification, the remote control), they have also been the Age of the Chromosome (gene-splicing, the clone, the male and the female). Indeed, social mobility (the need for and possibility of change, rooted in the post-Feudal division of experience and self), technology, which made possible both the exploitation of other people's work and the systematic perusal of their activity, and gender have been deeply interconnected; so that gender has been established as something to spy on *and* a way of spying (Mulvey), something to profit by (Armstrong and Armstrong), and a kit-bag of occupational and recreational tricks as well. Before 1925 it was already not only possible but internationally necessary for men and women to conceive of themselves in terms of images held up not as static aesthetic ideals but as a shuttling currency of representation, and the movie star, originally invented for economic diversification in film production (Gomery), was both a cause and an effect of this situation.

1

Further, in the aftermath of the First World War, the nineteenth-century male was broken, and the nineteenth-century female was obsolete. The change in the structure of labor concomitant with the Second World War produced a state of affairs in which gender identity was only a shard in the ineffable mosaic of the self, when earlier it had been more diffuse and more thoroughly integrated both socially, theologically, politically, and philosophically in a worldview where people were known, if fixed, markers in a relatively predictable scene. Gender had become a mask that could be worn—and taken off—so that by the end of the twentieth century the entity that had once been seen as a solid biological fact was now a matter of cultural, linguistic, dramaturgical, and economic convention, a probability, a ghost.

Seen in the contemporary context, some of the more notable developments in gender portrayal in film from 1960 onward may seem tacit, unremarkable, even regular, not to say "naturalized." The rejection of behavioral conventions that began in many ways with Hitchcock—a flattening of the aesthetic of prudery, a motive toward adventure in women and a comprehending softness in men—was developed by producers and responded to by audiences in terms of comedy (*Cat Ballou* [1965], *The Apartment* [1960]) and serious drama alike (Claire Bloom and Richard Burton in *The Spy Who Came In from the Cold* [1965]). By the end of the 1980s the active, protean female was herself so conventionalized that audiences watching *Thelma & Louise* could be astounded only by the sad gravity of the ending, in which it was possible to read the protagonists' adventure as having been brutally curbed. An age of mobility and fracture demanded *moments*: compactions and reductions of experience *between which* it was possible to move; and experience had to be chiseled, battered, exploded in order to seem momentary. So, gender portraits revealed a certain *ad hoc* situational focus, an address to the exigencies of circumstance, even as circumstances—contexts—had to be seen as changeable, as waystations that could be points of departure and arrival. Gender was *for the moment*, for the scene, and changed with some frequency. And it was to the prison of the nineteenth century—perhaps especially the very late nineteenth century—that we confined those whose gender performance and/or sexual need seemed wearily fixed or obsessive, such as von Eschenbach (Dirk Bogarde) in Visconti's *Death in Venice*.

Similarly, our fascination for telecommunications and electric light made for visions with new kinds of shadow. Darkness now held not the mere scaffolding upon which a perduring gender identity had been built

(on the use of scaffoldings in general, it is helpful to watch Fellini's *8 1/2* [1963]) but also the potential to be transformed instantaneously—shockingly—into highlight. With the telephone, distance could be shrunk, the "here" made instantly into the "there." As with the new light, and with film in general, there were a myriad possible illuminations and visions of the male and the female, and with every new angle, every new cast of light and shadow, every new moment, a new gendered being was possible. So it is that films about gender confusion (*Dressed to Kill* [1980], *The Year of Living Dangerously* [1982]) could proliferate and be read as being sensible, as being features of the given terrain and not obstructive confusions themselves.

It hardly need be said, indeed, that by the 1990s the screen was teeming with new types. Following Bette Davis (*All about Eve* [1950]) and Barbara Stanwyck (*No Man of Her Own* [1949]), pariahs and paragons in their time, to be sure, the more codified and bourgeois Janet Leigh (*Touch of Evil* [1958]; *Psycho* [1960]) and Jill St. John (*Tony Rome* [1967]) were transmogrified into Jennifer Jason Leigh in *Single White Female* (1992), Demi Moore in *G. I. Jane* (1997), the hyperactive little Dot in *Animaniacs*, raspy Kathleen Turner, the diamond-cold Sharon Stone, the urchinesque Winona Ryder, the statuesque Susan Sarandon (in, say, Mazursky's *Tempest* [1982]), the kingly Vanessa Redgrave, the extraterrestrial Grace Jones. And the blindly self-assured, dignified James Stewart, Cary Grant, Gary Cooper, and John Wayne were shifted by way of the riddling music of first Humphrey Bogart, James Dean, and Montgomery Clift and later John Travolta into the sensitive, all-seeing, intellectual masculinities of Gene Hackman and Johnny Depp.

Of course gender is both an attribute and an experience. It has the characteristic of being structured—through a range of modes from hegemonic imposition to creative performance—from the outside, a topographic field, toward a pose and postulation that can be imagined as "inner"; but also of being felt sublimely and then constrained, an essence upon which, or toward which, conventionalized and conventionalizing rituals of bounding are applied. Butler has become noteworthy for articulating this distinction between the shaped and the expressed as one between "performative" and embodied gender, the former tending toward the space inhabited by Jamesonian postmodernism and the latter originating in the ethnoanthropological metaphysics of Mary Douglas. Her analysis does not make clear how performative gender is an essentially consumerist notion, a form of identification and acquisition through the

agency of packaging, or how experiential gender is propertied. A relatively long history of phenomenological and political-economic consideration precedes Douglas, to be sure, and a substantial body of thought, proceeding through Durkheim and William James to Goffman and the ethnomethodologists—especially Garfinkel's groundbreaking essay on passing—establishes the social character as a performed one.

As a symbolizing attribute, reformulated through staging, gender constitutes one of our many ways of dividing the world and then classifying and ordering the divisions. Resultant from an elaborate and culturally directed project of attribution is a class hierarchy of gender, a system of power, privilege, and past record that differentiates life chances and the quality of socially organized being. Seen from this point of view, gender is the stuff of the patriarchal system contemporary critics (like Firestone, Dworkin, and Modleski) have sensibly seen as an aggression and a hegemony. It is toward the hegemony of male dominance—a dominance, Marilyn French astutely points out, not so much of male persons as of male interests—that the spectral array of feminist argumentation has been aimed. And it is the hegemony of male dominance that critics who take films as representations of the social world in which they have been made claim to see typified, depicted, alluded to, or dismissed in most contemporary motion pictures. In this volume, for example, Gina Marchetti sees Clara Law's migration trilogy as a reference to a tension between patriarchal and traditional Chinese gender codes and the hybridizing pressures in the Chinese diaspora. That tension exists before films show it, as a feature of late-twentieth-century patterns of migration, acculturation, and socio-economic adaptation. The films *Autumn Moon, Farewell, China,* and *Floating Life* reflect it, at least partly. In the same critical vein, using film as reflection, Murray Forman writes about male-male interaction in Cronenberg's *Crash*, basing his argument on a sensitive perception of trends in behavior and lifestyle in the real world, typified and exemplified (directly) in narrative film. Cronenberg is thus shown to be revealing something about masculinity in our culture, masculinity in real lived life, not merely playing a road game with wounded bodies.

Two things can be said broadly about gender as a socially attributed characteristic, at the end of the twentieth century. It looks different than it did before, and its looks, as symbols to be read as verisimilitudinous, are more problematic.

As a mask, or public face—how many genders are there, and what suffices as a presentation of any one of them?—gender is constructed and

disported through the agency of conventions, and as the century has worn on, these have significantly changed. Men have seemed to acquire delicacy, but a sort that lacks maturity; perhaps it could be said they have preserved childish sensitivities—see Ballard in *Crash* by way of Forman, or Ralph Fiennes's performance in Bigelow's *Strange Days* by way of Barry Keith Grant. Women have become more serious, often, in films admired and also loathed by female critics and viewers—such as *Thelma & Louise*—dangerously so (for them and for men they encounter). Janice R. Welsch's discussion of Ridley Scott's important film reveals some of the latent reasons why its audience should have been so split. And Lenuta Giukin's foray into the world of Hong Kong action pictures displays variants of the cross-dressing female action hero, raising the importance of costume in the gender masquerade. Hamid Naficy's eloquent analysis of the films of Rakhshan Banietemad positions her work as a methodical breakout against traditional gender conventions of the Iranian culture in which both the work and the working are embedded. Contrariwise, Michael DeAngelis provides a reading of Johnny Depp's performance in *Dead Man* as a model of a rule-breaking and revolutionary form of manhood. And Kevin S. Sandler's analysis of *Space Jam* and the Warner Bros. cartoon crowd nicely shows that gender can be pinned to the flat surface of animated, as well as three-dimensional, being.

Indeed, it is virtually impossible at the turn of the century to regard gendered portrayals in film—certainly Western film, but increasingly film around the globe, as Naficy, Marchetti, Giukin, and Woodward demonstrate—as straightforwardly prescribed by the Victorian conventions that guided filmmakers even through the refractive 1960s. Walter Bryan had appeared, if only momentarily, as a sensitive flower-sniffing male as early as 1928 (in *Queen Kelly*), but male sensitivity was framed (and closeted) as quirkiness through the 1930s and 1940s (Cary Grant in *Bringing Up Baby* [1938]), emerging in the 1950s as psychopathology (James Stewart in *Vertigo* [1958]). From *Easy Rider* (1969) through the 1970s, with few exceptions, sensitive males were inward and presocial; a nice example is Elliott Gould's chilling portrayal in Bergman's *The Touch* (1971).

And through the history of film, again with only sporadic—even if well-publicized—contradictions, women were emotive and powerless. The image of Monroe on the subway grating from *The Seven Year Itch* (1955) is an icon of self-indulgent, even solipsistic, nervosity constructed as beautiful. Until Jane Fonda's proactive, power-conscious, eponymous performance as Klute (1971), only Hitchcockian female protagonists

could be counted on for intellectual capability (Doris Day in *The Man Who Knew Too Much* [1956]), dramaturgical skill ("Tippi" Hedren in *Marnie* [1964]), and active curiosity (Julie Andrews in *Torn Curtain* [1966]), even if these qualities were camouflaged within the culturally approved rhetoric of home, love, marriage, and motherhood. The purposive woman of the late twentieth century—Louise (Susan Sarandon) in *Thelma & Louise,* the eponymous *Fifth Element,* Leeloo (Milla Jovovich), Luc Besson's Nikita (Anne Parillaud), Lelaina Pierce (Winona Ryder) in *Reality Bites* (1994), Ripley (Sigourney Weaver) in *Alien* (1979)—seems to emerge from the apparently ominous but ultimately vulnerable *femme fatale* by way of the kind of transformation effected upon the "good" woman by Hitchcock, or, say, Samuel Fuller in *The Naked Kiss* (1964): the moral power of the female is stripped completely away from her sexuality and grounded, as men's morality was, in practice, work, socialization, position, class. What is then made possible, late in the 1990s, is the kind of portrait of femininity we see in Shekhar Kapur's *Elizabeth* (1998): an eager and sensitive yet inconstant female Passion capable of being annealed into a fierce, feelingless female Purpose.

Gender styles, at any rate, have been at least inverted, so that Marilyn Monroe can survive only as a comedic figure, and so that the comedic figure that was once Gloria Swanson in *Sunset Blvd.* (1950) is now hard and practical and utterly real. Mastroianni's Guido in *8 1/2* spawns hundreds of other confused, static, pretty, and manipulable men—from John Travolta in *Saturday Night Fever* (1977) through Will Smith in *Six Degrees of Separation* (1993) to Ethan Hawke in *Great Expectations* (1998)—all of them beginning, as Leslie Fiedler put it in 1965, "to retrieve for themselves the cavalier role once piously and class-consciously surrendered to women: *that of being beautiful and being loved.*" Yet, consistently, beauty is powerlessness, so access to sexual reward meted out by the state as a means of assuring and promoting valued militaristic behavior (see Harris) can now be seen in films as not only the marketing to strong men of gorgeous (read helpless) women but also the marketing to men who can successfully connive and strategize of pretty, and militarily inutile, boys. John Sakeris has explored the disempowerment of the good-looking "sissy" at the hands of the industrial establishment in his study of the gay image, and particularly *In & Out.*

So the masks of gender are different—switched, turned upside-down, dragged inside-out. When I was growing up in the 1950s, however, something could have been said about the way gender identity was

styled and worn that cannot so easily or so unambiguously be said today. Regardless of what it looked like, the mask was sufficiently proximate to the face, and so rarely—if ever—adjusted or removed, that it could be thought to have a genuinely descriptive, even predictive, value. If gender was a performance, it was seamless. To go even further—as far, say, as critics and thinkers tended to go at that time—the mask was sufficiently unremoved from the face as to be equivalent to it; so, at least in everyday life, there was no mask. What we would now quite confidently call the "masquerade"—a scam that no reasonable thinker can take as being *really about* our lives—*did* describe and reflect the social world. As Thomas and Znaniecki put it, things believed to be real were real in their consequences. Though the imagining of some things to be real was one's only available option: women, for example, behaved as though they held positions subordinate to men's, but in the 1950s they had few options to do otherwise; then they were indeed subordinate; their power was mainly the power to gossip, inform, and effect discourse. From the early 1950s onward women did not tend to provide family incomes, and they exercised only as much control as their husbands delegated. Flamboyant contemporary parodies of this era, such as *Pleasantville* (1998) or the somewhat more ancient *Back to the Future* (1985), are very accurate in this respect.

But the masks of gender in the late 1990s may be less rooted in cultural practice, an expression of hope more than social fact; or a clever deception built and re-built to guide us away from the pathway to equality instead of toward it. Surely, much of the critique in this book seems perceptively to note a conservative, atavistic political abreaction beneath the surface of the apparently renovated society of sensitized men and empowered women we see laid before us on movie screens day after day. Liberation is everywhere, *but only as a garb*; and under it is the same old disenfranchisement, the same old inequality, perhaps even more brutal now than ever because painted as something else. Many of these chapters hint at what Barry Keith Grant openly suggests, that "new" filmic treatments are not as new as they purport to be. Sakeris sees the dispersion of homosexual portraiture with suspicion because at the core films continue to place gays in narrative compromise. As much as they claim to be inventing new kinds of stories about new kinds of men and women, Grant and Sakeris both suggest, filmmakers continue the old hegemony, the old domination, the old formula, the old "truths." In her analysis of eating and gender, Rebecca Bell-Metereau wrestles with this analysis,

showing that a certain kind of dependent femininity is preserved in many filmic sequences that purport to adventure into new territory. While we have remodeled the masks and performances, then, we have also loosened the connection between performance and social structure so that what conditions look like matters less and less.

I think no recent film more compactly or more directly exemplifies both what has commonly come to be thought of as the reversal of gender roles and the persisting underlying hegemonic dominion of male control even in the face of it, than Norman René's bizarre and haunting *Prelude to a Kiss* (1992). A twisted Cinder(f)ella/Sleeping Beauty tale, this film centers on a chance meeting, and instant gravitational attraction, of unemployed and adorable Peter (Alec Baldwin) and bartender Rita (Meg Ryan). Discovering that they have much in common, and that they are in love, they fall in with one another and she is soon bringing him home to meet her conventional suburban parents (Patty Duke, Ned Beatty). They marry. In another part of town, however, Charlie, an aging Alzheimer's case (Sydney Walker) wanders away from his home, onto the public transit, and off to suburbia, where the wedding is taking place. Lured by the strains of the music, he finds his way into the party and at a crucial moment asks to kiss the bride. The identities, or personalities, of the two are preternaturally exchanged at this moment, Ryan becoming the old man; and the old man becoming the spirit and essence of Peter's new wife. It is Charlie, for example, in Rita's body, who accompanies Peter on the honeymoon.

This is a profoundly interesting film, for its many plays upon the Shakespearean and the Hollywoodian; but it illustrates my present point powerfully in two moments. First, Peter's and Rita's "new"—that is, 90s—masculinity and femininity are shown very early in the film as they meet at a party given by a mutual friend (Stanley Tucci). Dancing to the Divinyls' song "I Touch Myself," Rita, leonine, Kaliesque, and artfully aggressive, virtually pounces upon Peter, shy, bespectacled, intimidated, and almost literally floored by her. This is a moment that prepares us handily for Peter's journey of self-exploration and self-discovery in this film since Rita and the old man's escapade in one another's bodies will constitute a play-within-a-play in which old-fashioned femininity and masculinity are converted *in extremis*; and it is only by learning to accept the new gender styles, or, as the narrative has it, the transcendence of inner spirit over outward manifestation enacted in this extended charade, that Peter will be able to keep his bearings and love his wife while she

seems to be an old man. Neither Baldwin nor Ryan has ever given a more intelligent and meticulous performance.

But *is* Rita not passive, nor "girlish," as the allegorical structure permits the film to hint? *Does* she participate in the dominant culture that is Peter's by birth and that, indeed, he must work hard to escape even briefly? The narrative requirement, in scenes before the identity exchange, that the two must not only marry but do so in a conventional, bourgeois, even suburban style; or that when they have a fight later on she should "go home to mother"; or that Peter must gain the approval of her parents, but especially her father, before the wedding can take place position this film on one level at least as a conventional gender portrait in an age when Hollywood takes some credit for flaunting conventionality. And old Charlie, as Rita's replacement, is poetic and soft, not muscular (like Rita's dad). The bizarreness of the film not only increases its aesthetic effect (and powerfully) but also aligns it with the project of critical unconventionality Hollywood extends through other "inverted" gender depictions—River Phoenix's many "soft" roles, for example, as in *My Own Private Idaho* (New Line Cinema, 1991) or *Running on Empty* (Warner, 1988) or Keanu Reeves's in *Little Buddha* (Miramax, 1993). The gender portraits are fascinating but also phantasmagorical.

It is, however, hardly necessary to watch films hungrily in order to derive this kind of reportorial analysis of gender as a social fact. If gender is seen as an identifier (of both class and status), it is essentially grammatical, part of a language that bounds, cuts, interrelates, negotiates, contains, and ultimately disperses a socially organized and now typically stratified world. To see this and derive a consistent argument about and against the enormous disparities between men's and women's experience in capitalist society, one need only look at snapshots or advertising photography, as Goffman has nicely shown; read the newspaper to see which articles, about what demographic categories, are placed where (see Miller); simply look around, as Greer did; or examine financial statistics, like Wolf. Berger's ground-breaking *Ways of Seeing* and Mulvey's "Visual Pleasure and Narrative Cinema," which followed it, do, in a way, examine and catalog, focusing on pictorial and narrative instantiations of power imbalances taken as reflections of "real" or "typical" conditions in the social world. But one can analyze the turns of plot, character developments, body positions, and narrative outcomes in this way *without* reference to most of what makes film filmic: movement, memory, illumination, harmony, composition, unity, fracture, echo, pulse, uncertainty, need, subjectivity.

Each of us who experiences life, no matter how it is politically organized or culturally constructed for us, knows, too—as much as convention, portrayal, privilege, position, and social form—the facts of embodiment and desire, duration and motion, illumination and enchantment, composition and repose. So it is that we are not only social subjects and constructors of meaning but also speakers with memory. And so it is that we can take films not only as documents but also as expressions, as poiesis. If a film can show us a gendered individual whom we can recognize, and if it can show how social forces conspire to shape and constrain classes according to classifications of gender, it can also narrate a circumstance we apprehend and experience as gendered *viewers*. A history of film as a gendering culture in itself can be written. Without recourse to a group of guyings that affix any given narrative to some typical cultural base in an "actual" world, we can discover in the history of our own observation and response a filmic continuity—indeed, with generations—which culturizes us as a gendered, really generic, audience. As an artistic world, the world of film is far too complex to contain in its surface only males and females, and only one type of each for that matter. What is the diva in *The Fifth Element* (1997), a female? What is Yoda, a male? *The Neverending Story* (1984) has Rolf Zehetbauer's characteristic, generic stone wall, neither male nor female, but rockiness. *2001: A Space Odyssey* (1968) and *Star Trek* (1979) have generic spaceships, oddly formed, swiftly and variably— even sexily—moving. If in watching a film we open ourselves to the fully expansive range of stimulation offered; if we listen not only to every line of dialogue but also to every nuance multiply buried in every line—and if we not only watch the objective, commercial content of each shot but also attempt to appreciate the compositional qualities of the surface a shot presents—and if we also take the sorts of pains Michel Chion has taken to hear the reverberations, philosophical and musical, of sounds—and if we then ask, how is this experience apprehended and known as an embodiment for and by ourselves with others, we may come to some approximation of an engendered *experience* of film, an appreciation, that differs from a knowledgeable decoding. Could such an experience be fully and multiply articulated, some attempts at navigation, comparison, and acknowledgment might be made.

Watching film from this phenomenological perch, it is possible for the gendered viewer to acknowledge that gender is everywhere. And perhaps at the end of the century the examples of it that seem the most interesting are those that cannot claim to reflect sociologically upon the cul-

ture we live in: Scott's (Keanu Reeves) strange fear of Mike (River Phoenix) in *My Own Private Idaho*, his frantic sexual confusion: this is not mere homophobia, this is anxious attraction recognizing itself as such; or the awkward and beautiful mix of violence and innocence in the protagonist of *La Femme Nikita* (1990); Leonardo DiCaprio's stunning, electric presexuality in *What's Eating Gilbert Grape?* (1993); Winona Ryder's shocking vitiation in *The Age of Innocence* (1993); the combination of fragility and sophistication in Betty Buckley's Sondra Walker in *Frantic* (discussed in detail in this volume by Woodward); the limpid purposelessness of Vince Vaughn's Norman Bates in Van Sant's *Psycho*; or the frank centrality of the Lady Chablis (Frank Devau) in Eastwood's *Midnight in the Garden of Good and Evil* (1997) to point at just a few. A paradigm deserving of serious attention, indeed—and studied in these pages by Gaylyn Studlar with an exceptionally sensitive and precise approach—is Tom Cruise, whose gendered presence is exemplified as a kind of paragon of capability. In his performances, a dance of skilled energy and focused intent preoccupies him from savoring his experience as we do, looking from outside and far away.

As we experience gender—as film, indeed, reflects and generates our experience of gender (over and above our recognition and observation of it)—we apprehend it as being to some degree mechanistic or wild, shared or private, expressive (musical) or withheld (pensive), bonded (to products, places, codes), or free. And in all of these dimensions, it unfolds, *pli selon pli*. A nice illustration of mechanized gender is given by both Arnold Schwarzenegger and Sharon Stone in Verhoeven's *Total Recall* (1990)—but indeed, Schwarzenegger can be counted on always to exemplify the gendered body that operates according to a blueprint. In the same way, the diabolical giant spider in *Wild Wild West* (1999) is a male aggressor, supplanting with its pistons and hydraulics the device of gender missing in the evil genius (Kenneth Branagh) who controls it. On the contrary, the gender of Edward Scissorhands (Johnny Depp) is wild, sweet because unsystematized. His flair for haircutting, for example, is naturalized, unpredictable, auteurist. Cruise's agility seems both mechanical and prodigious, but his smile and twinkly eyes are wild, animal, seductive. I think it can be argued that more and more films are curtailing this wildness, showing us mechanizations of gender.

We see gender privatized, internalized, made arcane and, in Brown's term, undemocratic (1961) if we consider Nikita in Besson's *La Femme Nikita*. A similarly arcane, because excessive and almost masturbatory,

femaleness is Bette Midler's in, say, Mazursky's *Down and Out in Beverly Hills* (1986). But gender is transacted and shared in the filmic work of Roman Polanski, as we see in Steven Woodward's keen analysis, and indeed transacted in terms of the space of social activity. Gender is also a transacted, rather than an internalized, self-referential feature in the case of the motorcycle girls Frances Gateward discusses, and her analysis, indeed, while being both critical and sociological, suggests a culture in which gendered experience has no private component at all. David Desser's discussion of the neurotic Jewish screen male of *Deconstructing Harry* (1997), *Shadows and Fog* (1992), or *Oedipus Wrecks* (1989), now repositioned in prime time network television as a significant sex object, openly poses the self-referential against the public face of masculinity: self-referentiality, inwardness, and ultimately pensive maleness are the key features of the new media character that interests him. It is especially fascinating to see that this newly inward male inhabits television screens even more comfortably than film ones. We can see in Desser's essay, then, not only precisely how television is recasting the sexually alluring male in relation to Jewish intellectualism, but at the same time how this striking trend is *not* being widely echoed in film. Other scholarship might well explore this territorializing of "personality."

For expressive gender, projecting itself outward, we need look no further than *Basic Instinct* (1992) or *Saturday Night Fever*, while Clint Eastwood's *Midnight in the Garden of Good and Evil* is a pensive, even meditative, treatment of cases themselves organized around inwardness and gendered thought. As we moved to the end of the century, perhaps filmic gender was increasingly privatized and pensive, departing from a set of earlier conventions that called for openly displayed and even sung gender, the essence Garth Jowett discusses in his autobiographical treatment of the American film musical. Certainly we are seeing more screen cues about gender as self-absorption, self-manipulation, self-pleasuring, self-consciousness, and antisociality. Almost never sung about, gender is now coded (for the internet). Gender as withdrawal is also a latent analytical theme in Krin Gabbard's analysis of jazz nerds, who experience themselves as gendered beings (and invite us to share in their experience) by retreating into desire, memory, feeling, and aesthetics. What they know of jazz is only an index of what they feel.

Jowett's memoir brings another feature of gender to the fore. It is not always a presence, aesthetic and political, but is sometimes—indeed chillingly—a memory. His reflection on the present in terms of the past

makes it especially poignant, perhaps, that much theoretical reflection casts the past in terms of the present. In this time of news bites and relentless demands for propriety, it can be a serious moral challenge to consider sexual morality and gender definition, as they were constructed in the past, as responses that were typically treated as serious and sensible at the time. Jowett's excursion also shows how present-day social construction can be rooted in prior assumption, how analytical scholarship about film can be rooted in personal experience and feeling rather than suavely disconnected from it, and how film theory in general must make sense of actual personal audience reception in a language also sensitive to cultural construction and politically biased interpretation. That many of the films written about in his essay were made earlier in the century than most of the other films referred to in this volume has only a surface bizarreness: by carefully reading Jowett in the context of the other pieces, we see with a newly enriched clarity what contemporary filmic gender constructions *are not*.

"Bondedness" is a way of seeing the manifestation of gender as a function of an object (product), place (system), or idea (ideology) systematically operated as a basis for performance. The gender of athleticism, for example, exists in the context of the playing field and its associated venues, a theme touched upon as Sandler discusses the marketing synergies that lay at the basis of the affiliation between Michael Jordan and Bugs Bunny. The gender of stardom, as Gaylyn Studlar's intriguing treatment of masculinity shows, is linked to a production system and its economic need to maintain public appeal. While all gender construction relies upon bonding to some degree, some is noteworthy because beyond the bonding there is little or no experienced identity. Movie stars of the golden age give an extreme example, retreating, as they often did, into unfamiliar status as gendered beings when they existed in the depths of their personal privacies. The "starlet" *was*, both in terms of production and experience, the pose, the makeup, the setting, the costume, the light by means of which she was built in the studio. A delightful and interesting limiting case of bonded gender is that experienced in the face of animated cartoons, which are, after all, as Sandler suggests here, nothing but lines inside a frame.

That screen gender should now address our knowledge of the social world, our labeling and our power structure and our systematic social and cultural analysis, is one of its dominant features, then. Another is its call to us as experiencing beings with an aesthetic sense and a feeling of

being in the world. While all of the chapters in this book address one or the other, or both, of these features, I have chosen to organize them somewhat loosely into three groupings. The first, "Screened Gender beyond the Hollywood Hills," gathers analyses of film outside the dominant, conventionalizing North American scene which will have shaped the experience of most readers of this book. While it cannot represent all of what was going on in film production around the world at the end of the century, it does nicely suggest the range of activity one can find and imply that there is use in looking for such a range of activity. These essays, along with those in the second section, "Genders and Doings," articulate together a cultural and structural approach, concentrating on gender identity as a known and knowable organized entity, a status, an aspect of the social world. Then, in "Paragons and Pariahs," come discussions of exemplifications of gender as an extremity, an infraction, a violation, a disturbance—all of which are intended to provoke thought about gender as a facet of experience. By closely examining what paragons and pariahs are, we may come to understand ourselves as readers and viewers who approach the world through gendered, but perhaps even marginalized, sight.

A final word. All of these chapters reflect in some touching depth not only the professional but also the personal concerns and fascinations of the authors. These are the pieces the writers have been wanting to write, but holding back, now offered as a contribution to a kind of statement about where film is, and where we are as watchers of it, at a significant enough point in history. Much care has been taken to ensure that the chapters are widely accessible, and that they reflect a broad spectrum of analytical approaches, theoretical backgrounds, and filmic concentrations. By and large, they deal with film from about 1980 onward. And they should interest students of gender, popular culture, visual theory, history, politics, culture, and language; and, above all, lovers of film.

André Bazin wrote that cinema gives us a world that accords with our desire. The films discussed here, and others like them, should be taken seriously: as evidence about the kind of world we live in; as a reflection of, or at least a hint about, what we wish our world to be. If gender is inescapable, it is also not fixed. May the reader take pleasure and find illumination in these discussions of the gendered images that flicker on our screens and wonder, perhaps, what the screen *is* that it should query us precisely in this enchanting, yet perturbing, way.

WORKS CITED

Armstrong, Pat, and Hugh Armstrong. 1978. *Double Ghetto: Canadian Women and their Segregated Work.* Toronto: McClelland and Stewart.

Berger, John. 1972. *Ways of Seeing.* London: British Broadcasting Corporation.

Brown, Norman O. 1991. "Apocalypse: The Place of Mystery in the Life of the Mind." In *Apocalypse and/or Metamorphosis.* Berkeley: University of California Press.

Butler, Judith. 1990. *Gender Trouble: Feminism and the Subversion of Identity.* New York, London: Routledge.

Chion, Michel. 1982. *La Voix au cinéma.* Paris: Éditions de l'étoile.

Dworkin, Andrea. 1987. *Intercourse.* New York: Free Press.

Fiedler, Leslie A. 1972. "The New Mutants." In *Unfinished Business.* New York: Stein and Day.

Firestone, Shulamith. 1970. *Dialectic of Sex: The Case for Feminist Revolution.* New York: William Morrow.

French, Marilyn. 1985. *The War against Women.* New York: Ballantine.

Garfinkel, Harold. 1967. "Passing and the Managed Achievement of Sex Status in an Intersexed Person, Part 1." In *Studies in Ethnomethodology.* Englewood Cliffs, NJ: Prentice-Hall.

Goffman, Erving. 1979. *Gender Advertisements.* New York: Harper and Row.

Gomery, Douglas. 1987. *Hollywood L'Age d'or des studios.* Trans. Charles Tatum Jr. Paris: Cahiers du cinéma.

Greer, Germaine. 1970. *The Female Eunuch.* London: MacGibbon & Kee.

Harris, Marvin. 1974. "The Savage Male." In *Cows, Pigs, Wars and Witches: The Riddles of Culture.* New York: Random House.

Miller, John. 1998. *Yesterday's News: Why Canada's Daily Newspapers Are Failing Us.* Halifax: Fernwood.

Modleski, Tania. 1988. *The Women Who Knew Too Much: Hitchcock and Feminist Theory.* New York: Methuen.

Mulvey, Laura. 1975. "Visual Pleasure in Narrative Cinema." *Screen* 16:3 (Autumn).

Thomas, William I., and Florian Znaniecki. 1927. *The Polish Peasant in Europe and America.* New York: Alfred A. Knopf.

Wolf, Naomi. 1991. *The Beauty Myth.* New York: William Morrow.

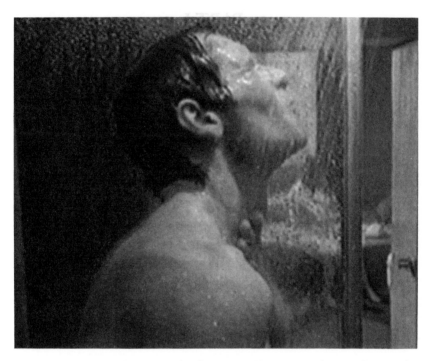

FIGURE 1. *Frantic* (Roman Polanski, 1988) We want to know what Sondra (Betty Buckley) is saying on the phone, but the camera stays resolutely inside the shower with Walker (Harrison Ford) as he imagines possibilities for passion. (frame enlargement)

CHAPTER TWO

◈

No Safe Place:
Gender and Space in
Polanski's Recent Films

STEVEN WOODWARD

GERARDO: Let's dream of happiness, my sweet girl, my bride, my savior.

PAULINA: I want us to live like suburban idiots.

—From *Death and the Maiden*

All of Roman Polanski's filmic oeuvre can be read as an extended examination and problematization of gender politics, a fact that allies if not identifies him with the feminist "project" and that qualifies the public perception of him as a manipulative misogynist. Polanski's films have always been charged with violence emanating from and oriented around sex and sexuality. His personal life has also involved a great deal of violence and a libertine indulgence in sex. Not surprisingly, then, the politics and themes of his films and of his life have become confused. And the popular media have exacerbated this confusion, using the occasions of the release of his films to examine Polanski the man. Certain details of his life—from his childhood in the Krakow ghetto, through the gruesome

murder of his first wife, Sharon Tate, and the 1977 charges of statutory rape that effectively barred him from working in the United States, to the marriage of the aging filmmaker to Emmanuelle Seigner, a woman thirty-five years younger than him—have become linked in the public mind. Polanski is pictured, in the media's grand narrative scheme, as an *enfant terrible* of the film world, "Polish terror-cum-cinematic genius" (Davis), or, as he himself reflected in his autobiography, an "evil, profligate dwarf" (Polanski, 450), who abuses his position of power to project and fulfill his own sexual fantasies. Even relatively detached film critics have confirmed this bias by focusing on the fact that in his films Polanski repeatedly makes women the victims of sexual violence.

Amazingly, even disparate details of Polanski's life are eventually made to jibe with the accepted image. The pattern for this amalgamation was established in 1969 with Sharon Tate's murder, which initially gener-ated sympathy but was subsequently interpreted, through a tenuous con-nection between the satanic elements of *Rosemary's Baby* (1968) and of the Manson cult, as the bitter fruit of a profligate lifestyle. As Polanski him-self has mused, "The victims were blamed as if they'd killed themselves in some sort of orgy of sex and drugs and black magic" (quoted in Davis). Thus, even when Polanski finally achieved parenthood in the early 1990s, critic Peter Conrad could find it "disturbing to hear Roman Polanski bill and coo at his young daughter" yet integrate that detail into his view by characterizing Polanski as a nympholeptic whose "sexual tastes express a yearning for infancy" and who "himself retains the child's charmed pre-rogative to do as he pleases and to misbehave with impunity." But if Polanski's personal excess has been condemned from the point of view of normality, he has countered by thematically and symbolically challenging his audience's construction of normality itself.

The symbolic use of space is not new to Polanski. From the start of his career, he has used filmic space—either extremely confining or hope-lessly featureless—to define power relationships among his characters and to force confrontations between them. From *When Angels Fall* (1959), set in an underground washroom, through *Mammals* (1962), where two men move through a neverending vista of snow; *Knife in the Water* (1962), in which the action occurs on the tiny cabin and deck of a sailboat; *Cul-de-sac* (1966), with its small castle on Holy Island cut off from the mainland by the inundations of the sea, to *Repulsion* (1965), *Rosemary's Baby*, and *The Tenant* (1976), where the apartments are essentially prisons, his char-acters are physically, socially, or psychologically stranded in their environ-

ments. Even when he does not employ a physically limited constricting and reassuring space, he creates a dynamic visual instability based on the degree of enclosure of his characters. As an example, in *Macbeth* (1971) he used a wide-screen format to express the barren expanses of the landscape, the insignificance of human life and action within these expanses, and the physical and emotional estrangement of one character from another. In *Bitter Moon* (1992), an impotent American writer seduces an inhibited Englishman while both are bound on a shipboard voyage with their wives. In *Death and the Maiden* (1995), a woman who has suffered rape and torture under an authoritarian regime is given the chance to confront her rapist in her own home. In *Frantic* (1988), an American couple must abandon a Parisian *hôtel de grand confort* for the decrepit and threatening night world of the city.

Frantic presents the story of Richard Walker (Harrison Ford), a surgeon who comes to Paris for a medical conference and finds that everything has changed since he honeymooned there twenty years earlier, and his loyal wife, Sondra (Betty Buckley), a woman upon whom he is totally dependent to organize his life and keep him on schedule. Within an hour of their arrival at a hotel in the heart of Paris, however, Sondra has vanished. In the face of the indifference of the police and of the staff at the American Embassy, Walker has no choice but to find her by himself, and this inevitably involves an immersion in a more sordid, if also more intoxicating, Paris. Leaving behind the safe haven of his hotel and forgetting his presentation at the conference, Walker teams up with an alluring young Parisienne, Michelle (Emmanuelle Seigner), who has inadvertently been the cause of his wife's abduction and who is part of the "other Paris" into which Walker has been obliged to descend. After a number of bungles, he orchestrates an exchange of his wife for the electronic device her abductors, Arab agents, crave.

The coding of the film's diegetic and visual spaces is evident from the opening credits, indeed, where the titles recede away from us as we speed along a highway toward the horizon, an unnamed metropolis. This view is gradually dissolved into a close two-shot of a sleeping Sondra resting against a sombre Walker in the back seat of a car. The sense of disorientation effected by the titles and these limiting views is matched by the first dialogue of the film. As reggae music fills the cramped space of what turns out to be a taxi, Sondra asks Walker, "Do you know where *you* are?" (my emphasis). His reply—"No, it's changed too much"—is accompanied by one of Ford's acting hallmarks, the wry twist of mouth that has

to create an identity beyond what is available to him by convention as doctor and husband. Taking action forces him to enter a world of more polymorphous appetites than he has yet experienced, to regress to a more infantile self, to play with the other characters.

Indeed, if Sondra is a competent mother figure, the rest of the characters, including Michelle, are essentially children. The degree of incompetence of all the male characters is notable, from Walker himself, through the Israeli agents and the staff at the U.S. Embassy, to the Arab agents. All are playing the Spy Game. Young and morally irresponsible, Michelle comes back from San Francisco with a toy streetcar and a little statue of liberty for Dédé; but she cannot calculate the amount that is still owed to her for her smuggling job and in her childish incompetence picks up the wrong baggage at the airport—a muff that precipitates the entire misadventure. In fact, Walker enters a kind of toyland when he enters Michelle's world. When she is being interrogated by Israeli agents, he emerges from her bedroom, a teddy bear held in front of his genitals.

Growing up requires coming to understand not only the significance of the words we use to refer to things, but also the nature of things themselves, and in *Frantic* the scale of things is difficult to fathom. Walker confuses the tiny model of the Statue of Liberty with the much larger, but still reduced, version of the statue at the Pont de Grenelle (when he awakes on Michelle's friends' barge). And the tiny Krytron device is paradoxically concealed inside the toy statue—the world is miniaturized. Michelle's toy streetcar brings all of San Francisco—the Walkers' past—to the present Parisian adventure in miniature. Also, the scale of things and the relative weight of meaning are confused. The Krytron, for example, is very valuable and very important, its tiny size notwithstanding. Finally, the absurdity of the entire adventure is underlined when, at the end of the film, Walker throws the Krytron into the Seine, thereby ending the "game."

If *Frantic* has received less, or at least more moderate, critical response than either *Bitter Moon* or *Death and the Maiden*, it is because Polanski's themes are more covertly represented in what appears to be a genre film. But this suspense story, jumping between the institutionalized spaces of airport, hotel, parking lot, nightclub and domesticated home and the uncharted shadows of the city at night, hides a suspension of a different kind, a suspension of a normal married existence and the male and female identities that support it.

Bitter Moon provides a vastly extended and overt version of the covert male fantasy of a passionate escape from home space embedded in

ments. Even when he does not employ a physically limited constricting and reassuring space, he creates a dynamic visual instability based on the degree of enclosure of his characters. As an example, in *Macbeth* (1971) he used a wide-screen format to express the barren expanses of the landscape, the insignificance of human life and action within these expanses, and the physical and emotional estrangement of one character from another. In *Bitter Moon* (1992), an impotent American writer seduces an inhibited Englishman while both are bound on a shipboard voyage with their wives. In *Death and the Maiden* (1995), a woman who has suffered rape and torture under an authoritarian regime is given the chance to confront her rapist in her own home. In *Frantic* (1988), an American couple must abandon a Parisian *hôtel de grand confort* for the decrepit and threatening night world of the city.

Frantic presents the story of Richard Walker (Harrison Ford), a surgeon who comes to Paris for a medical conference and finds that everything has changed since he honeymooned there twenty years earlier, and his loyal wife, Sondra (Betty Buckley), a woman upon whom he is totally dependent to organize his life and keep him on schedule. Within an hour of their arrival at a hotel in the heart of Paris, however, Sondra has vanished. In the face of the indifference of the police and of the staff at the American Embassy, Walker has no choice but to find her by himself, and this inevitably involves an immersion in a more sordid, if also more intoxicating, Paris. Leaving behind the safe haven of his hotel and forgetting his presentation at the conference, Walker teams up with an alluring young Parisienne, Michelle (Emmanuelle Seigner), who has inadvertently been the cause of his wife's abduction and who is part of the "other Paris" into which Walker has been obliged to descend. After a number of bungles, he orchestrates an exchange of his wife for the electronic device her abductors, Arab agents, crave.

The coding of the film's diegetic and visual spaces is evident from the opening credits, indeed, where the titles recede away from us as we speed along a highway toward the horizon, an unnamed metropolis. This view is gradually dissolved into a close two-shot of a sleeping Sondra resting against a sombre Walker in the back seat of a car. The sense of disorientation effected by the titles and these limiting views is matched by the first dialogue of the film. As reggae music fills the cramped space of what turns out to be a taxi, Sondra asks Walker, "Do you know where *you* are?" (my emphasis). His reply—"No, it's changed too much"—is accompanied by one of Ford's acting hallmarks, the wry twist of mouth that has

been part of his boyish charm from *Star Wars* on. When the taxi gets a flat tire and the driver pulls over, loudly uttering a string of imprecations in an uncertain language, our disorientation is magnified. Polanski uses this tension of uncertainty to establish two different kinds of space in these opening shots: the disorienting and unsafe territory of the highway beside which we are stranded and the confining but protective nest inside the cab. Significantly, these spaces will become coincident with two different views of gender: a sexually and morally transgressive domain represented by the dark urban "underworld" of clubs and drugs and by sexual promiscuity and the limiting and comforting gender roles defined by family life, represented in the film primarily by the supposedly safe space of the Grand Hôtel Intercontinental at which the Walkers are staying.

From a low shot of the first taxi stranded beside the highway, we cut abruptly to the interior of a second taxi and the sound of typical Parisian accordion music. A dog pants over the seat back toward Sondra and Walker, who are both now fully awake but separated, sitting at opposite edges of the frame. As the taxi gets stuck behind a garbage truck somewhere in the center of the city, the accordion music falls off-key and Sondra asks again, "*Now* do you know where you are?" Walker does, and we do too as the garbage truck veers away, revealing a view of the Eiffel Tower at the end of a boulevard—a stereotypical, postcard, romantic Paris.

As the Walkers check in at the hotel, we are given a few more clues about the domestic nature of their relationship. While it is Walker who signs the registration form and searches vainly in his jacket pocket for their passports, it is Sondra who pulls both passports from her bag and asks the concierge if he would be "kind enough to hold the doctor's calls." If Walker is the nominal head of the family and a protector figure, Sondra is the one who quietly manages their affairs. She speaks French (falteringly), understands the phone system, and hands Walker passports, airline tickets, and his reading glasses like a nurse handing instruments to a surgeon. But in these early scenes in the hotel, sexual tension arises. The Walkers have come to Paris a day ahead of schedule for a quiet cuddle, but the conference organizer has left Walker an invitation to lunch at the Jules Verne restaurant. Sondra jealously teases him about the wonderful view he and his friend will have, lunching on the Eiffel Tower. But if Sondra is jealous of the homoerotic intimacy between the two doctors, Walker soon has reason to be jealous of her, learning in a call home to San Francisco to check on their kids that a man has telephoned for Sondra from Paris. Indeed, while he phones TWA to try to track down a lost bag, she is in the shower, blissfully singing

Cole Porter: "Why, oh why do I love Paris?" an interesting question, to be sure, to which the lyric supplies an answer, "Because my lover is here . . . near . . . is here." The ambiguity in the song reference—*here* in the hotel room/ *nearby* the hotel, where someone she is waiting for may be waiting for her—is amplified when, moments later, Sondra disappears. At this point, the meaning of Sondra's disappearance is as uncertain for the audience as it is for Walker. Frustrated by his unfulfilled amorous promises, perhaps she has run off with a Parisian lover, as the hotel detective and embassy staff suggest. However, if we were to read her disappearance from the narrative in a psychoanalytic light, we might wonder if Walker himself has willed it, if both he and the voyeuristic audience want a Parisian story of deeper adventure than one presided over by the managerial/maternal Sondra. Walker, after all, wants his youth and the uninhibited sex, driven by passion, that accompanied it, the kind of sex tasted perhaps on their honeymoon many years before, part of the allure and promise of Paris itself. But Sondra is unwilling to play along with the fantasy, which thus becomes his alone. What makes the tension between the possibility of her infidelity and the possibility of his projection stunning and chilling is the third possibility, that evil has fallen upon her and that he does not yet know it.

The point at which Walker's elimination fantasy begins could be very clearly demarcated in the narrative. After Sondra complains that she has nothing to wear and will have to go on a Parisian shopping spree (a defining experience for the domesticated housewife we have been taking Sondra to be), Walker proposes a suggestive, yet also chaste, alternative: "You won't need anything to wear for the next twenty-four hours." But as response to this suggestion that they relive the passion of their honeymoon, Sondra insists on taking a shower; and it is ultimately because of her need to be respectably clean in a world she has perfectly ordered, her refusal to submit to (dirty) passion, her insistence, even by implication, that her husband should be clean, too, that she is abducted—for it is while Walker is taking his cleansing shower that a man lures her by telephone from the lobby. We want to know what Sondra is saying on the phone, but the camera stays resolutely inside the shower with Walker as he imagines the possibilities for passion Sondra's shopping spree will sever. She is in the background, seen vaguely but not heard through the shower door. When she tries to explain what is going on, Walker doesn't bother to open the shower door the better to hear her. We watch her exasperated charade but cannot imagine its meaning. Walker expects that competent Sondra will take care of the problem, whatever it is.

But if Sondra's disappearance is partly a product of Walker's stifled fantasy, her absence also renders him helpless. His entire world becomes somewhat infantile and he becomes just one of many incompetent men in the film, a fact that is sometimes rendered in slapstick style, as when he tries to walk over the slick slate roof to Michelle's apartment or when Williams (John Mahoney) and Shaap (Jimmie Ray Weeks), American embassy bureaucrats, careen into each other after being blinded with pepper spray at the Café du Midi. And although the hotel concierge, manager, and head of security exude competence, they can only follow procedure and the law of hospitality, which say nothing about the exigency of kidnapping.

In his search for Sondra, Walker is forced to transgress, or at least to appear to transgress, the boundaries of heterosexual marriage. In search of a mysterious personage named Dédé (Boll Boyer) at the Blue Parrot club, Walker meets a Rastafarian drug dealer (Thomas M. Pollard) who puts his arm around him and leads him into a stall in the men's washroom to show off the "White Lady." Visiting Dédé's apartment, Walker finds the character a decaying, and extremely androgynous, corpse. When he returns to his hotel with Dédé's answering machine tape, Walker must proposition the handsome concierge Gaillard (Gérard Klein) to "come to my room for a moment?" in order to get a translation. And Sondra's jealousy about his "lunch date" with the conference organizer suggests that she, at least, expects the two men to be sharing intimacy on some level.

Even more likely seems the transgression of adultery. The possibility of an affair between Walker and Michelle is, of course, a strong factor from their first meeting, when he ambushes her at Dédé's apartment and they roll down the stairs together, remaining remarkably unscathed by their tumble. As the two spend more and more time together, the possibility of a sexual tryst increases. Echoing the opening scene of the film, they drive out to the airport together, pulling off the autoroute at one point not because they have a flat but because Michelle believes they are being followed. Polanski plays on the idea that the only possible relationship between two such different social types is sexual. At the airport, they run into some of Walker's American cronies (David Huddleston, Alexandra Stewart) who are clearly both titillated and disturbed by his "little friend." Back at the hotel, in front of the police and the hotel staff, he pretends to pay Michelle for services rendered. And at A Touch of Class, the nightclub "for old jerks," he is recognized by an Arab doctor who teases him about "having fun" with Michelle.

But in contrast with the appearance of their relationship from an outside perspective (a perspective that also represents the wish of the

voyeuristic audience), Walker forcefully retains a chaste distance from Michelle. When she undresses in the bedroom of her apartment, he shuts the door on the sight. When on the dance floor at A Touch of Class she contorts her body suggestively against his, with a number of Arabs leering at her, he repositions her hands and tries to adopt a more conventional dance step. Nor is Michelle just lustful in her interest in Walker—two very clear shots over his shoulder show a direct and open look that signals an increasing emotional attachment to him. Polanski is careful not to supply any corresponding shots of Walker's reaction to these looks. We can judge him only by his actions, which are chaste but caring (as a doctor's may be expected to be).

Walker's relationship with Michelle conjures up a figure not just of adultery but also of incest. Michelle is clearly a surrogate for Sondra, one who literally leads Walker by the hand through an unknown Paris. By the end of the film, in fact, Sondra and Michelle match in their scarlet dresses, though Michelle sports a leather biker jacket, too. As a result, as some critics astutely observed, Michelle "must be martyred when her predecessor is restored" (Conrad). But Michelle also stands for the youthful, more passionately sexual Sondra of the long-lost honeymoon and for Casey, the Walkers' daughter.

Interestingly, the confusion of Walker's gender role and identity is signaled by a confusion of space. What becomes clear as the film progresses is that the two kinds of spaces defined in the opening sequence, the domestically secure hotel room and the wild and unpredictable nocturnal city, are not very distinct. As they become more and more immersed in an uncertain intrigue—as Sondra is abducted from the hotel and Walker enters the Parisian night world—it's clear that their home territory in San Francisco has been invaded, too: in Walker's first call home he was mildly unsettled to hear that a man had phoned for his wife, but in his second call he hears as part of the background sound of his daughter's party precisely the same "oldie" that Michelle played in her car driving him back from the airport (Grace Jones's cover of "I've Seen That Face Before"). If men and women use space as a way of creating gender identities, of defining themselves against a physically distinct and distant other, then the confusion of space inevitably results in a confusion of identity. When Walker is on the phone home, he is simultaneously huddled in Michelle's Volkswagen. He is Casey's father and Michelle's nocturnal friend in one breath. The film can be read, then, as being about Walker's coming-of-age, his learning to feel what is important and acting

to create an identity beyond what is available to him by convention as doctor and husband. Taking action forces him to enter a world of more polymorphous appetites than he has yet experienced, to regress to a more infantile self, to play with the other characters.

Indeed, if Sondra is a competent mother figure, the rest of the characters, including Michelle, are essentially children. The degree of incompetence of all the male characters is notable, from Walker himself, through the Israeli agents and the staff at the U.S. Embassy, to the Arab agents. All are playing the Spy Game. Young and morally irresponsible, Michelle comes back from San Francisco with a toy streetcar and a little statue of liberty for Dédé; but she cannot calculate the amount that is still owed to her for her smuggling job and in her childish incompetence picks up the wrong baggage at the airport—a muff that precipitates the entire misadventure. In fact, Walker enters a kind of toyland when he enters Michelle's world. When she is being interrogated by Israeli agents, he emerges from her bedroom, a teddy bear held in front of his genitals.

Growing up requires coming to understand not only the significance of the words we use to refer to things, but also the nature of things themselves, and in *Frantic* the scale of things is difficult to fathom. Walker confuses the tiny model of the Statue of Liberty with the much larger, but still reduced, version of the statue at the Pont de Grenelle (when he awakes on Michelle's friends' barge). And the tiny Krytron device is paradoxically concealed inside the toy statue—the world is miniaturized. Michelle's toy streetcar brings all of San Francisco—the Walkers' past—to the present Parisian adventure in miniature. Also, the scale of things and the relative weight of meaning are confused. The Krytron, for example, is very valuable and very important, its tiny size notwithstanding. Finally, the absurdity of the entire adventure is underlined when, at the end of the film, Walker throws the Krytron into the Seine, thereby ending the "game."

If *Frantic* has received less, or at least more moderate, critical response than either *Bitter Moon* or *Death and the Maiden*, it is because Polanski's themes are more covertly represented in what appears to be a genre film. But this suspense story, jumping between the institutionalized spaces of airport, hotel, parking lot, nightclub and domesticated home and the uncharted shadows of the city at night, hides a suspension of a different kind, a suspension of a normal married existence and the male and female identities that support it.

Bitter Moon provides a vastly extended and overt version of the covert male fantasy of a passionate escape from home space embedded in

the suspense elements of *Frantic*. A young English couple, Nigel (Hugh Grant) and Fiona Dobson (Kristin Scott-Thomas), entertain the hope of rejuvenating their sterile marriage on a cruise ship bound for Istanbul and India. But instead, Nigel finds himself allured by a sensuous French-woman, Mimi (again, Emmanuelle Seigner), and subsequently accosted by her American, wheelchair-bound husband, Oscar (Peter Coyote). In the hope of having Mimi and no doubt voyeuristically titillated in the interim, Nigel listens to Oscar's sordid tale of his and Mimi's Parisian passion and its enervating aftermath. Oscar's story is, in fact, a long moral tale about the price of passion, a tale that ends only with the death of Mimi and of the storyteller himself. The moral is given in Oscar's last words to Mimi: "We were just too greedy, baby. That was all." (The significant play of the title with "honeymoon" is more evident in the French, where *lune de fiel* is only one letter distant from *lune de miel*.)

Like *Frantic*, *Bitter Moon* is composed of a number of distinct spatial worlds that are forced together. And again, the idea of the opposition of a safe constriction and a dangerous liberation is suggested in the opening title sequence. The shot pulls back from an open blue-grey expanse of ocean to show the frame of a ship's porthole, then moves in again to the unrestricted view (with an obvious sexual pun, too). Going all the way "out" is dangerous and unbounded; retreating all the way "in" is safe and neatly framed. We cut to Nigel and Fiona gazing out over the sunlit sea, demonstrating a rather conventional affection for each other. When Fiona disappears for a length of time in the ladies' room, Nigel goes in after her and finds her comforting a distraught Mimi. Walking Mimi around on the deck to give her "a deep breath of fresh air," they tell her that they are going all the way to Istanbul, then flying on to Bombay. But when they ask her, "How far are you going?" her reply is equivocal: "Oh . . . further. Much further." And in fact, both Nigel and Fiona are drawn, through Oscar's subsequent tale, into a journey far beyond the horizons of their own conventionalized heterosexual expectations, one that is ultimately constricting rather than liberating.

That Fiona and Nigel are voyaging to reawaken passion becomes evident as they sit in the restaurant, discussing their reasons for going to India with an Indian man, Mr. Singh (Victor Bannerjee). While Nigel rhapsodizes about "inner serenity," Mr. Singh counters that India is "all flies and smells and beggars" and "the noisiest place on Earth." And when Fiona explains that this trip is Nigel's present to her on the occasion of their seventh anniversary, Mr. Singh deduces another meaning: "Ah, so it's a form of marital therapy! Quite unnecessary, dear lady. With a wife as

beautiful as yourself, any man would be proofed against the seven-year itch, what?" But Nigel is blind to that beauty, unaware of what Oscar later describes as Fiona's "untapped potentiality," and entirely conventional in believing that passion lies outside of convention. He quickly develops the itch when he sees Mimi dancing alone in the bar and she challenges and then mocks his male prowess. Shortly afterward, out on the deck, Nigel is gazing at a moonlit sea when Oscar suddenly blurts out, "Romantic, isn't it!" Approaching in his wheelchair, he clutches Nigel's arm and warns: "Beware of her. She's a walking mantrap. I'm her husband, and look what she did to me." From this point on, Nigel is intent on having Mimi and on hearing Oscar's story of passion gone awry. Indeed, Oscar grants Mimi to Nigel only on condition that Nigel listen to his entire tale. Thus, the film alternates between the installments of Oscar's tale of psychosexual infatuation and the developing relationships on the ship.

There is, then, an elaborate confusion of spaces and frames. We move through the frame of the nautical voyage to the storytelling space of Oscar's cabin to the inner narrative space of Oscar's Parisian tale. Each space corresponds to a different set of motivations. Nigel and Fiona are *bound* on this voyage to a distant country in the hope of finding *inner* serenity. Nigel yearns for a sexual escape outside the *boundaries* of his marriage. But his obsession with Mimi results in him being *bound* to Oscar and his story of physical (ultimately disabling) passion.

That story, too, has its own spatial dynamics, oriented around Oscar's apartment. He tells of a relationship that begins in passion, reaches extremes of perverse indulgence, then descends into masochistic dependence and sadistic resentment. It begins with his vision of the beautiful young Mimi, "a glimpse of heaven," on the N° 96 bus in Paris. Haunted, he searches the bus route to find her. When they do meet again, they quickly develop a powerful passion for each other, staying locked in Oscar's apartment for three days. But though this first romantic sojourn ends with a kiss, Polanski gives us some hint of where this passion is going when he cuts abruptly to a close-up of Oscar shooting a pistol toward the camera. Although the pistol is, at this point, only part of a carnival game, the idea of alternating passion with violence has been clearly introduced. The violence will be partly directed outward, toward the audience (as is Oscar's suicide shot).

While the degeneration of passion is a familiar enough scenario, the details in this case are extreme. After tiring of her, Oscar provokes Mimi into leaving his apartment. When she comes back and begs to be taken in on any terms, his "sadistic streak" stirs: "If she really fancied living in a liv-

ing hell, I'd make it so hot, even she'd want out." His emotional abuse of her gradually increases until, after forcing her into having an abortion, he tricks her into flying to Martinique alone. With her out of his apartment and his life, Oscar returns to his sexually indulgent lifestyle. But when he is run over by a van and laid up in traction in a hospital, Mimi returns and executes her revenge, dragging him from his hospital bed, thereby paralyzing him from the waist down. The sadistic relationship comes full circle when Mimi announces that she will now be acting as Oscar's nurse. She keeps him in his apartment, entirely dependent upon her care. But as Oscar muses about Mimi's abuse of him, "It crossed my mind she still loved me. After all, it's no fun hurting someone who means nothing to you."

Thus, the shifts and turns of their relationship do not signal a gradual dissolution of it but merely a change in its power structure. If they begin bound together by a mutual and equal love, they end in sado-masochistic dependence. Oscar's apartment is at first a love nest and haven for unlimited sexual experimentation. But it subsequently becomes the site of a perverse dependence, symbolic of a prison of souls from which neither he nor Mimi can escape. If she does occasionally abandon him in the bathtub or leave him alone for the evening, she inevitably returns in order to continue his humiliation.

Even though Oscar and Mimi have left their Parisian apartment, they are just as bound by this shipboard voyage, confined by the cramped cabins and swaying spaces of the ship. The only power they have beyond themselves lies in drawing others into their realm, Mimi through her sensual allurement, Oscar through his lurid taletelling. And so Nigel is duped into scurrying between Oscar's and Mimi's cabins. But Oscar's control soon extends beyond his cabin and Nigel. If the ship is a kind of microcosm of the normal world, then Oscar's and Mimi's antics represent a kind of carnivalesque mockery of conventional gender roles, which reaches its height at the New Year's Eve party. Here, Oscar is clearly the ringmaster, pouring champagne and handing out streamers and party hats. He prods Nigel into action with Mimi, then mocks his lack of success. As the culmination of events, Oscar summons Fiona from her cabin, then watches bemused as Fiona and Mimi start "getting it on." At this unexpected turn of events, Nigel becomes disoriented (the camera starts to roll slightly, something of a ship itself) and the crowd, initially cheering the two on in their sexual charade, is soon reduced to staggering and vomiting (partly motivated by a storm that suddenly engulfs the ship) when it becomes clear that here on this open sea of feeling and action the women are in earnest.

But, unlike *Frantic*, in which the filmic reality is nominally anchored to the viewer's own reality and any deviations are motivated by genre conventions, *Bitter Moon's* two worlds are both "unmoored." Certainly, Fiona and Nigel's relationship is close enough to mundane experience to seem real. But the two main sites of the film's action invoke genre conventions more closely associated with fantasy. The cruise ship is literally cut off from the normal rhythms of life, an idea that the TV series "The Love Boat" (1977–1986) played upon. Likewise, Oscar's Parisian tale of well-funded Bohemian living in Paris is equally unreal, a purely literary image. Oscar admits that he went to Paris in order to become a writer, to follow in the footsteps of Henry Miller, F. Scott Fitzgerald, and Ernest Hemingway. Indeed, he reaches heights of Millerian excess with his description of Mimi's clitoris as "a little duck dabbling in a pool of pink flesh." And the overall shape of the story he tells Nigel has much affinity with *The Sun Also Rises*, the novel in which Hemingway most directly figured the image of paralyzing desire. But beyond Oscar's forced mimicry of his literary masters, which "killed any originality [he] ever possessed," is a larger literary allusion: Nigel is bound to Oscar like the wedding guest held and tormented by the tale of the Ancient Mariner. This self-conscious literary fashioning throws the truth of Oscar's story into question. At one point, Mimi promises to tell her side of the tale but never comes through. Oscar remains the sole author of their fantasy. If Mimi and Fiona momentarily escape his narrative to find pleasures of their own feminine devising, they are soon drawn back into it as Oscar admires their sleeping forms, describing them as "an allegory of grace and beauty."

The power of Oscar's control over the filmic narrative becomes evident when like an omnipotent author he suddenly kills off Mimi and then himself, and we are suddenly thrown out of two of the film's stabilizing frames and left to founder in uncertainty on the deck of the ship with Nigel and Fiona. With the approach of Mr. Singh's young daughter to wish the couple a happy New Year, we are perhaps reminded of Mr. Singh's alternate moral conclusion (representing a different narrative line), given near the beginning of the voyage: "Children are a much better form of marital therapy than any trip to India."

In contrast to the indulgence of male fantasy in *Frantic* and *Bitter Moon*, *Death and the Maiden* concerns the struggle of a woman to verify the truth of her experience in the eyes of men. It is a reprise of *Repulsion*, in which the woman's apparently mad convictions are finally confirmed as reality.

Once again the opening title sequence is crucial to establishing the film's rhetorical terms, offering both realistic and unsettling, symbolic elements. The first titles loom toward us, accompanied only by the sound of muffled voices and string instruments being tuned. Suddenly, a close-up of a bow being drawn across cello strings is accompanied by the first few chords of Schubert's string quartet popularly known as "Death and the Maiden." We cut to a medium shot of the quartet players onstage, then to a close-up of one person's hand tightly grasping another's. A two-shot shows us Gerardo (Stuart Wilson) and Paulina (Sigourney Weaver) in an auditorium, Paulina concentrating her gaze and attention straight ahead, Gerardo glancing worriedly at her. We go back to the shot of the stage until, with the music finding the dramatic opening chords again, we cut abruptly to waves surging and breaking over rocks.

While the emotional impact of the music is emphasized by this sequence, we are left wondering about the possible connection between the titles of the quartet and of the film, between the movement of the music and its significance to these characters, particularly Paulina. In fact, as the film progresses, we quickly realize that this film is to be focused quite singularly on Paulina and her experience. A long shot shows us a house on a rocky cliff above the sea as lightning breaks through the sky and a title offers a frame for the action: "A country in South America . . . after the fall of the dictatorship." In the next shot, we are looking through the window of the rain-soaked house as Paulina moves around the kitchen. We track to a different window to watch her move into another room, then move inside with her. She is listening to the radio news. As the details of a story about the formation of a commission to investigate human rights abuses under the former government are announced, there is a sizzling sound, and the power goes off. Paulina moves around lighting candles, finds that the telephone is dead, then looks out the front door at a distant lighthouse, the light of which still sweeps rhythmically through the air. Hacking at a roasted chicken, she pulls off a slab, throws it on a plate, grabs a bottle of wine, and retreats to a closet to eat.

Her nervous reaction to the music in the title sequence becomes equivalent to her physical vulnerability in this isolated house, cut off from the rest of the world.

Furthermore, the audience's position in relation to Paulina is carefully modulated in these opening scenes. While we begin the film outside her house, peering in at her, we are soon trapped inside with her, responding nervously to her unpredictable actions and shifts of mood. For when

she sees a strange car approaching the house, she snuffs the candles, pulls out a gun from a table drawer and competently loads it, then braces herself beside a window as the car pulls up in front. Now we guess that there is some connection between the news item that she listened to so intently and her fear. But with the entrance of her husband, Gerardo, late home for dinner after his car got a flat tire, fresh from being appointed head of the human rights commission, a battle of wills ensues. Gerardo wants to eat and chat. Paulina wants an explanation of why Gerardo accepted the appointment when it would clearly not result in any justice for victims of human rights abuses and torture such as herself. "Make love to me. Let's be happy," Gerardo says. "Happy . . . that's real bullshit," she replies. Gerardo promises that he will avenge her, then quips: "I'll bring you justice instead of a flat tire." The irony of this will soon be revealed, for the chance for justice comes when Dr. Miranda (Ben Kingsley), the "good Samaritan" who gave Gerardo a ride home, comes back to drop off the flat. Paulina quickly recognizes him as a doctor who, while tending her wounds and pain during her torture, also took the opportunity to rape her repeatedly, playing Schubert's "Death and the Maiden" quartet "on a wobbly turntable over cheap speakers." She is convinced of his identity by a host of strange details: his snorting laugh, his voice and pet phrases, and finally by his smell.

Paulina steals Miranda's car, searches it, and disposes of it over the cliff, while the two men are stuck back at the house, contemplating the behavior of women, drinking, and becoming friends. In consideration of Paulina's mad actions, Miranda quotes Nietzsche: "We can never entirely possess the female soul." Gerardo, stranded at the house, infuriated by his powerlessness, draws a more immediate parallel: "I hate this house. It's like her." When Paulina returns, the two men are in a drunken sleep, and she is easily able to take control. Yet she is able to insist on her version of events only as long as they remain at the house, cut off from the rest of the world. As she assures Dr. Miranda, "Out there, maybe you bastards are still running things behind the scenes, but in here . . . in here, I'm in charge." She conducts a trial in which she is witness, prosecution, and judge, and in which she assigns Gerardo the role of Miranda's defense.

Like the apartment in *Repulsion*, the house becomes an extension of Paulina's sense of reality, a fact that is subtly signaled in small details. From the living room, for instance, her bedroom looks like a closet. And on one of the outside walls of the house hangs a strange loop of rope looking somewhat like a noose, somewhat like an upsidedown heart. While Gerardo is a privileged visitor to this psychic space, Miranda is made a

prisoner within it. As he says when he temporarily gains control of the gun with which Paulina has armed herself and tries to escape, "I don't care what games you play in this fucking madhouse. I just want out."

Paulina demonstrates her power in this place through an inversion of her own rape scene. When she first approaches the sleeping Dr. Miranda, she takes a long draw of his scent. As he awakes and begins to protest, she pistol whips him and warns him, "Shut up, bitch." Stuffing his mouth with her panties, she straddles him, tapes his mouth shut and bites the end off the tape as if she's kissing him. Indeed, this strongly sexual action, which continues throughout his interrogation, is one of the main differences from the stage version of the story, as Peter Conrad has noted: "the sado-masochistic sexual games . . . in the film displace Dorfman's intellectual debate about victimology."

Another crucial difference between film and play, one noted by numerous critics, is the spatial and temporal concentration of the action. "The cinema is not, by nature, a miniaturist medium: why, given the splash of the big screen image, and film's capacity to make giant leaps in space and time, would a director confine himself to a small canvas?" (Johnston 1995b). In the film, the action is confined to one night, and the locale is given the sketchiest of treatments. Polanski could easily supply shots of Gerardo in the city, in conference with the president, tight-lipped as he is swamped by reporters when he leaves for his beach house and waiting wife. But instead, the action is largely limited to the interior of the house, Paulina's domain. This concentration of the action spatially and temporally—Paulina must extract a confession from Miranda before the police arrive at 6 A.M. to protect Gerardo—increases the dramatic tension by intensifying our sense of Paulina's neurosis and encouraging us to see the space as a projection of it. Indeed, Paulina's experience is inward, secret. It is trapped within her just as she is trapped within the house, both protected and vulnerable in her isolation. She has not even told Gerardo the full story of her torture: he hears of her multiple rapes for the first time when she pronounces the charges against Dr. Miranda.

What Paulina needs in order to escape her neurosis and her house is a more public assertion of the truth of her experience—the sort of assertion a human rights commission ought ideally to be able to stage. Gerardo cannot supply this since his mandate is to investigate only abductions and tortures that resulted in death. Paulina must, therefore, extract a confession from Dr. Miranda herself. Convinced as she is of his guilt, she is enraged both by his refusal to confess and by Gerardo's uncertain loyalties. Opting

instead for a summary execution, she leads Miranda to the clifftop. And it is here, outside of the house, that the truth is revealed, if not in the full light of day, at least in the first light of dawn. Finally, as Paulina prepares to throw him off the clifftop, he offers a compelling confession of his corruption, of the inevitability of the transition from holding medical authority over the torture victims to lording complete power over them. With Gerardo as witness, Paulina's experience is finally vindicated, not, perhaps, as objective truth, but as a truth recognized within this triangle of relationships. The film recapitulates with a return to the concert hall. Now, Gerardo, Dr. Miranda, and Paulina exchange glances, acknowledging that truth and showing that they are forever bound together by it.

In this closing moment, all three characters are laden with a new understanding that crosses the limits of not just their own individual identities but their gender identities as well. And our comprehension of this filmic world has been severely complicated, our point of view trifurcated and shattered by our knowledge of all three characters. We are not allowed the luxury of an easy catharsis. Instead, we are more aware than we would like to be of Gerardo's guilt and hopelessly inadequate legalistic comprehension, of Miranda's impulse to torture and eagerness to forget, and of Paulina's yearning for innocence and justice, figured in the music of the Schubert quartet that began the film and to which now, enlightened by the story of Paulina's dark horror, we return. Now we know culture is more than a mere luxury accorded to these middle-class folk or to us, a mere question of entertainment. The emotional drama of Schubert's music is no longer a vicarious experience for these characters: all three recognize that it has a real correspondence to Paulina's experience, an experience that all three now recognize and share. We can take that relationship between the characters and the music as a model for our own relationship to Polanski's films, that grip and implicate us rather than merely entertaining. Polanski's dramas are built on a progressively cramping cinematic vision that pushes the self and the other, character and viewer, closer and closer together. Space within the film is no longer viable as a means of maintaining boundaries between one person's reality and another's. The contiguity of different spaces and the simultaneity of different experiences have disrupted the characters' sense of boundaries and identities: the three of them—joined in this finale in a spectacular boom shot—are many different people in the same moment. Paulina, for instance, is both victim and survivor. Likewise, Polanski has disrupted the space between film and viewer: his films implicate those who watch them in the extreme experiences that are normally a part of our voyeuristic pleasure in watching movies. We are caught up in

an unholy alliance between being victims ourselves and being torturers. Polanski suggests that, even underneath our tame suburban existence, a drama of similar proportions is silently unfolding.

Polanski began his autobiography: "For as far back as I can remember, the line between fantasy and reality has been hopelessly blurred" (9). His biography, then, obviously relates to his films. And there is no doubt that many in his audience, both critics and a larger public, would like to view Polanski's continuing interest in sexuality and perversion as his personal obsession rather than as a more or less artistic examination of the politics of power enacted in *all* sexual relationships. But rather than seeing his films as expressions of his individual perversions, it is far more helpful and enriching to suppose that his personal life has given him a predisposition to recognize and give overt expression to the power relationships that exist in a gendered world, that his fantasy has made the prejudices of our reality visible.

WORKS CITED

Conrad, Peter. 1995. "The Sins of the Father." *The Guardian.* 16 April, 4.

Davis, Ivor. 1995. "Out of Exile? Is Roman Polanski Directing His Hollywood Return?" *Los Angeles Magazine* 40:1 (1 January), 90.

Eagle, Herbert. 1994. "Polanski." In Daniel J. Goulding, ed., *Five Filmmakers: Tarkovsky, Forman, Polanski, Szabó, Makavejev.* Bloomington: Indiana University Press.

Johnston, Sheila. 1995a. "Great Minds Share a Cesspool." *The Independent.* 13 April, 24.

———. 1995b. "Ships That Pass in the Night." *The Independent.* 20 April, 25.

Polanski, Roman. 1984. *Roman.* New York: William Morrow.

Schaefer, Stephen. 1995. "'Death' Eerily Echoes Polanski's Grisly Life." *Boston Herald.* 8 January, 54.

Thompson, David. 1995. "I Make Films for Adults." Interview with Roman Polanski. *Sight and Sound* 5:4 (April), 6–11.

Travers, Peter. 1994. Rev. of *Bitter Moon. Rolling Stone* 676 (24 February), 62.

———. 1995. Rev. of *Death and the Maiden. Rolling Stone* 700 (26 January), 68.

Wexman, Virginia Wright. 1985. *Roman Polanski.* Boston: Twayne Publishers.

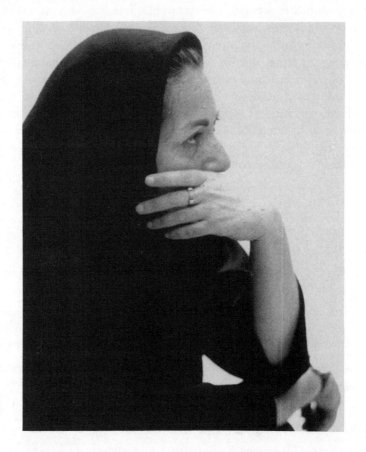

FIGURE 2. Rakhshan Banietemad (collection Hamid Naficy)

CHAPTER THREE

◈

Veiled Voice and Vision
in Iranian Cinema:
The Evolution of
Rakhshan Banietemad's Films

HAMID NAFICY

In the early 1990s, a journalist in Paris asked renowned Iranian film-maker Abbas Kiarostami to evaluate the status of the current Iranian cinema. With a mixture of pride and sly satisfaction, he answered: "I think of it as one of Iran's major exports: in addition to pistachio nuts, carpets, and oil, now there is cinema" (Rosen, 40). Called one of the preeminent national cinemas in the world today by both the Toronto International Film Festival and the New York Film Festival, Iranian cinema is a new, vital cinema with its own special industrial and financial structure and unique ideological, thematic, generic, and production values. It is also

This chapter was published in an earlier, somewhat different, version as "Veiled Visions/Powerful Presences: Women in Postrevolutionary Iranian Cinema." In Mahnaz Afkhami and Erika Friedl, eds., *In the Eye of the Storm: Women in Postrevolutionary Iran*. 1994. London and New York: I. B. Tauris and Syracuse University Press, 131–50.

part of a more general transformation in the political culture of the country since the revolution of 1978–79. However, this cinema is not an "Islamic" cinema, which upholds the ruling ideology. In fact, at least two major types of cinemas have evolved side by side. The "populist cinema" affirms the postrevolutionary Islamic values more fully at the level of plot, theme, characterization, *mise-en-scène*, and portrayal of women. The "quality cinema" engages with those values and tends to critique current social conditions. In terms of quantity, Iranian cinema is quite productive, with its output in the last five years standing at around sixty feature films annually.

A unique and unexpected achievement of this cinema has been the significant and signifying role of women both behind and in front of the camera. Here, I will provide a brief historical analysis of principles of modesty as practiced in the Islamic Republic followed by an account of the institutionalization and evolution of these principles in cinema in the context of the emergence of women filmmakers, particularly Raskhshan Banietemad.

What is unique is the inscription of modesty rules, and what is unexpected is that more women feature film directors emerged in a single decade after the revolution than in all the preceding eight decades of filmmaking—and this in a patriarchal and traditional society, which is ruled by an Islamist ideology that is highly suspicious of the corruptive influence of cinema on women and of women on cinema. This achievement was made possible partly by the incorporation of a complex system of modesty (*hejab* in its widest sense) at all levels of the motion picture industry and in the cinematic texts. A major goal of this system was to disrupt the direct discursive link between representation of women and promotion of corruption, amorality, and pornography, which the prerevolution cinema was said to have established. To that end it became necessary for the postrevolutionary government to strengthen two existing discourses: the "injection" theory of cinematic power and the "realist illusionist" theory of cinematic representation. The injection theory posited that the mere exposure to unveiled or immodest women would turn autonomous, centered, and moral individuals (particularly the men) into dependent, deceived, and corrupt subjects. The realist illusionist theory claimed a direct and unmediated correspondence between "reality" and its representation (or illusion) on the screen. For the illusion to be Islamically modest, reality had to become (or to be made to appear) modest. This

necessitated a total "purification" to cleanse both the film industry and the movie screens of the offending vices and corruption. The result was that both the industry and the screens became open to women as never before as long as women abided by very specific and binding Islamic codes of modesty.

MODESTY AS SOCIAL PRACTICE

Iranian hermeneutics is driven by a dynamic and artful relationship between veiling and unveiling, which together constitute "modesty." Indeed, this hermeneutics is based on distrusting manifest meanings and concealing core values. People are thus motivated to search for hidden, inner meanings in all they see, hear, and receive in daily interaction with others, while trying to conceal their own intentions. Since women are taken in Iran to be a constitutive part of the male core self, they must be protected from the vision of unrelated males by following a set of rules of modesty that apply to architecture, dress, behavior, voice, eye contact, and relations with men. Walls, words, and veils mark, mask, separate, and confine both women and men (Milani). Instances abound in Iranian culture: high walls separate and conceal private space from public space, the inner rooms of a house protect/hide the family, the veil hides women, formal language suppresses unbridled public expression of private feelings, modesty suppresses and conceals women, decorum and status hide men, the exoteric meanings of religious texts hide the esoteric meanings, and the perspectiveless miniature paintings convey their messages in layers instead of organizing a unified vision for a centered viewer. Modesty is thus operative within the self and pervasive within society. In cinema, modesty necessitates that men and women treat each other at all times as though they are in public, even when they are in the privacy of their own home or bedroom. The repercussions of this on the diegetic characters' behavior, dress, voice, and gaze are explored fully in the next sections.

Veiling is the armature of modesty, requiring further elaboration. With the onset of menses women must cover their hair, body parts, and body shape by wearing either a veil or *chador* (a head-to-toe cloth) or some other modest garb, including head scarf, loose tunic, and long pants. Further, the related/unrelated rules (*mahram/namahram*) govern

the segregation and association of men and women. Chief among these is that a woman need not wear a veil in front of male members of her immediate family (her husband, sons, brothers, father, and uncles). All other men are considered unrelated, and women must veil themselves in their presence, and men must avert their eyes from them.

It must be noted that many of these psychological and social practices of veiling and unveiling predate the Islamic revolution in Iran, although some of them have been intensified since then. Significantly, many of them are present in other Muslim societies (Abu-Lughod; Mernissi 1991, 1987), and they are applied not only to the women but also to the men. Finally, the veil does not necessarily imply lower status: in ancient Persia, for example, it conferred higher status to the women who wore it and to their men, and among the Tuareq of North Africa today it implies the higher status of the men who wear it (Murphy).

In the aesthetics of veiling, the voice has a complementary function: before entering a house, men are required to make their presence known by voice in order to give the women inside a chance to cover themselves or to organize the scene for the male gaze. Women must veil from unrelated men not only their bodies but also to some extent their voices. Veiling of the voice includes using formal language with unrelated males and females, decorous tone of voice, and avoidance of singing, boisterous laughter, and generally any emotional outburst in public other than expression of grief or anger.

However, veiling as a social practice is not fixed or unidirectional; instead, it is a dynamic practice in which both men and women are implicated. In addition, there is a dialectical relationship between veiling and unveiling: that which covers is capable also of uncovering. In practice, women have a great deal of latitude in how they present themselves to the gaze of the male onlookers, involving body language, eye contact, types of veil worn, clothing worn underneath the veil, and the manner in which the veil itself is fanned open or closed at strategic moments to lure or to mask, to reveal or to conceal the face, the body, or the clothing underneath. Shahla Haeri aptly notes the dynamic relationship that exists between the veil and vision:

> [N]ot only does the veil deny the penetrating male gaze, it enables women to use their own judiciously. Because men and women are forbidden to socialize with each other, or to come into contact, their

gazes find new dimensions in Muslim Iran. Not easily controllable, or subject to religious curfew, glances become one of the most intricate and locally meaningful means of communication between the genders. (229)

This "communication" involves not only voyeurism and exhibitionism but also a system of surveillance, of controlling the look and of being controlled by the look. Veiling-unveiling, therefore, is not a panoptic process in the manner Foucault (1979) describes because in this system vision is not unidirectional or in the possession of only one side. Both women and men see and organize the field of vision of the other. Furthermore, although the other dualities of religiously related/not related (*mahram/namahram*), inside/outside (*baten/zaher*), religiously allowed/forbidden (*halal/haram*) are structured psychically and socially, they are not only porous but also invite transgressive pleasures. In addition, although the veil restricts and oppresses women, it can also empower them through anonymity (Mills).

The social principles of modesty and veiled vision govern male/female social interactions both in daily life and in movies.

VEILING AS CINEMATIC PRACTICE

Although veiling and modesty existed in Iranian cinema before, they were first codified and instituted in cinema in 1982 (for a full discussion of these, see Naficy 1994, 1992). However, they did not remain static, as they evolved gradually and steadily toward liberal interpretations. The evolution of the codes and the use of women both behind and in front of the cameras occurred in three overlapping phases, which I have called the "absence," the "pale presence," and the "powerful presence" of women.

During the first phase, immediately after the revolution (early 1980s), the images of unveiled women were cut from existing Iranian and imported films. When cutting caused unacceptable narrative confusion—and it did, as some films were cut by over half an hour—the offending parts were blacked out directly in the frames with magic markers. As part of the purification process, the existing films were reviewed, a majority of which were banned. For example, of 2,208 locally made films that were reviewed in this phase, only 252 received exhibition permits (Naficy

1992, 187). Many entertainers, singers, and actors were banned selectively, by what distinguished them: their voices, faces, and bodies were banned from film and TV screens, radio, periodicals, and all forms of advertising. Women were excised from local films through self-censorship by a frightened industry unsure of official attitudes and regulations regarding cinema. Instead, many filmmakers resorted to making war films and children's films, or adult films that involved children, two new genres of postrevolutionary cinema.

In the second phase (mid-1980s), women appeared on the screen either as ghostly presences in the background or as domesticated subjects in the home. They were rarely the bearers of the story or the plot. An aesthetics and grammar of vision and veiling based on gender segregation developed, which governed the characters' dress, posture, behavior, voice, and gaze. Female characters wore headscarf, *chador* or veil, and a long, loose-fitting tunic. They behaved in a dignified manner and avoided body contact of any sort with men, even if they were related to each other by marriage or by birth. The evolving filming grammar discouraged close-up photography of women's faces or of exchanges of desirous looks between men and women. In addition, women were often filmed in long shot and in inactive roles so as to prevent the contours of their bodies from showing. Both women and men were desexualized, and cinematic texts became androgynous. As a prominent director, Dariush Mehrju'i, told me: "In postrevolutionary cinema the religiously unlawful (*haram*) look does not exist. All women must be treated like one's own sister" (personal interview, Los Angeles, April 1990). Love and physical expression of love (even between intimates) were absent.

One of the most significant consequences of veiling in films was that filmmakers were forced to represent all spaces in the films, even bedroom scenes, as if they were public spaces. This resulted in unrealistic and distorted representation of women since they were shown veiling themselves from their next of kin in the privacy of their homes—something they would not do in real life. This was true even if the diegetic husband and wife were married to each other in real life. This curious situation arose because female characters had to veil themselves *not* from their diegetic next of kin but from the male audience members, who by definition were considered to be unrelated to them. In this manner, the spectators were always already sutured into the text. This undermined the voyeuristic structure of looking that Western film the-

orists posited for cinema, which is based on the unawareness of the subject of the fact that she is being watched.

Another result was that nonverbal intimacy was absent from the screen for quite some time, as women veiled not only their bodies but also their sentiments. This tended to present a formidable challenge to the actors who had to express their feelings "realistically" to their intimate relatives in ways that were psychologically unrealistic to themselves, without touching them (Naficy 1991). Poetry became the only option for expressing intimacy, at first primarily for the men. Another result of veiling was that certain historical periods (such as the prerevolution era) and certain civilizations (such as the West) were closed to Iranian cinema. They were simply unrepresentable because of the unrepresentability of the unveiled women in those periods and civilizations. Finally, the aesthetics of veiling also affected the onscreen relationships of the men, resulting in fascinating gender and sexual reconfigurations that were sometimes inimical to the ruling ideology, such as those that suggested male homoeroticism—as in Mohammad Reza A'lami's *The Weak Point* (*Noqteh Za'f*, 1983)—a form of sexuality that is severely punished in Islamic Iran.

The third phase appeared gradually (since the late 1980s), and it was marked by a more dramatic presence of women both on the screen in strong leading roles and behind the cameras as directors. A 1991 film entitled *For Everything* (*Beh Khater-e Hameh Cheez*, directed by Rajab Mohammadin) is an example of the changed screen presence of women. It examines with moving realism the difficult lives of garment workers, *all* of whom are women—a long way from an all-male cast just a few years earlier. The director's comments express the perception of the changes: "Previously, Iranian women were portrayed as miserable, ignorant and superficial creatures who were used by men for sexual or decorative purposes. I wanted to tell a story in which women were virtuous, active, and socially constructive" (Anonymous 1991 [I have edited the English for smoothness, HN]).

While laudable, this replacement of the negative images of women by wholly positive ones could not guarantee a more realistic and complex representation. The restrictions on women served to represent women as "modest" and "chaste," preventing them from becoming sexual fetishes. This changed representation signaled the successful implementation of the injection theory of ideology and the realist illusionist theory of representation. However, this accomplishment was not counterhegemonic

insofar as it replicated the dominant/subordinate relations of power between men and women in the society at large.

The strong presence of women behind the camera was officially recognized in 1990, when the Ninth Fajr Film Festival—the country's foremost national film event—devoted a whole program to the "women's cinema." This cinema is very diverse, as women are involved in all aspects of feature, documentary, short subject, and animated films, as well as in all aspects of television films and serials production. Some of the filmmakers are quite versatile, and they make documentaries, television soap operas, and feature films. Of particular significance is the emergence of a new cadre of feature film directors (and prominent actresses) trained after the revolution, who have begun to make their mark on the cinema and provide powerful role models for other women. Prior to the revolution, only one woman, Shahla Riahi, had directed a feature film (*Marjan*, 1956). Today, ten women have directed feature films since the revolution. They are Tahmineh Ardekani (died in a plane crash in 1995), Faryal Behzad, Rakhshan Banietemad, Marziyeh Borumand, Puran Derakhshandeh, Zohreh Mahasti Badii, Samira Makhmalbaf, Yasmin Maleknasr, Tahmineh Milani, and Kobra Saidi.

The output of women directors has been abundant. More important, most of them have directed several films, indicating that after the purification process filmmaking has become not a one-time shot-in-the-dark, but a legitimate profession for women. Increase in quantity, however, has not been matched by corresponding improvement in quality, which remains uneven. It would be inaccurate and politically naive to expect that female directors in the Islamic Republic necessarily present a better rounded or a more radically feminist perspective in their films than do male directors. In fact, many of them did not, particularly in the years immediately after the revolution; but since then the situation has gradually and steadily improved.

BANIETEMAD'S VEILING AND UNVEILING STRATEGIES

Looking at the film career of the foremost woman director Rakhshan Banietemad, it becomes clear that her artistic development parallels the transformations from the first to the third phase of Iranian cinema itself. She was born in 1954 in Tehran, graduated from the College of Dramatic

Arts in 1979 (just before the purification process shut down universities), and began work as a set designer for National Iranian Television. For the next six years she directed television documentaries and worked as assistant director on several feature films.

Her first feature film, *Off the Limit* (*Kharej az Mahdudeh*, 1988), set the pattern for what became a characteristic of her style, social realism. The film is about a young middle-class couple who discover that their newly acquired house is located in a district that has accidentally been omitted from city zoning maps and for all intents and purposes does not exist and is not subject to the jurisdiction and protection of any legal or police authority. As a result, thieves and robbers have a field day in this no-mans-land, which is ironically called "Chaos City" (*hertabad*). The residents are placed off limits, out of bounds, and therefore made invisible (veiled). However, in a move toward self-determination (visibility), they begin to enforce the laws themselves, capturing the thieves and reforming them. The name of the city is now changed to "New City" (*nowabad*). Although the film is a biting social satire that criticizes the chaotic social conditions, which the film conveniently labels as belonging to 1972, Banietemad reproduces the dominant view of women under the Islamic Republic. The wife is uncritically shown to be so confined to the home that her husband has to do the shopping for their daily necessities. Moreover, she is not only confined to the four walls of the home, but also deprived of the one avenue of intimate expression available to women, recitation of poetry. Her husband, however, has access to it, as is evident in a scene in which he recites a famous love ballad to her while she serves him his meal. This is clearly a phase-two representation of women. American and Iranian audiences abroad consistently expressed surprise that the director of such a traditional representation of women was a woman. Despite its timidity in representing the wife, the film is somewhat bold in the political solution that it offers to the community's dilemma. For it urges the community to take charge, restore order, and patrol its boundaries. Ultimately, however, the zealotry of this new order is no less problematic than the lawlessness of the previous order.

The aesthetics of veiling that govern the actors' behavior, dress, and emotional expression also affect *Off the Limit*'s *mise-en-scène* and filming style. Objects and boundary-marking features such as fences, walls, and columns constantly obstruct vision. Long tracking shots with these

obstacles in the foreground highlight them as visual barriers and as metaphors for modesty and veiling. The reciprocity of veiling and unveiling, however, necessitates that the obstructions that seem to conceal certain things from view also reveal something else, namely, the director's intention. Indeed, in one of the early shots, before the residents of Chaos City have realized their zoning problem, the camera looks down from above the walls of a house into the adjacent street. In the background, the husband is walking down the street, alongside a wall. In the foreground, a fence made of barbed wire and dry bushes on top of the wall partially obstructs the view of the street below. Toward the film's end, after the community has taken up the enforcement of the laws, a similarly composed shot is shown, but with a major difference. The foreground is no longer a decrepit fence but a row of beautiful flowers in full bloom, signaling the transformation from Chaos City to New City. The director's activist vision that beauty and prosperity require political will and independent action is made visible in the barrier that conceals vision. That which veils also unveils.

In her next film, *Canary Yellow* (*Zard-e Qanari*, 1988), Banietemad depicts the women of a family, particularly the mother, to be strong, mature, and levelheaded, ruling the men who are naive, unscrupulous, or weak through the force of their personality and acumen. Despite such a strong representation of women, the film's moral center is a man, who defiantly demonstrates that virtue overpowers vice. This ambivalent configuration of female-male power relations points to the internal tug of war in Banietemad's works between liberalism and conservatism. In *Nargess* (1992), her groundbreaking film noir that brought her to international attention, she not only continues to focus on the lives of ordinary—even marginal—people, but also transgresses the limits on the depiction of love in cinema by examining a love triangle involving two women and a male petty thief. The film also pushes the boundaries of what is permissible in terms of direct eye contact, especially between the male protagonist and his young wife-to-be, Nargess. However, the love triangle configuration itself is not as radical an idea as it seems, for polygamy is a traditional practice in Iran that was revived under the Islamic Republic. Banietemad recuperates this practice in the interest of romance. But this recuperation demonstrates again the political balancing act that Banietemad has engaged in in each of her films. Banietemad insists that she does not want to be identified as a female filmmaker or a

feminist filmmaker, but as a filmmaker who happens to be a woman
(Anonymous 1995). She won the first prize in the 1991 Fajr Film Festi-
val for directing *Nargess*, the first woman in Iranian cinema to garner
such an award for a feature film. Indeed, this recognition by the film
industry and the official film culture corroborates her status not as a
woman filmmaker but as a top Iranian filmmaker.

In her subsequent film, *The Blue Veiled* (*Rusari-ye Abi*, 1995), she
continued with her social realist examination of Iranian society, this time
centering on the manner in which love between a proud young peasant
woman (Nobar, who wears a blue scarf) and an aging owner of a tomato
plantation (Rasul) makes possible the crossing of age and class barriers.
They express their secret love for each other in affectionate words and
actions that defy social norms but make for an uncertain future. This is
symbolized in the film's last shot, which shows the lovers walking toward
each other when suddenly a passing freight train splits the frame, separat-
ing the two. The modesty rules, which force directors to continually
devise new, ingenious, and sometimes distorted ways of implying hetero-
sexual relations, are at work in this film as well. To suggest that the lovers,
who never touch each other, have consummated their relationship, Bani-
etemad employs a remarkably economical and beautiful single close-up
shot: Nobar's bare feet sticking out of her fancy embroidered white skirt
(implying a wedding dress) walk gracefully and playfully on a richly
designed Persian carpet to the sound of extradiegetic dance music. With
this single shot, Banietemad implies lovemaking without breaking mod-
esty rules. On other occasions, however, she does break the rules. Disre-
garding the modesty conventions, Nobar is not a passive figure in her
body language and behavior. She walks purposefully and assertively, fights
for her rights, and in one scene violates the rule of no physical contact
between men and women by beating up her younger brother, whom she
catches stealing. In another scene, Banietemad resorts to a ploy for evad-
ing modesty censors that has become common in the Iranian postrevolu-
tionary films; that is, she uses a child as an adult substitute. One night,
Rasul is affectionately telling a story to Nobar's young daughter from a
previous marriage, who has placed her head on his lap. While Rasul and
Nobar's daughter seem to have genuine affection for one another, this is
a ruse, for the exchange of glances and smiles between Nobar and Rasul
strongly suggests that the daughter is a stand in for her mother who,
because of modesty rules, cannot touch her lover.

Banietemad's latest film, *The May Lady* (*Banu-ye Ordibehesht*, 1998), pushes the boundaries of modesty and tradition further by centering the story on a female documentary film director who is a divorced single mother who insists on pursuing her profession; on her liaison with a man to whom she is not married; and on her raising of her rebellious teenage son, who likes photography and partying. However, the film breaks more than just the thematic taboos of divorce, single motherhood, and unmarried relations with men. It also expands the vocabulary and extends the grammar of veiling and modesty in cinema by introducing fascinating textual and narrative innovations forced by the imposition of the veil.

One of these textual innovations is the way *mise-en-scène* and filming suggest unveiling. In one shot, the diegetic director (named Foruq Kian) arrives home from a day's hard work filming a documentary. In a medium shot, she walks through a hallway toward her bedroom. The camera pans with her as she walks briskly in that direction. As she gets close to the door, she reaches for her headscarf and lifts it in a characteristic gesture that signals the imminent removal of the scarf. But just before the scarf is off, she disappears through the door, leaving the unmistakable impression of unveiling without actually doing it. Unlike some male filmmakers, such as Dariush Mehrju'i in his *Leila* (1996), who have attempted by means of ingenious *mise-en-scène* and filming to distract the audience from the artificiality of the veil in private spaces, Banietemad has ingenuously incorporated it in *The May Lady* as a natural part of the diegesis. As Norma Claire Moruzzi astutely observes, this direct incorporation of veiling as a cinematic issue may be the most effective way of establishing the film's realism (1998, 7). The result is intensified spectator identification with diegetic characters.

One of the narrative innovations is the way the male lover (Mr. Rahbar) is simultaneously both effaced and inscribed in the film by means of a complex game of veiling and unveiling, as well as voicing and unvoicing. He is visually absent from the entire film, but he is simultaneously present throughout by the epistolary means of telephone, letters, and voice-over poetry. Using her cordless telephone, the diegetic director (Foruq) talks with him frequently and intimately. They also exchange letters and, using one of the favorite Iranian devices of intimacy, sexuality, and love, quote poetry to each other (Foruq's name is an homage to Foruq Farrokhzad, one of the greatest and boldest modernist poets of Iran).

While throughout these exchanges the woman is the primary speaking subject, from time to time the man's voice is heard speaking to her on the phone or reading his own poetic and flowery letters to her. In addition, from time to time Foruq's voice on the soundtrack tells of her feelings and thoughts about her son, her career, her films, and her lover. Sometimes these first-person musings are inserted in the middle of her phone conversations with her man, deepening our access to her subjectivity. The lovers' voices on the soundtrack reading letters and poems to each other and Foruq's autobiographical voice-over musings create a dense tapestry of free indirect discourse braided together by various voices and subjectivities. This is the first example of this discourse that I know of in Iranian feature films.

These interweaving male and female voices symbolically substitute for the desired but dreaded—because outlawed—physical contact between unmarried couples. By means of the verbal epistolary communications, they are able to express their mutual love for one another, and by means of voice fusion they are able to become one vocally. None of this type of expression would have been possible if the characters were shown together. But veiling rules do not govern vision and voice uniformly, and by cleverly taking advantage of this discrepancy, voice contact more than replaces the missing eye contact between the lovers, which would have been constrained anyway or would have been deflected and averted by unfulfilled desire and by modesty rules. The filmmaker's expressive use of the voice turns the characters' voices into acoustic mirrors in whose grains the spectators recognize not only the lovers' love and longing for each other but also our own spectatorial desire for such intimacy in the tabooridden Islamic Republic's cinema. The absence of the male object of desire, and the female-point-of-view filming have another felicitous outcome, which is that the film forces us to focus on female desire as such, regardless of its specific object—and this is a very feminist move in the restrictive Iranian social context.

A comparison of *The Blue Veiled* and *The May Lady* demonstrates the plasticity of the hermeneutics of male-female physical contact. It appears that physical contact is permissible in situations of violence but not in moments of tenderness. In the former film, Nobar's beating up of her brother is shown prominently, while in the latter film, Foruq, who wants to express her concern and love for her son, is forced to do so by touching him through a mediating cloth. In one scene, she shows

tenderness by drying his wet hair with a towel. In another scene, when after a heated verbal fight her son retreats to his bed, she follows him, sits by his side, and caresses him through his covers. These gestures of physical expression may seem innocent and small, but they are potent and transgressive in the context of modesty rules and prevailing practices that prohibit public heterosexual physical contact.

To be sure, the insistence in *The May Lady* on female representation (Foruq is the sole star), female subjectivity (Foruq's visual and vocal viewpoints dominate), female autobiography (Foruq provides the film's first person voice-over narration), and female enunciation and authorship (represented by both diegetic and extradiegetic directors) overdetermines female subjectivity and agency. At the same time, however, this insistence points to Banietemad's anxiety about the uncertain and complicated social position of women in Iran, which stems from a burning desire to stake a claim on cinema but also from the profound fear that the ground underneath may shift and crumble. Perhaps it is this fear in Banietemad that drives Foruq to intervene in a dispute between her Westernized son and a young Islamist security agent, whereby she urges them to reconcile. Some people have criticized that by urging reconciliation she is appeasing society's reactionary forces. I do not think that is the case, for this episode points once again to a characteristic of Banietemad's style (and perhaps personality), which is the internal tug of war between rebellion and resignation, progressivism and conservatism.

The May Lady intermingles the two forms of filmmaking that Banietemad has practiced throughout her career: documentary and fiction. As Foruq films and edits her documentary on "ideal mothers," snippets of it are shown. Some of the women are actors playing a variety of ordinary women, and some of them are prominent women (a lawyer, a publisher, a newspaper editor) who play themselves in their direct-address interviews about social conditions of women. This documentary film within a fictional film functions in two ways: it embeds Banietemad's usual concern for the society's lower depths in the fictional story of Foruq that is highly personal and private, and it gives *The May Lady* a decidedly self-reflexive style—one that has become popular with prominent quality cinema filmmakers (especially with Abbas Kiarostami and Mohsen Makhmalbaf). But what goes beyond the self-reflexivity formula in Banietemad is the intertextual manner in which she deploys in *The May Lady* the actors and characters of her previous

films. For example, Nargess appears as one of the women in the documentary, this time carrying a baby in her arms, thus updating her story from the previous film in which Nargess appeared with no child. Finally, the intertextuality of documentary and fictional modes bespeaks Banietemad's own continued dual involvement with these forms. For while she was making these fictional films, she continued to make documentaries, including *Last Visit with Iran Daftari* (*Akharin Didar ba Iran-e Daftari*, 1995), an affectionate portrait of a famous actress, and *Who Will You Show These Films To?* (*In Filmharo beh ki Neshun Midin?* 1992–94), a searing documentary about the homeless people and the shanty-town dwellers of Tehran, which has not been shown publicly (*Nargess* was also banned for a while).

During the third phase, despite the continued oppression of women and Draconian censorship, the constraints on women's representation lessened, and filmmakers with each film pushed the boundaries of what was allowed. In addition, not all women directors fully or equally abided by the regulations. Some fought them by indirection and implication, others head-on. Women were not alone in this struggle, as several prominent male directors engaged in sustained efforts of both sorts. Bahram Baizai, Dariush Mehrju'i, and Mohsen Makhmalbaf cast women as strong protagonists and seriously explored gender roles, male-female relations, and women's position in society. While all female directors cast women in key roles, not all male directors did so, even some prominent ones, such as Abbas Kiarostami, whose film world is usually without women. While women's presence as directors is impressive, women are underrepresented in many technical areas of the film industry, such as production, distribution, and exhibition.

Finally, a large number of Iranian women directors are working in exile and diaspora in Europe and North America in all formats and genres of film and television. Among them are Shirin Bazleh, Shirin Etessam, Marva Nabili, Shirin Neshat, Mehrnaz Saeedvafa, Mitra Tabrizian, and Persheng Vaziri. Interestingly, a few of them returned home to make films, and a few of those who normally work at home made films abroad for home consumption. This crossing of geographical and national boundaries—which is also occurring with male filmmakers—is part of the globalization of culture and cinema in general and of Iranian cinema in particular, as well as of the emergence of a transnational Iranian cinema.

WORKS CITED

Abu-Lughod, Lila. 1986. *Veiled Sentiments: Honor and Poetry in a Bedouin Society*. Berkeley: University of California Press.

Anonymous. 1991. "For the Sake of Women's Image." *Mahnameh-ye Sinema'i-ye Film* 117 (Dey 1370/February 1991), 3.

Anonymous. 1995. "Ghamkhar-e bi Edde'a-ye Zanan-e Darmandeh: Goftogu ba Rakhshan Banietemad." *Zanan* 25 (Mordad/Shahrivar 1374/1995), 44–50.

Foucault, Michel. 1979. *Discipline and Punish: The Birth of the Prison*. Trans. Alan Sheridan. New York: Vintage.

Haeri, Shahla. 1989. *Law of Desire: Temporary Marriage in Shi'i Iran*. Syracuse: Syracuse University Press.

Mernissi, Fatima. 1987. *Beyond the Veil: Male-Female Dynamics in Modern Muslim Society*. Rev. ed. 1st Midland Book ed. Bloomington: Indiana University Press.

———. 1991. *The Veil and the Male Elite: A Feminist Interpretation of Women's Rights in Islam*. Trans. Mary Jo Lakeland. Reading, MA: Addison-Wesley Publishing Co.

Milani, Farzaneh. 1992. *Veils and Words: The Emerging Voice of Iranian Women Writers*. Syracuse: Syracuse University Press.

Mills, Margaret. 1985. "Sex Role Reversals, Sex Exchanges, and Transvestite Disguise in the Oral Tradition of a Conservative Muslim Community in Afghanistan." In Rosan Jordan and Susan Kalicik, eds., *Women's Folklore, Women's Culture*. Philadelphia: University of Pennsylvania Press.

Moruzzi, Norma Clair. 1998. "Women's Space/Cinema Space: Representation of Public and Private in Iranian Films." Paper presented at the Middle East Studies Association Conference. Chicago, 3–6 December, 1–14.

Murphy, Robert F. 1964. "Social Distance and the Veil." *American Anthropologist* 64, 1257–74.

Naficy, Hamid. 1991. "Zan va Mas'aleh-ye Zan dar Sinema-ye Iran-e Ba'd az Enqelab." *Nimeye Digar* 14 (Spring), 123–69.

———. 1992. "Islamizing Film Culture in Iran." In Samih Farsoun and Mehrdad Mashayekhi, eds., *Iran: Political Culture in the Islamic Republic*. London: Routledge & Kegan Paul, 173–208.

————. 1994. "Veiled Visions/Powerful Presences: Women in Postrevolution-
ary Iranian Cinema." In Mahnaz Afkhami and Erika Friedl, eds., *In the Eye
of the Storm: Women in Postrevolutionary Iran.* London and New York:
I. B.Tauris and Syracuse University Press, 131–50.

Rosen, Miriam. 1992. "The Camera Art: An Interview with Abbas Kiarostami."
Cinéaste 19: 2/3, 38–40.

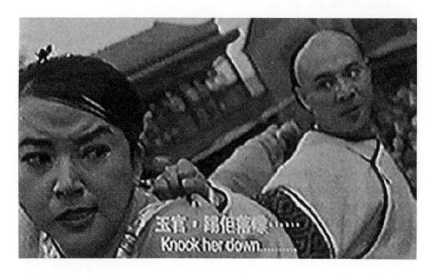

FIGURE 3. *The Legend of Fong Sai Yuk* (Corey Yuen, 1993): Mother Fong (Josephine Siao, left) throws herself into combat and wins the undying love of her opponent. (frame enlargement)

CHAPTER FOUR

◈

Boy-Girls:
Gender, Body, and Popular Culture in Hong Kong Action Movies

LENUTA GIUKIN

In her study *Femmes Fatales, Film Theory, Psychoanalysis*, Mary Ann Doane remarks that "it's precisely the massive reading, writing, filming of the female body which constructs and maintains a hierarchy along the lines of sexual difference assumed as natural. The ideological complicity of the concept of the natural dictates the impossibility of a nostalgic return to an unwritten body" (166). The split of the gender roles along the lines of the "natural" originates in a longlasting cultural construction that equates femininity with reproduction and domesticity, passivity and submissiveness (Ortner, introduction). But in the action movie, especially the Hong Kong cinema of the eighties and nineties—for example, *Swordsman II* (1991) and *The East Is Red* (1992)—the strong masculinization of the heroine often creates a break with the classical representation of feminine passivity in cinema, a transformation that affects her body representation to a degree that questions the received notion of gender. In order to control the more and more fluid boundaries of gender, the hero or heroine's more and more ambiguous body is frequently marked as feminine or masculine through costumes and/or other techniques, such as the masquerade. Costumes play an important role in the cinema because of their semiotic function as cultural and social identifiers.

J. Gaines emphasizes the transparency of the costume (193) as a necessary technique that allows the spectator to "read" the character, this reading extending from psychological traits to the social and sexual identity of the hero/heroine. Masculine and feminine costumes are especially important in the action movie where the fetishizing of the hero/heroine and the processes of masculinization or feminization impose a strong codification of clothing and appearance.

This study concentrates on the use and implications of gender-defining techniques in Hong Kong martial arts movies, where gender boundaries and narrative conventions are more flexible than in Hollywood action movies. To some extent I use an application of Western psychoanalytical theory, which may seem, but is not, an odd approach to Hong Kong film. It is important to understand that the strong influence of the Hollywood film on Hong Kong film led to a hybrid cinema strongly marked by the Western models of representation. In this context, the applying of Western psychoanalytical theory to Asian film is not out of place, despite ethnic and racial differences. Assuming that the Asian culture was a very different type of society, one cannot ignore that under British rule, Hong Kong was already exposed to the Western ideology in diverse forms, nor that in the period following the war, cinema became one of the strongest means of globalization. Though this chapter will rely on a partial psychoanalytical approach, the focus is on the action heroines, due to their large number and the extremely diverse roles women are allowed to have in Hong Kong action films.

Commenting on the status of these heroines, Hammond and Wilkins observe that the Hong Kong cinema "may be the only place in the world where men and women fight as equals" (49). The wide presence of fighting women in Hong Kong movies affected female representation in cinema and definitely influenced the status of the masculine hero. A look at Chinese history and culture shows that China had secular traditions of men playing women's roles (Peking opera, Cantonese opera) or women playing men's (Cantonese opera), as well as many warrior narratives referring to women fighters and their heroic deeds that remained in the popular memory. Therefore, having women play masculine or masculinized roles (Josephine Siao, Brigitte Lin, Michelle Yeoh, Anita Mui) or men play feminized roles (Leslie Cheung) appears to be an open option in Asian cinema because of an already existing historical and cultural tradition. In *Stage Door* (1996), Josephine Siao Fong-Fong plays the role of an actress interpreting male roles in Cantonese operas. The stylized costumes and action

of the operatic performance allow her to successfully interpret warrior roles without being limited by realist conventions. Indeed, realist conventions of gender portrayal may generally have been quite pliable in Cantonese opera, considering the extended use of costumes and masks that concealed the actor's body, and also the small physical differences between men and women in certain areas of the Asian continent. Besides the transfer of gender mobility from theater and opera to the screen, the action genre based its plot on the use of traditional fighting techniques, such as martial arts, which were accessible to both men and women.

The physical aspect plays an important role in the practice of martial arts, which do not require excessive force but instead emphasize speed of movement rather than—as in Western fighting techniques—the weight of the blow. Although in martial arts movies the demand for realism is much stronger than in traditional Chinese opera, the knowledge of different martial arts ceased to function as a limitation in the eighties, when actors were no longer expected to give "real" performances and when the shows were enhanced by different scenic effects—such as the use of wires for realizing spectacular jumps, for flying, or for lingering in the air.

Another major feature of the eighties and nineties martial arts movies is the presence of modern technology—such as cars, motorbikes, explosives, guns, and automatic weapons—which, combined with special effects and fast editing techniques, was at the base of a new modality of making and viewing martial arts films. The stress is no longer on the martial arts technique itself—which was exceptionally difficult to film, notably in the case of Bruce Lee in real action—but on the spectacle offered by the fighters' bodies in interaction and the ballet of movements within the shot. Consequently, actresses such as Maggie Cheung, Michelle Yeoh, Brigitte Lin, or Anita Mui, who were not trained martial artists and made action movies after playing mostly in melodramas or comedies, could adapt to the requirements of the genre and bring memorable performances to the screen.

But most important was the rapid integration of women in a narrative that represented mainly a male space, despite the lack of similar feminine models elsewhere (especially in the Hollywood action cinema). Therefore, the heroine in action movies followed the only available model, the male hero, developing into a diverse array of more or less mirrorlike versions of this masculine protagonist. In this context of the invasion by new characters of the male action space, establishing gender differences became essential, particularly when the plot was based on

transgressions that might otherwise have created ambiguities. Appearance and conventional behavior became codes regulating the meaning in a narrative whose structure changed to a degree that affected the hero's and heroine's status. Separating and establishing the limits of the hero/heroine's body is essential both to define the entire context of the cinematic narrative and to establish the place of truth that should insure the further definition of ideological and ethical values within the text. The "place of truth" is represented in a traditional narrative of good against evil by the hero's body, which embodies the "real" or "true" social order. Due to its physical strength, the male body is associated with the ability to protect positive social values, a fact that transforms his victory against evil into a reaffirmation of the system's legitimacy. When this very stable image is replaced with, or challenged by, other gender images, the choice between the hero or the heroine as the "place of truth" becomes problematic, an aspect that will be treated below in the analysis of *The East Is Red.* Inscribing meaning on the bodies serves the purpose of the narrative, which uses conventional signifiers, like clothes or coded behavior, to define and classify its protagonists in terms of gender and/or social function. I concentrate here on analyzing the different representations of the heroine in the martial arts film and try to locate the "unwritten body" that escapes the convention of natural gender.

A first category of fighting women is placed within the limits of the traditional discourse, their visual representation being a combination of conventional gender roles and spectacular transgressions into the action space. The linking of feminine appearance marked through female clothes and masculine fighting skills represents an appealing image for the viewer, but as a rule, wearing a dress in the action movie carries connotations of vulnerability and weakness. In *Butterfly and Sword* (1993) Kau's (Michelle Yeoh) romantic involvement with the male hero is expressed through her rich dresses in vivid purple and pink. Each encounter with the hero is characterized by an obvious display of feminine clothing and the masquerading of femininity. By exhibiting her body, the heroine asks to be watched, submitting herself to the gaze of the male in an attempt to capture his attention. The same technique of displaying her femininity is present in Maggie Cheung's portrayal of Jade in *Dragon Inn* (1992). Jade is a skillful fighter with a strong, aggressive mind, but in order to survive and run her business, she has to ignore the insults of her male customers, play the helpless woman, and seek the protection of armed guards. In Joan Riviere's opinion, womanliness is "worn as a mask . . . to hide the

possession of masculinity" (Doane, 25) and to prevent punishment for possessing it. In the case of the action heroine, as her masculinity is already known and/or recognized, the masquerading might rather conceal a lack of femininity or maybe the loss of real femininity. Used as a tool, masquerading is more than just displaying a portrayal of what is generally accepted as femininity; it is playing the well-known game of seduction that belongs to a cultural construct of feminine-masculine relationships. Further, if "womanliness" is mask not essence, if it can be worn or taken off, is masculinity the real and only stable locus in the action narrative?

Conceived originally for a male audience, the action movie was, and often still is, centered on the male action hero who became the principal model for the genre. The action heroine followed in his steps. In this context, not only is masquerading a safe place for experimenting with cultural behavior, but it also reveals the deep metamorphosis of a heroine whose evolution led to a split of identity. Both Kau and Jade know their assigned roles and play them for the others, but they conceal a second more aggressive identity, one that grants them the status of heroine in this male-dominated space. Penetrating the mythical space of the heroes becomes a matter of transcending gender conventions, therefore, of rewriting destinies in different ways than prescribed by the norm. But this new position of the heroine is often questioned by, or analyzed in terms of, the existing social gender codes.

The awareness of the social game and the questioning of the unconventional heroine find an evident expression in *Wing Chun* (1994), a movie that reveals the difference between femininity as excess and femininity as lack. Choosing independence instead of becoming a submissive housewife in an arranged marriage, Wing Chun distinguishes herself as a heroine in a challenging exploit: she saves her village and also her kidnapped employee, the new Tofu Beauty, from constant attacks by bandits by fighting the bandits' chief. Parodically, the traditional fairy tale of a hero saving a princess becomes the story of a woman saving another woman in trouble. Wing Chun's victory in the deadly combat establishes her final authority as heroine, winning her the respect and love of her lost-and-found fiancé. In the filmic context, not only is Wing Chun (Michelle Yeoh), who has renounced displaying her femininity, perceived as unattractive by men in the village, but her colorless male clothes render her invisible as a woman to the point that her fiancé mistakes her for a man. In opposition to Wing Chun's seriousness and verbal laconicism, the new Tofu Beauty is popular because of the excessive exhibition of her

feminine charms through clothing and body display. Despite the two extremes they represent, Wing Chun and the Tofu Beauty cannot easily fit in the society: while the Beauty is constantly preyed upon, the independent heroine is continually challenged and harassed. In addition, the act of refusing to submit to parental authority (an arranged marriage for Wing Chun) and transgressing into the male action space (her involvement in social matters—like defending the village from bandits) put the identity of the heroine into question and marginalize her. The village men despise her ability to defend the village from thieves and bandits, a humiliating situation for so many men who seem to be successful only at harassing women. Wing Chun's reinstatement as woman is possible only in the end, after she gives up fighting and men's clothes. Her social reintegration as woman is expressed through the symbolic gesture of replacing her male clothes with regular female clothes and her accepting the social convention of marriage.

Most important in *Wing Chun* is the obvious claim made on a married woman's body, which in submission loses its independence. In fact, in most of the action movies, the coexistence of an action heroine and a wife/mother is impossible. For example, *The Legend of Fong Sai Yuk* (1993) and *The Executioners* (1993) both show that the mother's venture into action depends on the approval of the father. As the authority figure in the family, the father becomes the symbol of social order in any patriarchal society. Due to her reproductive function and maternal obligations, the mother has to submit not only to the family law but also to the patriarchal social system itself, which controls and determines the individual's social functions. In *The Heroic Trio* (1992), Anita Mui plays the role of a married woman who conceals her identity under a black leather mask and costume. The sequel, *The Executioners,* introduces a powerless mother heroine who has to give up her former role as Wonder Woman. The mask and the costume protect the heroine's identity, her anonymity being a necessary condition for action, but when her husband discovers her superheroine status, she loses her independence to act or to make decisions. At the birth of their daughter, with the intention of protecting his family, her husband makes her promise not to fight ever again. The loss of identity as superheroine is expressed by her locking the Wonder Woman costume in a wooden chest and wearing female clothes, which ensure her blending in with the crowd. Further, the submission to social conventions entails the formal impossibility for the mother of becoming someone else's object of desire. As Wonder Woman in *The Heroic Trio*, Anita Mui's body is

eroticized through tight clothes and exposure of arms and legs, an image that displays her to the desiring gaze of the spectators inside and outside the filmic space.

Both body exposure and masquerading are acceptable only when the heroine is a potential sexual partner, precisely because they are signifiers of feminine desire. Jade (*Dragon Inn*), Comet (*Butterfly and Sword*) and the new Tofu Beauty (*Wing Chun*) are involved in some kind of romantic pursuit of the male hero, while Wing Chun is not, and therefore her male clothes are a metaphor for her repressed desire and feelings. Similarly, in *Dragon Inn*, Brigitte Lin's male clothes not only conceal her character's identity to the other characters but also reveal the repression of her feelings for the hero. While her lover, Chow Wai (Tony Leung), is the object of constant verbal and physical assaults of attention, passion, and marital proposals from Jade (Maggie Cheung), Yau Mo-yin (Lin) has to hide her feelings of love, doubts, and jealousy under colorless male clothes. Her restraint in expressive movement and speech is in contrast with Maggie Cheung's masquerade show and feminine display (that hides an aggressive, skillful woman fighter).

Sexual and emotional repression is a central characteristic of the superheroine who is defined in opposition to the classical association of the woman with a preference for romantic involvement and a passive attitude. A romantically involved action heroine (*The Bride with White Hair* [1993], *The Heroic Trio*, *A Chinese Ghost Story* [1987]) defeats the purpose of the conventional narrative; she becomes a disobedient servant because her focus shifts from serving the state or the lord to fulfilling personal goals and desires. Consequently, an action heroine's masculinity is closely related to an asexuality that contributes to her image of invulnerability on the screen. Like the hero, the transvested action heroine on her way to becoming a superheroine has to repress desire, an accomplishment represented cinematically through costume conventions. While color, richness, and exoticism in clothing are associated with feminine characteristics, restraint, simplicity, and a reduced range of colors suggest masculinity.

It is ultimately through fetishism that male clothes contribute to the masculinization of the female image. Considering that "fetishism . . . is a strategy of disavowal faced by the fear of castration: the fetishist 'completes' the female body and in so doing denies difference, denies the lack [of phallus]" (Hayward, 283), we can see the female-to-male transvestitism becoming an instance of gender denial. Surrounded by fetishistic phallus substitutes—men's clothes (*The Legend of Fong Sai Yuk*, *Dragon Inn*, *Peking*

Opera Blues [1986]); piercing objects such as swords or knives (*Dragon Inn,* *The Bride with White Hair, The Heroic Trio*); guns (*Peking Opera Blues,* *Heroic Trio*); musical instruments, such as the flute, played traditionally only by men (*Dragon Inn*); motorcycles and cars (*Heroic Trio*); horses (*Dragon Inn, Heroic Trio, Chinese Ghost Story*)—the body of the action heroine is often marked in more than one way. The presence of more than one fetish makes us suspicious since it can only emphasize the heroine's lack by pointing to the insufficiency of the fetishes. Further, the fetishistic representation of the action heroine reveals the difficult position of the male viewer, who relates to the feminine body as an object of desire, while fearfully, and through fetishes, trying to avoid the castration she implies. Also, the ambiguity of a feminine body heavily marked as masculine becomes, for both male and female spectators, the space of an unnamed transgression, a narcissistic place for experimenting with unspoken or unrecognized subconscious desires. This type of image brings to the screen a hybrid heroine whose function has been transferred from the traditional sphere of reproduction to that of seduction. The implication of such a dislocation affects its public reception, generating a new reading in which, through the combination of the feminine look with the masculine function, a certain taboo is established regarding the heroine's body and its vulnerability. As a seductive image, the heroine can be watched and desired, but physically possessing her is problematic, her fighting skills being a protection against penetration.

Most of the images associated with penetrating instruments and technology are reminders of the act of penetration, against which the fetish substitutes must insure the hero/heroine's impenetrability. Possessing or lacking, penetrating or being penetrated are major binary oppositions associated with the masculine-feminine bodily functions and the reproductive process. To penetrate is to invade and take control over the other's body; consequently clothing and defense instruments emphasize the importance of the hero/heroine's safety. This explains why the mother (*The Executioners, The Legend of Fong Sai Yuk*) as penetrated or invaded body belongs to the penetrator, the father. Associated with defeat or loss of independence, the penetrated body becomes someone else's property.

Protecting the body through all means starts with the most obvious surface: clothing. Contrary to the impermeable muscles of the Hollywood action hero (especially the Arnold Schwarzenegger type), the Asian hero's body is rarely exposed. In most action movies, the presence of the costumes plays an important role in defining the moral and physical impenetrability

of the hero/heroine. Analyzing *Once upon a Time in China* (1991), Yang Mingyu demonstrates the importance of showing the hero (Jet Li) dressed at all times. Being a historical figure, he has an authority that can be preserved only through respect, and as a result, his clothes become a metaphor of morality and credibility. *Wing Chun* and *Dragon Inn* respect this coded pattern, but this is not the case for other heroines whose body image (*The Bride with White Hair, Butterfly and Sword, The East Is Red*, etc.), despite fetishism, remains sufficiently transparent to the spectator's eye.

In the modern Hong Kong action movie, the visibility of the heroine's body is linked to her marketing function. Hence she becomes a commercial product on display. Such a treatment is realized in *The Heroic Trio*, where masculinization and erotic investment of the female body create a commercial image of the heroine. The erotic look is very much reminiscent of the femme fatale image, the three heroines—Wonder Woman (Anita Mui), Thief Catcher (Maggie Cheung), and the Invisible Woman (Michelle Yeoh)—being associated through their black costumes, their body build (slim bodies, long legs and hands, red long nails), and the force of their action with the possible seductive and destructive power of the femme fatale. But, unlike the Hollywood femme fatale of the forties and fifties, whose greed for power and money made her a monster and brought her punishment, the European femme fatale was often an extremely attractive woman whose beauty generated a passion that became self-destructive for the hero. In *Pépé le Moko* (1937), Jean Gabin, the king of thieves in the Casbah of Algiers, is caught by the police only when he falls in love with Gaby Gould (Mireille Balin) and decides to follow her outside the Casbah. Gaby is the femme fatale, who brings destructive passion; when her power of seduction over the hero is established, the low-angle camera shows a tall, thin woman, dressed in a dark costume that emphasizes her thin body, long hands, and red nails. The image of her towering phallic body is a metaphor of her new position of power and domination. The heroines in *The Heroic Trio* belong to the seductive femme fatale frame; both desiring (Wonder Woman in love with her husband, the Invisible Woman in love with the Professor), and desirable (all of them), their destructive powers are safely directed against evil forces. The camera will often film them from low angles, emphasizing their powerful status as subjects and objects of desire.

If their phallic bodies evoke the femme fatale, the look of these heroines and, more generally, of a whole category of modern Hong Kong action heroines has been largely influenced by the fitness culture and fashion of the

last decades. The stillness of the traditional seductive woman has been replaced with a highly dynamic heroine, whose attractiveness emanates from her body in movement and whose athletic figure is emphasized through marketable sport clothes. The relationship between martial arts movies and sports and commercial products is based on the close association between martial arts and sports, on one hand, and the marketing goals of any movie, on the other.

For instance, the longevity and popularity of martial arts has produced a public interest in their practice as sports, rather than fighting arts. The association of the long Chinese tradition in sports and martial arts, as well as the strong influence of the Hollywood muscular hero, has generated the commercialization of a "healthy body" in terms of muscles, resistant to and malleable in physical activities. But, unlike the Hollywood static hero, whose immobile, often exposed body becomes the locus of power, the Hong Kong action hero/heroine has always been highly dynamic, his or her success depending on the ability to move quickly and efficiently in the action space. The promotion of an athletic mobile body, perfectly adequate to the Hong Kong action style, combined with the large popularity of superstars such as Michelle Yeoh (formerly Miss Malaysia, 1983), Maggie Cheung (who won second place in the Miss Hong Kong pageant, 1983), or Anita Mui (famous also as a pop singer), invests these stars with more than one marketable function. Using their superstar status as "a marketable entity" (Gaines and Herzog, 199), *The Heroic Trio* creates a commercial body image that associates the fitness look and clothes with such characteristics as agility, force, capacity of control, and eroticism. Of the three characters, the most erotic look (through higher exposure of arms, legs, and upper chest) belongs to Thief Catcher (Maggie Cheung), who is also the most vulnerable physically and spiritually; on the other hand, the Invisible Woman (Michelle Yeoh) is rendered totally invulnerable by the invisible robe she's fully covered with. The heroines' clothes contribute to their seductiveness, even in the case of Wonder Woman (Anita Mui), whose robe and mask serve to conceal her identity, not her body, which remains exposed. By buying similar clothes on the market with the hope of reproducing her look, the viewer tries to create an identification with the heroine. Clothes or objects transferred from film to reality serve to fulfill a fantasy of resemblance with figures of the screen. The superstar's commercial appeal becomes an extension of the marketable power of the movie, as well as an advertisement for its products that will expand its financial profits. Moreover, the superstars' popularity, combined with the projection of a

heroine highly desirable in terms of moral and physical characteristics, promotes the creation of a new image of femininity, which is expressed through cultural codes that have been renovated if not totally changed.

Despite the visible changes of the action heroine, the gender treatment on the screen remains, in many cases, strongly conventionalized. Consequently, even when women wear masculine clothing and are treated as men in terms of the narrative convention of the film, they frequently have to submit to female cultural conventions. Female-to-male transvestitism can occur for parodical purposes—the mother of Sai Yuk in *The Legend of Fong Sai Yuk* (Josephine Siao) or Yuet in *Deadful Melody* (1993) (Carina Lau)—and also in dramatic contexts, such as *Swordsman II* and *The East Is Red*. Parodic transvestitism emphasizes a certain masculinization of the heroine, but this cannot challenge the fundamental condition of the male hero. In the parodic context, women are often compared with men to their detriment, like Sai Yuk's mother, whose tough, eager aggression is opposed to the wise, calm, vulnerable attitude of her husband. Mother (Josephine Siao) and son (Jet Li) mirror each other, their hasty involvement in fights and conflicts around town bringing only trouble. The spectator's judgment of Sai Yuk cannot but be tolerant when the young man, pushed by his friends, decides without much thinking to compete for Tiger Lu's (Chen Sung Yung) daughter's hand. During the competition fight, which is against Lu's wife (Sibelle Hu), Sai Yuk spots in the place of the temporarily missing girl, her old servant; panicked, he chooses to lose. This does not sit well with mother Fong who cannot accept her son's defeat. She throws herself into a second fight to avenge the family's honor. She wins both the competition and the undying love of her opponent. This platonic love with lesbian connotations enhances the parodic viewpoint of the narrative, the consequences of the mother's trespass in the men's action space placing her in a surprising position. Indirectly, this humorous situation represents the mothers' punishment for transgressing into the male action space. Both mothers could have been spared such an experience if they were not involved in martial arts.

Additionally, the film's moral lesson seems to emphasize how little women can relate to the men's world, none of them having access to, or really knowing about, the secret implication of their husbands in state affairs. While both husbands are in contact with the underworld of imperial politics and actively participate in the public matters of their town, the women are marginal to the real events. They are regarded as occasional transgressors whose role in the narrative text remains inscribed within the

limits of social conventions. Approached more seriously, dramatic transvestitism becomes a place of experimentation and questioning of social representations of gender.

In the Chinese civilization, the presence of eunuchs, castrated men in the service of the emperor, prepared society for the imagination and perception of another gender: the neutral. In fiction film and literature, the treatment of eunuchs shows an obvious fear of the unfixable other. In action films eunuchs are often evil presences, associated with avidity for power, excessive force, and ruthless behavior. A typical eunuch, Donnie Yen in *Dragon Inn*, kills the emperor and any other opponent, imposing an inhuman, absolutist political system based on corruption and crime. His superpowerful martial arts skills make him almost invincible. Faithful to the emperor's lineage, the three heroes, Chow Wai (Tony Leung), Jade (Maggie Cheung), and Yau Mo-yin (Brigitte Lin), fight him in a life-and-death combat in which Yau Mo-yin loses her life. In Hong Kong action films, eunuchs have extraordinary fighting skills that make them feared, as well as enormous psychological power over others. Lured by the promises of the eunuch Jin (*The Tai-Chi Master* [1993]), Tianbao (Chin Siu-hou) turns against his best friend, Junbao (Jet Li), choosing to die for power and wealth instead of rejoining his lifetime companion. When eunuchs do not fight their emperor, they fulfill other evil plans. *The Heroic Trio* introduces an ageless Ming dynasty eunuch who wants to rebuild China's past glory. Trying to find a new emperor, he kidnaps baby boys, whose unearthly education takes place in a subterranean film noir underworld. His supernatural powers render him so effective that, even dead and reduced to bones, he represents a mortal threat. It being impossible to classify the eunuch within a controlled system of gender representation, this asexual type is an outsider, a being whose unreproductive forces cannot be invested but in a selfish goal, different from the people's goals and therefore dangerous to society. The physical castration of the eunuch becomes psychological, liberating him from submissiveness to the social laws. Already "castrated," his only object of desire is the unattainable, absolute power. Consequently, the eunuch becomes totally independent in the social economy. An entity that cannot be classified, controlled, or fixed in the language, he can only become irrational—meaning evil—because he escapes the common logic used by others.

Similar to the eunuch's, the woman's body, unlike the sexually marked male body, is a "tabula rasa": "anything and everything can be written on it" (Doane, 170). The phallus has long been associated with male social responsibility and power, a situation whose consequence was a rigid fixation

of the male image as social model. In the case of eunuchs or women, the lack of the phallus allows them to escape the socially predetermined male position, their bodies being more open to changes. The Hong Kong action narrative experiments with this possibility, creating a whole range of characters that elude the conventions of gender representation.

An example of unconventional, unnameable gender is provided by the Invincible Asia in *Swordsman II* and *The East Is Red* (1993). Played by Brigitte Lin, the hero/heroine proposes an extremely complex blending of feminine, masculine, and other gender characteristics. Castrating himself in order to acquire supernatural powers (impotence apparently leads to omnipotence), the Invincible Asia (*Swordsman II*) becomes not a eunuch, as expected, but some kind of female. The transformation is evident in the colorful public appearance of Invincible Asia. If masculinity is usually codified as vestural severity, the superpowerful Asia displays an unusual taste for rich, colorful costumes and decorum. This concealed transformation takes place under the masquerade of masculinity, his castration being "masked" (concealed) under male clothes until it is revealed later by his lifetime enemy. The transgression is even more problematic when these newly acquired feminine characteristics coexist with masculine codified behavior, such as drinking wine and keeping concubines. Moreover, in *Swordsman II*, the Invincible Asia develops a taste for the male hero, Ling (Jet Li), while in *The East Is Red*, he or she tries to recuperate his or her female lover. Ambivalence and ambiguity persist in his or her slippery taste for men and women and in the shift between male and female dressing with a permanent choice of feminine clothing in the sequel. The Invincible Asia refuses to be caught in the language, and determining his/her identity is as much a trap as any other cultural construct of gender.

Behind the mask play of masculinity and femininity, the Invincible Asia and Europe (the new name acquired in *The East Is Red*) propose a gender representation that endangers the only safe place in the action film, the body of the hero: "the body of the hero is the sole narrative space that is safe, . . . even [if] this space is constantly under attack" (Tasker 151). The deconstruction of masculinity as the locus of power and its displacement in a nongendered or neutral space is another violation of natural gender conventions. In the classical action narrative, the male body (the superhero) is the locus of power and the only subject in the confrontation between good and evil capable of generating the necessary energy to restore the balance of power in the world. In *Swordsman II* and *The East Is Red*, the Invincible Asia's body is dispossessed of its natural

identity, in order to become this locus of power. Masculinity and femininity become concepts that can exist outside the female or male body and be possessed by anybody in any body. With the Invincible Asia, the superhero is no longer gender-labeled or attached to any social cause. She or he is above human conventions, incomprehensible at times, often ambiguous, and impossible to be fully contained by the most defining system of all, the human language.

In the process of feminization of the Invincible Asia, the feminine clothes are the visible indices of the inner transformation of the hero. But the mutual mirroring relation of clothing and identity is confirmed and denied at the same time; the Invincible Asia's feminization is evident in his clothes and makeup, but the spectator cannot ignore that Brigitte Lin, a woman, plays the role of a man becoming, at least partially, a woman.

Intended or not, the transition from masquerading masculinity to masquerading femininity and the idea of gender blending point to rigid cultural constructs that deny the individual the freedom of choice. Born in a preestablished civilization, we are required to develop within the limits of the existing models and conventions. The superhero himself is a facade of this predetermined world, unless, like the Invincible Asia, he escapes the classical pattern.

This type of unconventional hybrid hero is made possible in the Hong Kong cinema because of the hybrid nature of the Hong Kong culture itself. If in Chinese cinema the authoritarian centralized regime forbids the presence in art of any ambiguous sexuality, Hong Kong had the freedom under English rule to come in contact through mass media with the popular debate(s) on gender issues. As a reaction to the many questions on gender, the film industry could explore diverse representations, the desire for originality in the competitive world of filmmaking resulting in the creation of new models. These models not only correspond to an existing need for renewal of gender conventions but also show how, on the ideological level, society creates mechanisms of representation. Further, the many versions of the masculinized and ambiguous gender heroine point to a series of transformations in the postmodern individual, to a process that leads from very stable conventional images to a multiplication of identities that can be both concealed and expressed by clothes.

The modern Hong Kong heroine no longer possesses unity but is the locus of metamorphoses that mirror the *fin de siècle* fragmentation of the subject and the breakdown of the notion of gender. Hong Kong cinema is in the privileged position of playing with these diverse and contradictory

gender images where convention and transgression are written on the body. The presence in Hong Kong cinema of a masculinized heroine who challenges the established norms of the genre (the hero as the locus of power) or the social conventions (the traditional gender representation) also relates to a reaction against the Western perception of Chinese as "feminine," due to their physical aspect. Compared to Western action movies, where the hero is portrayed in an armor of muscles, the smaller size and greater mobility of the Chinese hero express an idea of heroism that looks almost unconvincing to a Western viewer. In this context of the lither hero, the heroine was also masculinized, proving that heroism does not relate only to force or physical size, but involves other skills.

The success of the Hong Kong heroine certainly made her an appealing marketable opportunity for the Western film industry. Perhaps Michele Yeoh's presence in the James Bond movie *Tomorrow Never Dies* (1997) represents a conquest for the Hong Kong cinema, which, through its specific treatment of the action genre, inscribes itself in the international language of film. The gender representation in Hong Kong action film becomes a voice that transgresses local concerns and addresses a more universal aspect of gender politics.

WORKS CITED

Doane, Mary Ann. 1991. *Femmes Fatales, Film Theory, Psychoanalysis*. New York: Routledge.

Gaines, J., and C. Herzog, eds. 1990. *Fabrications: Costume and the Female Body*. New York: Routledge.

Hammond, Stefan, and Mike Wilkins. 1996. *Sex and Then a Bullet in the Head*. New York: Simon and Schuster.

Hayward, Susan. 1996. *Key Concepts in Cinema Studies*. London; New York: Routledge.

Ortner, Sherry B. 1996. *Making Gender: The Politics and the Erotics of Culture*. Boston: Beacon Press.

Tasker, Yvonne. 1993. *Spectacular Bodies: Gender, Genre, and the Action Cinema*. London; New York: Routledge.

Yang, Mingyu. 1995. "China: Once upon a Time/Hong Kong: 1997. A Critical Study of Contemporary Hong Kong Martial Arts Films." Dissertation, University of Michigan.

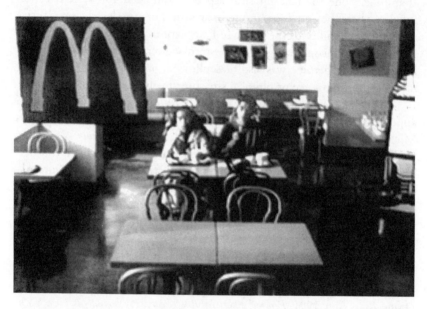

FIGURE 4. Pui-Wai (Li Pui-Wai), the "spirit" of Hong Kong, treats Tokio (Masatoshi Nagase) to "authentic Chineseness" at McDonald's in Clara Law's *Autumn Moon* (1992): diaspora need not be across the sea. (frame enlargement)

CHAPTER FIVE

◆

The Gender of GenerAsian X in Clara Law's Migration Trilogy

GINA MARCHETTI

Since long before the advent of mass communications, race, gender, and sexuality have been intertwined in the popular imagination. In America and Europe, fantasies of white expansionism have been imagined in sexual terms as narratives of rape, romantic conquest, unrequited longing, and miscegenation (see Bernardi, Dyer, Marchetti, Shohat and Stam). Third cinemas exploded around the world to counter the hegemony of Hollywood and the racism inherent in the colonial film industries of Europe. In recent years, colonial reveries have metamorphosed into postcolonial chimeras within these narrative equations. Essential identities based on white, patriarchal, heterosexual norms have given way to thinking of gender and other aspects of the self as performances of roles that can be imagined as sites of subversion and resistance (see Butler). Youth plays a special role in many of these fantasies of race and gender since it marks a period of particular malleability in the creation of the self. Increasingly, that moment has been expanded to mark an era and a generation. The hybridity of transnational culture has enabled the dismantling of stable categories and has created the potential for the reformulation of increasingly fluid notions of race and gender. Examining the intersection of race and gender

71

within GenerAsian X provides simply one entry into this global trans-formation of the imagination of identity.

Postcolonial and postmodern, the combination of "Asian" with "Generation X" recognizes a separation based on racism and the legacy of colonialism, while embracing the hybridity the condensation implies. On the move around the world, this is a polyglot generation in which English as a Second Language dominates much of the popu-lar imagination. It is a generation marked by its class and class aspira-tions, defined by consumption and its ability to consume, forging an identity out of commodities.

An important part of GenerAsian X's cultural makeup comes from global Chinese culture (see Lu). Here, Hong Kong, as a major metropo-lis with a large (if currently fading) culture industry, plays a major role. Hong Kong profits from its ability to blend British(/Commonwealth), European, American, Japanese, Mainland Chinese, Taiwanese, and Southeast Asian/Chinese diasporic elements into an Asian version of the "melting pot" to feed regional as well as international consumption. Although Hong Kong's position in the economic and cultural vanguard of Asia may change as the effects of its return to the sovereignty of the People's Republic of China sink in, even now, after the July 1, 1997 Handover, Hong Kong is still associated with youth, modernity, a fast pace, and the *au courant*. Hence, Hong Kong and GenerAsian X have a peculiar affinity.

GenerAsian X also finds itself enmeshed in the rapidly changing gender politics that have permeated the globe. In Asia and within the Chinese diaspora, a cosmopolitan, postfeminist acceptance of equal opportunity for women vies with the resurgence of Confucian values. A desire to cling to a "traditional" Chinese identity clashes with a hybridized culture that allows for deviation from accepted gender roles.

As a woman filmmaker in a male-dominated industry, Clara Law seems particularly able to articulate in her work the gender contradictions faced by the global Chinese. Three of her more recent films, *Farewell, China* (*Ai zai taxiang de jijie*, 1990), *Autumn Moon* (*Qiuyue*, 1992), and *Floating Life* (1996), feature striking depictions of gender and GenerAsian X. However, before Law's treatment of gender and sexuality in these films is examined, it is important to situate her work within the complexities of contemporary Chinese politics, Hong Kong's changing status, and the crises of ethnic identity encountered within the Chinese diaspora. In these films, questions of gender and sexuality often stand in a metaphoric

relationship to issues of race, nation, and ethnicity, and it is important to understand these symbolic resonances as part of Law's exploration of gender and sexuality within the postmodern moment.

CLARA LAW'S GENERATION

Clara Law is not a member of GenerAsian X. However, she is a member of the generation responsible for Hong Kong cinema's "New Wave" that began in the early 1980s and continues to the present day. Although Stephen Teo rightly places her within what he calls the "Second Wave" of this movement, Law shares many noteworthy aspects of her personal and professional career with others associated with both the "first" and "second" waves of this movement.

Although Law is most often associated with her husband and collaborator, Eddie Fong (who wrote or co-wrote all three films under discussion here), she has had to battle the odds in a male-dominated industry. Like Ann Hui and Mabel Cheung, women who have also risen to prominence in the Hong Kong film industry, Clara Law studied abroad. She attended the National Film and Television School in England. Like Hui and Cheung, Law worked in television, including a stint at RTHK, before moving on to feature film production.

Law's summation of her life experience serves as an entry into the preoccupations of her oeuvre:

> We Hongkong Chinese are more like an abandoned child, because we don't really have Hongkong. I mean, Hongkong will be taken back by the Chinese. I was born in Macao; I went to Hongkong when I was ten. Later, I went to England to study. Now I am trying to settle down here, in Australia with my family. The fact that we don't have a home weighs heavily on our minds. (Tan, Clemens, and Hogan, 51)

Hui, Cheung, and Law have tackled similar subject matter, often involving romance, melodrama and female-centered narratives. More specifically, they have a preoccupation with themes of exile, nomadism, migration, split/multiple/uncertain identities, and intergenerational conflicts (Fore [1993, 1998]; Teo; Chua; Williams; Erens). They have a dedicated interest in exploring questions of identity within the Chinese

diaspora and a commitment to examining the meaning of "Chineseness" within the processes of globalization. The Chinese diaspora has been fueled by the political and economic uncertainties of the People's Republic, Taiwan, and Hong Kong; changes in immigration laws in the United States and many parts of the British Commonwealth; the increased ease of travel and communication; and changing attitudes toward family obligations and the meaning of personal fulfillment. To this end, personal relationships (between parents and children, among siblings, between husbands and wives as well as lovers) are used to understand global political, economic, social, and cultural dynamics. Hong Kong and its people provide the focus for this investigation.

LAW'S MIGRATION TRILOGY
AND THE POLITICS OF ALLEGORY

As Ackbar Abbas notes, "Almost every film made since the mid-eighties, regardless of quality or seriousness of intention, seems constrained to make some mandatory reference to 1997" (24). Clara Law's films are no exceptions. *Farewell, China, Autumn Moon,* and *Floating Life* look at the issue of 1997 through allegorical journeys. Members of GenerAsian X make these journeys, and the particular global concerns of the generation inflect the narratives. In *Farewell, China,* Zhao Nansheng (Tony Leung Ka-Fai) goes in search of his missing wife, Li Hong (Maggie Cheung), who has emigrated from Mainland China to build a better life in New York City. Zhao meets up with Jane (Hayley Man Hei-Lin), an American-born GenerAsian X street girl, searching for soft johns and easy scores. In *Autumn Moon,* aptly named Tokio (Masatoshi Nagase) travels from Japan to Hong Kong in search of "authentic" Cantonese cuisine. He meets up with a teenage girl, Pui-Wai (Li Pui-Wai), who is on her own search for the meaning of love and commitment as she readies herself to leave Hong Kong, her self-absorbed boyfriend, and her self-sacrificing grandmother in order to join her parents who have already emigrated to Canada. In *Floating Life,* the Chan family leaves Hong Kong to seek out a better life in Germany and Australia. A twentysomething man, Gar Ming (Anthony Wong) meets up with a younger woman, Apple (Nina Liu), who, like Jane in *Farewell, China,* has been raised in North America (Canada, in this case).

In each film the journey seems to promote a different transnational allegory, however, with Hong Kong both present and absent as a major

player. *Farewell, China,* for example, ostensibly functions as a cautionary tale for those planning to emigrate from China to the West. Stephen Teo has compared it to Dante's *Inferno,* and the film makes its descent into the underworld of New York City with the same sense of horror coupled with moral certitude as is found in Dante's poem. China represents home, hearth, and a Chinese identity free from racism (and colonialism); the West, in the form of New York, symbolizes the excesses of capitalism, the decadence of a rootless and materialistic lifestyle, and, ultimately, death and madness. Characters from Hong Kong and Taiwan appear within the New York Inferno to drive home the point that the West provides no safe haven for the Chinese emigrant. If Hong Kong as colony soon to become "special territory" is substituted for the wandering Chinese characters in the film, the allegory becomes absolutely clear: Hong Kong and its inhabitants are cautioned against wandering away from their Chinese roots.

The film's denouement shows the body of Zhao, who was stabbed to death by his insane wife, Li. As the camera pulls away, the view of his body diminishes as a replica of the Goddess of Democracy looms over him in a square in New York's Chinatown. The image can be read as ironic—in the seat of democratic freedom, urban decadence swallows up the dispossessed. As the film closes with images of the Chinese countryside and Zhao and Li's child framed by the buildings of an alleyway in their small town, the future (with the hopes symbolized by the child) seems to reside in China.

However, this reading of *Farewell, China* misses several subtle and some not so subtle visual, dramatic, and narrative markers that indicate a contradictory reading. From the beginning of the film, when Li asks for sympathy from an American embassy bureaucrat because she is part of the "lost generation" victimized by the Cultural Revolution, the political excesses of Chinese government policies surface as explanations for the characters' actions throughout the film. What is alluded to here conjures up Hong Kong's nightmares about China in the wake of the events of May/June 1989 in Tian'anmen Square. In fact, the film was in production when these events happened, and Law altered her original script to reflect on Tian'anmen (Tan, Clemens, and Hogan). Faith in New York's Statue of Liberty and faith in Beijing's Goddess of Democracy are equally eroded. If New York is an Inferno, the Mainland is far from Paradise. While the film's Chinese title is innocuous and misleading, *The Season of Love in Another Land,* its English title bids good-bye to China in no uncertain terms.

At first glance, *Autumn Moon* also offers a neat, superficial allegory. Tokio leaves Japan to look for authentic "Chineseness" in Hong Kong (the Mainland and Taiwan are not on his itinerary). He befriends the "spirit" of Hong Kong in the person of Pui-Wai, who acts as his guide. For her, McDonald's epitomizes "authentic" Hong Kong cuisine (Fore 1998). After parallel romantic and sexual disappointments and a shared concern for Pui-Wai's ailing, hospitalized grandmother, Tokio and Pui-Wai solidify their fleeting, platonic relationship with a celebration of Mid-Autumn Festival, a Chinese holiday dedicated to the full autumn moon, the harvest, and family harmony. The Japanese and the Chinese share a common Asian heritage and a common postmodern position of disaffection, fragmentation, and uncertain identity within advanced, global capitalism. Tokio and Pui-Wai find a sense of peace and harmony, as Hong Kong defines itself against a modern or premodern People's Republic and in reference to a clearly postmodern Japan.

Grandma (Choi Siu Wan) embodies what must be left behind as Pui-Wai and her family move on in their lives, away from a Hong Kong destined to revert to China. They escape, as well, from all that China represents for the bourgeoisie of Hong Kong: "authentic" Chinese poverty, outmoded customs, rural sensibilities, and a collective past filled with real and imagined horrors. Grandma is loved, as China may be loved, as a "homeland" (see Yau). However, both must be left behind as unsuitable for survival in the fragmenting postmodern dispersal of the diaspora.

Given that the film is a co-production, financed by Japanese money and featuring Japanese acting talent, it is not surprising that it should pay homage to the relationship between Japan and Hong Kong. Stylistically, there are hints of Ozu, for example, in the use of cutaways to objects to halt the narrative and set a contemplative mood (e.g., the close-ups of the jars of preserved foods and traditional cooking implements in Grandma's kitchen).

With the presentation of the cultural similarities between the hybridized, postmodern Japan and Hong Kong, there emerges a sense that Hong Kong really does not belong to China economically, historically, or culturally. The fantasy that Hong Kong is not "Chinese" and, therefore, can never be a part of China despite the fact of July 1, 1997 has its appeal. Chinese language, arts, food, and customs flow into a pan-Asian cultural melting pot and are fully appreciated by the Japanese tourist. However, this harmony is based on a double forgetfulness of both the Pacific War and the 1997 Handover.

In her final voice-over, Pui-Wai recites a poem she only partially remembers from past Mid-Autumn celebrations with her deceased grandfather. The acceptance of a flawed memory has its purpose in the present moment captured by *Autumn Moon*. Memory functions best within the postmodern moment in Hong Kong when it contains lacunae. As a young woman of GenerAsian X, Pui-Wai is particularly able to symbolize the tensions inherent in the fluctuations between rootedness and the necessity of rapid movement, as well as between tradition and the hybridity of a global culture. For her, it is not a question of moving between a traditional patriarchy and a liberated feminism. Rather, she symbolizes the pull of the paternal and, by extension, the national, and the necessity of female self-sufficiency and movement beyond the family that are characteristic of her generation. As a metaphor for Hong Kong, she embodies nostalgia for Chinese tradition coupled with a practical commitment to pursuing that tradition as far from China as physically possible.

Floating Life presents an allegory that seems to be different from *Farewell, China* and *Autumn Moon*. Like *Farewell, China*, *Floating Life* looks at ethnic Chinese emigrants trying to adjust to a new nation. In this case, the Chan family from Hong Kong finally acclimates to life in Germany and Australia. However, while the horrors of life in Europe, the United States, Canada, and Australia are mentioned, the overwhelming thrust of this Australian-produced film is to embrace a new homeland (Berry). The Chans have successfully completed their journey and are depicted as rooted in their new countries. At the conclusion of *Floating Life*, for example, the disturbed second sister, Bing (Annie Yip), has been recuperated through traditional Chinese means (i.e., familial affection and ancestor worship) and is pictured as pregnant and timidly walking at the side of her mother, Mrs. Chan (Cecilia Lee). She has left her career ambitions and business suits behind. The eldest daughter, Yen (Annette Shun Wah), and her family similarly find peace in a home with good "feng shui"—traditional Chinese geographical orientation to ensure harmony between people and the natural environment—in the German countryside. Nostalgic feelings for the remote homeland of China are reduced to photos of an ancestral home that represents a distant place, a possible burial ground or retirement home, not the present moment of immigration.

In this film, a young child and a hopeful pregnancy symbolize life for the Chinese outside of China. Hong Kong, however, only promises death and decay. In this case, Gar Ming carries the burden of reburying his

grandfather and burying the aborted fetus that he fathered with his Chinese American lover, Apple. Hong Kong becomes the land in which sex and death are inextricably linked and remains a mystery for the two younger Chan brothers, Yue and Chau (Toby Wong and Toby Chan), who prefer to speak English and have become accustomed to life in Australia.

However, the links between the throbbing fetus that lived, according to Gar Ming, for three seconds and the Crown Colony on the verge of re-absorption into the maternal body of China seem fairly obvious. In voice-overs, Gar Ming obsesses on the number and duration of his ejaculations and associates them with Hong Kong's Handover: "The pleasure still only lasts three seconds. Will it be the same in 1997? Where will I be in 1997?" Later, in another voice-over, as Gar Ming buries the fetus, it seems he could be talking about Hong Kong rather than his aborted flesh: "Three seconds of pleasure produces three inches of flesh. It throbs only once in its entire life. Its whole life is only one second. In one second, it experiences birth, aging, illness and death. . . . Too short . . . or too long? . . . It's not a piece of flesh. It's my child." As Ackbar Abbas has noted, after the Joint Declaration, Hong Kong's identity became transitional, neither British nor Chinese, but briefly a place that could be construed as having its own identity. However, that uncertain and very relative autonomy could only be realized briefly.

The enduring visceral force of the throbbing fetus and its allegorical connections to Hong Kong grate against the ostensibly happy conclusion of this tale of diaspora. The allegory of Hong Kong, through the journey of the Chan family, finding its true Chinese roots as far away from the People's Republic of China as possible retains its bitter side. In fact, in all three films Hong Kong slips gracefully out of the picture to resurface later as a "symptom" of psychological imbalances associated with GenerAsian X.

GENERASIAN X AND THE "POLITICALLY INCORRECT"

Farewell, China, Autumn Moon, and *Floating Life*'s principal address is to a middle-class audience within or necessarily affected by the Chinese diaspora. There is a tension between a desire or nostalgia for an "authentic" Chineseness and a denial of the ethnic self in order to assimilate into a non-Chinese global order. Consequently, the films often appear to be ambivalent or "politically incorrect" in their depiction of sex, gender, race, ethnicity, age, and class.

In *Floating Life*, for example, Jane loathes being ethnically Chinese. She calls Zhao "E.T.," to emphasize how alien he is in comparison to herself. Jane's internalized anti-Asian racism is linked to her background as a typically "American" child of separated parents and a weakened patriarchy. She associates her despised father with the smell of Chinese restaurants.

The chronicle of her life enfolds as a cliché of a dissolute youth in America. Jane went on the pill at ten, had an abortion at twelve, and had a baby girl given up for adoption at fourteen. Zhao asks, "Why have a child at all when you're so irresponsible?" Although Zhao may feel he is able to take the moral high ground with Jane, the film has already shown that he is cut from the same cloth since he has left his small child behind in China. Indeed, the film draws a strong parallel between the morally bankrupt American-born Chinese and the equally morally bereft Mainland Chinese.

Throughout *Floating Life*, Jane and Li Hong parallel one another in their internalized self-hatred, their ability to have a child and abandon it, their search for an ill-defined "freedom," their dishonesty, their ability to prostitute themselves, and their unselfconscious knack for leading men into men's own self-destructive universe. They hate themselves, hate being Chinese, and show the range of moral collapse suffered by the Chinese across continents. At the film's climax, Li Hong turns on her unsuspecting husband, with whom she has just had a tearful reunion, when he wakes up in her bed. She shouts: "Shut up. We're not to speak Chinese here in my apartment. Is that clear? . . . Shut up, you fucking, stupid Chink. Speak English; this is the United States of America."

A similar ethnic self-deprecation marks Bing as mentally unbalanced in *Floating Life*. Like Jane and Li Hong, Bing rails against Chinese culture as it prevents her from assimilating into mainstream Australian society. She refuses to speak Cantonese to her younger brothers, whom she browbeats with warnings that they will bring down all Asians in the eyes of Australians if they do not act in certain prescribed ways. Every action, then, becomes a contradiction. She and her brothers must prove the superiority of the Chinese immigrant by speaking impeccable English. For her, Australia is a land of poisonous snakes, ravenous pit bulls, skin cancer, clogged arteries, and endless hours of work that allow her to engage with her family only as a cultural policewoman who denies them television, soft-core porn magazines, and fatty foods, the emblems of Western decadence. She yells at her

younger brothers, "The house stinks. It's full of AIDS. You're here as immigrants, not to enjoy life!"

Bing internalizes the threatening environment of Australia from radio reports, television news, and the newspaper. However, no mention is made of any actual racism or xenophobia in Australia. Given that the film was funded by the federal government of Australia, the state government of Victoria, and the Special Broadcasting Service (SBS) (Law, 39), perhaps it should not come as a surprise that the openly racist politician Pauline Hansen and the controversy that surrounds the open expression of racism and xenophobia in contemporary Australia do not figure in the script. Yen, in Germany, is the one who encounters racism directly, embodied by the figure of a skinhead with a swastika tattooed on his naked scalp. After the incident, she muses, "I live in Germany, but I'm not German. Where is my home?"

However, while American, German, and Australian racism is clearly national, social, cultural, and institutional, the impact of that racism—on both ethnic and gender identity—remains personal and pathological. Thus, political critique wanes. Perhaps the most striking case exists in *Farewell, China*. A dramatic turning point in the film occurs when Zhao tracks down Li's former employers in Harlem. The carryout where Li Hong works is hellish. A bullet-proof partition separates the Taiwanese couple who work frantically to fill the orders for the noisy African American clientele on the other side. The Taiwanese pop music in the kitchen vies with the customers' hiphop on the soundtrack. Zhao helps the owners lock up. A strong metal gate secures the establishment. They all rush to the car; the boss and his wife clutching that day's earnings and a handgun. The proprietor talks amiably with Zhao about working in Harlem. He prefers African Americans to whites, whom he classifies as "snobs."

"Actually, Harlem's quite peaceful," he says. However, the increasing panic in his wife's voice as the car refuses to start shows this to be false, and he finally admits to being afraid when "they're drunk." When the car arrives at the couple's apartment, the proprietor's wife berates Zhao for allowing Li Hong to come to America alone. "Do you know what it's like not to have money for a tampon? To be raped?" At this point, the film takes on all the emotional energy of the Hollywood western. The Chinese have settled on the frontier of Harlem to seek their American Dream. Zhao has come in search of Li to a ghetto wilderness where she has been raped and brutalized by savages. Her purity has been compromised, and she loses her sanity.

A flashback shows the Taiwanese proprietor and his wife in their carryout. A woman's screams are heard outside; shadowy figures assault a woman. The proprietor takes out his gun to help the victim, but his wife stops him. Li Hong, beaten and hysterical, makes her way into the carryout. She refuses to let her employers call the police because of her illegal immigration status, and she huddles under a table, sobbing on the linoleum floor as the flashback ends. While the Immigration and Naturalization Service must take some of the blame for Li Hong's situation, the film, too, must acknowledge its own racist complicity. African Americans, purely by virtue of their race, act as signifiers of urban savagery and threats to Chinese purity. In condemning the racism of the United States government, the film legitimizes the racist fears of a global Chinese audience that, likely, has learned most of what it knows about the American black community from Hollywood action films. Further, and notably, in this sequence, socioeconomic threat is configured and discussed in terms of gender identity.

Race and racism are intimately connected with sex and gender in these films. If they can be read as cautionary tales for the Chinese abroad as well as celebrations of the enduring power of "Chineseness," they can also be read as cautionary tales for Chinese women and as celebrations of patriarchal tradition. The films have what can be termed a "postfeminist" sensibility. Thus, a taken-for-granted equality for women in the business world, governmentally sanctioned reproductive freedom, and the availability of opportunities for higher education and travel roughly on a par with those available to men are coupled with very conservative notions of sexual morality, femininity, and domesticity. The postmodern woman triumphs in the corporate, transnational workplace but finds herself alienated, unfulfilled, and profoundly unhappy, longing nostalgically for an idealized patriarchy that never existed historically. When the postfeminist wins, in other words, she loses.

Generation X harbors this postfeminist sensibility, and the generation has been criticized for enjoying the fruits of the women's movement while denigrating feminism. In *Farewell, China, Autumn Moon,* and *Floating Life,* this postfeminist sensibility casts its female characters in a suspect light. Women become the sites of moral laxity, potential cultural dissolution, and madness. Patriarchy is actively mourned, although the fact is accepted that it will not be resuscitated. If Gar Ming's aborted fetus in *Floating Life* can be read as an allegorical emblem for the plight of Hong Kong, it can also be interpreted as a symbol of mourning for the

patriarchy. Although the nurse pronounces the fetus "stone cold dead" in a matter-of-fact way, the film draws on a profound ambivalence surrounding women's reproductive rights in its depiction of the impact the abortion has on Gar Ming. Gar Ming teeters on the verge of insanity after the abortion. He suffers under the burden of the possible end of the Chan family line with this act, and the depiction of the abortion can be looked at as a critique of feminism as potentially nihilistic. Rather than positioning the abortion as Apple's choice and the assertion of female sexuality outside of patriarchal constraints, the film uses the abortion to examine male angst.

In the case of these films, too, postfeminism has a specifically transnational character. Bourgeois female labor finds favor in the transnational corporation, blending the need for a polyglot education with cross-cultural savvy. Traditionally associated with managing personal relationships, women work on easing interpersonal communications, smooth over intercultural misunderstandings, and create a less threatening environment to facilitate business transactions. So, Chinese women fit a niche in these transnational enterprises. Part model Asian worker and part exotic, eroticized ornament, these women can be displayed as a denial of the exploitation of working-class Asian women in sweatshops around the globe. A scene in *Floating Life*, for example, shows Bing's warm acceptance into a transnational workplace when she is literally embraced by her white Australian colleagues.

The persona of a successful transnational entrepreneur that Li Hong takes on in *Farewell, China* masks her desperate life on the street. Her desire to separate herself from China and her Chinese husband and son marks a threat to the authenticity of Chinese identity as well as to the prerogatives of the patriarchy. As a woman, she lives on the dark side of American capitalism. She prostitutes herself to get ahead, for example, when she attempts to sell herself as a wife to an aging Chinatown laundryman. When the scheme goes awry because she cannot secure her divorce, she turns to running cons on the vulnerable, elderly Chinese of New York City.

Li Hong's alter-ego, Jane, is literally a prostitute, and, through his association with her, Zhao becomes a pimp. Drunk and wearing the uniform of the street (jeans, leather jacket, and cigarette hanging from the lip), he hawks her on the streets: "Hey, fifteen-year-old Chinese girl, beautiful, clean, and sexy, $150." The flawed hero manages, really in spite of himself, to "rescue" the teenage prostitute. In this case, Jane comes to her

senses after nearly having sex with Zhao, and she decides to return to her Detroit family and go "back to school." There is a glimmer of hope for the survival of patriarchal control of female sexuality. Li Hong has gone mad, but Jane has gone home. While the film's condemnation of prostitution as an emblem of the excesses of Western capital cannot be denied, *Farewell, China* counters this capitalist patriarchal exploitation with a faith in the benevolence of the Chinese patriarchy. Despite the failures of her dysfunctional family, Jane goes back to try again rather than attempting to move beyond prostitution and the constraints of the traditional family to a life on her own terms.

In *Autumn Moon*, the situation is presented in more subtle ways. In this film, Pui-Wai and Miki (Maki Kiuchi) parallel one another as the two women in Tokio's life. Early in the film, Pui-Wai voices the idea that she represents a culture on the verge of dissolution, and that potential disappearance has sexual ramifications. She states in one of her numerous voice-overs that by the time she is twenty she and all her friends could all be married to "foreigners." Thus, Pui-Wai self-consciously acknowledges her potential role in the diffusion of Chinese values and identity. She is ambivalently vulnerable to the loss of Chinese identity and in the vanguard for the creation of diasporic hybridity.

Tokio represents an Asian masculinity in need of reform. At the beginning of the film, he videotapes a woman he picks up for sex in the same way he obsessively tapes all the other possessions he acquires in Hong Kong. Tokio also treats Miki as one of his possessions. He remembers her as the sister of a former girlfriend but gets her confused with some other girl's sister, since women, equated with commodities, are interchangeable for him. After having sex, they make a date for the next day; an empty table at the rendezvous point signals their lack of commitment to continuing their casual encounter. Divorced, Miki is committed to her corporate job, and she maintains a distance from men. Like Bing in *Floating Life*, she wears severe, Western-style business suits like suits of armor.

After discussing young love with Pui-Wai and visiting her stoic grandmother in her hospital bed, Tokio pays a visit to Miki at her office. Tokio seems to have changed; he has become the sensitive, "postfeminist" "new man," in tune with his own feelings and sensitive to women's emotional needs and desires. Now, with a softened Tokio, Miki becomes more than an interchangeable cipher after making love. In an intimate moment, Tokio talks about crying over *Bambi,* and he reminisces about

Miki's sister's breasts. Even this girl from his past takes on a new shape as Miki tells him of her sister's life with her husband and three children in Hawaii.

Pui-Wai's rendezvous with her boyfriend, however, is quite different. They fail to connect. Pui-Wai sits quietly by the hotel window as her boyfriend plays with his video game in bed. He only breaks the silence to talk about his plans in which both Pui-Wai and Hong Kong are noticeably absent. He will finish high school in the United States, with a double major in computer science and nuclear physics, and be sought after by American and Japanese transnationals. Ironically, Pui-Wai's boyfriend's self-absorption keeps her a virgin. The platonic connections the film favors over Tokio's womanizing ways win out as the film concludes with Tokio and Pui-Wai's chaste celebration of the Mid-Autumn family holiday. Female sexuality is contained and kept under familial control. Even though her parents are on another continent, Pui-Wai maintains loyalty to traditional patriarchal morality. She remains a virgin until legally sanctioned to change her status through marriage.

At a time when families are scattering and filial connections to the elderly are shattering, *Autumn Moon* clings to nostalgia for a Confucian, patriarchal order. Pui-Wai feeds her grandmother's cranky cat as a filial gesture, even if she must leave both grandmother and cat to live out her life alone and abandoned by her family; and she remembers her deceased grandfather during Mid-Autumn, even if she forgets his words. Similarly, Tokio's reminiscences with Miki reveal nostalgia for a traditional childhood as an analogue for a traditional cultural heritage. The postmodern moment may lay patriarchy to rest, but nostalgia for the patriarchy continues to be part of the cultural mix for GenerAsian X.

Floating Life pictures a similarly nostalgic view of Chinese patriarchal tradition. Female self-determination and sexual self-expression are depicted as threats that make racism and physical violence seem minor annoyances in comparison. Yen has difficulty continuing Chinese language and traditions through her headstrong daughter in Germany. Bing henpecks her husband with the rest of the household in Australia; comes close to an adulterous affair when separated from him for business reasons; divides the family with her ultimatum to her two younger brothers; and generally disrespects her elder sister, mother, and father. Gar Ming is led astray by the aptly named Apple, the free-spirited, "Westernized" temptress, who seduces him from his patriarchal obligation to marry and produce offspring.

Indeed, each member of the Chan family strays from his/her Confucian filial obligation. Even Mr. and Mrs. Chan neglect to pay their respects to their ancestors by not burning incense at the family shrine. The younger brothers split in their loyalties to the family. Traditionally, filial piety is meant to keep each gender and generation in line. Women are subordinate to men, younger to older, peasant to noble, noble to emperor. If any link in the chain is weak, the entire Chinese nation is threatened. With a dispersal of the Chinese away from a national center, the utility of Confucian values in a postmodern, postfeminist, hybridized society comes into question. The young men and women of GenerAsian X exist within this political and personal maelstrom.

Farewell, China, Autumn Moon, and *Floating Life* all recognize the political marks of postcolonialism, civil rights, feminism, the sexual revolution, various anti-Confucian movements, the Cultural Revolution, the May-June 1989 demonstrations in Tian'anmen Square, and the Hong Kong 1997 change in sovereignty, as well as consumerism, globalization, and the Chinese diaspora. However, while recognizing these momentous political, economic, social, and cultural changes, the films cling to conservative closures for their narrative conundrums. Women's sexuality, in particular, poses the most salient threat and is the element most harshly reined in as each film works through to its conclusion. Li Hong gives in to madness; Jane returns to her family; Pui-Wai retains her purity; her grandmother reconciles herself to her own expendability; Bing gets pregnant by her husband; Mrs. Chan enshrines the Chan ancestors properly; Yen finds her house; and her daughter finds her dream of traditional family harmony. Miki finds a moment of solace with Tokio and a type of redemption. However, the insouciant Apple has her abortion and is discarded by the narrative as a "dead end." From this perspective, the films become morality tales for GenerAsian X, warning of racism and cultural dissolution through the reconfigured presence of the liberated woman as the wanton vixen in need of a clear lesson. Narrative resolution rests on the elimination or recuperation of GenerAsian X's women for an uncertain patriarchal continuity of tradition within the Chinese diaspora.

WORKS CITED

Abbas, Ackbar. 1997. *Hong Kong: Culture and the Politics of Disappearance.* Minneapolis: University of Minnesota Press.

Bernardi, Daniel, ed. 1996. *The Birth of Whiteness: Race and the Emergence of U.S. Cinema*. New Brunswick, NJ: Rutgers University Press.

Berry, Chris. 1996. "Floating Life." *Cinemaya* 33 (Summer), 35–6.

Butler, Judith. 1990. *Gender Trouble: Feminism and the Subversion of Identity*. New York: Routledge.

Chua Siew Keng. 1998. "The Politics of 'Home': *Song of the Exile*." *Jump Cut* 42 (December), 90–93.

Dyer, Richard. 1997. *White*. New York: Routledge.

Erens, Patricia Brett. 1997. "Border Crossings: The Films of Ann Hui." Paper presented at the Society for Cinema Studies Conference, Ottawa, Canada, 17 May.

Fore, Steve. 1993. "Tales of Recombinant Femininity: *The Reincarnation of the Golden Lotus*, the *Chin P'ing Mei*, and the Politics of Melodrama in Hong Kong." *Journal of Film and Video* 45:4 (Winter), 57–70.

———. 1998. "Time-Traveling under an *Autumn Moon*." *Post Script* 17:3 (Summer), 34–46.

Generasian Life Website. http://home.inreach.com/asunaro/

Law Kar, ed. 1997. *Fifty Years of Electric Shadows: Report of Conference on Hong Kong Cinema*. Hong Kong: The 21ⁿ Hong Kong International Film Festival, Urban Council of Hong Kong.

Lu, Sheldon Hsiao-peng, ed. 1997. *Transnational Chinese Cinemas: Identity, Nationhood, Gender*. Honolulu: University of Hawaii Press.

Marchetti, Gina. 1993. *Romance and the "Yellow Peril": Race, Sex and Discursive Strategies in Hollywood Fiction*. Berkeley: University of California Press.

Shohat, Ella, and Robert Stam. 1994. *Unthinking Eurocentrism: Multiculturalism and the Media*. New York: Routledge.

Tan See Kam, Justin Clemens, and Eleanor Hogan. 1994–95. "Clara Law: Seeking an Audience Outside Hong Kong." *Cinemaya* 25/26 (Autumn-Winter), 50–54.

Teo, Stephen. 1997. *Hong Kong Cinema: The Extra Dimensions*. London: BFI.

Yau, Esther. 1994. "Border Crossing: Mainland China's Presence in Hong Kong Cinema." In Nick Browne, Paul Pickowicz, Vivian Sobchack, and Esther Yau, eds., *New Chinese Cinemas: Forms, Identities, Politics*. New York: Cambridge University Press.

Williams, Tony. 1998. "Border-crossing Melodrama: *Song of the Exile*." *Jump Cut* 42 (December), 94–100.

PART II

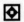

Genders and Doings

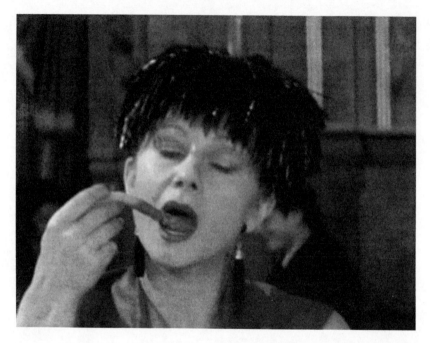

FIGURE 5. Georgina (Helen Mirren) snacking in *The Cook, the Thief, His Wife & Her Lover* (Peter Greenaway, 1989): control and gender are never far from cuisine. (frame enlargement)

CHAPTER SIX

\diamond

Eating and Drinking,
Men and Women

REBECCA BELL-METEREAU

Peter Greenaway's *The Cook, the Thief, His Wife & Her Lover* (1989) makes most viewers excruciatingly uncomfortable, and not simply because of the violence, the claustrophobic use of the camera, or the unappealing characters. What makes this film so disquieting is that it takes two of the most fundamental and life-affirming pleasures—eating and sex—and endows them with a creepy sense of excess. The sex scenes have that eerie feeling of dream about to turn into nightmare, of satiety about to turn into nausea. What often appears in film as an erotic situation—clandestine lovemaking—takes place here under aggressively unromantic conditions: almost in the open, behind a flimsy curtain, in a restroom stall, in a meat locker. And the eating scenes, far from being the usual warm and humanizing repasts of most Italian mafia films, offer some of the most unappetizing portraits of both food and people available in the history of cinema. Thoroughly grounded in a larger cultural critique, *The Cook, the Thief, His Wife & Her Lover* says something about the roles of gender, art, and consumption within the current system of wealth accumulation that goes far beyond the story of one psychotic criminal and his wayward wife. The metaphor of food takes primacy, with the cook appearing first in the title, the lover last, and the thief and wife sandwiched in between the two. Just as the filmmaker does, the cook remains

in the background, providing the meat of the film. The thief serves as catalyst and actor, while the wife begins as a trophy that later turns on her owner. Finally, the lover represents the aestheticization of human experience, the meat to be consumed. This film serves as a model for understanding what makes viewers uncomfortable about a number of films that blend food and sex.

Aside from the sex act, few human activities carry as much gendered psychological baggage as that of eating. While food and nurturing traditionally suggest feminine associations in Western culture, filmic depiction of meals often holds intentional or unintentional allusions to Leonardo da Vinci's painting of the Last Supper, an exclusively masculine image. Just as the absence of women in the painting suggests the presence of women out of the frame, cooking in the side rooms, the absence of women onscreen may prompt postmodern viewers to imagine women somewhere in the offscreen space explored by such theorists as Christian Metz and Noel Burch (Metz 1988; Burch 1973). Categorizing eating films creates a useful framework for examining filmmakers' conceptions about metaphorical forms of consumption, and this examination of the intersection between gender and eating further clarifies our cultural assumptions about food and sex. As ethnographic theorists from Claude Lévi-Strauss to Mary Douglas and Frank Lestringant have observed, eating practices have a social significance, and the rituals and taboos surrounding eating constitute a cohesive force as fundamental as the universal presence of incest taboos (Douglas 1966). Lévi-Strauss describes "the banquets, feasts, and ceremonies of various kinds" as that which forms the "web of social life" (Lévi-Strauss 1969, 480–81; see also Lévi-Strauss 1973). In Lévi-Strauss, the rule of exogamy applies in rules governing incest and eating, and women constitute the prized object of exchange.

Even if one argues that women have greater subjectivity than Lévi-Strauss envisions, his essential point remains that the rules do not reflect some natural state, but rather create an artificial one that attempts to resolve the most vexing social and existential contradictions. Mary Douglas describes how eating rituals, "based on discrimination of categories, human, animal, male, female, young, old, etc. . . . allow their initiates to eat what is normally dangerous and forbidden. . . . That which is rejected is ploughed back for a renewal of life" (Douglas, 167). According to Lévi-Strauss, "The prime role of culture is to ensure the group's existence as a group" (1969, 32).

As Lévi-Strauss and others have observed, the traditional function of art has been to provide imaginary resolutions for real social conflicts. The

culture's drive to maintain group cohesion at the same time that it manages conflicts among subgroups appears strikingly in film. Using the eating motif to unpack a movie shows how the majority of mainstream films are brilliantly supportive of the status quo, all the while pretending to subvert it.

A look at critical reception further demonstrates how the system perpetuates itself, internalizing possible subversions and rendering them just one more stack of commodities, to be consumed by viewers incessantly hungry for comforting images. Those rare films that offer the slightest genuine critique of consumer culture, of power relations in traditional gender roles, or of the larger capitalist/colonialist enterprise often prompt a barrage of scorn completely out of proportion to the actual supposed poor quality of the films in question. One reason for this response may be that these films touch on areas of pleasure and guilt that are most fundamental and inaccessible to rational analysis, the oral and sexual roots of the psyche, a realm that viewers prefer to leave undisturbed. This connection also makes films that employ such imagery intensely powerful. Like Poe's purloined letter, however, their power is hidden in plain sight, in activities that viewers take for granted and in culturally determined gender roles that people often naturalize as simply "the way things are."

Western commercial culture presents eating as a forbidden activity for women, often described as sinful, as Susan Bordo observes in *Unbearable Weight*. She notes that in commercials, "female eating is virtually always represented as private, secretive, illicit" (29). Women are the servers who feed men, and the activity of eating is a sign of health and vitality in men. For men, eating unusual or even supposedly disgusting foods usually signals virility and robust courage. In film, women who eat appear in a narrow range of settings: the vampirous woman, the carnivorous man-eating woman, the depressed woman who eats out of frustration and self-loathing or who eats as a substitute for sex, and the erotic woman whose hunger for food stands for sexual lust. An acceptable conflation of eating and sexuality occurs in such films as *Tom Jones* (1963) and *When Harry Met Sally* (1989). Sally can simulate an orgasm during a meal and prompt others in the restaurant to stop chewing and respond, "I'll have what she's having." This scene, while appearing to be about sexuality, is really about power and domination; Sally establishes her superiority and undermines Harry's self-confidence by demonstrating how easy it is for women to fake orgasms. Food can also be used to demonstrate sado-masochistic relationships and apparent male domination, as it is in films like Adrian Lyne's *9 1/2 Weeks* (1986). Lush scenes of food at the

opening of romantic comedies establish a hunger in their audiences, reminding them of their desire for both oral gratification and love. A long tracking shot of fruits and flowers at the market in *Notting Hill* (1999) makes viewers long for food and romance. The film's ultimate message may be for a woman to give up a $15 million-a-year career to make breakfast and babies for a bookseller, but the wrapping of this traditional message is visually and psychologically tasty. In the opening of Michael Hoffman's *A Midsummer Night's Dream* (1999), the loving shots of banquet preparations prime the audience to consume both the story and the snacks at the concession stand.

Filmmakers have long used food as the prop that lets viewers know the emotional and social conditions of characters. In Charlie Chaplin's *Gold Rush* (1925), Chaplin makes light of the real-life hunger that accompanies poverty by eating his shoes, a routine reprised by a number of actors, including Johnny Depp (*Benny & Joon,* 1993). Chaplin's scene of mechanized feeding in *Modern Times* (1936) demonstrates how industrialization and technological developments have dehumanized people. Filmmakers have continued to make connections to Chaplin's routine in such films as *Brazil* (1985), with the limp toast; *Dark City* (1998), with people falling asleep in their soup, and *The Truman Show* (1998), which points to product placement as one of the artificial elements in the constructed life of Truman (Jim Carrey). When Truman's wife (Laura Linney) uses food as an excuse to create an impromptu commercial, he responds with rage, questioning not only her love but also the carefully engineered life that includes incessant product placement and encouragement to consume.

Sometimes eating in film is neither a product placement nor a substitute or enhancement for sex. Those films that demonstrate women and men eating together in a nonsexual context clearly depict good women as those who tenderly prepare food as an act of nurturance. In the majority of films, both mainstream and independent, food and all of its concomitant rituals of cooking and eating constitute a vastly different symbolic act when performed by women as opposed to men. More often than not, films depict cooking and eating as acts of control for men, ways of domesticating or dominating, placating or subduing themselves and others. The filmmaker may insert eating scenes as a way of humanizing killers, as in a whole raft of mafia films. Food may underscore a criminal's humanity, as in the final supper in Tim Robbins's *Dead Man Walking* (1995). Eating tasteless grub or unusual parts may demonstrate bravery and manly toughness, as in Jeremiah Johnson's consumption of raw liver (1972) or

John Huston's famous eating of fish with the head on in Roman Polanski's *Chinatown* (1974). While men are given much more permission societally to eat with abandon, within the context of film women often express their liberation and rebellion through cooking and eating.

Gabriel Axel's *Babette's Feast* (1987) demonstrates this pattern by combining the models of Last Supper and feminine nurturance and sacrifice. What seems to be a traditional and natural female activity reveals itself to viewers by the end of the film as an extraordinary feat of both artistry and sacrifice. The film opens by introducing a culture in which food is as colorless as the drab, windswept coast of Jutland, where the story takes place. Babette (Stéphane Audran), once a famous chef in Paris, is taken in by two devout spinsters who dutifully instruct her how to boil lutfisk and bread to a tasteless mush. Eventually Babette wins the lottery and spends her entire winnings to create an extravagant meal for members of their puritanical religious sect. These good people do not wish to hurt Babette's feelings, but they all vow not to enjoy the food, which they suspect is sinful, perhaps even satanic. Although only one guest, a sophisticated outsider, is able to appreciate her artistry, the others enjoy a kind of spiritual redemption and reconciliation as a result of her labor. As (in spite of themselves) they enjoy course after delicious course, becoming quite tipsy with the finest French wines, they confess to each other their secrets, offer forgiveness, appreciate sensual pleasure, and express love. In addition, Babette stands as the archetype of the artist, who feeds others with beauty and spiritual inspiration, at great cost to herself and with full appreciation from only one recipient. Babette is aligned with Christ as well as with the isolated artist, even as she seems to mimic the behavior of a traditional woman who serves others first and herself last.

Alfonso Arau's *Like Water for Chocolate* (1992) uses magical realism to show another version of the power of the female chef. It is significant here, however, that the film focuses on others who eat the food of the central character, Tita (Lumi Cavazos), not on her own appreciation of what she has prepared. In a much more traditional take on the Cartesian mind-body split, *Like Water for Chocolate* presents Tita as the sensual earth mother, whose spiritual connection with food remains firmly rooted in her physical being. The part of the food that creates the magic literally comes from Tita's body, first in the tears she sheds into her sister's wedding cake and later in the blood pricked from her breasts by the roses her new brother-in-law, Pedro (Marco Leonardi), brings to her. The tear-filled cake produces a mirror of Tita's emotions in a hilarious scene of wedding guests

crying and vomiting. Often nausea and vomiting symbolize the psychological refusal to swallow one's pain over sexual rejection or molestation, as in Roman Polanski's *Repulsion* (1965), Paul Mazursky's *An Unmarried Woman* (1978), Sul Choo Park's *301, 302* (1995), and Ang Lee's *Eat Drink Man Woman* (1994). One of the things that makes this nauseating scene feel like pleasurable revenge in *Like Water for Chocolate* is the fact that the discomfort of the young female protagonist is displaced onto the inexperienced newlyweds and their wedding guests. Any viewer who has attended the marriage of an unextinguished flame may witness this scene with a combination of empathy and deliciously naughty delight. In a later quail-eating scene, the female chef expresses her own sexuality and forces others to lose control. The passion evoked by consuming the dish flavored with Tita's hot blood causes desire, heavy breathing, sweating, and eventually literal flames. The film poses the problem as a contrast between traditional and new ways of viewing women's roles, and although the film ends with the death of the female protagonist and her lover, her death is redemptive and liberatory rather than punitive. The final eating scene shows Tita and Pedro devouring candles as the intensity of their passion causes them to burst into flames at the moment of consummation.

In a much more sexually regressive film, James Brooks's *As Good as It Gets* (1997), the central problem is the white male protagonist's inability to comfortably occupy his central role as the patriarch, the one who is served. At the film's opening, Jack Nicholson makes the famous writer Melvin Udall's ritualized obsessions, particularly those surrounding food and cleanliness, seem humorous. It soon becomes clear, however, that the system of control he has developed no longer provides him with a sense of security. His routine is disrupted by a series of intruders, including a woman of color (Lupe Ontiveros), a gay man (Greg Kinnear), a mother (Helen Hunt), and an animal. In the real world of the nineties, the control system of white patriarchal hegemony suffers disruption from representatives from these categories: people of color, homosexuals, women and children, and the natural environment (as represented in the film by the dog). The patriarch's heart is softened by the woman and the animal (and even, to some extent, by the gay man), and he demonstrates this small transformation in part by carrying bacon in his pocket in order to curry favor with the canine. Even as this film follows a standard pattern of restoring "patriarchal order" to a state of equilibrium, for audience members who are neither white nor male nor heterosexual it provides enough fantasy tidbits to make it a popular success, with enormous

grosses and academy awards for Helen Hunt and Jack Nicholson. The woman's ability to convert a gay male, at least temporarily, and to humanize the hardened, wealthy patriarch dovetails with the Prince Charming rescue fantasy. Yet in *As Good as It Gets*, the aspirations of the woman are not even as ambitious as those of the rescued prostitute in Garry Marshall's *Pretty Woman* (1990). Hunt's character remains a servant to the wealthy male, whose gifts to her amount to not much more than medical insurance for her child.

The same associations between the gender assumptions of capitalism and rituals of consumption appear in David Fincher's *The Game* (1997), again without any apparent critique of the inequitable distribution of wealth. As in *As Good as It Gets*, a wealthy male (Nicholas Van Orton, played by Michael Douglas) is served by a female (Deborah Kara Unger), whom he later attempts to rescue from mysterious attackers. His entry into her world creates a disequilibrium that is manufactured, at the level of plot, by his brother (Sean Penn) and the company responsible for engineering "The Game," a high-priced action adventure guaranteed to teach participants the meaning of life. At the level of subtext, Van Orton's lack of connection to humanity—to his family, to a woman, even to his own childhood—is the problem to be solved. In spite of any trials or humiliations suffered by the wealthy Van Orton, the film returns audiences to an acceptance of the status quo. While the woman's supposed betrayal of Van Orton is initially located in an elite restaurant, perhaps creating suspicion of this elegant milieu, the later scenes of death, rebirth, redemption, and reconciliation take place in a similarly posh location, a huge hotel banquet room: any suspicion of wealth and power that we may have felt is dissipated. As the happy denouement unrolls, with the camera lovingly tracking down the table of food and drink, brotherly hugs accompany the sticker shock of a bill for the combination of spiritual enlightenment and big banquet. And the film closes with the young woman inviting the older man for coffee, a simultaneous nod to female liberation and a modest nineties version of the woman as nurturer. Instead of the intimacy of a woman making coffee for him in her home, *The Game* offers the impersonality and commercialism of an invitation to an airport coffee shop.

One might expect such relatively popular American mainstream films as *The Game* or *As Good as It Gets* to support the dominant paradigm in their depiction of gender and food, but even a Chinese art film such as *Eat Drink Man Woman* comes up with a similarly hegemonic message. On the surface, the film seems fairly progressive, with a variety

of intelligent, independent-minded female characters struggling to cope with love and family issues. It appears at first that the story focuses primarily on three daughters—Jia-Jen (Yu Wen Wang), Jia-Chien (Chien Lien Wu), and Jia-Ning (Kuei-Mei Yang)—of master chef Chu (Sihung Lung), who long ago lost his wife and his sense of taste. In the shuffle of the daughters' romances, brushes with illness and mortality, and dozens of mouth-watering meals, the underlying conservatism of the film may be obscured. Over one hundred recipes appear in various stages of completion in this tribute to cooking, family, and traditional gender roles, but since it is the father who does the cooking, it may seem like a reversal of the usual restriction of women to the kitchen.

As a complex work, the film wrestles with issues of control, and the framing of shots reveals an aesthetic and formal precision that underscores this theme. At one point, a fellow chef comments to the father on how no one can match his "control over the art of Chinese cuisine." Several of the meals are intercut with shots of beautifully balletic movements by a traffic conductor who controls the dense flow of street traffic. By its structure, the film gives viewers a sense of controlled revelation of the details of the three daughters' lives. The female lives are spectacularized, and in the end the father's announcement of his engagement to a much younger woman comes as a surprise to her mother, his daughters, and the audience alike. By keeping this part of the plot secret, the director places the father in the position of subject and the women and viewers surrounding him as objects to be manipulated. It may be a pleasurable manipulation for the majority of viewers, and in the end, even the remaining daughter seems happy to accept her subservient role vis-à-vis her father. In terms of wish fulfillment, the film is not far from As Good as It Gets: irascible older man gets beautiful young woman half his age. And the daughter who has been struggling with mixed feelings about abandoning her father finds a quiet satisfaction in feeding him, remaining at the periphery of his life, resisting only slightly his criticism of her cooking. After all, the discovery that he can taste too much ginger in her stir-fry is an indication that he has regained his taste for life. Accepting his criticism and letting him win the argument is a small price to pay for the renewal of her aging father's vitality.

Maggie Greenwald's The Ballad of Little Jo (1993) offers a more critical take on the power dynamics imposed by gender. Cooking ability, refined tastes, and fastidiousness are all associated with effeminacy and womanliness, just as sissies, intellectuals, and the civilization of Easterners are conglomerated in certain genres, particularly the western. In Ballad, the trans-

formation of Jo (Suzy Amis) from her female role to a new life as a man is intimately bound with eating scenes that serve to establish her new identity. Greenwald emphasizes the way Jo must learn to eat in a crude fashion as an important feature of behavior that will code her new persona as masculine. When Jo first disguises herself as a man, she watches how the men eat and then deliberately holds her spoon in her fist in order to capture the roughness of manners that is considered manly. When the Chinese Tinman (David Chung) comes to cook for her, Jo's facial expression indicates her immediate appreciation of the tastiness of his cuisine, but again she must suppress her refined tastes and ability to discriminate flavors as a feminine characteristic that will immediately unmask her gender.

Greenwald plays against gender stereotypes throughout by not using food or nurturing as proof of the goodness of Jo's character. Ordinarily a woman's failure to offer good food signals that her character is inadequate or even wicked. The image of the crone who fails to nourish or who gives those in her care poisonous food goes back to creation myths and later to fairy tales, for example the cruel, witchlike stepmother feeding a poisoned apple to Snow White, echoed in later incarnations of the archetype by Sigourney Weaver, by Uma Thurman as Poison Ivy in *Batman & Robin* (1997), or in Hugh O'Conor's male real-life poisoner in *The Young Poisoner's Handbook* (1995). This image, in turn, draws from its allusion to the apple in the garden of Eden. Women with knowledge—particularly of life-and-death matters such as food—are often depicted as treacherous and inherently evil, and as being associated with witchcraft and perdition.

One of the key acts of the evil woman is to give bad food, placing her into the category of what D. W. Winnicott called the "bad mother" (163). Occasionally such characters seem whimsical, for example the two sweet eccentric old ladies (Josephine Hull, Jean Adair) who benevolently poison lonely bachelors in Frank Capra's *Arsenic and Old Lace* (1944). More often than not films present this kind of behavior as the action of an archetypal female villain. One of the most shocking acts of cruelty occurs in Robert Aldrich's *Whatever Happened to Baby Jane?* (1962) when the elder sister (Joan Crawford) feeds her sister (Bette Davis) a cooked rat. In Lyne's *Fatal Attraction* (1987), Glenn Close reveals her depravity by boiling the family bunny, a perverse invasion of domestic space and an attack on the dual symbol of fertility and innocence.

Across genders, associations between consumption of food and the consumption of commodities or engulfment of cultures almost universally employ the metaphor of cannibalism. Ever since the Greeks' fascination

with cannibalism in myths and drama based on the House of Atreus, on through to Swift's "A Modest Proposal" and the American public's more recent obsession with such real- and reel-life cannibals as Jeffrey Dahmer and Hannibal Lecter, eating human flesh has stood with incest and murder as a nearly universal taboo. Much of the vicarious pleasure audiences take in the horror genre derives from the forbidden expression of pure id in cannibalistic characters. Georges Bataille points out that taboos surrounding cannibalism or consumption of certain sacrificed animals exhibit their real power in the ritualized breaking of boundaries: "The very prohibition attached to it is what arouses the desire" (71–72). From Tobe Hooper's *The Texas Chainsaw Massacre* (1974) to Jonathan Demme's *Silence of the Lambs* (1991) to Antonia Bird's *Ravenous* (1999), portrayal of the vicious cannibal not only satisfies fantasies of oral aggression but also often provides a commentary on issues of class. For example, in *Texas Chainsaw Massacre*, Hooper plays on stereotypes of the Texas redneck, celebrating the triumph of the primitive underclass and glorying in its grossness and viciousness. Racial issues also emerge in George Romero's cult classic *Night of the Living Dead* (1968). Opening with a brother and sister visiting a grave site, the film almost immediately leaps into the midst of the flesh-eating ghoul's world. At a pace as relentless as the zombies' walk, the film lurches into the forbidden territories of cannibalism at the surface level and racism at the subtextual level. In the end, law officers gun down the lone human survivor, a black man who, despite his ability to conquer the mindless zombies that destroyed his white companions, is ultimately destroyed by the mindless system of white authority. In *Silence of the Lambs*, Hannibal Lecter (Anthony Hopkins) fascinates American audiences because he combines evil with the sophistication and supposedly superior intellect of the high-class, British persona. Placing Jodie Foster's working-class Clarice Starling in contention with the father figure of Lecter manages a number of anxieties surrounding parental conflict, incestuous desire, and a sense of social inferiority. All of these films indulge audiences in the vicarious pleasure of aggressive orality.

An even more playful treatment of food, offbeat sex, and murder occurs in Paul Bartel's *Eating Raoul* (1982), which opens with voice-over narration commenting on how the culture has become so decadent that the distinction between sex and food has disappeared. Bartel and Mary Woronov play a celibate couple victimized by a series of swingers who assume that Mary, an attractive nurse, must be sexually available. In order to get money to start up a restaurant, they decide to turn the tables on the

swingers by inviting them for sex games and then killing them and taking all their cash. They fall in with small-time con-man Raoul, who helps by "recycling" the corpses in local restaurants. He gets Mary to smoke marijuana in order to seduce her and then blackmail her for more sex. The conclusion is given away by the title, a humorous take on cannibalism that nonetheless shows up the shallow and hypocritical rapaciousness of the small business entrepreneur. While Mary and Paul are relatively likable characters in the midst of obnoxious hedonists, their mouthing of free enterprise and elitist slogans helps point up the ruthlessness of laissez-faire economic development in American society. A later and more sophisticated version of simply murdering dinner guests who are ideologically offensive occurs in Stacy Title's black comedy *Last Supper* (1995), an independent directing debut that shows liberal do-gooders killing and burying their dinner guests as punishment for spouting objectionable right-wing views.

This same sort of campy humor combined with attention to social issues appears in Quentin Tarantino's *Reservoir Dogs* (1992) in the opening discussion at the restaurant. When Mr. Pink (Steve Buscemi) wants to leave without tipping, Joe Cabot (Laurence Tierney) makes a populist point of insisting that waitresses deserve the extra money. The themes of self-sacrifice and ritual violence are underscored by allusions to Christ and the apostles throughout the film. Indeed, any film that opens with a shared meal will bring up the motif of the last supper.

Even in this exceptionally violent film, the director follows a pattern that repeats itself in practically every mafia movie ever made. Food and eating scenes promote the humanity and warmth of the male-dominated social system, seriously undermining any transgressive elements or critique of capitalism that might be hinted at in isolated speeches. *Reservoir Dogs* simply substitutes one boys' club for another, thereby demonstrating that the outlaw version of patriarchy is somehow true and noble in its brutal simplicity and directness. Another food-centered film celebrating Italian masculine culture that is praised for its originality is Stanley Tucci and Campbell Scott's *Big Night* (1996). This film presents a pale and lifeless Italian shadow of the joyous Nordic reconciliation created in *Babette's Feast*. Like a cross between *Waiting for Godot* and *Like Water for Chocolate*, *Big Night* makes viewers sit through countless courses that create a sort of mental indigestion but never satisfy, as the audience awaits a regeneration that never materializes.

The ultimate example of deferred satisfaction appears in Martin Scorsese's *The Age of Innocence* (1993), in which elaborate meals are occasions for avoiding genuine interaction. The first abortive dinner scene

begins with a basket of turtles and a few dead ducks draped over a counter, all of which fade to nothing visually in a series of dissolves, just as the social prospects of the sexually unconventional Countess Olenska (Michelle Pfeiffer) disappear when all of New York society refuses to attend her dinner. When the irreproachable van der Luydens (Michael Gough and Alexis Smith) invite Madame Olenska to dinner, the narrator (Joanne Woodward) describes the preparations as having "almost a religious solemnity" and the elaborately arranged food—practically unrecognizable as such, so artfully has it been prepared—is displayed in formally exquisite beauty on gorgeous china. The banquet scenes are shot from a birdseye angle, and Scorsese almost never shows anyone actually eating. Form takes precedence over substance; food and people are meant to look beautiful, with actual taste or pleasure not even an issue. The artificial-looking food arrangements meticulously captured by the camera mimic the tightly arranged and circumscribed roles of both men and women in this social milieu. In the final dinner scene, every action is scripted in what the narrator calls a "seamless performance" of ritual designed to remove Madame Olenska's tempting presence from Archer Newland (Daniel Day-Lewis), the "prisoner at the center of armed camps." In its depiction of food and sex, *The Age of Innocence* tells a wistful tale of missed chances, deferred pleasures, and suppressed appetites.

A more negative picture of missed connections and alienation forms the foundation for a number of foreign and independent films, which are also more explicit than mainstream movies in establishing links between eating and sexuality. One of the earliest and most powerful films to capture a sense of shame and disgust over bodily functions was Polanski's *Repulsion*, featuring Catherine Deneuve as a woman undergoing a mental breakdown. Her decline is portrayed naturalistically through gross distortions of her surroundings as witnessed from her point of view: a suddenly bulging wall in the hallway or a giant crack in her bedroom wall. As she deteriorates, she is pictured alone in her darkened apartment, drinking water, eating clumps of sugar, and gazing in disgust at the rotting carcass of a roast rabbit that her sister made. Associations between the rabbit, fertility, and her disgust with sexuality are apparent in a sequence in which she hears her sister making love with her boyfriend, fantasizes that a man has entered her room and raped her, and gags at the smell of a man's undershirt. A shot of a photograph at the film's opening and closing gives viewers a hint as to the early source of her psychosis, in the suggestive gaze of a frightened girl in the direction of a menacing and possibly molesting father.

the same patterns traced by Frank Lestringant's new historicist analysis of various transformations in the image of cannibalism. Lestringant describes how Columbus's Renaissance naming and villainizing of the cannibal was followed by Montaigne's Enlightenment idealization, an image later naturalized and silenced by twentieth-century ethnographers. In her depiction of the windigo cannibal as a white soldier, Bird comes closest to Voltaire's notion that the so-called primitive was far less barbarous and cruel than the supposedly civilized European conquerors were.

In a critique of current society, Harry Jaglom's *Eating* (1990) attempts a serious treatment of gender roles, eating disorders, and women's obsession with body image, but the film succeeds in creating a picture of women primarily from a male perspective. Jaglom's women constantly tell each other how beautiful each other's bodies are, confess their utter dependence on men for their sense of worth, and gossip and backstab their way through a day-long eating binge. A more interesting and sensitive portrayal of an eating disorder appears in Lasse Hallström's *What's Eating Gilbert Grape?* (1993), in which Gilbert (Johnny Depp) must deal with a retarded younger brother (Leonardo DiCaprio) and a reclusive mother (Darlene Cates) so obese that the entire town makes fun of her. The demands placed on the protagonist by his mother, siblings, and economic hardship all constitute "what's eating Gilbert Grape." By focusing on the anxieties surrounding food and sex, all of these films violate the viewer's sense of order in profound and disturbing ways, portraying eating as excess, showing sexual relations as hungry power struggles, and depicting consumption as theft.

This notion of theft brings us back full circle to *The Cook, the Thief, His Wife & Her Lover,* set in an environment as ruthless and cold and self-consciously formal as a walk-in refrigerator. The film's hyperaesthetic depiction of food and sexuality draws attention to the emptiness of these categories of meaning. Catherine Russell points to the limitations of this type of aestheticized imagery in her analysis of David Lynch and Peter Greenaway's relation to, and understanding of, the body: "For both directors the body is the site of transience, semiosis and transformation, and the most potent symptoms of decay are Lynch's flies on vomit and Greenaway's maggot-ridden meat. And yet the body is also eroticized, the decay corrected and historical temporality closed off in the symbolization of transcendence, resurrection and immortality" (197).

But it may be argued that Greenaway offers an alternative to the dominant gender role paradigm in the role reversals that occur between the wife, Georgina (Helen Mirren), and the lover, Michael (Alan Howard), from the

very beginning. When Michael tells Georgina demurely that she has beautiful eyes, she tells him boldly that he has a beautiful prick, which we will see in great detail as it is being consumed during the final banquet. Later, the camera intercuts between scenes of sexual intercourse and images of a knife slicing through a cabbage and then slicing off bits of a cucumber. This campy food metaphor provides a rare moment when the filmmaker lightens the mood of the scene, suggesting that the male lover is somehow being castrated by his relative passivity in the relationship. Yet control is never far from cuisine. Words are powerful, and speaking proves dangerous, as one woman quickly learns when she talks to the thief, Spica (Michael Gambon). After she tells him of his wife's infidelity, he jabs her face, and we see her in close-up with a fork sticking out of her cheek. Slowly the camera tilts up to Spica, whose face is above hers, establishing through *mise-en-scène* his superior power. Despite the subjugation of women throughout the film, however, in the end it is the male characters who must literally eat their words. Michael is forced to choke on one of his texts from the French Revolution, and Spica must eat the lover, as he vowed to do. Spica has dominated the conversation, leaving almost no room for dialogue with any other character, but in the end Georgina silences him with a gun, the appropriated phallic power that she has claimed for her own purposes.

If women are present but often powerless in *The Cook, the Thief, His Wife & Her Lover*, people of color are notable for their absence, and when they are mentioned, it is often in connection with sexuality and eating. When Georgina answers Spica's taunts about her doctor, she replies that he is Ethiopian, "black as the ace of spades" and "probably drinks his own pee." After Michael's death, Georgina talks with the cook about cooking her lover and serving him to Spica. She asks him what foods he charges the most for, and he replies that anything black is more expensive. There are extra charges for vanity foods and aphrodisiacs, but the most expensive food is black because, the cook claims, "Eating black food is like consuming death. . . . Death, I am eating you." The cook's words bear a striking resemblance to Bataille's description of eating forbidden foods in animal sacrifice: "The sacrifice links the act of eating with the truth of life revealed in death" (91). Robert Sinnerbrink argues that in Greenaway's film, "Cooking becomes a metaphor for a series of transformations throughout the rest of the film: nature into culture; raw flesh into food and art, both of which are linked in an economy of excess; and finally, murder into sacrifice" (11).

Fear of death and the yearning for an undifferentiated connection with another human being find expression in images of eating and sex, and the expression of these emotions links the films I have considered. In ana-

lyzing almost any film, from such high art works as *The Discreet Charm of the Bourgeoisie* (1972) to such low art as *American Pie* (1999), casting scrutiny through the double lenses of gender and consumption yields an extraordinarily rich vein of meaning. Films about food are about anything but food. They allow audiences to displace anxieties about sex and death onto images of consumption. And the acts of consuming in the final scenes of films as disparate as *301, 302*; *The Cook, the Thief, His Wife & Her Lover*; and *Eat Drink Man Woman* all represent simultaneous sacrifice, acceptance of mortality, hope for regeneration, and ultimate love.

WORKS CITED

Bataille, Georges. 1986 (first published 1957). *Erotism: Depth and Sensuality*, trans. Mary Dalwood. San Francisco, City Lights Books.

Bordo, Susan. 1993. *Unbearable Weight*. Berkeley, Los Angeles, London: University of California Press.

Burch, Noel. 1973. *Theory of Film Practice*. Trans. Helen R. Lane. New York: Praeger.

Douglas, Mary. 1966. *Purity and Danger: An Analysis of the Concepts of Pollution and Taboo*. London, New York: Ark.

Lestringant, Frank. 1997. *Cannibals: The Discovery and Representation of the Cannibal from Columbus to Jules Verne*. Trans. Rosemary Morris. Cambridge: Polity Press.

Lévi-Strauss, Claude. 1969. *The Elementary Structures of Kinship*. Trans. James Harle Bell, John Richard von Sturmer, Rodney Needham. Boston: Beacon Press.

———. 1973. *The Raw and the Cooked*. Trans. John and Doreen Weightman. New York: Harper and Row.

Metz, Christian. 1982. *The Imaginary Signifier: Psychoanalysis and the Cinema*. Trans. C. Britton, A. Williams, B. Brewster, and A. Guzzetti. Bloomington: Indiana University Press.

Russell, Catherine. 1993. "The Spectacular Representation of Death." In Christopher Sharrett, ed., *Crisis Cinema: The Apocalyptic Idea in Postmodern Narrative Film*. Washington, DC: Maisonneuve Press.

Sinnerbrink, Robert. 1990. "*The Cook, the Thief, His Wife and Her Lover*: A Discourse on Disgust." *Continuum: The Australian Journal of Media & Culture* 5:2.

Winnicott, D. W. 1974. *Playing and Reality*. London: Penguin.

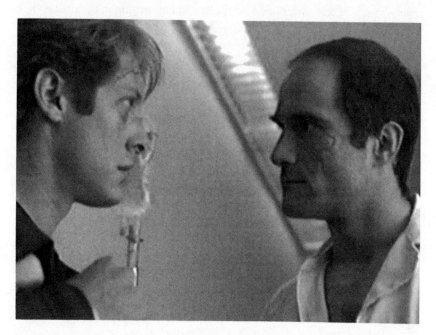

FIGURE 6. *Crash* (David Cronenberg, 1996): Vaughan (Elias Koteas, right) is a
powerful and seductive foil—visual, emotional, and physical—for Ballard (James
Spader). (frame enlargement)

CHAPTER SEVEN

◈

Boys Will Be Boys:
David Cronenberg's
Crash *Course in Heavy Mettle*

MURRAY FORMAN

> Road and automobile engineers are properly concerned with
> the psychology of perception, reaction times, information
> load, and the ergonomics of design. Intrinsic to car-driving is
> a constant inflow of all kinds of information; and on the basis
> of what is perceived actions have to be taken, some of which
> are of an emergency nature.
>
> —Whitlock, "The Psychology and
> Psychopathology of Drivers"

The history of cinematic portrayals of American car culture is long and
varied. *Rebel Without a Cause* (1955), *High School Confidential!* (1958),
Bullitt (1968), *American Graffiti* (1973), *Christine* (1983), and *To Live
and Die in L.A.* (1985) are but a brief sampling of the myriad of films
that, in different ways and to varying extent, embrace the automobile and
its accompanying social practices. Common to all of these films is the
ubiquitous representation of highway violence and car crashes, reflecting
Paul Virilio's insight that

each period of technological development, with its instruments and machines, brings its share of specialized accidents. . . . To acquire a tool, a new piece of industrial equipment or whatever, is also to acquire a danger, a particular risk; it is to open one's door, to expose one's intimacy to hazards, slight or major. (81)

Much about Virilio's logic is identifiable in J. G. Ballard's controversial novel *Crash*, which explores the interfaces between men and automobiles and the unforeseen products of their union. With the production and release in 1996 of David Cronenberg's cinematic version of *Crash*, the automotive theme is sustained, although Cronenberg absorbs and redirects society's pervasive and arguably perverse fascination with vehicular collisions.

It is crucial to note at the outset that *Crash* is not about catastrophic accidents and their attendant effects that are, in Virilio's conception, an inevitable outcome of each technology. The film is itself a site of catastrophe or cultural crisis, as widespread critical derision and public outrage indicate. This "catastrophe" can be approached from two main perspectives. First, following Ballard's literary model, Cronenberg tampers with the sacred role of the car in modern society, subjecting automobiles and their common status to a series of sacrilegious atrocities that invite a public reevaluation of their normal presence in our everyday lives. Secondly, and more interestingly, he tampers with normative, mainstream images of masculinity.

In this sense, Cronenberg remains a director of horror films (Ramsay), for his assault on the values invested in both cars and masculinity constitutes an American horror. Like the novel upon which it is based, however, the film also explores a darker area that includes *deliberate* collisions and choreographed *non*accidents, articulations of intentional highway violence involving cars, celebrity images, women, and men that are carefully planned and orchestrated solely for their transformative erotic potentials.

In this chapter, my interests steer only briefly toward the representation of automobiles in *Crash*. Despite the film's title and ostensible emphasis, the display of automotive destruction and human carnage is not prioritized. In both Ballard's and Cronenberg's versions, cars function metaphorically as a means of drawing attention to and exposing various realms and expressions of late-twentieth-century social malaise. They are also tools that inscribe this malaise as a gendered phenomenon. The main emphasis in *Crash* lies with the representational velocity that Cronenberg brings to his analysis of society and gender and, as I will illustrate, the

accelerated impact of competing masculinities that are embedded within the cinematic version of Ballard's unnerving novel.

Cars are mobile signifiers that communicate ideals and values within a nexus of cultural variables. To suggest otherwise would mean ignoring established social attitudes, especially in North America, where the "meaning" of cars corresponds with, among other things, expressions of capital accumulation, taste, age or generational status, or gender-loaded relations of power. Describing the shift in automobile designs between the early and late 1950s, an era that sets the tone for many contemporary attitudes toward cars, Thomas Hine provides a clear, if extreme example of the interpretive lens through which Americans often view their vehicles:

> Throughout the early 1950s, the faces of cars tended toward hostility and defensiveness. . . . The chrome was thick. The teeth were large, the bumpers suggested armor. One is tempted to find the countenance of Senator Joseph McCarthy glaring out defensively from their front ends. . . . That image changed in the Populuxe era. Cars gained a friendlier look. If they had teeth they were smaller, but the mouth was often stretched the entire width of the car in an almost Eisenhowerish smile. (96)

Cars in films and films about cars thus enter into a wider economy of semiotic and symbolic value, circulating images that merge with broader social systems of meaning. While it is true that sometimes a car *is* just a car, in *Crash* this is almost never the case.

In her analysis of William Friedkin's *To Live and Die in L.A.*, a film that is perhaps best remembered for its compelling car chase scene, Sharon Willis describes the concept of "conditioning" and the symbiotic processes of production and reception:

> Cinematic production and consumption, reciprocally conditioning as they are, are embedded in social power formations. Produced within cultural exchange and circulation, images also construct the conditions of their reception, the positions the spectator occupies or invests. The spectator's act of filmic consumption involves accepting its forms of address, but it also entails producing its legibility, and negotiating its disjunctions, the elaborate exchanges among its semiotic registers. (265–66)

The social reality of automobiles and the accompanying tradition of car films provide a corpus of preexisting ideas and images into which more recent productions must enter and upon which audience comprehension is based. Years of experience and "conditioning" inevitably build anticipation on the part of viewers who have an established knowledge and familiarity with the ways in which cars, drivers, races, and accidents are (and have long been) depicted and with how the vehicles function as mediating forces among characters. With *Crash*, Cronenberg encounters a dilemma that requires him to acknowledge the cinematic past and its traditions while attempting to present the radical and alien concepts that comprise the core themes of Ballard's iconoclastic novel. In effect, he must embrace the cinematic conventions of the past in order to deviate from them.

Commenting on Cronenberg's "amazing failure to stage any good car crashes," Bart Testa (16) voices a dissatisfaction rooted in his own particular hopes and expectations of the film that are, at least partially, steeped in such a prior conditioning and understanding of the cinematic tradition of displaying cars and crashes. The collisions in *Crash* are, in fact, discreet, understated, perhaps even Canadian in their composition, at least in relation to the dominant mainstream model that emerges from Hollywood cinema, for example, in *Gone in Sixty Seconds* (2000).

Despite their low dramatic quality, Testa raises a weak point, for the crashes are never intended in either the book or the film to be explosive displays of mechanized destruction. There is also a notable absence of road rage in the representations of cars and expressway driving, the director's fascination being focused on the sheer volume of traffic without a direct emphasis on its content or quality. On this point, Cronenberg actively resists the lure of traditional standards, rebuffing the accumulated expectations forged in years of viewing with his depiction of admittedly unspectacular crash sequences:

> I wanted them to be fast, brutal and over before you knew it. There's not one foot of slow motion. No repeated shots. I wanted to make them realistic in a cinematic way because it's the *aftermath* that is delicious: that can be savored and apprehended by the senses. What happens during a crash is too fast to feel without slow-motion replay. Most of us don't get replays on our car crashes. (Rodley, 203)

Within the contexts of most mainstream films, car crashes tend to be ends unto themselves, punctuating scenes (usually preceded by an adrenaline-

charged chase scene or car race) and providing a key point of viewer grat-ification that may be climactic, if not precisely orgasmic in the sense orig-inally conceived in Ballard's novel.

In keeping with J. G. Ballard's intentions, it is not blood, integu-mentary tissue, and human viscera that are invoked in an attempt to com-municate the appalling gore of impact. It is, rather, a much more com-plicated fascination with the transformative potentials that accompany deeper psychological or emotional scarring resulting from recurrent colli-sions. In Cronenberg's *Crash*, cars are frequently displayed as being wielded with skilled precision, and, following Ballard, the collisions are predetermined means to a sexual, psychological, and deeply pathological end. As Gregory Stephenson writes:

> The true purpose of the automobile is thus not a means of trans-portation but a vehicle of our deepest desires; its real end and object is not efficiency and convenience of movement but sexual consum-mation, spiritual affirmation, ritual mutilation, sacrifice, self-immo-lation, and a shamanistic release of fertilizing, creative energy into the modern world of the spirit. (68–69)

The interrelations among characters are not, therefore, simply mediated by the crashes they experience, but the crashes actually inscribe and sus-tain their relationships, carried as memories, scars, or injuries that are essential to human actions and emotions. The crash sequences themselves are a secondary concern and accordingly warrant only basic exposition to maintain the film's narrative flow.

The notion of "conditioning" also produces a set of expectations about gender, and here I would argue that Cronenberg fares less well in his attempts to deviate from the norms and traditions of masculine representa-tion in relation to the cinematic depiction of car culture. The mainstream cinematic tradition strongly privileges male characters who physically and symbolically occupy the driver's seat. The automobile is one of the least ambiguously gendered technologies of the twentieth century, its association with men and masculinities being closely tied to its sign value in the popu-lar media, as well as in the areas of production, maintenance, and sport.

R. W. Connell addresses the prevailing influence of "gender structuring practices" or "gender projects" that "need have nothing biological to do with reproduction. The link with the reproductive arena is social" (73). Films that reproduce highway driving or cataclysmic collisions as predominantly male

practices are entered into a gendered social "arena," merging with prevailing discourses of masculinity, virility, and power, all of which reinforce and extend an image of the human connection with cars as an especially masculine devotion. This does not eradicate the possibility of an empowering female association with cars, as *Heart Like a Wheel (1983)* and *Thelma & Louise* (1991) illustrate. Indeed, associating strong female characters with cars emerges as a strategy through which to both enunciate their autonomy and power and inscribe nuanced masculine identities onto the characters.

These exceptions notwithstanding, the prevailing imagery in our popular culture suggests that men are much more predisposed to particular practices and outcomes formed in and through their identification with automobiles. As Connell states, "Masculinity . . . is a configuration of practice *within* a system of gender relations" (84). The same can generally be said of the particular masculine formations that commonly cohere around cinematic portrayals of automobiles. For example, the image of an assertive and controlled masculinity that is traced onto Steve McQueen in *Bullitt* is pointedly linked to his car, as a vehicle connoting speed, thrust, and agility—each structuring his relentless pursuit of various goals and objectives. Although there is a strong emphasis on the association of men with cars, there also exists a tendency to portray heterosexual practices as the dominant norm in the automotive context. In the cinematic tradition, the road upon which cars and their male drivers travel is decidedly straight and narrow.

Automobiles carry out the main signifying work in *Crash* since the film is largely devoid of explicit topographical and cultural references. Yet, there is also an important, if sparse or restricted, distribution of ancillary icons and symbols that provide coordinates through which to map the characters' identities and motivations. These thinly distributed cues define the contours of a submerged class dynamic that is continually relevant to the characters and their odd relationships. Cronenberg is on record as regarding class as a crucial force in the ordering of social relations and experiences in *Crash*, despite harboring his own elitist predilections that continually ripple the narrative surface:

> In most sci-fi movies, it's usually the elite who are on the cutting edge of whatever's going on, but I think it's quite the contrary. It's going to be a grassroots-type movement. Those are the ones who are not fighting it, not analysing it, not organizing it. They're just experiencing it. (Rodley, 201)

The submerged emphasis on class-based differences is pertinent to the film's overall structure, for the central tensions that arise among the characters are concentrated at the precise point where professional or elite identities and working-class identities meet. More than a simple nod to the general dilemma of high/low cultural distinctions, the representation of competing class factions also suggests vastly differing attitudes and approaches to social existence and, in the end, to other human concerns such as sexuality, life, and death, and also the multiple microdistinctions within feminine and masculine gendered identities.

The Ballards, James (James Spader) and Catherine (Deborah Kara Unger), appear to live in upper-middle-class comfort, although this is seen obliquely, displayed through their casually stylish clothes or the few images of furniture and the domestic arrangement of their apartment. James works as a commercial film and television producer, focusing his labor on the representation of motor vehicles and car products for commercials or promotions. Catherine's work is less clearly discernible, although it is, like that of James, concerned with style and images, suggesting advertising or fashion publishing. Helen Remington (Holly Hunter), who is injured in a tragic head-on collision with James, is a doctor, shown throughout the film wearing slightly conservative but refined skirts and blazers.

In this triad, the emphasis is on James, whose bourgeois status is initially illustrated as being relatively secure. Yet, as Christine Ramsay has observed, "Without exception, each of Cronenberg's films opens with a strange sense that the standards of rational, controlled, and controlling masculinity that order daily life have gone off-balance, awry, askew" (86). This can certainly be said of *Crash* as James is introduced. His position of authority is confirmed and reinforced in a single instant: at the precise moment that he engages in backroom sex with a female camera assistant, taking her urgently from behind, his attention and presence is called for to expedite the production process. Rather than establishing his unwavering masculine or professional authority, which such a scene might generally do, these acts evoke the more powerful notion of emptiness, his vacant gaze upon the world suggesting an absence of focus and insight. James is quickly depicted as a man who is profoundly lacking, lost and incapable of emotional connection. The authority to which he might lay claim is forged in rapidly eroding forms—such as the traditional heterosexual couple and unchallenged male dominance in the workplace—that are based on the traditional institutionalized relations of labor capital and

physical masculinity, arguably the most predictable—and therefore the most boring—loci of male privilege.

Cronenberg challenges male achievement in a capitalist society, its images and its attendant masculine rewards, throwing them into question. His portrayal of James's apparent anomie corresponds with Christopher Lasch's description of the late twentieth century as an "age of diminishing expectations":

> Having internalized the social restraints by means of which they formerly sought to keep possibility within civilized limits, they feel themselves overwhelmed by an annihilating boredom, like animals whose instincts have withered in captivity. A reversion to savagery threatens them so little that they long precisely for a more vigorous instinctual existence. People nowadays complain of an inability to feel. They cultivate more vivid experiences, seek to beat sluggish flesh to life, attempt to revive jaded appetites. (39–40)

The issue of vitiating boredom is interesting, especially since it is such a core facet of the film itself (most notably registered in the faces of James, Catherine, and Helen, who form the professional/elite triad), this despite claims that the entire film strains against the repressive weight of boredom as the characters wander listlessly through their empty lives (Testa), a critique that fails to give boredom its due. There is rich potential in the concept of deep boredom, which introduces a psychological depth to be plumbed. Boredom is not a lack of affect or an emotional void. Quite the contrary, it is a particular disposition related to the internal psychological processing of external stimuli and can further involve elements of one's social bearing, including such factors as class, privilege, and, according to Patricia Spacks (1995), relations to work, leisure, and time. By presenting the characters in this light, Cronenberg implies that these people seem on the surface to have everything they could want; what, then, *is* their problem? What might it take to reach them and to what stimuli will they respond?

Contrasting these coded images of professionalism, economic comfort, and bourgeois boredom is Vaughan (Elias Koteas), who emerges as the film's *enfant terrible*. With a generally grimy appearance, his scarred and mutilated body clad in tight greasy jeans, t-shirt, and a dark denim jacket, he presents a powerful visual foil to James's restrained demeanor. In an indirect way, Vaughan also resonates with cinema's archetypal bad boys, such as Marlon Brando in *The Wild One* (1954) or James Dean

in *Rebel Without a Cause*, connecting with several postwar representations of tough, influential vehicle-controlling masculine leaders who challenge or in some way threaten the stability of the social order. James and Catherine exhibit a genteel patina that overlays a strangely decentered and disturbed hunger for something more, for something decidedly *other*. It is this hungering for affect, sensation, and exotic otherness that Vaughan satisfies with his scarred visage, testosterone-drenched swagger, ambiguous sexual proclivities, and intensely manic driving habits. Vaughan introduces a point of entry (which is correspondingly a point of departure), offering James, Catherine, and Helen an invitation to "take a walk on the wild side."

Vaughan has a distilled quality, his essences boiled down until all that remains is a single fused entity comprised of man and car. Helen explains to James that she once knew him as "a specialist in international computerized traffic systems," but, as she remarks without irony, "I don't know what he is now." More explicitly crossing the class divide, the Seagraves (Vaughan's assistant and veritable crash test dummy [Peter Mac-Neil] and his doting wife [Cheryl Swarts]) are portrayed as being downwardly mobile. Their apartment, described in Cronenberg's screenplay as "dirty and depressing" (32), strongly suggests the low-brow taste patterns of stereotypical poor white trash. Vaughan's disabled cohort Gabrielle (Rosanna Arquette) is the most excessively conceived individual in the group, described in the screenplay as having previously been employed as a social worker and, thus, an advocate for the poor. Following what was evidently a horrific and damaging car crash that has left her permanently crippled, she wears what resembles a complicated S&M bondage outfit replete with a chrome support apparatus, fishnet stockings, and close-fitting skirt and jacket.

Among this rag-tag group of unlikely comrades, there is virtually no sense of a past, whether individualized or accumulated. This can also be said of children, who inhabit the present fully and experience the present as a site of pervasive and dynamic affect. In this narrative context, their lives effectively began at the moment of their crashes, sudden and violent events that awakened them to new possibilities, new ways of being in the world.

After the preliminary framing of the film's contrasting social loci, it is in and through the cars they drive that the characters in *Crash* most clearly shape the detailed nuances of their identities. James drives a sensible and unpretentious vehicle, described in Cronenberg's screenplay as "a boring American four-door sedan" (7), in which he performs a series of

banal, routinized tasks: starting the ignition, driving sedately (and poorly), fucking indifferently. His wife, Catherine, has something sportier, a silver Mazda Miata convertible, of which she seems always to have the top down. It seems to contradict her empty, affectless gaze, providing the hint of a slightly more adventurous attitude or lifestyle.

It is Vaughan who occupies the film's antagonistic position and provides the strongest links in the human-car interface that forms the film's thematic foundation. Throughout *Crash*, Vaughan drives a black 1963 Lincoln Continental convertible, at one point implying that his deep personal attachment to the car is based on its being the same model as President John F. Kennedy's death car that has been ingrained in the popular imagination since November 22, 1963. As in the original novel, however, Vaughan's connection to the car is more than historical. The '63 Lincoln is frequently described in Cronenberg's script as being "heavy":

> James rides in Vaughan's car. Vaughan drives aggressively, rolling the heavy car along the access roads, holding the battered bumpers a few feet behind any smaller vehicle until it moves out of the way. (40)

❖

> An engine starts with a roar. As James steps back into the roadway he is briefly aware of a heavy black vehicle accelerating toward him from the shadow of the overpass where he and Vaughan embraced together. (56)

Gender and power relations are starkly depicted in the comparisons between Vaughan's *muscular* Lincoln and Catherine's petite, even *effeminate* late model sportscar, or between James's practical sedan and Vaughan's gritty bordello on wheels. Vaughan's Lincoln communicates his intensities, his sinister character, emotions, and moods, which, like the car, are alternately "dusty," filthy, and damaged. When in motion, he is more aptly powerful and menacing, constituting a hurtling or "surging" force that signals to the viewer a convergence between his car's mechanized heavy metal and a peculiar, masculine heavy mettle.

Cronenberg's personal reflections on the social impact of the automobile reveal a pronounced heterosexual male bias, as well as a rather unsophisticated adolescent nostalgia for male freedom and sexual domination:

A car is not the highest of high tech. But is *has* affected us and changed us more than anything else in the last hundred years. We *have* incorporated it. The weird privacy in public that it gives us . . . I mean, the first guy who had a convertible in high school was the guy who had the sex. He could take girls out to the country and do things to them. . . . He had a mobile bedroom. (Rodley, 199)

Testa, too, has identified a similar trait in Cronenberg's exposition of sex, sensuality, and gender, noting that "what we get is a concatenation of peculiarly adolescent sex scenes, where the emphasis, contrary to all reports, falls less on the technology-flesh relation than the Victoria's Secret underwear on the women" (16). As this suggests, Cronenberg's portrayals of men and masculinity must be weighed in balance with his own yearnings and masculine authorial presence.

Christine Ramsay's analysis of the depiction of men throughout Cronenberg's directorial career may provide a means of accessing this authorial presence, especially when she refers to "Cronenberg's boys," the central protagonists who are invariably "derelicts, outsiders, exiles, and losers" (91). Her employment of the term *boys* presents an opening for a potentially wicked allegorical connection: in some circles (and usually among men), reference to "the boys" is a veiled allusion to one's testicles (or those of one's compadre). In this sense, Cronenberg's evident struggle with complicated issues of masculinity can be traced to his balls, to the fact that these issues reside within his own apprehension of an embodied maleness. I would argue that with *Crash*, Cronenberg remains true to the form delineated by Ramsay, advancing his analytical interrogation of men and masculinities in a public forum, exposing himself, showing us his own mettle.

In *Crash*, Vaughan and his Lincoln form twinned elements—boys of a sort—that in combination express a primarily masculine point of identification. Cronenberg adheres to a cinematic display of testosterone-fuelled imagery, working within a broad but standard series of gendered positions that include themes of male penetration (such as the corresponding meanings of vehicular rear-enders and anal sex that each recur throughout the film) and numerous articulations of male potency and virility. Vaughan represents a specific manifestation of masculine virility and automotive liberty that fulfills Cronenberg's expressed admiration for mobile youth who suddenly find themselves with the new capacity to take "girls out to the country and do things to them."

All of this encoded masculinity raises the question: what is under review in this film? Is it the human condition, as Vaughan suggests in describing the means of fulfilling a psycho-sexual "prophetic" vision, or is it more precisely the male condition, and with it the repertoire of symbolic images and cultural practices through which traditional notions of masculinity are delineated? It seems upon closer inspection that Cronenberg, like Ballard before him, is not really pushing toward such innovative themes of a transformative masculinity but is actually dredging the muck and mire of an already existing range of masculine identity positions.

Masculinity is never explicitly cited as such in Cronenberg's *Crash*, although like the semen-stained seats of Vaughan's Lincoln, the film is saturated with it. Vaughan and James are closely bound within a very particular and somewhat conservative conceptualization of masculinity that is mediated by modern technology and shaped by an encounter with speed and danger. They may not occupy the same economic class stratum, yet gender forms a powerful and defining bond between them. This bond gradually develops until it can be identified as something of a gender class itself, distinct but malleable. This tendency is outlined by Elisabeth Badinter in her description of some of the dominant and traditional manifestations of masculinity in Western society:

> Boys are forced to take risks that end in accidents (e.g., various sports); they smoke, drink, and use motorcycles and cars as symbols of virility. Some of them find confirmation of their virility only in their violence, either personal or collective. In addition, the competition and stress that follow in their professional life, and their obsession with performance, only add to men's fragility. (141–42)

For James, who finds a virile mentor in Vaughan, the journey from his staid existence into the twisted but sensation-filled world that Vaughan represents is undertaken with considerable risks. As the confident, liberated, and expressive male, by contrast, Vaughan seems more comfortable shifting between several overlapping and durable positions of masculinity and male authority. Acknowledging as much in written correspondence with Cronenberg, J. G. Ballard has aptly referred to Vaughan as "the hoodlum scientist," citing but two powerful male-inflected gender positions he easily occupies.

Vaughan functions at times as a benevolent father figure, ostensibly looking out for the interests of his extended "family" by being both

encouraging and protective. At other moments his demeanor resembles that of a child, acting out, rebelling, or desperately turning to others for attention, support, and validation. Vaughan's brooding presence is at still other times the equivalent of a taciturn male adolescent in the throes of resistance, whether against the restrictive rules of mainstream society, the hegemonic patterns of patriarchy, or the pressures of assuming and maintaining traditional heteronormative masculine identity positions in the face of fascination with other males. Indeed, the fatigue and weight of establishing and maintaining an accumulation of masculine identity positions gradually shows in his appearance and behavior, leading to more frequent and desperate transgressions. Rather than re-inventing sex and gender or extending the psycho-sexual boundaries of erotic release through his crash project, however, Vaughan keeps collapsing back into the same conventional masculine roles.

In most cases, Vaughan expresses his frustrations through his car, emoting wildly as he veers across highway lanes with abandon, racing his engine menacingly, flexing his virility, and leaving havoc in his wake. Havoc is, of course, a planned and eagerly anticipated result. Vaughan's capacity to produce havoc provides much of the film's narrative tension. His continuous eruptions across the spectrum of male gender positions are intended to erode the foundations of masculinity upon which many mainstream social institutions are structured, but instead reinforce them. Vaughan demonstrates a sly capacity to produce multiple expressions of masculinity and manliness, in some instances as a vulnerable man-child, in others as a clear-minded and controlled strategist, and in still others as a stereotypically aggressive male who thrives on personal and public endangerment. Apart from his driving, Vaughan's main skill is in manipulating others by positioning himself within an array of dominant masculine constructs that serve his needs best. His role doesn't so much call the established norms into question as elevate them. He is unique only in his capacity for a radical interchangeability that allows him to inhabit many facets of contemporary masculinity with an easy transition. At no time are these identity positions threatened.

Crossing through these various masculine positions, Vaughan fills the role of the unchallenged leader, the alpha male of his clique of crash enthusiasts, which resembles an alternative swingers' club more than a dangerous gang, despite the threat of imminent death the members collectively toy with. Girls are welcome, but the boys are unquestionably in charge. Traditional gender roles are repeatedly reinforced in many

sequences, such as when Gabrielle rolls joints for Vaughan and James, serving them as they discuss Vaughan's project in his darkroom-cum-command post. Vera Seagrave also reflects the extent to which the women in *Crash* are just along for the ride. A lost and forlorn character, her purpose in the group seems to involve little more than providing a passively nurturing presence as she ministers to her husband's repeated injuries or sews the crash performance costumes in which he sustains them. Similarly, after introducing James to Vaughan at the illegal James Dean death crash reenactment, Helen Remington's role in the group is severely curtailed, while Gabrielle never amounts to more than a strangely sensuous curiosity. Women are not absent, but they are subjected to a narrative exscription that is made all the more explicit as the relationship between Vaughan and James intensifies. As with the abrupt excision of Claire Niveau (Geneviève Bujold) from the plot of *Dead Ringers* (1988), the filmic focus in *Crash* takes a pronounced turn toward "the boys" and the issues of masculinity with which they grapple.

The portrayals of backseat sex also raise the issue of gender relations when Vaughan pays for the services of an airport prostitute and, later, when he and Catherine have rough sex, each time with James looking on voyeuristically from the front seat. Against the portrayal of male-female backseat sex, it is significant to highlight the sex scene between Vaughan and James, which takes place in the front seat, the *driver's seat*. As if to reinforce the symbolic authority to be obtained through location and placement, after initiating foreplay Vaughan slowly turns around to offer his buttocks to James, simultaneously gripping the steering wheel for support. The only other explicit homosexual sex act, between Helen and Gabrielle, who converge on Vaughan's ruined car at the police vehicular compound, returns women to the backseat. The real, intensified energy is generated between Vaughan and James as they circle one another warily, then succumb to their mutual lust in an act of hasty (and apparently unsafe) sex that also seals their shared destiny.

Cronenberg emphasizes Vaughan's excessive attempts at precision in the reenactments of tragic celebrity car accidents. If we sidestep the celebrity allure and the alternating exhilaration or titillation that accompanies each crash scene, it is evident to us that Vaughan's *modus operandi* is the engineering of a complex ongoing simulation in which he runs James through repeated patterns, retraining his mental and physical processes, syncretizing his responses, bringing the two men closer and closer in every way. By the film's midpoint, Vaughan has already crossed over

into the realm of the embodied machine, and the interface he yearns for lies not between himself and technology symbolized through his automobile but in the deep encounters between himself and the fleshly, still unmechanized James.

The cinematic portrayal of Vaughan's detailed reenactments overshadows his equally strong penchant for the simulation of simulations, for he is himself straining to become the human equivalent of a crash test mannequin, self-assigned to bounce from the hard edges of his car's interior upon impact. Vaughan's erotic economy is there not a standard fixation on the symbolic and mythical power of celebrity, though he comprehends such fascinations well. Rather, his erotic charge extends to an intensely sexualized desire that is sated within the crushed metal and shattering glass of simulated vehicular collisions and, even more heatedly, to the thrashing plastic test dummies with which he also strongly identifies. This point is more carefully sketched in Ballard's novel where Vaughan is described as being wholly absorbed in masturbatory pleasure as he witnesses a crash test administered by road safety engineers and government technicians in a lab setting.

Reproducing his ideals, desires, and response patterns in James is not Vaughan's ultimate goal. His deeper achievement in his work with—or on—James emerges in his capacity to dissolve the standard symbols and anchoring systems of "the everyday" that are the source of his own chronic *ennui* and James's sexual uptightness. Vaughan introduces and then accelerates a myriad images, scenarios, and hypothetical possibilities until James, like Vaughan himself, is adrift in the symbolic images of another order altogether, transcending social bonds and breaking ties to a somnambulistic populace. This concept is aligned with what Baudrillard (Poster) defines as *the hyperreal*, which involves the proliferation of repeated and infinitely reproducible images that efface any traditional notion of a concrete, sustainable, or fixed reality. As Vaughan and his motivated gang endlessly and incessantly endeavor to recreate celebrity deaths or to reinvoke images of automotive mayhem, they gradually create a new way of being in the world, replete with their own unique cosmology and symbolic system that is anchored in neither an existing fiction nor anything easily identifiable as "reality" (Gane, 190).

In both its literary and cinematic forms, *Crash* is organized as a series of strokes consisting of subtle variations on a recurring theme. In their narrative trajectory, the highway collisions, the sex, the brief but intense discussions all fold inwardly toward a common center. This

swirling narrative motion gradually reveals a sophisticated *pas de deux* between Vaughan and James who continually size each other up, first figuratively and then literally. Describing the trajectory of Cronenberg's male protagonists in his films prior to *Crash*, Ramsay explains how in all of Cronenberg's work, his male characters are plunged

> into the abyss of unconscious male desires, from sadism through sexual excess, bestiality, orgy, and incest to homosexuality, murder, and suicide. Rather than guys who rationally order reality . . . Cronenberg's boys are decidedly passive and lacking. Things happen *to* them, not *because* of them—things that they cannot control. (89)

The "thing," therefore, that happens to James and revitalizes his affective self is not his car accident, but Vaughan and the multiple masculinities that he inhabits. Vaughan presents a range of masculine options that are revelations to the comparatively unidimensional James.

Throughout the film, James is portrayed as a "soft man," not the embodiment of masculine virility at all, apparently unable to navigate his way toward the idealized masculine identity of "the tough guy" or the "hard" man (Badinter). It can be argued that the listlessness that James demonstrates throughout the film is based in his need to locate himself somewhere along the spectrum of masculine subject positions, for, as Badinter explains, "today, young men do not identify either with the caricatured virility of the past or with a total rejection of masculinity. They are already heirs to a first generation of mutants" (183). Badinter notes that it is unlikely that any man can ever realistically fulfill the full range of attributes that comprise society's masculine ideal, nor do they always want to, for the effort is daunting and, in the end, futile.

Badinter goes on to reason that "the promotion of this inaccessible image of virility leads to a painful realization: that one is an incomplete man. In order to fight a permanent feeling of insecurity, some men believe the answer is to promote a hypervirility" (133). James doesn't seem to recognize at first that he has been chosen as Vaughan's apprentice or acolyte in hypervirility, that he is being systematically trained to replace him upon his demise and to go forward as the embodied expression of Vaughan's variegated and exaggerated images of masculinity. It gradually becomes evident that James is responding to what he believes Vaughan possesses and he lacks, masculine force, virility, and male sensuality. To move closer to an idealized masculine position, it is not enough that

James watch Vaughan in action, staring into the car's rearview mirror while Vaughan copulates with an airport whore and then with his wife in the Lincoln. To learn the complex secrets of Vaughan's masculinity, James must also surrender himself to Vaughan, exploring the contours of his body firsthand, tasting the oil, sweat, and semen that seem to cling around him like a foul shroud or else a seductive perfume.

The symbolic achievement of this transferral of masculine authority and identity is sealed when James rehabilitates and inhabits the 1963 Lincoln after Vaughan has died, killed on the road by a lethal admixture of his own strange and seething masculine urges and his increasingly wanton and aimless navigation. James consequently ensures that the film's masculine point of reference vacated by Vaughan is resurrected, by literally sitting in the driver's seat, taking the wheel, and dominating the freeways. Yet, the return of an authoritative masculine presence is not simply communicated by James assuming the position, filling the void that Vaughan has left. Adhering to Cronenberg's own masculine perspectives and his patriarchal predilections, the final act of transfer between Vaughan and James is confirmed by Catherine's willing submission to James's virile expressions of masculine authority. In the end, the signifying gesture relating to scales and models of cars that first defined the identities of Catherine, James, and Vaughan, in tandem with James's newly adopted masculine identity position, serves as a final indicator that the social order has been neither transgressed nor transformed. Like Vaughan before him, James muscles his way forward, carrying the codes and practices of a traditional, socially gendered identity, his new masculinity weighing heavy around him.

Although *Crash* received a special jury prize at the Cannes Film Festival for "originality, daring, and audacity," its audacity and daring are questionable. As I have argued here, *Crash*, like much of Cronenberg's earlier work, draws attention to the norms that guide social practices, but this does not necessarily mean that by doing so his films are implicated in their erosion. Despite the shrill criticisms of conservative watchdogs who see it as their responsibility to police the frontiers of alternative values and modes of representation, nothing dangerous has transpired in *Crash*, nor has anything progressive. Quite the opposite; rather than dislodging dominant forms and concepts of sex, sexuality, and gender, Cronenberg has instead kept them in circulation, revitalizing standard practices in the same way that the film's fatal crash reenactments delve into, freeze, perpetuate, and glorify celebrity deaths.

In this regard, *Crash* is a return to the scene of the crime. One is left to wonder if it could be this failure to overturn the authority of traditional male gender identities or to deflate the pressure of idealized constructions of masculine power that leads James, as Cronenberg's vicarious voice, to whisper to his wife in the final scene, "Maybe the next one, darling, maybe the next one."

WORKS CITED

Badinter, Elisabeth. 1995. *XY: On Masculine Identity*. New York: Columbia University Press.

Connell, R. W. 1995. *Masculinities*. Berkeley: University of California Press.

Cronenberg, David. 1996. *Crash*. London: Faber and Faber.

Gane, Mike. 1991. *Baudrillard's Bestiary: Baudrillard and Culture*. New York: Routledge.

Hine, Thomas. 1987. *Populuxe*. New York: Alfred A. Knopf.

Lasch, Christopher. 1979. *The Culture of Narcissism: American Life in the Age of Diminishing Expectations*. New York: Warner Books.

Poster, Marc, ed. 1988. *Jean Baudrillard: Selected Writings*. Stanford: Stanford University Press.

Ramsay, Christine. 1996. "Male Horror: On David Cronenberg." In Paul Smith, ed., *Boys: Masculinities in Contemporary Culture*. Boulder: Westview Press.

Rodley, Chris, ed. 1997. *Cronenberg on Cronenberg*. London: Faber and Faber.

Savran, David. 1998. *Taking It Like a Man: White Masculinity, Masochism, and Contemporary American Culture*. Princeton, NJ: Princeton University Press.

Spacks, Patricia Meyer. 1995. *Boredom: The Literary History of a State of Mind*. Chicago: University of Chicago Press.

Stephenson, Gregory. 1991. *Out of the Night and Into the Dream: A Thematic Study of the Fiction of J. G. Ballard*. Westport, CT: Greenwood Press.

Testa, Bart. 1996. "Crash (and Burn?): Special Section: Cronenberg's Auto Eroticism." *Film Studies Association of Canada Newsletter* 21:1 (Fall).

Virilio, Paul. 1989. "The Museum of Accidents." *Public* 2.

Whitlock, Francis A. 1971. "The Psychology and Psychopathology of Drivers." In *Death on the Road: A Study in Social Violence*. London: Tavistock Publications.

Willis, Sharon. "Disputed Territories: Masculinity and Social Space." In Constance Penley and Sharon Willis, eds., *Male Trouble*. Minneapolis: University of Minnesota Press.

FIGURE 7. The new theatrical short *Carrotblanca* (1995): The 1990s saw Time Warner exploit the merchandising potential of its Looney Tunes characters. For an inkblot, Bugs has 'voive.' (frame enlargement)

CHAPTER EIGHT

The Wabbit We-negotiates: Looney Tunes in a Conglomerate Age

KEVIN S. SANDLER

BUGS: Speaking of toys, you know all of those mugs and t-shirts and lunch boxes with our pictures on them?

DAFFY: Yeah.

BUGS: Do you ever see any money from all that stuff?

DAFFY: Not a thent!

BUGS: Me neither.

DAFFY: It's a crying shame. We gotta get new agents. We're getting thcrewed.

—From *Space Jam*

Space Jam isn't a movie. It's a marketing event.

—Gerald Levin, Quoted in Handy,
"101 Movie Tie-Ins"

With branding, narrowcasting, and product differentiation leading to greater competition for advertising dollars in a megachannel television

environment, the last half of the 1990s saw an increase in the dimension-ality of gender roles for female cartoon characters. The terrain blazoned by the supporting roles of Marge and Lisa Simpson (Fox), Tiny Toons' Babs Bunny (syndicated), and the Rugrats' Angelica (Nickelodeon) spawned the leading ladies of "Daria" (MTV), "Madeline" (Disney Channel), "Pepper Ann" (ABC), and "The Powerpuff Girls" (Cartoon Network).

Even with such advances, two researchers found that present-day television cartoons still overwhelmingly reinforce sexism and gender stereotyping. At the 1997 annual meeting of the American Psychological Association, researchers Mary Hudek and Cynthia Spicher reported that male cartoon characters still outnumbered female cartoon personalities by four to one, that they displayed a broader range of behavioral traits, and that they portrayed a wider variety of occupational roles (see P. Bell; Hen-drick; and Hall). The findings of this study, although based on only a sin-gle episode of eight of the top-rated broadcast network shows—"The Bugs Bunny and Tweety Show," "Aladdin," "Teenage Mutant Ninja Tur-tles," "The Mask," "Eek! the Cat," "Spider-Man," "The Tick," and "Life with Louie"—corresponded with those conclusions earlier proffered by Ellen Seiter (1993), Elizabeth Bell (1995), Susan Jeffords (1995), Paul Wells (1998), and Sybil Delgaudio (1980) who recognized the gender incongruity in American animation.

In the Warner Bros. cartoons, Delgaudio argued, the female animal characters are consistently reduced to the "physical, emotional, and cul-tural stereotypes" associated with women, while the male cartoon charac-ters perform limitless roles. On the one hand, given the rare occurrences of female animal characters in the Looney Tunes pantheon, they appear almost exclusively in the guise of a sexualized object (the pussycat from the Pepé le Pew cartoons, Daisy Rabbit, Petunia Pig) or the desexualized housewife (Mama Bear, Miss Prissy, Granny, Witch Hazel); Bugs Bunny, Daffy Duck, and Porky Pig, on the other hand, perform a multitude of trickster, romantic, and superhero roles.

Ironically, the most frequent representation of "woman" in the Warner Bros. cartoons is performed by a male entity: Bugs Bunny. Of the 168 Bugs Bunny shorts theatrically released between 1940 and 1964, thirty-seven of them feature the rabbit "cross-gendered"—in other words, he imitates the behavioral, sartorial, and corporeal codes regularly associ-ated with femininity and femaleness. These cartoons belong to the genre that Chris Straayer has identified as the "temporary transvestite film." In this genre, characters adopt the performance of the opposite sex for pur-

poses of necessary, situated, and strategic disguise. The primary pleasure in these films for spectators, argues Straayer, is grounded in a momentary and vicarious transgression of gender boundaries. However, by film's end, any suggestion of sexual or gender indeterminacy is eventually "negated, stopped and corrected" through the reconstitution of gender difference and heterosexual preference. In those temporary transvestite texts, she suggests, where the disguise grossly fails to convince the viewer, the humor derived from "the 'obvious unnaturalness' of one sex being in the other sex's clothing" and "the resultant audience laughter" release the tension resulting from the character's sexual desire; humor functions as an early corrective measure for the eventual narrative reinstatement of gender binaries and rigid sex roles at the end of the film (52).

The narratives of the Bugs Bunny temporary transvestite cartoons function in a similar fashion: they always safely return the rabbit to his "original" masculine and assumedly sexed identity after a period of gender instability. The masquerade in these cartoons does not challenge gender constructions. It continually reifies gender and sexual difference by ridiculing femininity and labeling the feminized male as absurd. Bugs's inability to truly master the "feminine" eventually leads to the exposure of the masquerade and the reinstatement of gender binaries.

For instance, Robert McKimson's *Bedevilled Rabbit* (1957) features Bugs Bunny and his archnemesis, the Tasmanian Devil. As usual, Taz is committed to having rabbit for dinner. Ingesting a powderkeg-filled turkey by mistake after Bugs convinces him that "any real gourmet knows that you don't 'soiv' a tossed salad with rabbit, ya 'soiv' it with wild turkey surprise," Taz chases Bugs into a general store. There, Bugs buys some dry goods to disguise himself as a woman. Complete with a mop of blonde hair, a bear trap mouth with lipstick, dress, and hat, Bugs Bunny is egregiously mistaken for a Tasmanian She-Devil by the lovesick Taz. Taz howls and turns to the camera, addressing the audience with a lecherous growl. After he kisses Taz, Bugs Bunny's bear trap mouth appends itself to Taz's face, and Taz's "unfeminine" wife appears: hair in a bun, obese, and shabbily clothed. While she hits Taz over the head with a rolling pin, Bugs Bunny mockingly says to the audience, "She's a nice lady. Eeeew!"

Taz may be heterosexually coupled at the end of *Bedevilled Rabbit*, but Bugs Bunny is rarely coupled with a female character—nor does he express desire for one—in any of his cartoons. His identity as a heterosexual "male" is solidified in very infrequent narratives when cartoons feature a feminine-identified character as a love interest for him. He may be

romantically coupled with this "woman" at the end of the narrative: Daisy Rabbit in *Hare Splitter* (1948); Mama Bear in *Bugs Bunny and the Three Bears* (1944); the mechanical rabbits in *Hair-Raising Hare* (1946) and *Grey Hounded Hare* (1949); and various she-rabbits in *Bugs Bunny Nips the Nips* (1944), *Rabbit Romeo* (1957), *A-Lad-in His Lamp* (1948), and *Bewitched Bunny* (1954). In certain cartoons, Bugs Bunny expresses sexual desire for feminine identified characters: Bugs Bunny and Yosemite Sam howl at "bikini broads" in *Bugs Bunny Rides Again* (1948); Bugs Bunny howls at Lauren Bacall and whistles at Carmen Miranda in *Slick Hare* (1947); he peeks into a window again after originally hearing a surprised woman scream from it in *Hurdy Gurdy Hare* (1950); he agrees that "woman needs man and man must have his mate" in *The Unruly Hare* (1945); and he mistakenly shows one of his "stag" films at the Academy Awards in *What's Cookin' Doc?* (1944). An ill Bugs asks for a woman doctor in case he "might take a change for the worse" in *Hot Cross Bunny* (1948). And the end of *Hold the Lion, Please!* (1942) even features a Mrs. Bugs Bunny.

While the temporary transvestite shorts may reinforce naturalized gender categories of identity and desire after a period of cross-gendering (e.g., Bugs Bunny is male, masculine, and does not desire men), they cannot account for the rabbit's missing genitalia, his performing many feminine roles outside of his transvestite masquerade (vacuuming in a skirt, singing in the shower, dancing as a ballerina), or his appropriation of male human garb and masculine behavior for pleasure and escape. A resistant discourse emerges by means of the drag image itself, which cannot help but call gender conventions and sex role stereotypes into question even if the narrative is reifying gender dichotomies at the same time. But Bugs and his friends are even more indeterminate still. They are animated characters, inkblots, drawings with gendered characteristics without a sex attached to them at all.

The potential indeterminacy that lends itself to gender, sex, and sexuality in the animated form is astutely noted by Paul Wells in *Understanding Animation*. Because the representation of the body is so negotiable by a director, he argues, sexuality and gender become the most "destabilized and ambivalent areas of representation in the animated cartoon" (205). In what he calls "gender-blending," animated representations can always highlight the performative nature of gender practice without relying or falling back upon a stable set of signifiers. This practice he finds explicit in many Warner Bros. cartoons whose directors

(most notably Chuck Jones, Tex Avery, Robert Clampett, and Frank Tashlin), particularly when creating comic effect, use the instability of representational norms intrinsic to the medium itself.

> At any one time, Bugs and Daffy et al. are merely involved in momentary performances which demonstrate that the definition and recognition of gender representation is in flux. Consequently, both the physical and ideological boundaries of the anthropomorphised body as it exists in a cartoon are perpetually in a state of transition, refusing a consistent identity. (206)

Further, as perpetually floating signifiers, Bugs Bunny and Daffy Duck remain arbitrary and contradictory sites of identity. Homosexual/heterosexual, masculine/feminine, male/female are constantly open to interpretation in the Warner Bros. cartoons. Just as much as Bugs is not like a male, he is every bit like a male; as much as he is feigning interest in cross-gendering, he is passionate about it.

Perhaps the lack of significance of, and the resistance to, recognizing identity in the Looney Tunes is due to the fact that these cartoons rarely concern themselves with gender difference as a source of narrative or comment. Outside of the Pepé le Pew series—which Kirsten Moana Thompson sees as a "colorful spectacularization of heterosexual romance" (153)—the narrative structures of the Warner Bros. cartoons revolve mainly around an endless chase between natural opponents (hunter/prey, cat/bird, coyote/roadrunner) rather than a sexual pursuit between anthropomorphized animals. In this perspective, spectators may tend to degenderize and desexualize characters such as Bugs and Daffy and instead, according to Wells (206), prioritize character tendencies and narrative outcomes.

The peripheral nature of identity in Warner Bros. cartoons is perhaps best exemplified by the Sylvester and Tweety cartoons. While it is commonly assumed that Sylvester is a cat coded as a masculine male, Tweety's identity is indeterminate. The narrative premise of the central gag of the series—a tall, stubborn cat is never able to catch and gobble a teeny-weeny canary—overrides any necessity for gender certainty or for even a gendered construction of Tweety. The comedy in these shorts stems not from how Tweety looks and behaves, but from what Tweety *does* to Sylvester. The endless array of violent acts of the series not only legitimizes the comic aspect of the situation but also depersonalizes the characters, masking the specificity of at least Tweety's gender and, perhaps

temporarily, rendering Sylvester's identity genderless, meaningless, and pointless. As with Wile E. Coyote and the Roadrunner, the humor of the series lies in its structure, which in animated form allows for an ambiguous gender fiction not easily representable in live-action.

Recently, however, the Looney Tunes characters have undergone a transformation of sorts. Following the path of the Walt Disney Company, Time Warner is carefully controlling the dissemination of potentially controversial matter to its viewing and consuming public. Like the racially stereotyped *Song of the South* (1946) and the wartime *Der Führer's Face* (1943), Warner Bros. has removed from circulation, among others, *All This and Rabbit Stew* (1941) due to its portrayal of Native Americans and *Bugs Bunny Nips the Nips* for its insensitive portrayals of the Japanese. The seven-minute cartoon, *Blooper Bunny* (1991), a stylish and caustic parody of Warner Bros.' redundant and uninspired TV specials of the 1970s and 1980s, was shelved for six years before Time Warner allowed it to premiere on Cartoon Network in 1997. Shorts containing "excessive" imagery such as gunplay, alcohol and gasoline ingestion, and egregious violence are continually edited for television broadcast and made unavailable on home video.

I have argued elsewhere that the Looney Tunes characters have become metonyms in the 1990s (Sandler), iconic and symbolically loaded characters like Mickey Mouse. Bugs Bunny, Daffy Duck, Tweety, and others act as corporate messengers for the media giant Time Warner and its subsidiaries. Bugs, Daffy, and Tweety and Sylvester have appeared on United States postage stamps, fiscal ambassadors not only for the government but for Time Warner itself; Bugs appears as the trademark logo in front of Warner Bros. feature films; Michigan J. Frog, who appeared in one cartoon (*One Froggy Evening* [1955]), is the mascot of the WB broadcast television network. Each character has become a marketing brand, and together they are icons for entertainment retailing estimated to be valued at over $10 billion annually.

The movement toward commodification, however, did not affect just the representation of race, violence, and nationalism in the cartoons; commodification transfigured the characters themselves. By replacing identity and irreverence in the Looney Tunes menagerie with milquetoast and merchandising, Time Warner has genderized the characters, taking what were once sexless and androgynous representations and turning them into easily digestible, distinguishable, and definable sexed bodies. The potential valuable iconic stability for the corporation

has led to the gender stability of Bugs, Daffy, and Tweety. Gender blending has become gender mending.

By turning to the methodology behind Time Warner's production of its feature-length film *Space Jam* (1997), I will show how the recontextualizing of the identities of the Looney Tunes characters has fed the media conglomerate's need for synergy, branding, and product differentiation at the end of the twentieth century. By reconstituting their bodies as fixed gendered representations, Time Warner removes the playfulness, jouissance, and irreverence that had earlier been the source of the characters' immense pleasure for viewers around the world.

◈

I do hope that they treat the characters carefully.

—Chuck Jones, quoted in Johnson's "WB's Toon Targets"

Space Jam was the culmination of a corporate merchandising strategy that began shortly after Time Incorporated merged with Warner Communications in 1989. Encouraged by television's synergistic success in developing shows simultaneously with toy manufacturers' product releases or springing plot ideas from existing toys (a result of FCC chairman Mark Fowler's deregulation of children's programming), the new conglomerate Time Warner hit merchandising bonanzas with the television series "Beetlejuice" (1989) and the theatrical feature *Batman* (1989). At the time, said Dan Romanelli, president of Warner Bros. Consumer Products, the biggest lesson learned was "that movie marketing and merchandising can exist hand in hand. Before that was not the case" (Critser, 54). The following decade saw Time Warner exploit the licensing and merchandising potential of its Looney Tunes characters internationally: Warner Bros. Studio Stores; Six Flags and Warner Bros. Movie World amusement parks; new theatrical shorts such as *Box Office Bunny* (1990) and *Carrotblanca* (1995); ancillary television "spinoffs" such as "Tiny Toon Adventures" (1990) and "Animaniacs" (1993); as well as deals with food and beverage companies.

The commercial roots of *Space Jam* emerged from this last instance. Time Warner had previously combined live-action and animation in a Pepsi advertisement featuring a duel between Wile E. Coyote and sports star Deion Sanders, who stood in for the Roadrunner (perfectly typecast). However, it was Michael Jordan's Nike TV advertisements co-starring Bugs Bunny ("Hare-O-Space Jordan" and "Hare Jordan") that captured

the public's attention and enraptured Time Warner to a feature film's merchandising potentials. In fact, Michael Jordan's agent, David Falk, brought the idea of *Space Jam* to Warner Bros., and not the other way around. (Falk actually received executive producer credit on the film along with his partner, Kenny Ross). Not surprisingly, Falk viewed *Space Jam* predominantly as a showcase for Jordan. He stated, "We've screened several movie ideas for Michael over the years, and we really wanted to get a vehicle for him, rather than him be part of something else" (Anonymous, D5). He also admitted, "Some think it's a vehicle to sell merchandise. I'm sure it will. Some think it's an effort to broaden his appeal among kids. I'm sure it will. But first and foremost, we saw it as a great litmus test for a new class of opportunity for Michael after his NBA years are over" (Jensen). The director of the "Hare Jordan" commercials, Joe Pytka—who had only one feature film on his resume, the disastrous *Let It Ride* (1989)—was brought on to helm the picture but had only limited artistic control on a project ultimately guided by producer Ivan Reitman (Portman). *Variety's* Peter Bart reported that Jordan's deal included a 10 percent stake in merchandising (Bart). To Falk, Ross, and Pytka, Jordan was the "real" star of *Space Jam*.

However, Warner Bros. expected *Space Jam* to add $1 billion to its already lucrative Looney Tunes retail empire that amounted to $3 billion in sales annually. For years, the Walt Disney Company had branded its classic characters such as Mickey Mouse and Donald Duck for profit; ever since the company recaptured the magic of its earlier animated films with *The Little Mermaid* in 1989, Disney has sprinkled its pockets even further with a bi-annual merchandising blitz of new marketable characters. *Space Jam* launched the new feature animation unit at Warner Bros.—which subsequently produced *Quest for Camelot* (1998) and *The Iron Giant* (1999) with woeful results—to compete with Disney and grab a larger slice of this ancillary pie. The film, wrote columnist Naomi Klein, also provided Time Warner—which had merged, earlier in 1996, with Turner Broadcasting Incorporated—the perfect opportunity for the media conglomerate "to flex its new synergy muscles and blow the Disney-ABC merger out of the water" (N. Klein). *Space Jam's* promotional push included the following synergies: the introduction of a Warner Bros. toy division; behind-the-scenes television specials on Cartoon Network and advertisement interruptions during basketball games on the cable station WTBS—both owned by Turner; a musical soundtrack featuring performers such as Seal who remain under contract with Warner Music;

cross-promotion with *Entertainment Weekly* and *Sports Illustrated for Kids*, both owned by Time Incorporated; sports licensing under its WB Sports brand; and a comic book adaptation under its DC Comics label. Regardless of the marketing strategies being employed in any particular case, however, it was true that to Time Warner, Bugs Bunny and the Looney Tunes gang were the stars of *Space Jam*.

From the very beginning, *Space Jam* was a synergistic juggernaut for everybody involved, an observation noted by *New Times* critic Andy Klein:

> *Space Jam* is a marketing dream, matching up basketball superstar Michael Jordan with Warner Bros.' stable of Looney Tunes characters. It's easy to picture the eyes of studio execs ringing up animated dollar signs at the prospect of pulling in sports fans (to whom it is massively advertised), kids, their parents, African-American moviegoers, and nostalgic baby boomers raised on the library of Warner Bros.' golden age of cartoons.

"You couldn't have a better combination," added Steve McKeever, brand manager at JC Penney, one of the many licensees of *Space Jam* merchandise, "Looney Tunes and Michael Jordan will continue to be around, so it has the potential for staying power" (Frinton and Conroy). The main attraction of this combination for marketers and licensers was that consumers did not have to be educated or familiarized about Jordan or the Looney Tunes. They were presold properties known around the world. And Michael Jordan's persona of "trustworthiness" generated a swarm of companies who wanted their brands associated with him (Kanner).

Part of Jordan's appeal to Time Warner, much like his appeal to Nike, Gatorade, McDonalds, Coca-Cola, and now MCI, was his ability to overcome barriers of race, a power which for synergistic purposes is the hen that lays the golden egg every time. "He made us forget about race, appealing to black, white, all colors alike," said Jim Riswold, the Weiden and Kennedy creative director who wrote the Nike commercials (Lee, 132). Accordingly, everyone wanted to "be like Mike" as the tag line to the Gatorade commercial went (and presumably thought they could). By contrast, fellow NBA commodity players such as Charles Barkley, Dennis Rodman, and Latrell Sprewell offered only an attractive "edge" for advertisers, an image aimed at youth and the urban, rather than the universal, market. The consumer who might have wanted to be "like" Charles, Dennis, or Latrell had to negotiate with images that rested on a racial and

emotional psychodrama that embellished black stereotypes offensive to the majority of blacks and whites alike.

Jordan's celebrity status transcended the personae of these basket-ballers who embodied what John Hoberman, author of *Darwin's Athletes: How Sport Has Damaged Black America and Preserved the Myth of Race*, has called the predominant image of black masculinity in the United States and around the world at the end of the twentieth century: the merger of athlete, gangster rapper, and criminal (xviii). Aggressive and defiant, phys-ical and menacing, the black male bodies proffered by the sports, music, and advertising industry stand in stark contrast to the black male persona of Jordan: urbane, respectful, apolitical.

Jordan, however—unlike other stars—has never used his celebrity to pursue social change (for example, to address exploitation of child workers in Southeast Asian factories) or a change in hair color, perhaps knowing well that politics, marketing, and Clairol do not mix. As a result, wrote Michael Crowley, he has become a reflection of the times, much in the way that Muhammad Ali epitomized his day: "Ali was a rebel. Jordan is a brand name." As a brand, then, or better yet, a "bland," Jordan rep-resents the gentrification and domestication of blackness by basketball executives, corporations, and the advertising media afraid of alienating the affluent white public if displays of black assertiveness are not kept in check. Hoberman calls this process an example of "virtual integration," "an effortless commingling of the races (almost always in the service of corporate profits) that offers the illusion of progress to a public that wants both good news about race and the preservation of a racial status quo that seldom forces whites to examine their own racial attitudes" (xxii). Jordan perfectly embodied the image of the black man comfortably adapting and assimilating to white middle-class standards. The illusion of racial bon-homie signified by his athleticism, charisma, and unthreatening personal-ity neutralizes racial tensions, making him an ideal product endorser and commodity himself. In reply to Henry Louis Gates's comments that "Jor-dan has become the greatest corporate pitchman of all times," a renowned sports columnist commented that "the irony of the charge that Jordan has allowed crass white men to pass him off as some kind of cartoon charac-ter away from the court is that if Jordan is at all resonant of Disney, it is not because he is a cartoon, but rather a family-entertainment empire" (Deford, 48–50). Unfortunately for Disney, Time Warner got to Jordan first, virtually integrating him (in more ways than one) into the virtually lily-white world of the Looney Tunes.

With the second most recognized celebrity in the world (next to Princess Diana) in tow, Warner Bros. orchestrated its own promotional campaign for *Space Jam* (between $20 and $30 million). By providing an abundance of point-of-sale materials to retailers, tie-in marketers recognized a lucrative venture in front of them. Since the film brought a whole new playing field for the characters they had previously licensed with the accompaniment of a fresh and exciting merchandising campaign, these retailers supplied an additional $70 million to the film's merchandising efforts. They included the granddaddies of the business, over two hundred United States and international marketing partners: Toys R Us, Wal-Mart, K-Mart, Sears, Target, McDonald's, General Mills, Kraft Foods' Jell-O brand, Bayer, and Rayovac (Eller; Cuneo). To retailers, anybody—Michael Jordan, Bugs Bunny, or any other creation on earth—was the star of *Space Jam* if he or she could sell.

No matter whose financial interests were at stake, *Space Jam's* marketing and licensing success depended upon a credible entertainment product, that being the sole responsibility of Warner Bros. However, Warner Bros. animation, once the achievement of a few independent creative units in the days of theatrical shorts, now existed as a commercial subsidiary under conglomerate Time Warner, whose corporate heads felt a new direction was needed for the classic characters. Warner Bros. Consumer Products president Dan Romanelli abstrusely led a cavalcade of explainers as to what these new tendencies might be: "[*Space Jam*] is going to take these characters to a whole new level and build our brand" (Johnson 1996b). Mark Matheny, managing director of Warner Bros. Consumer Products, adds that the film presents "an extension of Looney Tunes, an attempt to enhance the characters and entertainment" (Glaister). A whole new level? Enhancement? Such terms mean only one thing in the age of entertainment retailing—commodification—and Bugs, Tweety, and the gang fell victim to the leviathan.

Before discussing the transfiguration of the Looney Tunes characters, a synopsis of *Space Jam* is useful, and I thankfully borrow one from Jonathan Romney:

> 1973. Ten-year-old Michael Jordan impresses his father with his basketball prowess but tells him that he also intends to play baseball one day. The present: Jordan, now a major basketball star, retires from the game to start a new career in baseball. A lamentable failure in his first game, he is assigned the services of sycophantic publicist Stan Podolak (Wayne Knight).

On a distant planet, Swackhammer, the boss of Moron Mountain amusement park, decides he needs a new attraction, and sends his minions the Nerdlucks to Earth to capture Bugs Bunny and the other Looney Tunes characters. Arriving on Earth, the Nerdlucks enter the Looney Tunes' cartoon universe and capture Bugs. The tunes trick their would-be captors by challenging them to a basketball match, convinced that the diminutive aliens stand no chance of winning. But the Nerdlucks steal the talents of five National Basketball Association stars, transforming themselves into the gigantic Monstars. The desperate Tunes kidnap Jordan and persuade him to join their team.

In a Looney Tune character-filled stadium, the Tune Squad are thrashed by the Monstars in the first half. Despite a better showing in the second half, the Monstars still outplay them. With ten seconds to go, comedian Bill Murray is brought in as replacement team member, and Jordan scores the winning shot. The defeated Nerdlucks turn on Swackhammer and send him back into space before relinquishing their powers, which Jordan restores to his NBA friends before resuming his career as star player for the Chicago Bulls.

Many critics lamented the renegotiation of the Looney Tunes characters' personae that took place in *Space Jam*. Soren Anderson, of the *News Tribune* in Tacoma, Washington, eloquently captured the spirit of these reviews: "But though the characters have a 3–D look, they have 2–D personalities, the exact reverse in the Golden Age. . . . They're put on display, but rarely put into play." This decontextualization has turned each character into a soulless, calculated, and crass commercial entity, a set of mannerisms and catchphrases without point or purpose. The comedy no longer springs from a conflict between opposing personalities— they are now all friends living in someplace called "Looney Tune Land." Instead, the comedy comes from the character going out of character or from the characters reprising old scenes out of context (as though Bugs and the others are now pathetically all suffering from memory loss). Tweety chirps, "I tawt I taw . . . I did, I did see Michael Jordan!" and later becomes a one-bird karate team. Pepé is inexplicably deodorized (except when odor is called for), though he maintains his Franglais. Porky Pig still stutters but states, "I wet myself." The Tasmanian Devil loses his vociferous appetite yet still retains his childlike enthusiasm, using his tongue to clean a basketball court after a spitting contest. And, not surprisingly, they

are all sycophants of Jordan. Even Bugs Bunny's trademark insouciant kiss of his opponents succumbs to this Jordanian idolization; it functions as a sign of adoration instead of the one-upmanship or superiority Bugs periodically used to taunt his foes.

This decontextualization of the kiss in *Space Jam* may serve as a point of entry for a discussion of the film's renegotiation of the gender, sex, and sexuality of the Looney Tunes characters. The kiss, or what I have called the "near kiss" (Sandler), a kiss that nearly touches the lips of another—in both nontemporary transvestite and temporary transvestite Bugs Bunny cartoons—creates simultaneous heterosexual and homosexual moments because of a male kissing another male or a female-masqueraded-male kissing a male. However, both kinds of sexual kisses are ambiguous, transgressive, and contradictory, requiring viewers to experience a "cross-gendered" moment whether they want to or not. The pleasure and comedy of the moment emanates from the medium itself, which enables a degree of gender plasticity and sexual unknowingness.

Space Jam disables this free-floating and disruptive mechanism in the name of character licensing, target groups, and audience demographics. Producer Ivan Reitman inadvertently alluded to this renegotiation:

> The Looney Tunes, with their tradition of irreverence going back to the 1940s, have always been the cartoon characters that were created for adults. Sure, kids love them, but their humor has always been wilder and hipper than anything else out there, so adults respond to them on a whole other level. I wanted to recapture that tradition with a story made for today's audience. (Warner Bros.)

What "today's audience" means for Time Warner is wholesome family entertainment, a careful reconfiguration or "Disneyfication" of its corporate icons for worldwide cultural consumption. Inoffensiveness, a diasporic coverage, and a "toyetic" style are the rationales behind such a process, grand terms for a simpler concept: everything sells everything else and its doppelgänger; everything can hurt the sale of everything else. Recontextualized as innocuous, asexual, and not fraught with ambiguity, Bugs Bunny's provocative kisses were intended or unintended victims of this 1990s megamerger policy.

The gendered effects of corporate synergy were more visible in the creation of Lola Bunny as a love interest for Bugs in *Space Jam*. Outside the intervention of the transvestite figure, the Bugs Bunny theatrical cartoons

rarely featured even a gendered moment. Expressing heterosexual desire for Lauren Bacall (*Slick Hare*), Daisy Lou (*Hare Splitter*), and an electronic decoy rabbit (*Grey Hounded Hare*) were rare for the hare. *Sight and Sound's* Jonathan Romney astutely noted this aberration in *Space Jam*, stating that "the introduction of gamine Lola Bunny" is "entirely out of keeping with the racy Chuck Jones tradition, . . . an attempt to defuse Bugs' much-debated polysexuality." Indeed, Bugs becomes a blithering twelve-year-old macho male, choked-up, muscle-flexing, and smitten by Lola's curvaceous body, tight dresswear, and seductive posing when she first appears at "Schlesinger Gym." As if to renegotiate or reaffirm the other Looney Tunes characters' identities, the camera cuts to a reaction shot of Foghorn Leghorn and the barnyard Dog, Daffy Duck, Yosemite Sam, Wile E. Coyote, Pepé le Pew, Tweety, Sylvester, Elmer Fudd, Porky Pig, and the little top-hatted "pen-ga-win" from *Frigid Hare* (1949) and *8 Ball Bunny* (1950), ogling in unison. After Lola demonstrates her basketball prowess, the film borrows a libidinous gag from the Tex Avery playbook and incorrectly recontextualizes it for Bugs Bunny: to demonstrate his lust for the girl bunny, Bugs priapically floats up in the air and crashes to the floor à la the hyper-hetero Wolf in the Red Hot Riding Hood cartoons. In one "swoop," the Warner Bros. gang has been reduced to GUYS.

This genderification is not surprising given the fact that the chase—the narrative trope of the theatrical shorts—has been vanquished from *Space Jam*. In its stead, the film offers romantic comedy: how will the "Heartthrob of the Hoops," Lola Bunny, get together with the "Doctor of Delight," Bugs? Lola's feminist mantra, "Don't call me doll," and her unfeminine nature as a basketballer are immediately shown to be a ruse—belied by the rhythmic swing of her cottontail and the swishy theme music that accompanies her. Tony Cervone, co-director of animation, expressed the filmmakers' fears of making Lola too masculine:

> [She was] a lot more tomboyish at first, but it didn't take us long to figure out, "Well, what do you do with that?" [Ivan Reitman and Warner Bros.] always wanted Bugs to be totally gaga over her, so we kind of pumped her up more in the feminine attributes department. (Carney and Misiroglu, 40)

In between her initial look and the final model drawn for the film, Lola transforms into the traditional Warner Bros. female character: a heterosexualized object, albeit one with "game." Eventually, the narrative progresses

toward resolution, a convention of classical Hollywood cinema that transforms the open-ended chase structure of the typical Warner Bros. cartoon into a sexual hunt that ends in heterosexual coupling. Bugs saves Lola from being "flattened" by an airborne Monstar, receives a thank-you kiss from her in midgame, and then—after Jordan tells him to "stay out of trouble"—plants a smooch on Lola that sends her reeling Tex Avery-style.

The narrative demands placed on their identities, however, are a byproduct of commodification in the 1990s. The diegetic insertion of a female-coded rabbit is a merchandising ploy, another shape, another personality, another sex that Time Warner can market to another demographic. Overdependence on the male or female form in a film's text means fewer merchandising opportunities, fewer target audiences, and subsequently fewer ancillary profits. Present-day demands of cross-marketing certainly influenced the movement away from the masculinized milieu of the theatrical cartoons to the heterosexual habitat of *Space Jam*. Abandoning the predatory chase structure for a scenario based on communal living between the sexes completes the final stage of Warner Bros.' "Disneyfication" of the Looney Tunes: Bugs, Daffy, Sylvester, Taz, and the rest of the menagerie living together in wholesome, harmonious, non-violent bliss.

◙

It is no disrespect to [Michael Jordan] that [*Space Jam*] might have benefited from a little more hare and a little less Air.

—Andy Klein, "Double Dribble"

Space Jam opened to mixed reviews on 15 November 1996 but still managed to earn a hearty $27.5 million at the North American box office in its first week, on its way to a grand total of $90.4 million domestically and over $200 million overseas. More important, the film earned Time Warner $1.2 billion in retail sales, surpassing expectations by $200 million. Ruth Clampett, the daughter of Looney Tunes director Robert Clampett, and the director of creative design for the Warner Bros. Studio Stores, reported that the most successful *Space Jam* items were children's toys, figurines, and collectible gift items such as cookie jars and gallery cels of the film (Simensky, 188). The marketing tie-in soundtrack to the film sold over a whopping 7 million copies in its eighteen-month run on the charts, and earned R & B singer R. Kelly three Grammy awards for his anthemic "I Believe I Can Fly." With *Space Jam*, wrote Linda Simensky, vice-president of original animation at Cartoon Network, Warner

Bros. made "its single biggest push . . . toward establishing brand loyalty toward its name and characters," and it proved highly successful.

Even so, synergy between the divisions of megacorporations can occasionally break down, as demonstrated by the commodification of Tweety by Time Warner in the 1990s. Once a genderless bird in the Golden Age of animation, Tweety was eventually transformed into an attitudinal gendered icon for the advertising age of entertainment retailing. Tweety's cuteness, innocence, and superiority over Sylvester have made Tweety, according to Warner Bros., the most popular of any of the Looney Tunes characters, even Bugs Bunny, among adults and children aged three to eleven (Warner Video). Tweety especially struck a merchandising chord with women and girls, perhaps a result of "its" yellowish color, infantilized personality, and diminutive size—three tropes culturally associated with femininity and femaleness.

Warner Bros. appropriated these distinctions to sell merchandise first through its Warner Bros. Studio Store catalog in the late 1980s and later through its Warner Bros. Studio Stores, which now number over 180 worldwide. A look through the Spring 1993 and Summer 1996 catalogs reveals Tweety's image modeled only by women and toddlers. In addition, Tweety's face appears only on unisex items, in designs featuring the entire Looney Tunes gang, or on merchandise specifically created for women, girls, or toddlers. This gendering practice continued on the Warner Bros. Consumer Products' newly designed E-commerce Web site, wbstore.com, which was launched 19 July 1999. Tweety's stand-alone image is offered only under categories for women. And of the 3,700 licensees of Looney Tunes characters, many offer Tweety as part of a gendered triptych: Tweety, female; the Tasmanian Devil,male; Bugs Bunny, male or female. For example, Signature Brands, LLC's Cake Mate Looney Tunes dessert decorations, and Cap Candy's Looney Tunes candy pen dispenser with Pez candy feature these three icons.

In *Space Jam,* however, Tweety bizarrely became one of the guys: a spitting, gesticulating, karate-chopping, babe-ogling member of the male race. The strangest moment occurs when Lola enters the gym, and Tweety says, "She's hot" as "he" takes his finger to "his" behind, simulating a sizzle. This gender incongruity reveals the slippery slopes and the even more slippery stakes of synergy when the working relationships among corporate execs, studio management, and consumer products operations do not remain in sync. Fortunately for Time Warner, neither critic nor consumer noticed this iconographic snafu, and Tweety's persona remains as pure

and guileless as ever before, evidenced by the plethora of MCI commercials starring Tweety and Sylvester, Michael Jordan, and the rest of the Looney Tuners.

Perhaps Bugs' polysexuality still exists intact as well—after all, no "man" would be caught dead in a Tweety pullover, but many women would adorn a Bugs fleece knitdown. It is quite possible that the rabbit stands guard as the last defender of gender-blending in entertainment retailing. As Naomi Klein writes, "In this era of so-called information choice, synergy has emerged as a means of controlling consumption so thoroughly that choice is practically taken out of the equation. *Space Jam* is the first" (A17). Most likely, the fate of Bugs Bunny's identity lies in the hands of the fans, that dedicated mass of true believers that shunned *Space Jam* in favor of repeated viewings of *What's Opera, Doc?* (1957). In the final frame of that little masterpiece, Bugs cries out, "Well, what did ya expect in an opera, a happy ending?"

But we do, Bugs. Yes, we do.

WORKS CITED

Anderson, Soren. 1996. "Despite 3–D Look, '*Space Jam*' Falls Flat," *News Tribune* (Tacoma, WA). 15 November.

Anonymous. 1996. "Tipoff." *Washington Times.* 28 October, D5.

Bart, Peter. 1996. "The Mighty Money Machine." *Variety.* 2–8 December.

Bell, Elizabeth. 1995. "Somatexts at the Disney Shop: Constructing the Pentimentos of Women's Animated Bodies." In Elizabeth Bell, Lynda Haas, and Laura Sells, eds., *From Mouse to Mermaid: The Politics of Film, Gender and Culture.* Bloomington: Indiana University Press.

Bell, Pat. 1997. "In Demographics of TV Cartoons, It's a Man's, Man's, Man's, Man's World." *Ottawa Citizen.* 21 August.

Carney, Charles, and Gina Misiroglu. 1996. *Space Jammin': Michael and Bugs Hit the Big Screen.* Nashville: Rutledge Hill Press.

Clark, Mike. 1997. "New in Stores." *USA Today.* 14 March, 3D.

Critser, Greg. 1990. "Bugs' Hollywood Agent." *Bugs Bunny Magazine.*

Crowley, Michael. 1999. "Muhammad Ali Was a Rebel. Michael Jordan Is a Brand Name." *Niemen Reports* (Fall).

Cuneo, Alice Z. 1996. "Looney Tunes Fold Find Time to Star in Target Effort." *Advertising Age.* 2 December.

Deford, Frank. 1998. "One of a Kind." *Sports Illustrated* (22 June).

Delgaudio, Sybil. 1980. "Seduced and Reduced: Female Animal Characters in Some Warners' Cartoons." In Danny and Gerald Peary, eds., *The American Animated Film: A Critical Anthology.* New York: Dutton.

Eller, Claudia. 1996. "More Than the Conversation Is Animated." *Los Angeles Times.* 20 August.

Frinton, Sandra, and David Conroy. 1996. "Space Jam License Fever." *HFN.* 29 April.

Gilbey, Ryan. 1997. "*Space Jam* (review)." *The Independent* (London). 22 March.

Glaister, Dan. 1997. "Value of the Dolls." *Guardian* (London). 21 March.

Hall, Lee. 1997. "D'OH! Cartoons No Longer a Man's World." *Electronic Media.* 25 August.

Handy, Bruce. 1996. "101 Movie Tie-Ins." *Time.* 25 November.

Hendrick, Bill. 1997. "TV Cartoons Reinforcing Sexism, Researchers Say." *Atlanta Journal and Constitution.* 18 August.

Hoberman, John. 1997. *Darwin's Athletes: How Sport Has Damaged Black America and Preserved the Myth of Race.* New York: Houghton Mifflin.

Jeffords, Susan. 1995. "The Curse of Masculinity: Disney's *Beauty and the Beast.*" In Elizabeth Bell, Lynda Haas, and Laura Sells, eds., *From Mouse to Mermaid: The Politics of Film, Gender and Culture.* Bloomington: Indiana University Press.

Jensen, Jeff. 1996. "'Space Jam' Turning Point for Warner Bros." *Advertising Age.* 28 October.

Johnson, Ted. 1996a. "Hare-y Issue: Who Conceived Jordan's 'Jam'?" *Variety* 25 November–1 December.

———. 1996b. "WB's Toon Targets Ride on 'Space' Case." *Variety.* 26 August–1 September.

Kanner, Bernice. 1996. "Turning Nice-Guyness into Big Bucks." *Journal of Commerce.* 10 September.

Klein, Andy. 1996. "Double Dribble; *Space Jam* Hits the Rim but Doesn't Score Too Often." *New Times* (Los Angeles). 14 November.

Klein, Naomi. 1996. "What's Up, Doc? Just Ask the Marketers." *Toronto Star.* 18 November.

Lee, Will. 1999. "Michael Jordan." *Entertainment Weekly, The 100 Greatest Entertainers* 510 (Winter).

Portman, Jamie. 1996. "Bugs Nets Laughs with Basketball's Jordan." *Vancouver Sun.* 8 November.

Reitman, Ivan. 1996. *Space Jam* Production Notes at www.spacejam.com.

Romney, Jonathan. 1997. "*Space Jam* (review)." *Sight and Sound* (April), 48–49.

Sandler, Kevin S. 1998. "Gendered Evasion: Bugs Bunny in Drag." In Kevin S. Sandler, ed., *Reading the Rabbit: Explorations in Warner Bros. Animation.* New Brunswick, NJ: Rutgers University Press.

Seiter, Ellen. 1993. *Sold Separately: Parents & Children in Consumer Culture.* New Brunswick, NJ: Rutgers University Press.

Simensky, Linda. 1998. "Selling Bugs Bunny: Warner Bros. and Character Merchandising in the Nineties." In Kevin S. Sandler, ed., *Reading the Rabbit: Explorations in Warner Bros. Animation.* New Brunswick, NJ: Rutgers University Press.

Straayer, Chris. 1992. "Redressing the 'Natural': The Temporary Transvestite Film." *Wide Angle* 14 (January).

Thompson, Kirsten Moana. 1998. "'Ah Love! Zee Grand Illusion!' Pepé le Pew, Narcissism, and Cats in the Casbah." In Kevin S. Sandler, ed., *Reading the Rabbit: Explorations in Warner Bros. Animation.* New Brunswick, NJ: Rutgers University Press.

Warner Bros. Consumer Products. 1996. "Warner Bros.' *Space Jam* Brings Michael Jordan, Bugs Bunny and the Looney Tunes Together for a Slam-Dunk Merchandising Opportunity at ISPO '96." Press Release. 6 August.

Warner Video. 1999. "Tweety, Warner Bros.' Most Popular Looney Tunes Character, to Star in Two All-New Video Collections Flying into Stores on June 22nd." Press Release. 1 June.

Wells, Paul. 1998. *Understanding Animation.* London: Routledge.

FIGURE 8. Garth Jowett, bopping in 1956, soon after Fred Astaire entertained Cyd Charisse in *The Band Wagon* (Vincente Minnelli, 1953). (photograph of Garth Jowett, collection Garth Jowett, reprinted by kind permission Garth Jowett; frame enlargement)

CHAPTER NINE

◈

"Real Men Don't Sing and Dance": Growing Up Male with the Hollywood Musical—A Memoir

GARTH JOWETT

Nowhere do I find myself more detached from modern film scholarship, while at the same time being more personally engaged, than in discussion of that lost genre, the movie musical. Movie musicals were a very important part of my earliest mediated socializing experiences, and my relationship and association with them is a highly personalized one, involving the movies not only as cultural content but also as a set of ritualistic practices and familial memories that form the bedrock of my persona. The musicals of the 1950s constituted a much slower, more rambling, less pressured, more delightful, less relentlessly commercial, more elegant, more sedate and even accepting response to life and culture than popular films do today, in our high-pressured, conglomerate, aggressive, computerized, ultraserious, stylistically casual, and more momentary world. One never expected one's filmgoing experience to be a conflict, the subject of a theoretical argument, a battle zone. I want to try to capture the nature of my movie-going experiences with those old films, especially my intimate relationship to movie musicals, and some of the difficulties I experienced in incorporating these influences into the shifting notion of what it meant to be a heterosexual male in the last half of this century.

The motion picture is now widely recognized as a major "shaper," as well as "reflector," of twentieth-century society and its shifting cultural expression. Like so many of my generation growing up in that pretelevision age, I found the movies to be a potent source of a wide variety of socializing experiences that are now internalized as an integral part of who and what I have become. I find it astonishing, and sometimes a little unseemly, that these very personal memories and associations, the warp and woof of my self, are often subjected to scrutiny and microscopic analysis by others who do not care about them, in alien contexts. It is like watching the threads of my psyche being pulled out coolly and dispassionately by strangers, in front of my own eyes—pulled out and then rewoven in a way quite different from how I had originally tied them myself. Often when I read such analyses, I find myself shaking my head and muttering, "That's not the way it was. You've got it all wrong. I was there, and I should know!"

There was another time, in another place, when I danced and pranced in front of the large mirror in my parents' bedroom, imagining that I was Gene Kelly, Fred Astaire, or Dan Dailey. I was between the ages of six and eleven, and I now recall those euphoric flights of fancy without any embarrassment or fear of gender role confusion requiring elaborate and lengthy psychological interrogation in my adult life. (I should mention that I also did this same pantomime routine, complete with a toy gun belt dangling around my waist, in the guise of Roy Rogers or Charles Starrett ["The Durango Kid!"], two of my favorite cowboy heroes.) My mind is untroubled by these memories now, but there was a brief time during my adolescence when I deliberately suppressed them as I struggled with creating my "masculine persona" as a young adult. The question in my mind at that time, framed in today's parlance, was, did real men sing and dance?

For those of us whose socialization was forged in the pretelevision years between 1946 and 1956, the movies were often an integral part of our maturation process, providing powerful and seductive images in relation to which we constructed ourselves by aping clothing or hair styles as we grappled with the complex issue of male/female relationships. Growing up in this era was, after all, a formative experience for a number of men and women who are now the creators of the films for the end of the twentieth century and also for many others who form the "senior" cohort of film scholars, critics, and film industry executives. It has become somewhat passé to talk about a "movie-made" gen-

eration, but in the absence of more formal sources of socialization in these salient areas (how many parents instructed their children in how to deal with the opposite sex, or how to look "cool" or "hot"?) the movies were undoubtedly a potent source of all sorts of socially useful information, as well as providing the ephemeral knowledge that could make you a hit at cocktail parties. (For instance, I learned all about the "marabunta"—the Amazon jungle soldier ants—by watching Charlton Heston fight them in *The Naked Jungle* in 1954. For most of my teenage years, this arcane tidbit allowed me to pose as an amateur entomologist if I ever needed to impress any young ladies that I was more than just a "dumb jock.")

To provide a framework for contextualizing my dilemma, and because we are the products of our total socialization, I believe it necessary to recount the history and nature of my personal moviegoing experiences as a young child. I was born in 1940 in that most beautiful of all cities, Cape Town, South Africa. The dramatic setting, between Table Bay and Table Mountain, the balmy Mediterranean-type climate not unlike that of San Diego, and an incredible melange of cultures, including Malaysian, African, English, Dutch, German, French and Indian, made this an exhilarating place to grow up, especially if you were white. I was, of course, a somewhat privileged white, working-class youth blissfully ignorant of the reality of the world around me. However, this illusion was irreparably shattered when at the age of eight, on the very day that the proseparationist Nationalist Party was voted into power, I was given a thorough beating by an older classmate on the playground of my elementary school. A big, blond Aryan-type, Andre van der Westhuizen pummeled me so severely I required medical attention, and all because I had innocently mouthed off political slogans that my "liberal" family had been using during the campaign. This was my personal welcome to the looming world of apartheid South Africa. (In 1994, when given the opportunity to cast a vote in Houston in the first multiracial South African elections, I was followed by a camera from a local television station. When I placed my ballot into the box, I raised my right hand, middle-finger extended, faced the camera and said: "That's for you, Andre!")

Before 1952, when the political structure of apartheid was formally introduced by the National Party, racism and divided public facilities were accepted as a natural part of my stimulating world. My first playmates were a mixture of the many races that make up the population of Cape

Town: white, Cape Coloured (mixed), Cape Malay, Indians and Portuguese, but no Africans. Since the turn of the century, the indigenous Africans had not been allowed to live permanently in the urban areas. The reality and absurdity of apartheid intruded itself into my movie-going quite extensively, from the segregated movie houses to the films that we were allowed to see. My local movie house—in the culturally isolated world of South Africa such places are even today called "bioscopes"—was the grimy Globe (fondly known to us kids as the "bug house"). Because it was in a "mixed" neighborhood, the Globe had the segregationist configuration so common in the southern United States, of white audiences downstairs and other races in the balcony. When I went with a group of my neighborhood friends, I sat in the upstairs section, but if I went alone, I sat downstairs where the audience was noticeably more sedate.

I know now that many movies dealing with racial issues, such as *Intruder in the Dust* (1949) or *Pinky* (1949) were shown in South Africa relatively uncensored, but by the mid 1950s the political climate had created those situations that always make official censorship look so silly. I have clear memories of the furor surrounding the film *Island in the Sun* (1957), based upon a best seller by Alec Waugh and highly publicized because it featured an interracial romance between Harry Belafonte and Joan Fontaine. South African audiences were "allowed" to see a version of this movie with more than thirty minutes removed, and it was not until a few years ago, thanks to television, that I finally saw the entire film. (In retrospect, perhaps the South African censor did us all a favor!) However, all-black films such as Otto Preminger's *Carmen Jones* (1954), starring Belafonte and Dorothy Dandridge, were not censored at all. At that time, throughout the Western world, the suggestive romantic imagery one now finds in a film such as *The Pelican Brief* (1993), depicting intimate connections between blacks and whites, was virtually nonexistent in movies; in the real South Africa it was totally unthinkable. Also, for unfathomable reasons, which is often the case with censorship, some films that had nothing to do with race were never shown in South Africa; for instance I had to wait until I went to live in England in 1958 before I could see my favorite actor Marlon Brando's first film, *The Men* (1950).

My mother and father were proudly working-class people. My mother had toiled practically all of her life, starting as a shopgirl when she was fourteen and eventually ending up as a manager and buyer for an exclusive jewelry store before retiring. My father, as was typical of those who matured during the Depression years, tried many jobs before

becoming an undertaker (a "funeral director" in today's parlance) and was highly regarded for his empathetic demeanor by all who knew him in this guise. It was always a peculiar thrill when sitting with my friends or mother in the movie theater, to see my dad driving the hearse in newsreels that showed the funeral cortèges of famous South Africans such as the RAF fighter pilot hero "Sailor" Malan, or a state president. (Despite my own acting ambitions, my dad appeared in more films than I ever did!) The family lore was that my parents had once been avid moviegoers, going together at least twice a week, but by the time I was old enough to remember, they seldom went together anymore to the Astoria down the hill on Main Road, or even to the big downtown movie palaces. Like so many men of his generation, my father's interest in movies faded as he got older, and he became more involved with his work, drinking with his "mates" at the local pub or moonlighting as a very much in-demand dance band drummer on the weekends. (I know that this does not fit with his role as a dour undertaker, but my father was a man of considerable contradictions.)

My mother's interest in the movies ("devotion" might be a more appropriate term) continued unabated throughout her life, and she seldom missed an opportunity to see the latest releases. Her companion for these excursions from the early forties and for the rest of their lives, was her older sister, May, who had been widowed in World War II and who loved films at least as much as my mother did. On Wednesday evenings they would meet at my mother's workplace, and after a light supper catch the 7 P.M. show at one of the major movie palaces that were clustered within a few blocks of each other in the heart of downtown Cape Town. (The normal practice at that time was to "book" reserved seats for a designated show.) Monuments, indeed, to the international popularity of the Hollywood movie were the Coliseum, the Metro, and that great "atmospheric palace" the Alhambra, with its twinkling stars in the ceiling and the light in the auditorium gradually fading into dusk—complete with singing bird sounds—while you sat back and waited for the movie to begin. Designed by the great American movie theater architect John Eberson, the Alhambra was the finest theater in Cape Town and was the preferred venue for live stage productions of touring shows. The Coliseum was full of wonderful art deco reliefs and decorations, while the Metro was sumptuous and had very comfortable, red velvet seats. In the early 1950s, in the heyday of CinemaScope, the Fox was constructed a block away from the original big three. It was a harbinger of things to come,

newly comfortable, functional, but lacking all character except for the wide screen on which we thrilled to *The Robe* (1953) or musicals such as *There's No Business Like Show Business* (1954). All of these old movie palaces (including the Fox) are gone now in the name of progress, replaced by new multiplexes with a depressing sameness.

Any recollection of my own moviegoing experiences would be incomplete without a mention of that peculiar South African hybrid, the "bio-cafe." Spotted throughout the downtown area the bio-cafes were third-run movie theaters, where the price of admission also included a soft drink, tea, or coffee (never to be ordered!). When you sat down, you were faced with a long, narrow counter attached to the back of the seats in front of you. Frazzled waitresses, invariably older women, walked up and down the aisles taking drink orders, but also fielding requests for hot dogs, hamburgers, and, my favorite, corned-beef sandwiches. The movies—always double-bills, with newsreels, short subjects, and cartoons included—ran continuously from 10 A.M. to 12 P.M., allowing audiences to enter and leave at will. Many people spent their lunch-hour (or two) at the bio-cafes. As I think about it now, I must have spent an inordinate amount of time in those places, stopping at my mother's store after school to "borrow" a shilling or two for lunch and a movie at the Elstree, the Ritz, the Roxy, or the Majestic (the movie theater of absolute last resort as it was a haven for the misbegotten of Cape Town society . . . but this is a different story for another time). It was in the bio-cafes that my fledgling appetite for what I now know to be "film noir" was first whetted. I can distinctly recall how much I enjoyed such then unknown classics as *He Walked by Night* (1948), *Gun Crazy* (1950), and *D.O.A.* (1950) while munching corned-beef and mustard sandwiches at the Elstree. The darkness was suffused with the smell of stale Rembrandt cigarettes and sour hot dogs. This was also where I indulged myself to second helpings of those movie musicals that I had previously seen and enjoyed in a more traditional moviegoing setting.

While Wednesday nights were for the adults, it was on Saturday nights that my own moviegoing experiences were born. Before I was old enough to take myself to see the movies (about eight for the neighborhood theaters as I remember), my mother and my aunt established a ritual that I eventually relinquished with mixed emotions when I was about fifteen. As young as five or six I was dressed up, taken to dinner (either steak and chips at Hildebrand's or fish and chips at the fabulous Waldorf, with its crisp white linens and five-piece orchestra), and then off to the

movies. I am now able to confirm, with the aid of the historical lists currently available, that more than half the time we went to the Metro Theater, which showed MGM movies exclusively. I know this to be a fact because I saw almost every MGM musical made between 1946 and 1956, as well as most other MGM productions.

MGM was the studio that was best known for its magnificent musicals, often from the fabled Freed Unit. But MGM also concentrated on the big star vehicle in extravagant, colorful productions such as *The Three Musketeers* (1948), in which Gene Kelly did not sing a song or dance at all. Different as his performance was, I loved Kelly enough to accept his vigorous athleticism as the very embodiment of D'Artagnan. I remember, too, *Ivanhoe* (1952) with Robert Taylor, dashing in shining armor, and Elizabeth Taylor, her beauty in full flower, as the romantic leads. One eagerly awaited (and heavily publicized) movie was *Quo Vadis?* (1951), with the bewitching Jean Simmons, the only movie star I ever publicly confessed to being "in love" with, as well as the incredibly mesmerizing young Peter Ustinov as the Emperor Nero. In *King Solomon's Mines* (1950) and *Scaramouche* (1952), as well as many other adventure epics, the dashing Stewart Granger showed that he could wear safari hats and tights with equal aplomb. Outside of the Astaire-Kelly-Dailey triumvirate, it was Granger whom I most wanted to emulate; I was impressed with his voice, his carriage, and his incredible good looks. (The fact that he was actually married to Jean Simmons at this time was undoubtedly a factor as well.) How well I recall his performance in a somewhat minor MGM costume epic, *Beau Brummell* (1954), where Granger got to instruct me (as the audience) not only how to dress (I still vividly recall his use of tiny heated irons to put the proper creases into his cravat), but also how to woo Elizabeth Taylor and to exchange barbs with his friend the Prince of Wales, again played by the wonderful Peter Ustinov. That film has given me a lifelong interest in the life of George Brian Brummell, the man who introduced long-legged trousers as we know them and did away with the fashion of powdering and wearing wigs. In between the musicals, these were the films that my mother and aunt took me to see on Saturday nights.

But the musicals were the highlights of our Saturday night rituals. Every visit to the Metro tempted us with a taste of a forthcoming musical through the "trailers" that preceded the feature for that night. Whispers of "We must see that when it comes out!" were shared among us as we passed the box of Cadbury's "Black Magic" chocolates. And so we

invariably did. I have estimated that in that "crucial decade" in my social-ization, which roughly coincides with what has been called "the Golden Age of movie musicals," I must have seen literally every MGM film musi-cal, and even a few earlier ones that were often recycled, such as *Meet Me in St. Louis* (1944), and those musical curiosities *Yolanda and the Thief* (1945) and *Cover Girl* (1944). Just because I willingly participated in this ritual did not mean that I felt compelled to enjoy each and every one of these films. I have distinct memories of being very bored with such fluffy MGM offerings as *Luxury Liner* (1948), which tried to make a film star out of aging operatic tenor Lauritz Melchior—a flabby and pasty dough-man, to be sure, and not my idea of the ideal masculine figure—or even Rouben Mamoulian's *Summer Holiday* (1948), which was a musical ver-sion of Eugene O'Neill's play *Ah! Wilderness* (I take this as a sign that my instincts for these "turkeys" were developing even at the tender age of eight). For obvious reasons I particularly distrusted those musicals that guest-featured classical music stars such as the effete Spanish pianist and conductor José Iturbi—such forgettable films as *Three Daring Daughters* (1948) and *That Midnight Kiss* (1949)—or the aforementioned Melchior, who seemed like a nice enough man out of place. (I must make special mention of the wonderful job that famed operatic star Helen Traubel did in the Sigmund Romberg biopic *Deep in My Heart* in 1954, a perfor-mance I still enjoy, as ersatz as the story is.)

There were certain guest stars whom I actually looked forward to seeing. Even then, pre-adolescent tastes were veering toward the rhythms of jazz, and I loved Lena Horne's frequent "drop-ins" in films such as *Till the Clouds Roll by* (1947), *Words and Music* (1948), and *Duchess of Idaho* (1950). In my naiveté, even growing up in such a racially sensitive envi-ronment, I never grasped why she was always featured as a performer and not an actor. Carmen Miranda, "The Brazilian Bombshell," was another star I enjoyed seeing, and while she really only "guested" in MGM films such as *A Date with Judy* (1948) and *Nancy Goes to Rio* (1950), she was a featured performer in 20th-Century Fox musicals, which were decidedly second-tier. One strange guest star who never ceased to amaze me was Ethel Smith (*Easy to Wed* [1946]), who could play the Hammond organ with enormous energy and enthusiasm, but has now faded into obscurity. Did I dream her up? Anyone who ever heard her spirited rendition of "Tico-Tico" could never forget her.

Of course not every Saturday night was spent at the Metro, and occasionally we would shift our allegiance to Warner Bros. for Doris Day

in *Tea for Two* (1950), *On Moonlight Bay* (1951), and *Calamity Jane* (1953). These were fine films, with talented casts, but they did not have the glamour associated with the MGM films. This was particularly true of the Fox musicals, which usually had stronger story lines, with stars such as Betty Grable, Jane Russell, Mitzi Gaynor, Donald O'Connor, and the vastly underappreciated Dan Dailey, but here too there was something not quite right. The sets always seemed chintzier and lacked the majesty of what the Lion seemed to offer so effortlessly. When I look at these films today (courtesy of the American Movie Classics and Turner Classic Movie cable channels) my appreciation for them increases greatly; perhaps the small screen serves to emphasize the stories at the expense of the production numbers. The opposite is true of the MGM films, and the small screen harshly exposes how flimsy most of the plots of those great musicals were in reality.

This comparison between studios and their film musicals raises an interesting series of "what-ifs." What if the great Betty Grable, blond and brash, had worked for MGM under the guiding hand of Vincente Minnelli or Joe Pasternak rather than for Henry Koster or Lloyd Bacon at Fox? What if Dan Dailey had become part of the MGM stable early in his career instead of having to wait until he starred in one of the last great MGM musicals, *It's Always Fair Weather* (1955) together with Gene Kelly and Michael Kidd? And indeed, I often wonder, what if the charming young performers of the present day—Leonardo DiCaprio, Claire Danes, Matt Damon, Christina Ricci, or Winona Ryder—had apprenticed somehow, by meeting in "real life," or by absorbing a style—an "attitude"—from the screen images of, the great musical stars Fred Astaire, Gene Kelly, Ginger Rogers, Leslie Caron, Cyd Charisse, Donald O'Connor, Dan Dailey, or Judy Garland?

These stars were more than just screen icons for my generation. They represented an elite style of life and a level of talent that was not really attainable for ordinary viewers, although everyone liked to fantasize that it was. In reality we could only marvel at what these talented individuals did on the screen and secretly mimic their performances in our most private moments. So Stewart Granger, Robert Taylor, and Howard Keel were the men I secretly wanted to be, even if I knew Garth Jowett was the person I really was.

I have no problem in vividly recalling my futile attempts as an eleven-year-old to run up a wall the way Fred Astaire did in *Royal Wedding* (1951) or earlier to shadow dance with Jerry the Mouse, as Gene

Kelly so miraculously did in *Anchors Aweigh* (1945). By the time I was fourteen, I was a relatively sophisticated moviegoer, but I still had secret longings to be able to jump, legs akimbo, like Matt Mattox did in choreographer Michael Kidd's "barn-raising challenge" dance in *Seven Brides for Seven Brothers* (1954). Even in late adolescence, when my own brief acting career was just beginning, I marveled at the sexuality and "hipness" of the slinky choreography of the (to me anyway) unknown Bob Fosse in *The Pajama Game* (1957).

By the mid-1950s the influence of the movie musical was clearly on the wane, but it was still an important source of popular music and personal style. (MTV videos, with their teenybopper Madonna or Michael Jackson clones, serve as a sort of modern equivalent today.) The musical's significance in even minor segments of my life stimulates one particularly fond and vivid recollection. At the closing of our production of Aristophanes's *Lysistrata* at the University of Cape Town in late 1957, the entire cast performed a parody of several numbers from the movie of *The Pajama Game*, each reflecting the enormous rehearsal and production efforts that the director, Johan De Meester, of the Dutch National Theater, had subjected us to for six long weeks. The words to one of these parodies still echo loudly in my brain forty years later, as we sang them to the tune of Richard Adler and Jerry Ross's title song:

> The *Lysistrata* is the play we're in,
> And the play we're in is the *Lysistrata*,
> We can hardly wait,
> For the play to begin at eight,
> Nothing's quite the same as the *Lysistrata*.

The fact that the cast put a lot of effort into this elaborate parody, rehearsing in private after the long hours at the theater, was in itself a homage of sorts to the movie musical, for none of us had ever seen a live stage production of *The Pajama Game* at that point. Musicals were for us essentially filmic experiences, for few live musicals, with the exception of English pantomimes at Christmas time, were ever seen on the stages of Cape Town theaters. The lively music of *The Pajama Game* was perfectly suited to convey our own "labor struggles" with Herr De Meester, although I am certain that this barb of ours entirely missed its target.

It was through the vehicle of the movie musical that we discovered the great songs from Broadway, for there was no television available to

South Africans at that time, and, in fact, this medium would not be introduced until the mid-1970s. While radio was the primary source of "pop" music, it was through the movies that we were provided the context for this music. I particularly recall popular songs such as "My Secret Love," which was high on the hit parade for months before the release of Doris Day's *Calamity Jane* gave the tune a contextual perspective, although a somewhat bizarre one. This was true of other popular hit parade songs, such as Sammy Davis's version of "Hey There" from *The Pajama Game*, "I've Never Been in Love Before," from *Guys and Dolls* (1955), and all of the music from such megahits as *My Fair Lady* and *West Side Story* in the late 1950s. It was not until the release of the film versions of these musicals in the 1960s that South Africans understood the relationship between these "isolated" tunes and the libretto.

When it came to "Broadway-style" dancing, there was virtually no context outside the movies in which this could be appreciated. While there were local ballet and modern dance companies, they seldom ventured into the realm of stage musicals. This placed the "film-dancing" of Astaire, Kelly, Dailey, Cyd Charisse, Ann Miller, Betty Grable, and Ray Bolger into a highly specialized category, associated with the magic of the Hollywood film, performed only on the large screen, and therefore outside the realm of public performance by mere mortals. No one ever tried to dance like Gene Kelly or Fred Astaire at my local dance palais. They would have been laughed off the floor, for this was a hallowed, highly specialized dance form, unlike the simple gyrations that were beginning to take hold among teenagers in the 1950s with the introduction of rock 'n' roll. It was, of course, the emergence of the rock culture that sounded the final death knell of movie musicals and fundamentally altered the relationship between youth culture and its music. Now music became much more a means of expressing, and exploring, one's personal lifestyle, and public dancing for the most part lost all semblance of elegance or skill. The essential populism and egalitarianism of the rock culture discouraged elitist behavior, except for the performers themselves, whose skills were vastly different from those of the previous age. To an audience sweatily doing the monkey or the mashed potato, the graceful twirls of a Fred Astaire or the athletic leaps of a Gene Kelly were considered "square" and laughable. Now what we worshiped as athleticism and grace, formed and bounded musically, has given way to a more violent physicality in which our "heroes" are the gun-toting Brad Pitt, Nicholas Cage, or (hardly ever dancing anymore)

John Travolta. I see in the career of that arch-practitioner of quirkiness actor Christopher Walken a microcosm of these changes. His stunning, almost menacing style of dancing in the barroom scene in *Pennies from Heaven* (1981) is also the genesis of many of his subsequent roles as a charming psychopath in such movies as *The King of New York* (1990), *True Romance* (1993), and many others. Every time I watch Walken, I can see him stripping off his clothes in that sinuous dance on the bar counter in *Pennies*. Is this where our dancers have gone? As the birds are the evolutionary remnants of the dinosaurs, are the sinewy gangsters, cops, psychopaths, and con men that now populate our screens the natural descendants of Astaire, Kelly, and Dailey?

The image of Robert De Niro from *Taxi Driver* (1976), standing in front of the mirror in his dingy room trying out various "looks" as he asks his famous question, "Are you talking to me? Are *you* talking to me?" has become an icon of modern popular culture. This image has captured the imaginations of almost two generations of moviegoers, is widely imitated and parodied (especially as an audition piece for would-be actors), and is entirely symbolic of the shift from the dancing male to the violent one.

But appreciating the dancing male as a gender type was connected to one's social class roots. It was only during my years as a graduate student researching and writing about movies that I came to understand the definite issue of social class involved in how one viewed and internalized movies in general and movie musicals in particular. The musical was always a fantasyland, a mixture of vivid costumes and acceptable aberrant behavior (after all, if we were to walk through the streets in the rain swinging from lampposts, we'd run the risk of being taken to some sort of shelter), and it almost always had as a central theme, the realization of dreams. This combination, for a "working-class lad" like myself, was irresistible. I could dress, dance, and sing my way to success in life, and no one would object. For after all, this type of behavior was quite common in my neighborhood; "sing-alongs" were required fare at festive holidays, as were communal dances like "knees-up Mother Brown," "the Lambeth walk," or "the hootchy-koochie." I was unfettered by the constraints of an upper-class, or even a middle-class upbringing, which severely frowned upon such "low-class" rites. And yet, there on the screen, larger than life, was the elegant Fred, almost always playing the rich playboy, dancing and singing all that he wished. Gene Kelly was more one of us, with his pants up around his ankles, showing his white socks (shades of Archie Bunker

many years later), and soft leather penny loafers. However, Gene also ended up with "the girl" and had a wonderful time in the process. Only now, as I reflect on the Saturday nights I spent at the "open house" at the Mundah Berks Dance Studio in downtown Cape Town—doing the various jive routines, the samba, and the rhumba, but avoiding waltzes and fox-trots like the upper-class plague they were—do I see that my working-class background actually enhanced my "willing suspension of disbelief" about the veracity of such behavior in movie musicals. No wonder that my students today, experiencing a film world increasingly distanced from class, find it difficult to appreciate the class overtones of Frank Sinatra and Bing Crosby singing and dancing together ("Well, Did You Ever?") in the famous library scene from *High Society* (1956). Such behavior may well be considered bizarre by audiences hooked on film as reality rather than dream.

During the late '50s and early '60s, indeed, my own feelings about "real men singing and dancing" were put to a test. I've already admitted to the fact that the movie musical was an integral part of my growing up, and upon reflection, this genre has been a considerable socializing influence on many aspects of my life. In the realms of personal taste in music, clothing, design, and aesthetics in general, movies and more especially musicals, have left a deep imprint on my psyche. While little has been formally written on "movie socialization" (it seems to be one of the most eternally elusive subjects for film scholars), there has been an increasing appreciation for the significant role that movies have played in the development and shaping of modern culture. In personal terms, what was the influence of the masculine figures of animated Dan Dailey, elegant Fred Astaire, and athletic Gene Kelly in films such as *My Blue Heaven* (1950), *The Band Wagon* (1953), and *An American in Paris* (1951) upon the male I was turning into and that I eventually became? How is my idea of what women are supposed to be—and the idea of my generation, in fact—founded upon the screen images of wholesome Doris Day and ebullient Judy Garland and smoldering Cyd Charisse in *On Moonlight Bay* (1951), *Easter Parade* (1948), and *It's Always Fair Weather* (1955)?

The shifting interest in "movie socialization" is a curious case study in the vagaries of academic politics and intellectual elitism. Up until the mid-1940s, the attempt to study "the impact of movies" was conducted by two very different groups. The first was a small coterie of pioneering social scientists eager to develop research methodologies that

would allow them to understand how mass media "worked"; the second was a more amorphous group, doing largely "content analysis" or audience composition studies in order to provide information that would lead to the imposition of more rigid censorship or other forms of social control of the motion picture industry. The fact is that we knew more about the lives and cultural influences of the Trobriand Islanders, thanks to Bronislaw Malinowski and other anthropologists such as Hortense Powdermaker (1933), than we knew about American moviegoers, their viewing habits, and what influences the movies had on their lives. Powdermaker's later book, *Hollywood, the Dream Factory*, is a fascinating, if ultimately flawed, attempt to apply anthropological study to the workings of the studio system, but the book offers little analysis of audience structure or behavior.

What little academic interest there had been in studying movie socialization dwindled completely after the movie industry's zenith year of 1946. Now there was a new media/entertainment/socializing force to be reckoned with—television—and almost immediately this medium became the subject of a massive and continuous research effort, often well sponsored by the giant broadcasting interests themselves. When film studies began to emerge as a subject of "legitimate" academic and critical enquiry in the mid-1960s, spurred on by an exciting new set of "critical" theories as tools for analysis, even to raise the issue of "the impact of the movies" was enough to get one hissed at at conferences or condemned as "an outdated, irrelevant positivist" (my personal fate as a graduate student in the early '70s). But somewhere in the last decade, with the "poverty-of-theory" argument hovering ominously overhead, scholars have begun to rekindle an interest in understanding what real movies do to real people.

Although film socialization stubbornly defies the rigor of academic analysis, the fact is that there were and are hundreds of millions of moviegoers in the world who have been "influenced" in myriad ways by movies, sometimes ephemerally and sometimes profoundly. But the role of the motion picture has changed in our culture from being one of "experience" to one of "evaluation." Of course specific demographic groups, especially teenagers, still want to experience certain films, but on the whole, as a society, and especially as scholars, we now discuss, analyze, evaluate, and pass judgment on film in a much more methodical way than moviegoers of the '30s and '40s—like my parents, and like me as a child—ever did. In our desire to give the movies a legitimate place

in the evolution of our culture, we have demystified them, and as a result this has led to a distancing of ourselves from our "real" experiences in the darkened cinema. The forms of imitative "movie" behavior, which are now acceptable, have been circumscribed to a considerable extent, or, like the "comedic" performance of Vincent Gallo in *Arizona Dream* imitating Cary Grant in *North by Northwest* in a talent contest, they are openly decried as preposterous clowning. There is no doubt that today I would be very self-conscious about singing or dancing in front of a mirror. Would I be more comfortable with a gun in my hand imitating Robert De Niro? Probably so.

Film scholarship now engages in an alarming range of intense analyses trying to determine "exactly" what the movies have done to us. There are literally thousands of books, articles, and academic papers that purport to examine every facet of what those images up there on the screen did, or are continuing to do, to us. In very recent years there has been an increased emphasis on questions dealing with "gender," "male gaze," or "queer studies," all of which examine the role of the movies in contributing to the "structuring" of sexual identity in modern society. (In fact, the number of recent publications on film that includes the word *body* in the title is the subject of some cynicism on the part of an older generation of film scholars.) The issue of the body is an interesting example of intergenerational shift in both definition and focus. Of course, the current interest in evaluating the way in which bodies have been depicted in popular culture, and especially movies, is an attempt at historical re-engineering in order to better understand the implications such depictions may have had for our culture. The same is true of other theoretical constructs such as the male gaze, or queer studies, which purport to provide a new, more incisive way to look at films we have known and loved for many years. These theoretical approaches may yet yield a rich crop of insights, but in the '40s and '50s the body was much less complicated. It was Marlon Brando in a torn t-shirt; it was William Holden, stripped to the waist (and heavily featured as such on the publicity poster) in *Picnic* (1955); Marilyn Monroe's skirt being blown upward by a subway airshaft in *The Seven Year Itch* (1955); or Carol Baker, her thumb in her mouth, lying in the crib in *Baby Doll* (1956). The "function" of these iconographic images was obvious to me as a teenager, and I had no need for notions about male gaze or queer theory to inform my personal reactions. But the emergence of these theoretical perspectives, and their wide acceptance by younger scholars, made me feel somewhat foolish as it suggested

that I might have missed the subtexts of all those thousands of films that I have seen. That was only a momentary insecurity, and after examining these theories, I now feel much more secure in my own initial judgments. Patriarchal and heterosexist as they might be, it is also true of them that they emerge from the deep earth of my own true biography.

This rigorous application of theoretical perspectives has had the effect of giving a veneer of academic legitimacy to the study of film, but at the same time it seems to have taken some of the sheer fun out of recalling personal reactions to films. Now I feel strangely guilty when I recall my adolescent reactions in the darkened Elstree to Rita Hayworth singing "Put the Blame on Mame," in *Gilda* (1946), or my first glimpse of female nudity in a film I vaguely recall as being a French "coming-of-age" story that I saw at the Odeon Cinema in the rich suburb of Sea Point. This was the only movie theater in Cape Town that regularly showed foreign films. Was I merely being betrayed by my "patriarchal" socialization and viewing those films through a socially and culturally structured "male gaze"? Many contemporary scholars, perhaps themselves betrayed by other invisible forms, would say I was.

Whatever the impulse for this focus on sexuality/physiology/gender, as a major aspect of movie influence, it has not provided me with answers to my fundamental problem: how was I to deal with the apparently conflicting issue of my emerging adolescent maleness and my increasingly manqué interest in movie musicals? Did I as a "real man" continue to sing and dance? The decreasing numbers of movie musicals in the late '50s certainly provided no clue, other than the obvious symbolism of their decline and apparent unpopularity with audiences. Music did not entirely disappear from movies—far from it—but it now took a much more accessible form. Teenage males on the screen were now surfing or riding hotrods or motorcycles while listening to rock 'n' roll and "bopping" (which was the local South African term for "jiving" and what is today called "swing") to the ubiquitous music of Elvis Presley, Bill Haley and the Comets, Little Richard, and Jerry Lee Lewis. At the local dance palais, except for those who wished to continue to demonstrate their hard-earned proficiency, the crowd had stopped waltzing, fox trotting, and doing the samba.

The entire teenage male aesthetic had undergone a dramatic change as well. Just a few years before we bragged about our sports coats, pleated slacks, and Jarman shoes; now we were beginning to wear blue jeans, t-shirts, and leather jackets, even if we did not own a motorcycle. I was con-

fused, very confused. When I was about fifteen, I had taken to affecting the wearing of an old tie as a belt; something that I should have realized only Fred Astaire could actually get away with with any panache. But I tried it anyway; and it just amused people, who asked if I had forgotten my real belt. I also loved wearing ascots under an open-necked shirt with a blazer, a rather English affectation, which nonetheless was a quite acceptable style in what was then still a colonial corner of the British Empire. I was extremely impressed with Gene Kelly's casual "American artist" look in *An American in Paris* and wore a similar outfit (khaki slacks, black sweater, white socks, tennis shoes, and even a version of his peak cap) for many years afterwards. But the sudden emergence and domination of the rock culture took me and many of my jazz-loving friends by surprise. We had consciously considered ourselves to be "cool" and even "Beat" (we had all read, or tried to read Kerouac's *On the Road*), and this new "hot" phenomenon, eschewing all pretense at intellectual subtlety or aesthetic refinement, was hard to adapt to, even for a malleable teenager.

My confusion over what aesthetic path to take (either "the cool school" or "the duckies"—referring to the ducktail haircuts of the rockers) was wonderfully captured by one film of the period, which is still, for me, an iconographic Hollywood movie. In 1956, director Frank Tashlin made *The Girl Can't Help It* with Jayne Mansfield, Edmund O'Brien, and Tom Ewell as the hapless, alcoholic talent agent hired by O'Brien to groom his girlfriend, Mansfield, for stardom. In a plot written by Garson Kanin, and stolen from *Born Yesterday*, Ewell attempts the impossible, but coming out of his alcoholic hiatus, he quickly discovers that the world of popular music he knew just a few years before has completely disappeared and has been replaced by Little Richard, the Platters, Gene Vincent, and Fats Domino. In his alcoholic haze, he sees a former client and paramour, the beautiful Julie London, descending a staircase while tastefully offering her hit song "Cry Me a River" accompanied only by the guitar of jazzman Barney Kessel. For those of us cognoscenti of the "cool school," this was what is currently referred to as "a defining moment" in our own musical tastes. We all knew this version of "Cry Me a River." It was only a few years old, and *here it was being offered as a symbol of the musical past, an aesthetic "has-been"!* Audiences were flocking to this quasimusical to see the "new" stars of pop music in their screen debuts, and despite the hackneyed plot, the film was a commercial success and increased the popularity of these performers. But they weren't interested in London and Kessel at all!

In retrospect, *The Girl Can't Help It* can be seen as a musical version of *Easy Rider* (1969). The central message was stated loud and clear and without equivocation: the aesthetic embodied in the classic and extremely tasteful Julie London sequence was now just a dream from the past, gone forever, while "old fogies" like the hapless Tom Ewell (who only the previous year had played a man hip enough to seriously contemplate coupling with Marilyn Monroe in *The Seven Year Itch*) were now essentially dinosaurs, good for laughs, but not really "where it's at."

The Girl Can't Help It is significant in several other ways as a symbol of the change in musical tastes. It is a musical film—in that it contains a great deal of music—but other than the Julie London fantasy sequence, all of the music is presented in a performance context; that is, there is no singing and dancing in the streets, in drawing rooms, or on top of buildings or airplane wings. In what was to become standard procedure for these early rock 'n' roll movies, the music was presented as musical acts, in nightclubs, rehearsal halls, auditions, or parties. This was a return to the practice of performance-based musical films from the early sound era, before Ernst Lubitsch in *The Love Parade* (1929) and *The Merry Widow* (1934), King Vidor with *Hallelujah* (1929), and especially Rouben Mamoulian with *Love Me Tonight* (1932) combined plot and music into a seamless whole in which characters went happily into the streets to share their music with others. For the next few years after 1956, we were taken back to that static period when the cameras were aimed dead-on at the performers reprising their latest releases, essentially a pre-MTV format, but without the dazzling production values. Even though it was in the form of Elvis Presley and his endless series of films in the '60s that we once again found singing on the streets, in jails, in casinos, and at both horse and automobile racetracks, nevertheless these star vehicles, featuring colorful backgrounds, interchangeably pretty girls, and many Presley songs, were the last original movie musicals made by the studios. It was an end we should have seen coming, for Presley's musical film debut, *Jailhouse Rock* (1957), was a smash hit throughout the world.

The other obvious point about these "musicals" is that there was no dancing! Well, there were "real" dancing scenes of kids doing the latest dance craze to the music on the screen, but there was no virtuoso dancing by the modern equivalents of Astaire and Kelly. Dancing in these films was reduced now to being merely the visual expression of joy/energy/sexuality that was inherent in rock 'n' roll. The music would

start, and as if someone had flipped a switch, the kids got up and danced. There was no individuality in the dancing; in fact, too much individuality was deliberately used as a convention for identifying "weirdos." The "good guys" were never too conspicuous or were out of the dancing mainstream. So I was left with my dilemma; in the world of adolescent sex, drugs (mainly alcohol and "dagga," a potent form of marijuana), and rock 'n' roll, did "real" men sing and dance?

I moved to London in 1958 to work in the theater and found that an uncharted world lay before me on the Earl's Court Road. There, with thousands of other colonials from every corner of the fading British Empire (already by then being called "the Commonwealth") I discovered that there were many different kinds of "real" men and that most of these did sing and dance. My liberation from the restricted Calvinistic and racist society in South Africa opened my eyes to all the possible routes that were available to me. The two years I spent living alone in London, being responsible for and to myself, removed any doubts about any gender confusion and showed me that my movie idols were not to be feared but cherished for what they gave me. I saw a lot of movies in the two years I lived in London—it was catch-up time for all those classics of the cinema, old and new, that I had not been able to see before. According to my diary, I averaged about three films a week during this period, watching everything from those delightfully awful American-International monster movies (*I Was a Teenage Werewolf* [1957]) to several helpings of Kurosawa, especially *Rashomon* and *The Seven Samurai*. I also took in such diverse fare as *Ben-Hur, Darby O'Gill and the Little People* (Sean Connery's first major role), and *Pillow Talk*. I vividly remember going to the Empire Theater in Leicester Square to see *Damn Yankees!*, the ultimate "real men" movie musical, even though it starred the androgynous Tab Hunter. My moviegoing was enriched by healthy doses of live theater, both in terms of work and as a spectator, and here too, gender bending was all around me, but I took it all in stride. If Fred and Gene could do it, ooze masculinity in a world of singing and dancing, then so could I.

And this is still true. Perhaps my scholarly objectivity gets in the way of my emotions, but of the thousands of movies I have seen in the last forty years, there are few that still move me to my core. Yet, in a world increasingly dominated by a harsh aesthetic of violence, I can always cherish the athletic grace of Gene Kelly doing "Broadway Melody" in *Singin' in the Rain*. In a society filled with gyrating, screaming masses, there will

always be Fred Astaire, with his tie belt, white bucks, and the kerchief around his neck, dancing in the dark with Cyd Charisse in *The Band Wagon*. These men, singing and dancing, are at the heart of the true masculinity I know, and their work never fails to leave me exhilarated and at peace with myself.

WORKS CITED

I found the following sources to be useful background in the framing of this personal essay:

Altman, Rick, ed. 1981. *Genre: The Musical*. London: Routledge.

Butler, Judith. 1990. *Gender Trouble: Feminism and the Subversion of Identity*. New York: Routledge.

Cohan, Steven. 1993. "'Feminising' the Song-and-Dance Man: Fred Astaire and the Spectacle of Masculinity in the Hollywood Musical." In Steven Cohan and Ina Rae Hark, eds. *Screening the Male: Exploring Masculinities in Hollywood Cinema*. New York: Routledge, 46–69.

Cohan, Steven, and Ina Rae Hark, eds. 1993. *Screening the Male: Exploring Masculinities in Hollywood Cinema*. New York: Routledge.

Dyer, Richard. 1987. *Heavenly Bodies: Film Stars and Society*. London: Macmillan.

————. 1998. *Stars*. London: British Film Institute Publishing.

Feuer, Jane. 1982. *The Hollywood Musical*. Bloomington: Indiana University Press.

Gledhill, Christine, ed. 1991. *Stardom: The Industry of Desire*. New York: Routledge.

Kirkham, Pat, and Janet Thumin, eds. 1993. *You Tarzan: Masculinity, Movies, and Men*. London: Lawrence and Wishart.

Mordden, Ethan. 1981. *The Hollywood Musical*. Newton Abbot: David M. Charles Ltd.

Powdermaker, Hortense. 1933. *Life in Lesu: The Study of a Melanesia Society in New Ireland*. New York: W.W. Norton.

————. 1950. *Hollywood, the Dream Factory: An Anthropologist Looks at the Movie-Makers*. Boston: Little, Brown and Company.

Tasker, Yvonne. 1993. *Spectacular Bodies: Gender, Genre and the Action Cinema.* London: Comedia/Routledge.

Vincendeau, Ginette. 1985. "Community, Nostalgia and the Spectacle of Masculinity." *Screen* 26:6 (November–December), 18–38.

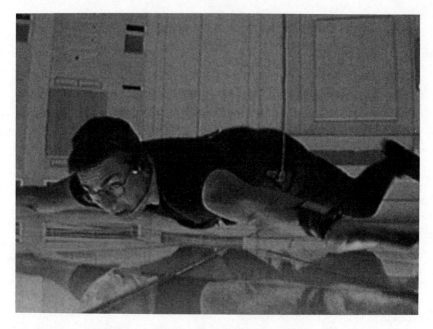

FIGURE 9. *Mission Impossible* (Brian De Palma, 1996): Ethan Hunt (Tom Cruise) in the secret room. If he touches himself, the game will be up. (frame enlargement)

CHAPTER TEN

◈

Cruise-ing into the Millennium: Performative Masculinity, Stardom, and the All-American Boy's Body

GAYLYN STUDLAR

You're a hella'va candy ass.

—Rowdy (Michael Rooker) to Cole
(Tom Cruise) from *Days of Thunder*

HOLLYWOOD'S RISKY BUSINESS: REPRESENTING THE ALL-AMERICAN MALE

Early on in *Risky Business* (1983), there is a famous scene that has been endlessly imitated and parodied in the years since the film's release. The opening piano riff of the Bob Seger song, "Old Time Rock 'n' Roll," reverberates over a full shot of an empty double doorway separating two rooms in the middle-class, suburban home of the Goodsen family. Suddenly, into this impromptu proscenium arch slides (literally) Joel Goodsen (Tom Cruise), a high school student left home alone while his parents vacation. Goodsen's attenuated attire (tail-out oxford shirt, an almost imperceptible pair of BVDs peeking out from under it, and socks)

171

emphasizes his slim but muscular legs and, as the scene progresses, his tight little butt, much as a similarly configured outfit (sans socks) will do for Demi Moore in *Striptease* (1996).

As Seger's vocals begin, Joel, who up to this point has had his back to the camera, turns around. With a silver candlestick in hand to serve as a mike, he dances with the music and mimes the lyrics. He moves forward, and the camera reverses to view him from behind in a medium shot as he dances into the living room. Then, an overhead full shot captures his movements as he turns around and leaps on top of the coffee table, where he imitates a guitarist with the candlestick poised between his open legs. The camera reverses again as he jumps down to his knees on the floor to finish his guitar solo, then cuts to a high-angle close-up of his head/face in profile. The camera moves to various vantage points (mostly overhead full shots) as he gyrates in rhythm to the music and then jumps onto the couch and—butt up, then butt down—wiggles his entire body to the music. Suddenly, framed by a medium close shot, Joel jumps up, and facing away from the camera, with his hands behind his head, he stops, then takes up a rhythmic shift from one leg to the other in a movement reminiscent of an old time burlesque bump and grind. The camera cuts to a long shot outside the house showing him, in silhouetted profile, continuing to dance to the music.

Marjorie Garber has argued that "the All-American boy doesn't have a body or didn't until recently. . . . Indeed, it could be said that a 'real male' cannot be embodied at all, that embodiment *itself* is a form of feminization" (372). However, as this memorable scene from *Risky Business* suggests, and as scholars such as Steve Cohan, Peter Lehman, Paul Smith, and I have argued, masculine embodiment is a complex phenomenon that exceeds the limits of observations such as Garber's (Cohan, 198–99; Lehman, 1–36; Smith, 155–60; Studlar 1996, 10–89). Indeed, the All-American boy has had a body for a very long time. This is especially true with regards to the relatively short history of the cinema even if, in various periods of U.S. history and in specific social and discursive contexts, that body has been regarded and represented differently.

For example, referring to the visual treatment of male bodies in 1950s films, Steve Cohan argues that Joshua Logan's film *Picnic* (1955) "openly eroticizes [William Holden's body] as spectacle, configuring the possibility of an alternative masculinity" (199). Holden, labeled in the press of the time as "a red-blooded American boy," is subjected, says Cohan, to the kind of "unrelenting visual interest supposedly reserved for

a female star" (195, 199). The eroticized images of Holden in this partic-
ular film may be presumed to be directed at a female spectator through the
conventions of the film's romantic and/or melodramatic narrative, but the
visualization of Holden as *image* ends up soliciting or enticing "an assort-
ment of possible gazes across a continuum of gendered/sexed viewing posi-
tions: female, male, heterosexual, homosexual" (Cohan, 199). Cohan's
argument vis-à-vis Holden's performance of masculinity in *Picnic* resonates
with my own observation in *This Mad Masquerade* regarding the cinematic
and theatrical construction of John Barrymore in the 1910s and 1920s,
that is, that the erotic appeal of representational strategies is difficult to
control with certain aim and that if such strategies lead to increased pop-
ularity of the "product" (i.e., the star), then they will be tolerated, whether
they evoke erotically anxious controversy or not (116–40).

Recently, the work of film scholars such as Cohan, Smith, Lehman,
and Studlar has called attention to numerous instances of classical and
postclassical representation of cinematic masculinity that feminist-psy-
choanalytic film theory has often left us unprepared to encounter and
explain. This scholarship on masculine representation also invites us to
consider the fragility of the Hollywood system as it comes to construct-
ing a "safe," hegemonically secure male subjectivity when that subjectiv-
ity depends upon a fundamental display of the male body, especially the
youthful or youthful-looking male body.

Thus, we might suppose that mainstream film has a cultural imper-
ative to delimit or disavow the dangerous multiplicity of desire (across gen-
ders and sexualities) set into circulation by an attention to masculinity as
an erotically marked object of attention; however, we are forced to consider
the possibility that the simultaneous commercial need to exploit a star's
appeal to the broadest possible demographic (one that at the very least
includes spectators of both genders) may regularly threaten Hollywood
cinema's ability to unequivocally affirm gender dichotomies and conven-
tional divisions of sexual desire. As this chapter will argue, the messy
unpredictability of actual cinematic practice can often create a transgres-
sive spectacle of eroticized stardom—including male stardom—with quite
culturally troublesome implications for dominant notions of gender and
sexuality. Such a line of thinking demands that we address masculine
embodiment in specific historical as well as textual terms in order to bring
into focus the whole exhibitionist nature of male-centered cinema.

Several scholars have suggested that U.S. cinema of the 1980s her-
alded an overt return to the male body as spectacle (Jeffords 1993, 245;

Tasker, 231). Masculinity became a pure spectacle for consumption in narrative-starved postmodern action films populated by "hard bodies," muscle-clad male stars such as Sylvester Stallone, Arnold Schwarzenegger, and Bruce Willis. Susan Jeffords has argued that defining the male body as the era's "most fulfilling form of spectacle" (245) was itself an embodiment—of a conservative national character established in Reaganism and of its creation of a national identity centered around a sense of macho physical (i.e. military) might (Jeffords 1994, 13).

Tom Cruise was one of the most popular male stars of the 1980s. He came to stardom as a wholesome, virile masculine American type early in the decade with *Risky Business* as his breakthrough role after appearances in five other films, including supporting roles in *Taps* (1981) and *Endless Love* (1981) and a leading part as the working-class football hero in *All the Right Moves* (1983). He emerged as one of the few male stars of the 1980s who sustained his top-rank stardom (and box-office clout) throughout the 1990s. As one measure of this popularity, exhibitors consistently ranked him in the top ten box-office draws, with one poll listing him number 10 in 1983, 1 in 1986, 6 in 1987, 1 in 1988, 2 in 1989, 4 in 1990, 1 in 1992, and 2 in 1993 (Brown, 359, 371, 375, 378, 382, 387, 397, 403).

Did Cruise become so popular because he was another '80s hard body? Jeffords does not mention Cruise in her analysis of the masculine body's role in the decade's "formation of national and popular cultures" (1994, 13). Yet, in the context of this cultural phenomenon and its emphasis on male spectacle, Tom Cruise appears to be an ideal "star site" for examining the cinematic inscription of the male body, not only in the 1980s, but in late-twentieth-century Hollywood film in general. In this chapter, I wish to examine how specific textual representations of the body and screen persona of Cruise render the male star an object of a polymorphous gaze that cuts across the desiring possibilities of male and female, gay and straight spectatorship.

While figuring a performance of masculinity as a visual spectacle might not always eroticize a male star or make the viewer's gaze potentially transgressive, I would argue that some evidence of the transgressive quality of Cruise's screen embodiment exists extratextually as well as textually. It can be discerned in the slippage between the construction of his onscreen desirability as both a homoerotic and a heteroerotic sign and offscreen fan inscriptions of him as the object of gay desire coupled with media innuendoes to the effect that he is gay. Cruise's photographs regularly grace gay movie fan Internet sites as well as the numerous sites belonging to teenage

girls. Recently, a court in the United Kingdom ruled in Cruise's favor in a libel case that he brought against a British newspaper's "malicious" claim that he was gay and his marriage a sham. It is interesting to recall in this context that Liberace won a similarly motivated litigation in the United Kingdom in the 1950s (Drewal, 174–75), and Oscar Wilde undertook a libel suit against the marquess of Queensberry, who accused him of "posing as a somdomite [*sic*]." Such gossip in extratextual sites is not unique to Cruise but is in keeping with the origins of stardom as an industrial practice, with the star system being linked (through fan magazines, newspaper publicity, etc.) to the fans' impulse to indulge in a fantasy of completely "knowing" the star, of intensifying the impact of the cinematic signifier (the star) by discovering the "truth" behind the screen identity (Studlar 1991, 28).

Setting aside any crude jokes regarding the gay innuendoes to be found in the name *Tom Cruise*, Cruise's screen persona suggests the kind of "cocky, self-assured, flaunting of masculinity" associated with both straight men and "butch clones," gay men who pass as heterosexual because they act and look like a straight man—a "real" man (Holmlund, 215–17). Nevertheless, as Christine Holmlund has noted, there is slippage in a masculine masquerade that links the homosexual and the heterosexual, for both the straight man and the butch clone "are merely masquerading" (Holmlund, 217). The male body in a performative mode draws attention to the construction of masculinity as a masquerade that attempts to create a set of readable signs signifying "manliness" and to display these signs as a coherent subjectivity.

HUSTLING THE LOOK, SEDUCING THE VIEWER

Cruise's films emphasize the notion of male identity as performative, and at the center of his star vehicles of the 1980s and early 1990s meaning is anchored by the spectacle of the star's body. This fact is obvious at the beginning of a film such as *Days of Thunder* (1990), when Cruise's star entrance is via motorcycle, a pretext for full shots of his body that give ample display of him costumed in tight jeans and leather jacket. His provocative display of swaggering egotism in this scene is nothing more than a masquerade of male identity, as the film will reveal when he admits to the racing team leader, Harry (Robert Duvall), that he is actually very insecure in his professional skills and without knowledge of cars or of the terminology and technical aspects involved in racing them.

What is the motivation for this display of masculinity as a perfor-
mance? How is Cruise's body constructed as an erotic object? What are its
implications for masquerade as an arena of "slippage" between the homo-
sexual and the heterosexual? In this particular film, as in so many of his
vehicles, Cruise's character is depicted as moving from a manly "boy" who
is attractive, muscular, and talented in some physical pursuit (playing
football, race car driving, piloting a plane, bedding women, shooting
pool, etc.) to a true "man." Although he presents himself as a man, films
such as *Days of Thunder, The Color of Money* (1986), *Top Gun* (1986), *A
Few Good Men* (1992), and *Rain Man* (1988) inevitably suggest through
the narrative that he is still not one because he is a "hustler," inauthentic,
greedy, narcissistic, self-absorbed, selfish, lacking in self-control, and/or
"dangerous" to others. He is overconfident, displaying a stubborn disobe-
dience to patriarchal rules. He is a stereotype of masculinity, instead of
possessing true manliness, which the films present as being the result of
blending strength and gentleness, professional skill or physical prowess
with self-control, courage and compassion. In other words, his films con-
sistently move his characters from a performance of manliness into
"authentic" manliness through the incorporation of qualities—gentleness,
self-control, compassion—that might be regarded as "feminine." In this
respect, Cruise straddles "hard" and "soft" modes of masculinity. It is not
his physical but his moral nature that must be changed.

Cruise's character must move from narcissism (which Freud associ-
ated with females and homosexuals) to object love (which Freud associ-
ated with "normal" heterosexual men), and from inauthenticity to appar-
ent authenticity. In spite of this, he does not give up soliciting the gaze
through his performance of exhibitionist masculinity but continues to do
so through a masculine identity that focuses on the appeal of his body and
toothy, All-American boy's grin. Thus, authentic masculinity is also held
up for scrutiny as a construction, a masquerade. In Cruise's films of the
1980s and early 1990s, his body is inevitably revealed (nude, seminude,
in revealing, tight clothes), with more frequency and intensity than that
of the female love interest. This revelation takes place, as in *Top Gun*,
within the intimate spaces (such as locker rooms) of an all-male milieu
that pays attention to male competitiveness, and, more crucially, to male
emotional bonding.

Although a heterosexual love interest is provided in most of Cruise's
films (arguably not in *Mission Impossible* [1996]), that female figure is
made visually marginal as an erotic object. At the same time, she is placed

in a "no-woman's land" with regard to her narrative importance to the emotional development of the hero. The Cruise protagonist, as in *Days of Thunder* and *Top Gun*, is inscribed as being socially and professionally aggressive to a fault, yet he is visually inscribed as being rather passive sexually in the presence of assertive female sexuality. This is at the most extreme in *Days of Thunder*, in which Dr. Claire (Nicole Kidman) lies in wait and then literally slams him against a wall and begins kissing him all over. One of the few scenes in which the gaze of the woman is explicitly inscribed as being attached to the camera's revelation of Cruise's nude or seminude body occurs in *Far and Away* (1992). After being hurt, Joseph Donnelly (Cruise) is allowed to recuperate in the house of the local Irish landowner. The only thing separating the naked body of farmer Donnelly from the prying eyes of aristocrat Shannon Christy (Nicole Kidman) is a chamber pot that covers his penis, which she lifts. Here, he is the spectacle for a desirous gaze implicit in the vision of a woman who is central to the narrative's development.

More typical in terms of the display of his body is his representation in *Cocktail* (1988). In this star vehicle, Cruise's working-class hero, Brian Flanagan, becomes a practiced seducer of women. He uses his skills as a bartender to snare a rich girlfriend, an older professional woman who treats him as a kept man and publicly humiliates him. In this film, as in so many Cruise vehicles, including *Top Gun, Days of Thunder, The Color of Money*, and even the postmodern *Mission Impossible*, intensity of commitment and feeling is displaced from the heterosexual to the homosocial to the homoerotic. Virginia Wright Wexman notes that the "homosexual subtext" in westerns such as *Red River* (1948) is "a developmental interlude in the life of the young man that eventually gives way to a narrative resolution in which these characters are paired off with a woman" (170). Cruise's character, in keeping with Montgomery Clift's embodiment of slim, androgynous Matthew Garth in *Red River*, puts into circulation a bisexual desire by virtue of the camera's lingering on his youthful, athletic body as a desirable object. At the same time, there is a narrative focus on the all-important eroticized bond between father figure and surrogate son. Just as in *Red River*, which ends with Matthew and Thomas Dunston (John Wayne) sitting in a heap of dust after beating each other up in a fight—that as Tess Millay (Joanne Dru) observes, only confirms that "you love each other"—in *Days of Thunder*, Cole Trickle may kiss Claire in the winner's circle, but he leaves her to bring his father figure, Harry, into the celebration. The film knows which emotions are of real importance to

this story: it ends not with an embrace between heterosexual lovers but in a freeze-frame capturing Harry and Cole in what has been established as their teasing, ritualized expression of love, a foot race.

The emphasis on homosociality and male love in this film provoked an amusing response from *Washington Post* critic Desson Howe. He rewrote the film into his own "version":

> In *Days of Thunder*, driver Tom Cruise suddenly decides that stock car racing is a sport for brash, juvenile egomaniacs. So he turns his back on the Daytona 500 just minutes before the race is due to start, tells girlfriend Nicole Kidman he never was interested in women and intentionally rides a motorbike off a cliff to his tragic death.

Howe's fantasy remake of *Days of Thunder* targets the obvious lack of heterosexuality-as-something-that-matters in Cruise's films. The relations between men are all-important. Many of Cruise's films, such as *Cocktail, Top Gun, Mission Impossible,* and *Days of Thunder,* construct heterosexuality so thinly that one might argue space is created in the film to allow more than heterosexual fantasies about the ostensibly heterosexual men who are depicted. Howe's comments support such a position; and, as has been noted, "The only way gay desire can be signified within a heterosexual frame is in the guise of heterosexuality itself" (Drewal, 176). *Cocktail* certainly has all the makings of a love story between two attractive men (Bryan Brown and Cruise), including scenes that suggest that Doug Coughlin (Brown) attempts to undermine every heterosexual relationship that Brian Flanagan (Cruise) enters into. One sequence offers everything for a night of seduction between the two: alcohol, laughter, mutual appreciation, the morning after in-the-kitchen *tête-à-tête* in which they lay out plans for their future together. The only thing elided, of course, is the sexual act. Everything else is there to construct a "queer reading" of the film.

Admittedly, the male gaze of erotic attraction may be deflected or disavowed by the story's elision of the particular male-to-male sexual desire that is displayed through male-to-male looking overtly motivated by sexuality. In this elision, the film is true in *some* ways to Steve Neale's remark about Hollywood's avoidance of male eroticism that "the male body cannot be marked explicitly as the erotic object of another male look: that look must be motivated in some other way, its erotic component repressed . . . the male body must be disqualified, so to speak, as an object

of erotic contemplation and desire" (8). Although Coughlin's gaze at his bartending protegé, Flanagan, may not be overtly sexualized, there is a decidedly homoerotic undercurrent to the narrative that cannot be denied.

Coughlin's teasing admiration for, and admitted attachment to, the younger man gets caught up in the film's insistent focus on the latter's body, often moving in tandem with Coughlin in behind-the-bar dance routines that bring them into physical proximity and contact. Sometimes the looks directed at Flanagan are projected by female characters, but these characters remain anonymous bar patrons. More often, they are free-floating looks, open, so that both males and females can attach fantasies to the eroticized male body whose exhibitionist performance marks him/it as being "captured" by another's gaze.

"THIS MAN BELONGS TO ME!":
FROM DRACULA AND JONATHAN HARKER
TO LESTAT AND LOUIS

> My invitation was open to anyone . . . but it was a vampire that accepted.
>
> —Louis (Brad Pitt) from
> *Interview with the Vampire*

As may be expected, the presentation of Cruise as an embodied male star is not static over the years, but, in spite of different directors, story lines, and co-stars, his representation as an erotic spectacle is remarkably stable through the 1980s and into the early 1990s. One might argue that a major break occurs with his appearance in *Interview with the Vampire* (1994), in which he plays the role of Lestat, a vampire. This shift away from Cruise as erotic spectacle is ironic because *Interview* creates the most overt homoerotic frame of reference for Cruise's embodiment of masculinity. However, Cruise no longer functions as the most clearly marked erotic object of the camera's gaze: the camera's interest in the youthful male body as erotic object plays out the contradictions and possible pleasures of male erotic spectacle across the body of Brad Pitt, in the role of Louis, Lestat's victim, companion, and "lover."

Anne Rice's hugely popular novel (published in 1976), on which the film was based, foregrounds the homoerotic potential in the traditional vampire tale. Numerous scholars have noted how the vampire, especially

the male vampire, subverts gender distinctions: in particular, with the function of the mouth as both penetrating and receiving, and in the vampire's acquisition of both male and female victims to penetrate with his mouth. In *Interview with the Vampire*, not only does the vampire world become a world dominated by male relationships, but the dynamics of vampires' mutual forbidden desire (for the blood of living human beings) are discussed by characters in terms that recall the double life of closeted homosexuals: "They know about us," intones Louis to Lestat as crowds ominously gather with torches outside Louis's shuttered plantation house.

The movie, and the character of Lestat, in particular, represent vampirism as a form of homosexual coming out: Lestat always needs a male companion, and he encourages Louis, whom he has made into a vampire, to accept that "you are what you are." Lestat, Louis, and a little girl, Claudia (Kirsten Dunst, soon to be a girl vampire), whom Lestat brings home as bait to entice Louis to stay with him, live as a family. Lestat tells the child that he and Louis are her "father and mother."

Interview is still a coming-of-age story, but in this case, it is the story of Louis, the beautiful young man educated into his identity as one of the undead who survives off the blood of the living. Cruise's Lestat becomes the perverse, seductive lover/father. When Louis lies suspended between life and death after being bitten by Lestat, the latter glides beside Louis's bed and fondles the curtains seductively. Lestat appears as a lace-cuffed dandy with a campy sense of humor that offends even his vampire companions (as when he scoops up a rotting corpse of a woman to dance with it). He is a master of irony, of exaggeration, and of sexual performance. In this respect, he impersonates a heterosexual to seduce female victims into circumstances in which he can prey on them. Thus, sexual performance is crucial to his survival since his desire for blood must masquerade as a desire for human sexuality. Women are not his only prey; he also seduces male victims. In one scene, he entices the effeminate male companion of an older woman into the darkness. Lestat begins to caress the man's face with his hand, and the man is obviously aroused at the very moment before Lestat bites his neck to feed on his blood.

The film might seem to be completely transgressive of Hollywood norms by assigning its vampire "heroes" stereotypical gay attributes and by placing them in situations that often look like gay cruising, but the film assimilates homosexuality into the existing phallocratic discourse by making Lestat triumphantly phallic as well as "effeminate." Lestat may be feminized through his "homosexual" signs of behavior and manner, but

he is phallic in his powers. The subject position the film invokes visually in the first scene that introduces Louis to Lestat supports rather than subverts the notion of the controlling, voyeuristic gaze attached to a powerful male character. The camera takes a position behind and to the side of Lestat as he first sees Louis in an eighteenth-century road house. Louis sits back, spread-eagled in a chair. His chest is bared as he melodramatically offers himself up to the knife of a man who has accused him of cheating in cards. Instead, it will be Lestat who will penetrate Louis. Thus, Louis's "invitation was open to anyone," just as is the camera's gaze that shows the nature of his invitation being inseparable from the display of his body. However, the invitation, like the camera's gaze, cannot control its aim.

Lestat, the vampire, accepts Louis's "invitations" and inducts him into a new life through a ritual of mutual blood-letting that is photographed from above and culminates in the moment when the two men are literally thrown backwards in a shared "orgasm."

At the film's release, film critic Richard Corliss asked: "Why would Tom Cruise be playing Lestat, a gaunt, suave European vampire with a taste for young men? Because a big movie star can do whatever he wants." The answer could be, why not, especially since Cruise had been playing at masculine masquerade for so long in the boyish mode. Here, at least, at thirty-two, attention is turned away from Cruise's body so that he is allowed to do something truly different, that is, not play the "homosexual," but play the "mature," dominant male who marks other men's bodies with his desire instead of having his own body marked by theirs. Lestat may be feminized in his "homosexual" signs of behavior and manner, but he is phallic in his powers, no less so at the end of the film than in the beginning, in spite of his being stabbed, burned, drowned, and almost succumbing to an apparent case of agoraphobia when faced by the techno-horrors of the twentieth century.

CONCLUSION: PLAYING DOCTOR IN
KUBRICK'S MAGNIFICENT OBSESSION

Until recently, Cruise's star vehicles have affirmed the powerful appeal to be found in the convergence of modernist storytelling, with its stress on character coherence, and stardom's reliance on the creation of a consistent star persona with intertextual stability (from film to film). Suggesting male exhibitionism to a degree perhaps unmatched by any other contemporary

star, Tom Cruise's cinematic representation reveals the multiple pleasures to be had from the play of desirous imaginings across the male body engaged in the performance of male masquerade.

Cruise's body is still sometimes offered as an object of the gaze (as in one scene in *Mission Impossible* in which he is suspended from the ceiling over a mirrorlike floor in a caper). Increasingly, however, male exhibitionism is displaced onto other bodies. This occurs in *Interview with the Vampire*, and also in *Jerry Maguire* (1996), where male performance is displaced onto Cuban Gooding Jr.'s exuberant football player. It also occurs in *Eyes Wide Shut* (1999), where both extratextually (in magazine covers and news coverage) and textually, Nicole Kidman's body rather than Cruise's becomes the focus of the camera's attention. A voyeuristic full shot of Kidman dressing became a "signature" image of the film used in trailers and other publicity. Cruise's body, by comparison, is treated in keeping with film scholar Dennis Bingham's claim that for a male star "to put himself on exhibition [is] in a way untenable to principles of masculinism, which pose the male as subject of the gaze, not as its object" (25).

As the cinematic representation of Tom Cruise as erotic object suggests, such a male mode of exhibition may be "untenable to principles of masculinism," but it can be both common and remarkably pleasurable to large numbers of film viewers. Cruise's performances of masculinity played out through the beautiful male body have allowed him to become an erotic sign that can be appropriated by more than heterosexual female audiences. But his more recent films suggest a change in the cinematic exhibition of Tom Cruise's body, a turning away from objectifying him. If this trend is sustained, will his stardom be similarly sustained into the new millennium? Or will this create a "postmodern crisis" for his stardom? If the mature body of Tom Cruise becomes "unseen," will we remain interested in the nonboy with the nonbody? We can only speculate—and wait to see what we are allowed to see through Hollywood's generous gaze.

WORKS CITED

Bingham, Dennis. 1990. "Men with No Names." *Journal of Film and Video* 42: 4.

Brown, Gene. 1995. *Movie Time*. New York: Macmillan.

Cohan, Steve. 1997. *Masked Men: Masculinity and the Movies in the Fifties.* Bloomington: Indiana University Press.

Corliss, Richard. 1994. "Toothless." *Time* 144: 21 (November 21). pathfinder.com/time/magazin . . ./941121/931121.cinema.vamp.html.

Drewal, Margaret Thompson. 1994. "The Camp Trace in Corporate America." In Moe Meyer, ed., *The Politics and Poetics of Camp*. London: Routledge, 149–81.

Garber, Marjorie. 1992. *Vested Interests: Cross-Dressing and Cultural Anxiety*. New York: Routledge.

Holmlund, Christine. 1993. "Masculinity as Multiple Masquerade." In Steven Cohan and Ina Rae Hark, eds., *Screening the Male: Exploring Masculinities in Hollywood Cinema*. New York: Routledge.

Howe, Desson. 1990. "Days of Thunder." *Washington Post*. www.washington-post.com/wp-s.

Jeffords, Susan. 1993. "Can Masculinity Be Terminated?" In Steven Cohan and Ina Rae Hark, eds., *Screening the Male: Exploring Masculinities in Hollywood Cinema*. New York: Routledge.

——. 1994. *Hard Bodies: Hollywood Masculinity in the Reagan Era*. New Brunswick, NJ: Rutgers University Press.

Lehman, Peter. 1993. *Running Scared: Masculinity and the Representation of the Male Body*. Philadelphia: Temple University Press.

Neale, Steve. 1983. "Masculinity as Spectacle." *Screen* 24: 6, 2–16.

Smith, Paul. 1993. *Clint Eastwood: A Cultural Production*. Minneapolis: University of Minnesota Press.

Studlar, Gaylyn. 1991. "The Perils of Pleasure? Fan Magazine Discourse as Women's Commodified Culture in the 1920s." *Wide Angle* 13:1, 6–33.

——. 1996. *This Mad Masquerade: Stardom and Masculinity in the Jazz Age*. New York: Columbia University Press.

Tasker, Yvonne. 1993. "Dumb Movies for Dumb People." In Steven Cohan and Ina Rae Hark, eds., *Screening the Male: Exploring Masculinities in Hollywood Cinema*. New York: Routledge.

Wexman, Virginia Wright. 1993. *Creating the Couple: Love, Marriage, and Hollywood Performance*. Princeton, NJ: Princeton University Press.

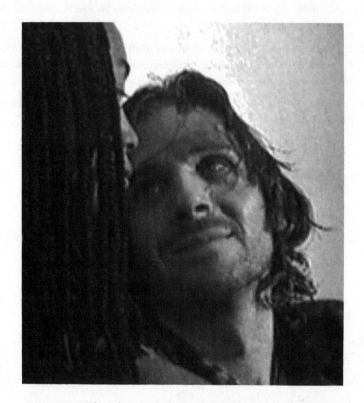

FIGURE 10. The white male hero (Ralph Fiennes, right) is femi-
nized in relation to the black female heroine (Angela Bassett) until
the finale of *Strange Days* (Kathryn Bigelow, 1995), when mascu-
line power reasserts itself. (frame enlargement)

CHAPTER ELEVEN

◈

Strange Days:
Gender and Ideology
in New Genre Films

BARRY KEITH GRANT

Contemporary American movies across a range of genres have come to an ideological crossroads, increasingly pressured to address, if not redress, the regressive implications of conventional representations of gender and race. In fact, many recent genre films have had as a central focus the acknowledgment of the previously marginalized groups that Robin Wood identified twenty years ago as the repressed Others of American culture in his famous essay on the American horror film (1979, 7–28). Several scholars have written about gendered representations in these new genre films (Jeffords, Willis, Tasker), but the critical tendency has been to focus, somewhat incorrectly, I think, on how these films recuperate any ideological challenges rather than to illuminate the ways in which some of them do indeed challenge the ideology of traditional representations.

In his influential 1979 essay "*Chinatown* and Generic Transformation in Recent American Films," John Cawelti noted that a period of unprecedented generic change had been taking place in American cinema during the 1970s. He identified in popular movies of the time a new emphasis on the demythification of classic conventions and extrapolated

from this trend a serious cultural crisis of belief. Cawelti's particular examples were Arthur Penn's *Little Big Man* (1970) and Roman Polanski's *Chinatown* (1974), although he might just as easily have considered, say, George Romero's *Night of the Living Dead* (1968) as a satire of bourgeois America, Francis Ford Coppola's *The Godfather* (1972) as a gangster movie that critiqued capitalism and patriarchy, and Martin Scorsese's *Taxi Driver* (1976) as a disillusioned epitaph for the western.

Many genre films at the time seemed to demonstrate Cawelti's thesis that "not only the traditional genres but the cultural myths they once embodied are no longer fully adequate to the imaginative needs of our time" (244). Cawelti's conclusion, perhaps suggested by John Barth's important 1967 *Atlantic* piece, "The Literature of Exhaustion" (Barth, 1984), was that the traditional genres had "exhausted" their mythic function and so became out of tune with the cultural *zeitgeist.* Certainly genre movies are intimately connected with the shifting winds of cultural fashion, but with the benefit of hindsight we can see that those genre movies Cawelti discusses were in fact somewhat less subversive than he claimed. For while they did tend to treat their animating myths ironically, the crisis they represented was hardly irreparable. I would suggest, rather, that it would be more accurate to say that the fundamental generic myths were not really abandoned, but merely updated.

The fate of the western, its decline, and the incorporation of many of the genre's elements into science fiction is perhaps the most obvious example. The genre that André Bazin so aptly referred to as the "American film *par excellence*" (1971, 140–48) had been a staple of Hollywood production from the beginning and, in the 1940s and 50s, experienced the golden age of the "adult western." But by the 1960s the genre was beginning to seem less relevant, and the western's importance within American culture accordingly began to wither. Post-Vietnam audiences, accustomed to indecisive and compromised military actions in both the real world and onscreen, and more attuned to the genre's inherent imperialist and racist ideology, have difficulty accepting the convention of the cavalry coming to the rescue, as it does in, say, John Ford's classic *Stagecoach* (1939). Indeed, modern viewers often laugh at this climactic moment in Ford's film, the western Bazin praised as nothing less than the genre's Platonic ideal ("the ideal example of the maturity of a style brought to classic perfection" [149]).

Yet the same audiences were thrilled when Han Solo flies back to the fray in the climax of *Star Wars* (1977) or when in *Independence Day*

(1996) heroes flying the rag-tag remnants of Earth's fighter planes—with the American president as squadron leader, no less!—save the world from annihilation by overwhelmingly malevolent invading aliens just in the nick of time. The futuristic iconographical trappings of these movies presumably allow a safer ideological distance, enabling tested conventions of the western, and the war movie as well, to "work" again. Within a different generic context, with different iconography, the old ideology remains capable of being invoked and endorsed. So beginning with *Star Wars*, with its famous reference to the burned ranch house in Ford's *The Searchers* (1956)—and further back, to a similar scene in *Drums along the Mohawk* (1939)—in the scene where Luke Skywalker discovers the scorched bodies of his aunt and uncle, science fiction movies of the last two decades have borrowed explicitly from earlier westerns. *Enemy Mine* (1985) applied the liberal message of racial tolerance in *Broken Arrow* (1950) to aliens; *Outland* (1981) relocated the story of *High Noon* (1952) from a frontier mining town to a mining station at the edge of the solar system; and *Battle Beyond the Stars* (1980) was a galactic remake of *The Magnificent Seven* (1960, itself an adaptation of Kurosawa's *Seven Samurai* [1954]).

Because today we are more likely to be familiar with computers than with horses, more likely to visit the internet than what remains of the wilderness, the technological genre of science fiction seems more relevant—particularly to a younger audience, the first "computer generation" and the demographic group that accounts for the lion's (now, Wookiee's) share of box-office revenue. But home on the range has not been abandoned: the computer hackers of William Gibson's cyberpunk novels (*Neuromancer* [1984]; *Count Zero* [1986]) are explicitly called "cowboys" because of their lone adventures in the virtual expanse of cyberspace. In most science fiction westerns, heroes and villains wield lasers and light sabres instead of sixguns and rifles; assorted aliens take the place of Native Americans (and, as *The Phantom Menace* [1999] demonstrates, of most other visible minorities as well); and space cowboys jockey customized rockets instead of noble steeds through the vast emptiness that is, in the famous introductory monologue of "Star Trek" (1966), the "final frontier."

The cult phenomenon of the TV series "Star Trek" may be best explained as its conscious modification of the western to fit the needs of a postindustrial, technological society. Gene Roddenberry's description of the show as a "wagon train to the stars" explicitly acknowledges this

generic hybridity. At least two episodes of "Star Trek" devised scenarios for placing the show's characters in Wild West settings. (They also appeared in scenarios derived from the horror and gangster genres.) The relationship of Kirk and the Vulcan Spock is an extension of the pattern of white male bonding with the dark other in American fiction that, as Leslie Fiedler has noted, begins with Hawkeye and Chingachgook in the formative western novels of James Fenimore Cooper (23–27).

Thus, although some genre movies of the '70s tended to treat their animating myths ironically, the myths themselves have survived. And it is interesting that if these films—from *Doc* (1971) to *Kid Blue* (1973), from *Mean Streets* to *The Long Goodbye* (both 1973)—were politically more sophisticated than the genre movies that preceded them, they still maintained the perspective of established cultural power, rarely abandoning the privileged perspective of white heterosexual masculinity. Tellingly, this period that witnessed the rise of the modern women's movement also saw the unprecedented popularity of the (white male) buddy film. Indeed, genres and genre movies remained until the mid-1980s almost exclusively the cultural property of a white male consciousness, the center from which any difference regarding race, gender, and sexuality was measured and marginalized.

Until recently, in all the "male" or action genres, it was white men who had to get the job done, whether driving the cattle, solving the crime, capturing the spies, or defeating the aliens. In westerns, spy thrillers, science fiction, and horror movies, detective and war films, women and visible minorities assumed subsidiary and stereotyped roles. With the ghettoized exceptions of musicals and melodramas—at one time referred to in the industry as "women's films"—genre movies addressed an assumed viewer who was, like most of the filmmakers themselves, white, male, and heterosexual.

But within the last decade, particularly since the huge commercial success of *Thelma & Louise* in 1991, the essentially monolithic construction of white masculinity in genre movies has been fractured by the emergence of other voices, other representations. One of the most popular movies in North America that year, *Thelma & Louise* is a generic hybrid of the western, the buddy film, and the road movie—genres traditionally regarded as male—and the heterosexual outlaw couple movie. This admixture in a narrative about two women (Susan Sarandon and Geena Davis) who are fleeing the law in their car across the American Southwest reversed Hollywood's conventional definition of woman's

place as the domestic sphere and reimagined the buddy movie as female adventure. The pair's adventures, such as blowing up the tanker truck of a driver who makes obscene gestures at them, come to seem nothing less than acts of retribution for all women, transcending the personal plight of the two characters. As Peter Chumo observes, "What Bonnie and Clyde do for Depression evils, Thelma and Louise do for the evil of sexual violence" (5).

In the film's controversial ending, Thelma and Louise drive their convertible over the edge of the Grand Canyon rather than capitulate to the police. The last image is a freeze frame of the car in midair, at the apogee of its arching flight, followed by a fade to white. This ending is, of course, a direct reference to one of the most famous of buddy movies, *Butch Cassidy and the Sundance Kid* (1969). In *Butch Cassidy* the two western outlaws are surrounded by the Mexican army, and in *Thelma & Louise*, the two women are outflanked by the police of patriarchy. But unlike the conclusion of *Butch Cassidy*, the end of *Thelma & Louise* sparked considerable debate regarding the film's political value: did it signify suicidal defeatism or triumphant transcendence? This debate in itself was significant because, as Rebecca Bell-Metereau has noted, "Critics did not concern themselves with the outcome of *Butch Cassidy and the Sundance Kid* [or] *Easy Rider*, because a male death in the conclusion is sacrificial, symbolic, and Christ-like. A female death at the end of the story rarely receives such a heroic interpretation, from feminists or non-feminists" (248). The contentious but popular reception of *Thelma & Louise* suggests how novel the film was at the time; and however one interprets the film's ending, it does show that the fate of women could also be represented as transcendent, that they too could remain true to their values and achieve glory in death, like any macho Wild Bunch. *Thelma & Louise* thus makes us realize the masculine bias of such generic myths even as it appropriates them.

The influence of *Thelma & Louise* on gender and genre in popular cinema is acknowledged explicitly in the 1996 action thriller *The Long Kiss Goodnight*, starring Geena Davis as a government operative with a license to kill. In the beginning of the film, Davis is a conventional housewife and mother who gradually discovers that she is really a secret agent suffering from an extended period of amnesia. As she remembers her deadly skills, she begins chopping her dinner vegetables with the rapidity of a sushi chef, and in the process, the ideal homemaker she seemed to have been is revealed as a postmodern performance, a masquerade, rather

than her true identity. As she defeats the villain in the climax, she utters the kind of pithy one-liner typically reserved for male action heroes. Her particular comment ("Suck my cock") harkens back to the scene with the potential rapist in *Thelma & Louise*, echoing the line that provokes Louise to shoot the man who says it and so initiate the women's outlaw adventure. At one point in *Long Kiss*, we see Davis in a convertible with a kerchief tied around her hair, an explicit reference to her earlier role as Thelma.

In the wake of *Thelma & Louise's* box-office success, all the action genres have been revisited from the perspective of groups previously marginalized within mainstream Hollywood cinema. Representations of gender, as well as race and sexuality, began to be re-visioned. For example, such films as *The People under the Stairs* (1992), *Candyman* (1992), *Tales from the Hood* (1995), and *Vampire in Brooklyn* (1995) have used the conventions of the horror genre to focus on the real horrors of racism. Similarly, *The Meteor Man* (1993) and *White Man's Burden* (1995) explore the same theme within the generic context of science fiction, using that genre's characteristic strategy of defamiliarization to challenge stereotypical representations of race. Recent examples of the road movie, a particularly apposite generic site for marginal voices since its characters typically are decentered, include John Singleton's *Poetic Justice* (1993), about a black woman's journey toward self-discovery; Spike Lee's *Get on the Bus* (1996), featuring a disparate group of black men who find themselves together on a chartered bus from Los Angeles to Washington to attend the Million Man March; and *To Wong Foo, Thanks for Everything, Julie Newmar* (1995), an American remake of the Australian gay road movie *The Adventures of Priscilla, Queen of the Desert* (1994) that features action stars Patrick Swayze and Wesley Snipes "in their most difficult roles," as the previews put it.

Even the western has been reanimated by this generic revisionism. *Dead Man* (1995) critiques civilization from the perspective of the Native American's response to the "crazy fucking white man." In the film's opening sequence, the journey west—through, of course, Monument Valley—redefines Ford's redemptive journey in *Stagecoach* as a Stygian passage through European civilization and its discontents. As the history of the west became myth, as the fact became legend, blacks were written out of the genre, but Mario Van Peebles's *Posse* (1993) reintegrates them, while women are able to survive independently in the wilderness in *The Ballad of Little Jo* (1993) and *Bad Girls* (1994). In *The Quick and the Dead*

(1995), Sharon Stone is a competent shootist, able to slap leather with the fastest men in a frontier world wholly determined by the phallic competition of the gunfight.

The narrative voice of *Posse* is explicitly black, as the film opens with the image of a black man speaking directly to the camera, presenting the entire story in flashback during an interview. Significantly, this interviewed witness is played by actor Woody Strode, himself an icon who had appeared in several of John Ford's westerns. But whereas in Ford's films—even in the liberal, pro-integrationist *Sergeant Rutledge* (1960)—Strode always embodied a respectful, subordinate presence (for example, consider his shuffling endorsement of the Declaration of Independence's principle that "all men are created equal" in the crucial schoolroom scene in *The Man Who Shot Liberty Valance* [1962]), in *Posse* he expresses a more militant point of view, directly criticizing whites (the normative spectator of the classic genre film) for the exploitation of Native Americans. The framing device of the interviewed first-person witness is borrowed directly from *Little Big Man*, in which the aged Jack Crabbe in the present subverts the legend by telling the truth about famous western people and events he knew and experienced firsthand. In *Posse* the black man's status as personal witness of the story from the past similarly provides a form of authentication, working in conjunction with a montage of archival photographs. A graphic in *Posse*'s closing credits informs us that in fact one out of every three cowboys was a black man and that, "Although ignored by Hollywood and most history books, the memory of the more than 8,000 black cowboys that roamed the west lives on." Just as Strode mentions the single-shot Colt .45 rather than the traditional revolvers of western myth, so the film seeks to correct the genre's traditional inaccuracy regarding the racial representation of cowboys.

However, *Posse* has no particularly progressive approach to the genre's traditional depictions of gender as does Maggie Greenwald's *The Ballad of Little Jo* (1993). The film is based on the true story of Josephine Monaghan, a woman who in the 1880s dropped out of New York society when she had a child out of wedlock, went West, and for the rest of her life passed as a man, making a successful career for herself as a sheep rancher in Idaho. Her true gender and identity were discovered only after her death.

The film opens not with the conventional lone cowboy hero riding into town on his horse, but with the image of a woman (Suzy Amis) in

Eastern dress walking down a busy road. The film's first image is a bird's-eye view of Josephine's white parasol entering the frame before her. She is the feminist version of the dude—innocent, frail, sheltered— in a patriarchal wilderness. Freedom to sing what Walt Whitman called "the song of the open road" is immediately depicted as a patriarchal privilege. Two men pass her by on horseback, one of them pausing to assess her as "a pretty filly"—and while men move freely up and down the road, she is threatened with vagrancy for traveling alone. A wagon loaded with supplies appears in the foreground of the frame and momentarily blocks her from our view. At last she is offered a ride by a passing peddler, who we soon find out has secretly sold her to some soldiers for their sexual pleasure.

Greenwald thus uses the imagery of the western to express the feminist insight that capitalism and patriarchy are intertwined and that women are positioned as objects of exchange within that economy. She refuses to let the image of Suzy Amis as Jo itself become part of that economy, as in close-up Jo slashes her face with a razor while in the process of disguising herself as a man, a gesture designed to thwart the voyeuristic gaze, both of the male characters *in* the film and of the male spectator. Later, when Little Jo becomes romantically involved with her male Chinese cook, Tinman (David Chung), initially it is he who is presented as the object of the erotic gaze, who is coded in a way traditionally reserved for women; subsequently in their lovemaking the film presents them as visually equal. One might say that in *The Ballad of Little Jo*, the frontier comes to mean that relatively unexplored space where new racial and gendered representations are explored.

It would seem as if all the traditional genres are in the process of being reworked as systematically as Robert Altman moved his way through the genre catalog at the time Cawelti was writing his essay. But to this point, perhaps the most consistently impressive achievement in new genre movies has been in the various genres collectively known as crime films. *Bound* (1996), for example, subjugates the conventional macho mafioso types to lesbian desire, showing the two women (Gina Gershon, Jennifer Tilly) ultimately to be wiser than the guys, while *Set It Off* (1996) is a female caper movie about a quartet of both straight and gay inner-city black women who rob banks. Ernest Dickerson's *Surviving the Game* (1994) brashly inflects the classic thriller *The Most Dangerous Game* (1932) with racial politics, as the human prey hunted for sport are specifically poor urban blacks whom it is believed no one will miss, and

the detective film has been recast from a black perspective in Carl Franklin's *Devil in a Blue Dress* (1995), its post–World War II south central Los Angeles setting giving it a bittersweet nostalgia comparable to that of *Chinatown*. Now, even the tough dick can be female, as in *V.I. Warshawski* (1991), based on the fiction of Sara Paretsky.

The most fully realized example of this active evolution of the crime film has been the development of an entirely new subgenre, the 'hood film. Some of the proletarian Warner Bros. movies of the 1930s, such as *Wild Boys of the Road* (1933), are obvious precedents, but 'hood films are a distinctly cohesive group of movies that, in Henry Louis Gates Jr.'s sense, "signifies upon" the traditional gangster film (1988). Like many classic gangster movies, such films as *Boyz N the Hood* (1991), *Juice* (1992), *Menace II Society* (1993) and *Dead Presidents* (1995) emphasize the environmental influence on criminal and antisocial behavior, but they explore this theme somewhat differently. If the classic gangster's rise to the top of the mob is on one level a validation of capitalism and the American Dream, the 'hood movie exposes a darker side, the result of years of racist exploitation. These films avoid the classical narrative paradigm of the gangster's rise and fall because they espouse the view that crime is not caused by aberrant individuals but is the result of systemic problems of mainstream society—which they define as white, patriarchal, and capitalist—and thus requires collective solutions. This is a markedly more complex view of crime and poverty than one finds in the classic gangster film, in which the gangster, a masculine epitome, might be "explained" as the inevitable result of Social Darwinism but where the root causes of this environmental impoverishment are never addressed.

It is fitting, I think, to conclude this overview of changing representations of gender and race in contemporary genre films by briefly discussing Kathryn Bigelow's *Strange Days*, because of its disquieting examination of the male gaze in Hollywood's most popular genre of this decade, the action movie. The action (which is considerable) in *Strange Days* is critiqued not only as sadistic and voyeuristic but also as essentially masculine. The tension between the traditional representations of race and gender in genre films and the recent push to examine the ideological bases of those representations is perhaps the central dynamic of Bigelow's films and is most explicit in *Strange Days*. Her work is in one sense about this very attempt to recast the white heterosexist ideology that has informed action movies in the past. Critics have duly noted the thematic and stylistic importance of vision in her work—one writer even asserting that

"Kathryn Bigelow's cinema is essentially a discourse on vision" (Rascaroli, 232)—but have tended to underestimate the relation of this theme to the gendered nature of both the genre system and spectatorship.

Bigelow has established herself as a Hollywood auteur who works within these male genres while at the same time attempting to critique their traditional pleasures, much as Douglas Sirk and R.W. Fassbinder approached melodrama. *The Loveless* (1983, co-directed with Mont Montgomery) and *Near Dark* (1987) are concerned with the depiction of masculinity in biker movies and vampire movies, respectively. *Blue Steel* (1990) is a police thriller that focuses on a female cop, played by Jamie Lee Curtis, whose gender troubles all the men in the film once she dons her uniform. The casting of Curtis as the female cop suggests an attempt on the part of the film to reclaim agency for the actress who became famous as the prey in such slasher films as *Halloween* (1978), and her battle for the pivotal pistol with maniacal killer Ron Silver becomes a conflict over possession of the power of the phallus. *Point Break* (1991) is a buddy/caper movie about a band of surfer–bank robbers known as "The Presidents" because they wear masks of former U.S. presidents while committing their robberies. Apart from this barbed metaphor about institutionalized masculine greed and corruption, *Point Break* quite slyly subverts the masculine myths of action cinema in several ways.

Strange Days (1995) is set just slightly in the future, in Los Angeles on the day before New Year's Eve, 1999, when a new kind of total cinema experience (SQUID), which taps directly into the cerebral cortex for both recording and playback, has filtered illegally into the streets. The film begins by positioning us as viewers of one of these SQUID clips, although we do not yet know what we are watching since no prior exposition is provided other than titles informing us of the date. Once the clip boots, there is no apparent difference, such as a frame within a frame or disparity in image resolution, to mark these images as a film-within-the-film rather than as the world-of-the-film. For all intents and purposes, what we are seeing *is* Bigelow's film—and by extension, any action film made by any filmmaker using similar techniques and principles. We are thrust immediately into the viewing dynamic, our identification fully mobilized. We do not know, or ever find out, who "we" are here, except that we are male, as we can tell from the soundtrack and the hands that come into the frame from "our" point of view periodically (as in *Lady in the Lake* [1947]). But the individual man here is irrelevant—we are, the film immediately suggests, *masculinity itself.*

As in *Point Break*, which contains an extended chase (featuring Bigelow's effective use of the Steadicam) through alleys, houses, and backyards, and that adeptly enhances the action by placing us squarely within it, in *Strange Days* we are immediately immersed in the action, an accessory to it, through a bravura use of the subjective camera. In what seems like one lengthy, technically breathtaking shot, we drive up to an Oriental restaurant with a group of robbers; then enter and rob it, intimidating staff and patrons in the process; frantically flee from the arriving police in a confusing shootout; attempt to escape across a series of rooftops; and finally plunge to "our" death in the street below when we fail to make the leap from one roof to another. The apparent long take (it actually contains one or two masked cuts) maintains a consistent point of view and thus heightens our sense of presence throughout the action, the appeal of which is marked as racist and sexist since "our" victims are "fucking chinks" and "bitches," in the words of our invisible surrogate.

This astonishing opening sequence exposes the subjective camera common to such genres as action and slasher movies as nothing less than a tool of naked male aggression. Many of the violent action sequences that follow in *Strange Days* involve the victimization of women with the SQUID apparatus, in the infamous manner of the protagonist Mark Lewis (Karlheinz Böhm) in Michael Powell's *Peeping Tom* (1960). But the subsequent scenes of violent action in the film cannot be viewed with the same kind of "innocent" pleasure we may have brought to the opening sequence, for we have been made aware at the outset of the gendered dynamics involved in such narrative pleasures.

Yet *Strange Days*, strangely—well, perhaps not so strangely since it is, after all, a Hollywood movie—builds to a climax that seems to deny what came before, that seems rather hypocritically to recuperate the object of its own ideological critique. In the climax, the white male and black female heroes, Lenny and Mace (Ralph Fiennes and Angela Bassett), manage to give to the police commissioner a SQUID tape containing the truth about the killing of a popular militant black rock star by two racist white cops. The two rogue policemen confront Mace during the wild celebration on the eve of the millennium and begin to assault her with their phallic nightsticks. The scene obviously invokes the videotape of the Rodney King beating, which also occurred in L.A. But in *Strange Days*, unlike the real world of that beating, the crowd responds actively, and the oppression ends. The honest white male commissioner, brandishing the evidence in his raised hand, parts the suddenly compliant

crowd like the archetypical patriarch Moses and calls for the arrest of the two rogue cops. In the end, then, power is retained in the (literal) hands of a white male, and the black woman, previously strong and independent, is reduced to a prone, beaten figure requiring his help.

Robin Wood has angrily dismissed *Strange Days* as "a tease and a cheat" because of the emphatic way it compromises its own premises (1997, 7). But this response may be somewhat ungenerous, for it is no more an ideological cheat than the majority of mainstream American movies are. Perhaps it only seems more disappointing because of how radical its initial premise is. Unlike so many popular movies, though, it at least troubles the dominant perspective. Wood might more accurately call it an incoherent text (1986, ch. 4), although its contradictory nature is in fact quite coherent and speaks eloquently of that crucial crossroads facing genre movies today to which I referred at the outset.

Many, perhaps even most, new genre movies are traditional or reactionary in terms of their representation of race and gender. Often these films merely plug in, or substitute, blacks, women, or gay characters for white male heroes but do little or nothing to challenge the sexist or racist assumptions that inform the myths by which they operate. Still other movies, with more commendable intentions, are ultimately neutralized ideologically by the various aesthetic strategies popular entertainment commonly employs to defuse potentially subversive elements.

True Lies (1994), to take one particularly unfortunate example, seems to work toward a progressive view of gender in the action cinema by depicting a husband-and-wife team of agents, played by Jamie Lee Curtis and action icon Arnold Schwarzenegger. But Curtis, first depicted as unbelievably stupid for thinking that her muscular hubby is merely a salesman, is unambiguously contained within patriarchy when she discovers the truth. In a scene that exceeds all narrative requirements and seems designed primarily to reassert the patriarchal power of male narrative control, she is forced to succumb to a humiliating process of visual objectification by being forced to undress for the pleasure of an anonymous male spectator sitting in the shadows. Thinking she is saving her husband, she never realizes that the shadowy figure *is* her husband, Der Arnold as J. Hoberman has called him, who also functions as the ego ideal of the male viewer similarly hiding in the shadows of the cinema.

But it is also true that some new genre films, such as *Posse* and *The Ballad of Little Jo*, are challenging the ideology of traditional genre film-

making at the very level of style and enunciation. And although many of them, like Bigelow's *Strange Days*, are ultimately compromised, this new generic transformation still signals a positive turn in popular filmmaking. In an interview, Maggie Greenwald replied to Tania Modleski's question about whether films such as *The Ballad of Little Jo* merely changed the gender of its character or truly critiqued it, by saying that even in the former case "critiquing comes by the way" (Modleski, 7). In other words, once the generic doors have been pried open, and the strange hordes at the margins have entered, there is no going back.

The converging conditions that Cawelti described in the 1970s are, if anything, more pronounced now, with the rise of American independent cinema and the transition from new Hollywood to postclassical Hollywood. Many of the newer genre directors—Bigelow, Greenwald, Van Peebles, as well as Katt Shea Ruben, Mary Lambert, Mary Harron, Spike Lee, John Singleton, Ernest Dickerson, Robert Townsend, and others—are other than white heterosexual males. As a group, the genre directors then—Martin Scorsese, Steven Spielberg, Paul Schrader, Brian De Palma, Francis Ford Coppola, Robert Altman—were quite aware of film history and often deliberately reworked the traditional genres with the intent of revitalizing American cinema for a younger generation of moviegoers. Today's genre filmmakers, many of them similarly aware and articulate about issues of gender and race in classic genre movies, have the same ambition.

Through the power of sheer repetition, these new representations have begun to gather cultural force. Eventually and inevitably, such changes in representations do bring about changes in popular perception. We should remember that it is this very argument that initially inspired the project of feminist criticism and its attack on sexist language in the first place. Like the transformations Cawelti noted, the new genre films discussed here also "set the elements of a conventional popular genre in an altered context, thereby making us perceive these traditional forms and images in a new way" (235). Indeed, as Jim Morrison sings in the Doors' "Strange Days," our casual joys have been "destroyed." And unlike before, such generic changes are providing us now with an imaginative landscape that is indeed more appropriate for the beginning of the new millennium. The final sequence of *Strange Days*, poised as it is on the dawn of the new century, speaks exactly to this issue, expressing both the difficulty and the possibility that face new genre films as they confront what have been the casual but questionable joys in movies of the past.

WORKS CITED

Barth, John. 1984. *The Friday Book: Essays and Other Nonfiction.* New York: G. P. Putnam's Sons.

Bazin, André. 1971a. "The Western, or the American Film *par excellence.*" In *What is Cinema?* volume 2, ed. and trans. Hugh Gray. Berkeley: University of California Press.

———. 1971b. "The Evolution of the Western." In *What Is Cinema?* volume 2, ed. and trans. Hugh Gray. Berkeley: University of California Press.

Bell-Metereau, Rebecca. 1993. *Hollywood Androgyny,* 2d ed. New York: Columbia University Press.

Cawelti, John. 1995. "*Chinatown* and Generic Transformation in Recent American Films." In Barry Keith Grant, ed., *Film Genre Reader II.* Austin: University of Texas Press.

Chumo, Peter N., II. 1994. "At the Generic Crossroads with *Thelma and Louise.*" *Post Script* 13: 2 (Winter/Spring).

Fiedler, Leslie. 1967. *Love and Death in the American Novel.* New York: Delta.

Gates, Henry Louis, Jr. 1988. *The Signifying Monkey: A Theory of Afro-American Literary Criticism.* New York, Oxford: Oxford University Press.

Jeffords, Susan. 1994. *Hard Bodies: Hollywood Masculinity in the Reagan Era.* New Brunswick, NJ: Rutgers University Press.

Modleski, Tania. 1995–96. "Our Heroes Have Sometimes Been Cowgirls—An Interview with Maggie Greenwald." *Film Quarterly* 49: 2 (Winter).

Rascaroli, Laura. 1997. "Steel in the Gaze: On POV and the Discourse of Vision in Kathryn Bigelow's Cinema." *Screen* 38: 3 (Autumn).

Tasker, Yvonne. 1993. *Spectacular Bodies: Gender, Genre and the Action Cinema.* New York: Routledge.

———. 1998. *Working Girls: Gender and Sexuality in Popular Cinema.* New York: Routledge.

Willis, Sharon. 1997. *High Contrast: Race and Gender in Contemporary Hollywood Film.* Durham, London: Duke University Press.

Wood, Robin. 1979. "An Introduction to the American Horror Film." In Robin Wood and Richard Lippe, eds., *The American Nightmare: Essays on the Horror Film.* Toronto: Festival of Festivals.

———. 1986. *Hollywood from Vietnam to Reagan.* New York: Columbia University Press.

———. 1997. "The Spectres Emerge in Daylight." *CineAction* 43.

PART III

Paragons and Pariahs

FIGURE 11. Asta Cadell (Deborra-Lee Furness, left) with rape victim Lizzie Cur-
tis (Simone Buchanan) in Steve Jodrell's *Shame* (1987): road trip as liberatory
experience. (frame enlargement)

CHAPTER TWELVE

◆

She-Devils on Wheels:
Women, Motorcycles, and Movies

FRANCES GATEWARD

The close of the nineteenth century was a tumultuous era of invention and innovation, when societies around the globe experienced vast economic, political, and social changes. Among those developments were new modes of transportation and new forms of entertainment: motorcycles and motion pictures. At first glance, one might assume that the two have little in common, but a closer inspection reveals some surprising commonalities. Both are European inventions: the motorcycle introduced by Gottlieb Daimler and Wilhelm Maybach in Germany in 1885, motion pictures only ten years later, by Louis and Auguste Lumière in France. Both were immediately associated with society's "undesirables," the working-class and immigrant communities; and both were protested against on moral grounds. And like the motion picture, the motorcycle was quickly transformed from a mechanical device into what Alt describes as "a cultural commodity," communicating ideologies, dreams, and fantasies (129). In contemporary cultural semiotic terms, motorcycles symbolize the quintessentially masculine: individuality, adventure, virility, and strength. Within such films as *The Wild One* (1954), *Easy Rider* (1969), *Top Gun* (1986), and *Terminator 2: Judgment Day* (1991), motorcycles have served to represent alienated youth, outsiders, rebellion, and more often than not, wild and reckless freedom. Yet motorcycles can also serve

as vehicles for gender transgression. What was popularly referred to as "biker culture" has evolved into several gender-bending subcultures, simultaneously presenting varied masculinities and femininities, including, as Kenneth Anger so brilliantly demonstrated in his experimental tour de force *Scorpio Rising* (1964), homoerotic, camp images. This chapter examines the increasing trend of women actually riding motorcycles in the movies and the images constructed when women ride motorcycles instead of adorning them as scantily clad seat ornaments.

The most prevalent image of motorcycling culture in the United States is that associated with outlaw motorcycle gangs, groups of tattooed renegades dressed in denim and black leather involved in violent criminal pursuits. Though the American Motorcycle Association claims these gangs make up only 1 percent of ridership, hence the sobriquet *1 percenters*, the perception of motorcyclists as marauding hellions remains over forty years after such groups came to national attention, much of it due to the motion pictures.

The event that brought biker culture to prominence was the 1947 raid on Hollister, California, during the July 4 weekend. Over four thousand bikers were involved, including gangs such as the Booze Fighters and the Galloping Gooses. (The devastation is most often mistakenly attributed to the most notorious biker gang, Hell's Angels.) The mayhem, resulting in over four hundred arrests, numerous injuries, and massive destruction, became the basis of the film that established Marlon Brando as a rebel and associated motorcycles with alienated and disaffected youth, *The Wild One*. The trend toward violent biker films continued to such a degree that it developed into a genre: the biker movie. Films within this grouping, for example *The Wild Angels* (1966), *Hell's Angels on Wheels* (1967), and *Hellriders* (1974), took aspects of the road movie—white male pairings or groups, rejection of conformist and conservative society, the outlaw hero, and, as Corrigan describes, "the displacement of the protagonist's identity onto the mechanized vehicle" (145)—and added not only sex, drugs, and rock 'n' roll, but extremely excessive violence as well. And, of course, no biker film is complete without the requisite montage sequence celebrating the pure joy of riding, with shots of the motorcyclists barreling down the road and subjective shots of the roadway accompanied by up-tempo or aggressive rock music. Motorcycling's association with counterculture was furthered by the success of Dennis Hopper's *Easy Rider*.

Despite the fact that women have been riding since the motorcycle's inception, as motocross, road, and drag racers, in stunt shows, as

endurance riders, and as everyday commuters, women in early motorcycle films basically serve to assure the heterosexuality of the men involved in the homosocial group. Costumed in form-fitting and revealing clothing, with leather worn not for protection but for sexual allure, they function within the film narratives very much as they do in the highly ritualized and hierarchical outlaw gangs, as sexual objects for male pleasure. The two primary roles are "sheep," women brought to the gang by a male initiate who seeks membership and then expected to engage in sexual relations with every member of the gang, and "mamas," also sexually available to all members but differing from "sheep" in that they regularly associate with the gang. Though women could rarely be seen operating a motorcycle in the more well known films of the biker genre, it was much more common to see them do so in exploitation films.

SEX, GUTS, BLOOD, AND ALL MEN ARE MOTHERS!

The term *exploitation* is used to describe films produced on such low budgets that they are sometimes referred to as "Z" pictures. Aimed at youth cultures, the films work with known Hollywood genres—film noir, melodrama, gangster films, horror, and science fiction—but do so in a campy and tasteless manner, highlighting material that would be considered offensive by mainstream audiences: homosexuality, orgies, recreational drug use, and lots of blood and gore. Though some exploitation films manage to make it into drive-in theaters and traditional exhibition houses, many considered too vulgar make use of alternative distribution methods, taking advantage of expanding technologies. They are easily accessed on cable television or on the home video market, with the films going directly to video.

Because they are considered a "lowbrow" form of entertainment, exploitation films are typically regarded with dismissive disdain by both popular critics and the public, despite their popularity. Yet like another denigrated popular culture form, the soap opera, these films are important, for they speak to a specialized audience, offering pleasure in a form not provided by the mainstream producers of the culture industry. The films, often lifted to cult status and watched in ritual contexts, may be cheap, raw, and "trashy" in terms of high-brow aesthetics, but their content directly challenges the dominant ideologies of sexism, white supremacy, homophobia, and capitalism upon which high-brow aesthetics pose. Such is the case in films such as *The Hellcats* (1967), *Bury Me an Angel* directed

by Barbara Peters (1971), *Rough Riders/Angel's Wild Women* (1972), *Surf Nazis Must Die* (1987), *Chopper Chicks in Zombietown* (1989), and the most infamous film of the genre, *She-Devils on Wheels* (1968), written by Louise Downs and directed by Herschell Gordon Lewis.

She-Devils on Wheels concentrates on the activities of the female motorcycle gang the Man-Eaters, whose motto is Sex, Guts, Blood, and All Men Are Mothers! Led by Queen (Betty Connell), the Man-Eaters spend most of their time engaged in "picks," ritualized orgies linked to drag racing. When they return to headquarters, the winner of the night's drag race gets to choose a male partner from among a group of willing participants for the orgy. One member of the club, Karen (Christie Wagner), breaks the bylaws because she continually chooses the same partner, preferring monogamy and an emotional relationship. She is given an ultimatum from the membership—she must either drag her lover, Bill (David Harris), from the back of her motorcycle across the pavement or be dragged herself. Bill doesn't survive the experience. Other plot points include the initiation of Honey-Pot, a teenaged junior member, in a ceremony that includes the recitation of dirty limericks, the dousing of the initiate with motor oil, fondling by the other members, an invitation to the men to "take a taste of honey," terrorizing the town, and competition with a group of men over territory. The film climaxes in a physical confrontation, where the Man-Eaters proceed to kick ass, beating the men with chains and even committing a decapitation. Though it certainly can be codified as a film exhibiting a "trash aesthetic," it is also possible to read the film as one celebrating female relationships, the value of female camaraderie over emotional ties to men, the importance of control over women-defined space, and the existence of female sexual desire and the will to act upon it.

As *She-Devils on Wheels* demonstrates, the emphasis on sexual activity is a significant element in the construction of female motorcyclists in the cinema. This association of motorcycling with sexuality is not surprising, for motorcycle riding is often described as an extremely visceral experience: the sound of the engine, the rush of the wind, exposure to the elements, flirtation with danger, and the thrilling experience of speed. The eroticization of women who ride is further heightened by the prevalent use of leather—primal, sensual, and linked to sadomasochism. Perhaps what makes female motorcyclists so provocative, like the femmes fatales of film noir, is assumption of the male prerogative. No mode of transportation could be described as more phallic, for riding a "crotch rocket" involves control of a great deal of power between the legs.

Because women in our culture are not supposed to possess, let alone act on, sexual desires, films depict women like the Man-Eaters and the Cycle Sluts from *Chopper Chicks in Zombietown* as dangerous and over-powering. Because they transgress the boundaries of proscribed gender behavior, they must be punished in order to restore the patriarchal order. In *She-Devils on Wheels* the women are arrested, an outcome preferable to the violent death suffered by the protagonist of the French/British co-production *Girl on a Motorcycle* (1968).

Directed by Jack Cardiff, *Girl on a Motorcycle* features pop music sensation Marianne Faithfull as Rebecca, the bored wife of a grade school teacher. Contemptuous of her middle-class, suburban housewife lifestyle, she escapes by riding her motorcycle to rendezvous with her lover, Daniel (Alain Delon), a university philosophy professor. Wearing nothing underneath her fur-lined leather, Rebecca is obsessed with sex, flirting with everyone from gas station attendants to border patrolmen. As she rides down the highway, eagerly anticipating a tryst with Daniel, Rebecca becomes sexually aroused. Her orgasmic ecstasy causes her to lose control of her motorcycle, and she is thrown through the windshield of an oncoming vehicle.

BIKER CHIC

In the late 1970s and early 1980s, shifting attitudes about gender, race, and national identity resulted in, among other things, a resurgence of motorcycling, or more specifically, the motorcycle culture associated with Harley-Davidson, the sole remaining mass producer of motorcycles in the United States. Founded in 1903, the Milwaukee-based manufacturer of heavy-weight cruisers, affectionately referred to as "hogs," lost its hold on domestic sales in the 1960s. Harley-Davidson's decline began in 1961, when champion Mike Hailwood introduced a Honda to the world of road racing. One year later, Japanese motorcycles set over a dozen records in twenty-five professional races, placing first in every one. The domination by the technologically advanced, more economical Japanese-manufactured motorcycles extended to the roads and highways of America when advertising campaigns such as Honda's "You Meet the Nicest People on a Honda" helped shift the image of motorcyclists from the bad-boy gangs associated with Harleys to fun-loving commuters and weekend enthusiasts. The unprecedented popularity of Hondas, Kawasakis,

Suzukis, and Yamahas continued as the sales of automobiles also manufactured in Japan began to overtake those of General Motors. This explosion of interest in Japanese motorcycles occurred during an American economic recession. With the rise of the so-called Asian tigers in manufacturing and export (such as Taiwan and Korea), American society saw increased immigration from Asia due to the removal of discriminatory practices with the passage of the Immigration Act of 1965; purchase of high profile real estate, such as Rockefeller Center, by Japanese banks and corporations; and a proliferation of Asian/Asian American-owned businesses. America was gripped by a virulent anti-Asian backlash. As history has shown, it is not uncommon in times of economic strife for Americans to turn to scapegoating (Farrell). As competition increases for what is perceived to be a "smaller piece of the pie," minority groups are commonly targeted as the cause of the shrinkage of economic reward. It has happened repeatedly to blacks, Jews, and peoples of Asian descent.

Threatened by failing stock prices and hostile takeovers, Harley-Davidson took advantage of the anti-Japanese climate by stressing Americanism and national pride in its advertisements. As Walle points out, the company "had rejected the renegade/loyalists, embraced the middle-class mainstream market, and then flip-flopped back to blatantly arousing the passion-filled fanatics," a strategy that resulted in Harley-Davidson breaking the fifty thousand sales mark for the first time in 1979 and achieving a 16 percent sales increase, outselling the combined output of heavyweight motorcycles produced by the two largest Japanese competitors (74).

The renewed popularity of the American-built motorcycles could be seen at bike rallies, such as the annual get-together in Daytona, where the destruction of "riceburners," motorcycles produced by Japanese manufacturers, is celebrated in ritualized bonfires. Harleys came into vogue, as "biker chic" infiltrated the fashion world.

As the hogs became more prevalent on the road, well-known designers, including Donna Karan, Anne Klein, and even Chanel, began to market styles inspired by the look of Harley-identified biker gangs, with an emphasis on leather. Fashion spreads in the leading magazines, *Mademoiselle, Glamour*, and *Cosmopolitan*, featured promotional displays of models astride motorcycles, dressed, of course, in variations of the classic motorcycle jacket. It was not unusual to see a supermodel such as Cindy Crawford atop a motorcycle selling cosmetics. Biker chic presented interesting and oppositional codings. The motorcycle leathers communicated strength and power, yet the connotations were undermined by the pairing

of motorcycle jackets with frilly skirts and revealing tops, flawless makeup, and models in sexually suggestive poses of passive availability. The style became so lucrative in the fashion world that in 1989 Harley-Davidson launched a new division, Harley-Davidson MotorClothes. According to John Marchese, in 1992 the division made close to $49 million, most of it from people who did not even ride motorcycles! Biker chic even affected America's most fashion-conscious female, Barbie. Today, in addition to clothes, one can go shopping for Harley Beanies, stuffed animals dressed in Harley-Davidson attire, Christmas ornaments, motorcycle miniatures and Hallmark/Harley ceramic bear figurines; or eat at the Harley-Davidson Cafés in Manhattan and Las Vegas, and return home to dinnerware, furnishings, and walls adorned with the Harley-Davidson logo.

Photographs of high-profile female celebrities, women with personae of independence and power, Wynnona Judd, Queen Latifah, k.d. lang, and Ann-Margret, were a boon to the campaign. Images of media darling Elizabeth Taylor with "Passion," the purple Harley-Davidson cruiser given to her by Malcom Forbes, inundated television and popular publications. Texas Governor Ann Richards, brought to national attention by her "Where's George" address at the Democratic National Convention, made the cover of the July 1988 issue of *Texas Monthly*. Dressed in a white leather jacket, astride the white Harley-Davidson she bought herself for her sixtieth birthday, Richards, with a stern expression, clearly demonstrated her mastery of the machine. The banner accompanying the image—"WHITE HOT MAMA Ann Richards is Riding High. Can She Be the First Woman President?"—certainly implies that only a woman who is "man" enough to ride a Harley could be considered for the most powerful political position in the world.

The motion picture industry picked up on Harley-Davidson's newfound respectability, and both men and women in the movies were soon using motorcycles as the vehicle of choice, mostly within the action genre. It is interesting to note that as Arnold Schwarzenegger became more visible in national politics, aligning himself publicly with the Republican Party, his screen persona shifted as well, so that when his character in *Terminator 2: Judgment Day* appropriates a Harley-Davidson and a black leather biker jacket, he defines himself not as a renegade, but as a thoroughgoing American: dangerous, strong, and, because of biker chic, cool.

It is important to point out that motorcycle riding occurs almost exclusively within action films, historically one of the most male-defined film genres. But increasingly, as demonstrated by the 1970s films of Pam Grier, perhaps America's first female action star, by the *Alien* series

(1979–1997), and by the more recent *The Long Kiss Goodnight* (1996), more contemporary action adventure films are featuring women as protagonists, often with characterizations more efficient, competent, and resourceful that those of male characters. Marchetti points out that "contemporary action adventure tales have allowed women to expand their traditional functions . . . reflecting changing and contradictory feelings about gender roles and women's equality" (191). Though this is relatively new to Hollywood, it is not new to the action cinema of Hong Kong, which has historically made great use of the tradition of the female warrior common in Chinese folklore and literature.

According to Ho, one of the first martial arts films ever made, *Huangjian nuxia wasade* (*The Heroine of Lone River* [1930]), featured a woman as the protagonist. The legacy established by renown female action stars Cheng Pei Pei of the 1960s and Angela Mao Ying of the 1970s is continued in films with Michelle Yeoh, Maggie Cheung, and Michiko Nishiwaki, women whose characters ride motorcycles often and ride them hard in *Ba hoi hung ying* (*Avenging Quartet* [1992]), *Ging chat goo si III* (*Police Story 3: Supercop* [1992]), *Dong fong sam hop* (*Heroic Trio* [1992]) and its sequel *Yin doi ho hap chuen* (*Executioners* [1993]), *Chat gam gong* (*Wonder 7* [1994]), *Hung faan au* (*Rumble in the Bronx* [1995]), and *Goo waak kui ji kuet chin kong woo* (*Sexy and Dangerous* [1996]).

In the United States, women on motorcycles are much more infrequent, usually used only in times of desperation and then often for comic effect, such as in *Burglar* (1987), where Bernice Rhodenbarr (Whoopi Goldberg), usurps a motorcycle in a chase scene. The first big-budget, studio-backed films to present a female motorcycle-riding protagonist were *Barb Wire* (1996), based on the comic book published by Dark Horse Comics, and Warner Bros.' *Batman & Robin* (1997).

Directed by David Hogan, *Barb Wire* is a remake of the classic Hollywood film *Casablanca* (1942), taking place in 2017, in a postapocalyptic America devastated by civil war. In this version, what is needed to escape fascist domination is not letters of transport but contact lenses that allow one to pass retinal scan tests. Rather than constructing the protagonist, Barb Wire, as the masculinized, tough heroine in the model set by films such as *Aliens* (1986) and *Terminator 2: Judgment Day*, this film functions as a hybrid of science fiction, action adventure, and soft-core pornography. Former *Baywatcher* and *Tool Time* girl from television's "Home Improvement" (1991) Pamela Anderson had the starring role, so it is no surprise that the film emphasized sexuality. (Anderson's most

noted "talents" are not in the thespian tradition.) From the very start, the film makes an erotic spectacle of woman. In the opening scene, Barb Wire is introduced onstage, a performer in a strip club. Wearing a revealing costume designed to highlight her exposed breasts, Wire strikes seductive poses as water is sprayed on her writhing body. The scene is enhanced by backlighting and slow motion, defining her character not as an action hero but as the all-too-common sex object providing visual pleasure for the heterosexual men in the audience—both onscreen and in the theater.

The film does offer some avowals to feminism, but we are never meant to take them seriously. How could we, when breasts are referred to as "guns" and dialogue espousing feminism is delivered by a character dressed in fetishistic clothing (a leather bustier; spandex pants; thigh-length, high-heeled boots; and a dog collar)? If she is a woman of power in the narrative, a dangerous Harley-riding bounty hunter motivated to kill men who call her "Babe"—the first time by throwing a shoe (the heel of the pump is embedded in a man's forehead)—she is also not above bemoaning the breaking of a fingernail. The glamorized female motorcyclist figure also appeared the following year, her leather replaced by a rubber sheath, in Joel Schumacher's *Batman & Robin*, which introduced Batgirl (Alicia Silverstone). Yet again, fetishized woman was on display.

IRON HORSES

What I find most intriguing about the trend of women and motorcycles in the movies is the mobilization of the western genre. Scholars such as Eyerman and Löfgren, and Corrigan have pointed out that the road movie draws heavily from American myth, most distinctly that of the American West, with its emphasis on wide open spaces, outlaw heroes, frontier justice, and hope for new possibilities. These revisionist texts address issues of sexism, sometimes in the form of remakes, such as *The Stranger* (1993), a modernized version of the faux spaghetti western *High Plains Drifter* (1972), but more often by adapting characteristic elements of the genre. The narrative of the Australian film *Shame* (1987), directed by Steve Jodrell, is a good example of the classic western plot as outlined in Wright's seminal work, *Six Guns and Society* (1975). Many have likened the film to George Stevens's *Shane* (1953) with Alan Ladd.

Shame centers around Asta Cadell (Deborra-Lee Furness), a barrister on holiday traveling about the Australian countryside on a motorcycle. The

road trip is constructed as a liberatory experience, much like that of Rebecca in *Girl on a Motorcycle*. It presents the common element of the road movie that Eyerman and Löfgren describe as "escape from the claustrophobia of petit bourgeois life, from corruption and injustice, and from intolerant 'normality'" (62). This freedom in the idyllic countryside from the pressures of daily life, complete with rolling hills and grazing sheep, is a false one, however, because Asta incurs damage to her motorcycle and must stop in an isolated backwater town to obtain repairs. Here she discovers a society where a group of men privileged by class and gender regularly assault men and rape women without threat of punishment. Within the course of the narrative, Asta persuades the victim of a gang rape, sixteen-year-old Lizzie Curtis (Simone Buchanan), to press charges against her aggressors.

According to Wright, the prototype of all westerns involves the story of the lone stranger (Asta Cadell) who rides into a troubled town (Ginbo-rak, Western Australia) and attempts to clean it up. The hero, unknown to the society, enters a social group (the Curtis family); reveals an exceptional ability (in this case numerous abilities: mechanical inclination—many are surprised she is capable of repairing the motorcycle herself; economic independence from men; the courage to challenge patriarchy, verbally and physically), which results not only in the recognition of the hero as a special and different kind of person but also in the hero's rejection from the society. Here the rejection is by those in power, for after initial reluctance, the women welcome Asta.

The film opens with a long shot of an anonymous rider in full motorcycle gear—boots, helmet, and functional leather—roaring down a country road. It is similar to what Calder has described as the cliché opening of a western: "A lone rider emerging from the landscape is guaranteed to make a certain impact. Hero or villain, [his/her] character is broadly defined even before [he/she] approaches near enough for us to see [his/her] face" (97). By initiating the film in this manner, Jodrell reveals a great deal through the use of one shot.

The riding gear, for example, along with the use of the long shot, conceals the rider's gender, playing on the biased assumptions of the audience and the other characters in the film. The helmet and choice of clothing illustrate the sensibility of the character, expressing concern for protection and safety rather than glamour or allure. And just as the film itself recodes the western genre by placing a woman in the protagonist role, the riding gear works to recode the image of female motorcyclists in motion pictures. The facts that Asta is a skilled rider, demonstrated later when she

takes one of the harassers for a ride, and that she chooses to travel the countryside alone powerfully illustrate her independence. Her autonomy is exemplified further by her choice of vehicle, a Suzuki Katana, a large, fast sport/touring bike that weighs over five hundred pounds.

The significance of the motorcycle is also crucial to the narrative because mobility serves as an important theme in *Shame*. As many historians and cultural critics have stated, the restriction of mobility is a common element of oppression; but here the motorcycle functions as a signifier of freedom. That Asta is the only woman in the film who utilizes vehicles for transportation clearly constructs her as active in a town full of passive victims. The other women are shown only as passengers in vehicles driven by men, or as pedestrians, until the end of the film, where a few take "control of the wheel" after their consciousness has been raised. The need for mobility is of such importance to the protagonist that while her Suzuki sits in disrepair, she rides through the countryside on a borrowed bicycle. She gets a flat tire and accepts a ride from Ross (Bill McClusky), a man whose wife, like Lizzie, has been raped. Traveling now in a four-wheeled vehicle, Asta is reduced to being a "passenger on the road of life" and is placed in a perilous situation.

The four-wheeled vehicles in *Shame*, driven almost exclusively by men, are continually associated with danger and violence. When not carousing in the local eatery or bar, the youths responsible for the rapes and assaults are constantly shown either inside their cars or congregating, much like a wolf pack, around them. It is with the aid of their car that the young men are able to attack Ross, running his truck off the road and beating him until Asta comes to his rescue. In another sequence, the men traumatize Lizzie's grandmother in a tow truck and drag her out of it, throwing her against the side of the vehicle. Asta herself is threatened twice, first by three teenage boys in a car and later by Gary (Phil Dean), who is associated with cars because he is an automobile mechanic. The theme is developed full circle when Lizzie, fighting for her life in the back of a car driven by two of the rapists, falls out the door to her death.

Shame is a thoughtful critique of rape culture, castigating not only those who commit rape, but the ineffectiveness of the judicial system and community attitudes about the victims as well.

Another film that makes use of the western genre to critique abuses of power is the independent feature *Bang* (1995), directed by Ash. Set in contemporary Los Angeles, this film is more a combination of Wright's revenge plot: where the hero is a member of society, the villains do harm, and the hero

seeks revenge; and the transitional plot, where the hero is inside the society at the start and outside at the close, and the society is large, firmly established, and stronger than the hero who fights against it. A complex film, *Bang* confronts the daily abuses of white male power in the lives of the disenfranchised.

The narrative focuses on one day in the life of a young aspiring Asian American actress, played by Darling Narita (the character remains nameless in the film). As she heads out to a film audition, she is evicted from her apartment as her landlord tells her of his intention to sell all her possessions. Her shabby surroundings are revealed to us, as she rides a bus to her destination, passing through dilapidated sections of Hollywood toward Beverly Hills. The producer (David Allen Graf), claiming to "want more powerful roles for women, especially minority women," has her read from a script chock full of Orientalism. He tries to assault her sexually, and when she resists, he slaps her and resorts to racial epithets. Adam (Peter Greene), a homeless man whom she befriends in the neighborhood, is upset at her distress and begins to destroy the property of the producer and his neighbors. A white motorcycle patrolman, Officer Rattler (Michael Newland), arrives, arrests the protagonist, and promises her release in exchange for sexual favors. Escaping his grasp, she handcuffs the officer to a tree, steals his uniform and his gun, and embarks on a journey of discovery through the urban blight of Los Angeles. The discomfort she experiences when first attempting to ride the police motorcycle—she has difficulty starting the engine and even drops the bike—and the ill-fitting uniform metaphorically illustrate the incongruity of the character's assumption of oppressive power. Upon seeing the reactions of the community to her authority, she is surprised, shocked, seduced, and eventually repulsed by the power of the law. As she rides through the city, her encounters reveal to her and to us the ease with which the police can resort to physical abuse, the racism of the government's war on drugs, the desperation of the homeless, and the atmosphere of violence that permeates the lives of people daily.

The independently produced features *She-Devils on Wheels, The Stranger, Shame,* and *Bang* offer film audiences narratives that directly address cultural anxieties about shifting gender relations. Like mainstream action-adventure films and westerns, these films rely on spectacle for entertainment value and remain true to conventional formulas. But some critics deride filmmakers' use of formulas. John Cawelti explains:

> Formulas resolve tensions and ambiguities from conflicting interests of different groups within culture or ambiguous attitudes towards partic-

ular values and assist the process of assimilating changes of values. For-
mulas enable the audience to explore in fantasy the boundary between
the permitted and the forbidden, and to experience in a carefully con-
trolled way, the possibility of stepping across this boundary. (35)

In the case of female biker films, the appropriation of formula allows
women to challenge gender roles by reclaiming the popular genre of
action adventure. When women are shown using motorcycles, they move
even further from the restrictions of the past, taking for their own one of
the most masculine icons in our culture.

WORKS CITED

Alt, John. 1982. "Popular Culture and Mass Consumption: The Motorcycle as
Cultural Commodity." *Journal of Popular Culture* 15:4.

Calder, Jack. 1974. *There Must Be a Lone Ranger.* New York: Taplinger.

Cawelti, John. 1976. *Adventure, Mystery, and Romance.* Chicago: University of
Chicago Press.

Corrigan, Timothy. 1991. *A Cinema Without Walls: Movies and Culture After
Vietnam.* New Brunswick, NJ: Rutgers University Press.

Eyerman, Ron, and Ovar Löfgren. 1995. "Romancing the Road: Road Movies
and Images of Mobility." *Theory, Culture, and Society* 12.

Farrell, Kirby. 1999. "Aliens Amok: *Men in Black* Policing Subjectivity in the '90s."
In Murray Pomerance and John Sakeris, eds., *Bang Bang, Shoot Shoot! Essays
on Guns and Popular Culture.* Needham Heights: Simon and Schuster.

Ho, Sam. 1996. "Licensed to Kick Men: The Jane Bond Film." In *The Restless
Breed: Cantonese Stars of the Sixties.* Hong Kong: Urban Council.

Hopper, Columbus B., and Johnny Moore. 1983. "Hell on Wheels: The Out-
law Motorcycle Gangs." *Journal of American Culture* 6:2.

Marchese, John. 1993. "Forever Harley." *New York Times.* 17 October.

Marchetti, Gina. 1989. "Action Adventure as Ideology." In Ian Angus and Sut
Jhally, eds., *Cultural Politics in Contemporary America.* New York: Routledge.

Walle, Alf H. 1984. "Harley Davidson: The Renegade Image Free at Last." *Jour-
nal of American Culture* 7:3.

Wright, Will. 1975. *Six Guns and Society: A Structural Study of the Western.*
Berkeley: University of California Press.

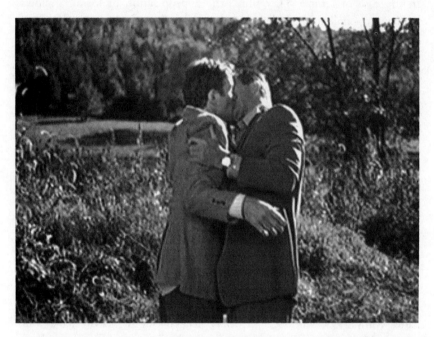

FIGURE 12. The precipitation of Howard Brackett's awakening. Kevin Kline, left, kissed by Tom Selleck, right, in *In & Out* (Frank Oz, 1997) (frame enlargement)

CHAPTER THIRTEEN

<center>◈</center>

Howard's First Kiss:
Sissies and Gender Police
in the "New" Old Hollywood

JOHN SAKERIS

Critics and activists alike have long noticed the negative, stereotypical portrayal of gays and lesbians in the mass media (Russo). Film portrayals of gay men have run the gamut of stereotypes from the sissy, as exemplified by Clifton Webb in *Mr. Belvedere Goes to College* (1949) and Edward Everett Horton in *The Gay Divorcee* (1934), to the menacing predator, such as Al Pacino's cop-turned-murderer in *Cruising* (1980). Lesbians have also been stereotyped as domineering and butch, in *The Killing of Sister George* (1968), or as murderous (yet glamorous) in *Basic Instinct* (1992). In general, before 1980 homosexuality was usually presented by Hollywood in a negative fashion if it was presented at all. Martha Dobie's (Shirley MacLaine) infamous "confession" of her love for Karen Wright (Audrey Hepburn) in *The Children's Hour* (1961) and her subsequent suicide exemplified Hollywood's moral subtext of homosexual behavior (or, in Martha's case, thoughts): people who expressed love for someone of the same sex were better off dead. Being gay was (and to many still is) reprehensible; selective readings of Judeao-Christian theology were, and are, used to support homophobia (Boswell). Hollywood did not counter this

<center>217</center>

ideology and in fact reinforced it in many ways. Men and women were expected to follow prescribed norms, and Hollywood provided the mirror by which society was to police itself.

That moral subtext was reinforced through the seemingly innocuous humor in portrayals of gay men; the sissy was always a figure apart, a man who was not quite a man, an androgynous, asexual foil who served as a target for the audience's ridicule. All of the portrayals of the so-called third sex served similar functions in the ideal world of gender in film, television, and the news for the society as a whole: they told men and women what they should not be while reinforcing rather conventional images of gender already dominant in the social world. Patriarchal attitudes were rarely challenged, and the hierarchy that existed in the workforce and in the home was seen as normal and natural. Some images were daring nonetheless: Marlene Dietrich's gender-bending portrayal of a nightclub singer in male attire who romances a female patron in public in *Morocco* (1930) created a stir at the time and even managed to influence female fashion (Hadleigh). However, anything that deviated from conventional images was deemed unnatural and treated as such. The sense of "otherness" that was exemplified by images of actual or imagined homosexuality is illustrated by the very idea of a "third sex"; homosexuality was so outside the realm of normality that a separate sexual category was reserved for both homosexual men and women.

In short, these images functioned as a kind of internal and external gender police: if you want ridicule and social approbation, you will behave as the stereotypical figures do in the movies; if you want acceptance and other forms of social reward, you will behave like, say, John Wayne or Clark Gable (who was rumored to have wanted Vincente Minnelli removed as director from *Gone with the Wind* because of his homosexuality [Hadleigh]). The contemporary leading man is merely a reworked version of these earlier stars; their power is essentially unaltered. Will Smith or Harrison Ford will still save the day through his toughness and superior physical skill, be it during an alien invasion in *Independence Day* (1996) or a National Security Agency takeover of the government in *Enemy of the State* (1998) or on an isolated island with modern-day pirates in *Six Days and Seven Nights* (1998). In *Six Days*, there was some question of whether Anne Heche's real-life live-in relationship with Ellen DeGeneres would damage the film's marketability—ironically this

seemed to overshadow the tremendous difference in age between the film's two leads. In the end, the publicists used the "issue" of Heche's orientation in the advertising for the film itself.

Hollywood's stories succeed in reinforcing social values by presenting narratives that have a strong emotional and intellectual component for viewers. We learn who we are at the movies or at least learn who we should be. Self-images are reinforced (both positively and negatively) by film and television. The relationship between images presented and self-image is a very complex one: we cannot assume that blacks in the Jim Crow era wholeheartedly accepted the images of themselves on the screen; there was a black film industry that existed from the silent era until after the Second World War that directly tried to negate these images with others, many of which themselves were racist. Likewise, Quentin Crisp appropriated the stereotype of effeminate homosexuality and used it for self-empowerment (Crisp). The appropriation of negative language (Seidman) is one other example of this reaction (e.g., Queer Nation). Yet homophobia, sexism, and racism are ideologies that are oftentimes internalized by the very minorities that are their targets.

Human beings are more than simple sponges who unquestioningly absorb the messages of the dominant social order; they filter and process images and ideas and weigh them against their own experience. Nevertheless, society's members do judge themselves against images that are popularized by the commercial media. Body size and shape, hair, stature, skin color, and clothes largely as depicted onscreen, are indicators that society uses to evaluate its members along dominant class, gender, and racial lines (Rubinstein). Men and women are evaluated in terms of their success or failure in embodying these media images; it is through this evaluation that a hierarchical society justifies its inequities daily. A good example of hierarchy is found in Cameron's *True Lies* (1994). At the beginning of the film, secret agent Harry Tasker (Arnold Schwarzenegger) is at the top of the heap. But his wife, Helen (Jamie Lee Curtis), must earn her elevated, but still second-class, status during the narrative. Simon (Bill Paxton), who is courting her and who is humiliated by Harry and his buddy "Gib" (Tom Arnold), is a lowly third, while the Arab terrorists Harry pursues are ultimately at the bottom of this gendered and ethnicized heap. Whiteness, strength, and power rule still, and men are their prime source. A weak man, and increasingly a weak woman, is subject to social scorn. In *Independence Day* quaking, nervous, anxious, and notably

gay Marty Gilbert (Harvey Fierstein) almost replicates Stepin Fetchit's Snowshoes from *Charlie Chan in Egypt* (1935). The sexual world is still divided along lines of strength and weakness even if strength is increasingly expected of women as well as men, and domination and power are still highly regarded status variables.

Class, too, is a pervasive theme in mass media. One's class position is represented as having been achieved through personal effort and perhaps luck. *Titanic* (1997), for example, reinforces the idea that America is a land of opportunity and social success is an individual achievement— the individual success in this case being represented by a woman, Rose (Kate Winslet). Yet her achievement is still incomplete without the love of the man who gave her independence, Jack (Leonardo DiCaprio). Like *Titanic,* films often interweave lessons about social class and sex. The two male protagonists in *Titanic* are polar opposites: the spoiled and effete cruelty of Rose's fiancé, "Cal" (Billy Zane), is a commonly stereotyped gay characteristic, this time associated with the monied classes. Even portrayed by the androgynous DiCaprio, Jack is the strongest character in the film and is meant to represent a working-class male whose potential is lost. DiCaprio's performance under Cameron's direction is, of course, a hypersensitive 1990s version of an early-twentieth-century masculinity that would probably have been tougher and more traditional. This "new male" is not really new, James Dean and Montgomery Clift having been the '50s predecessors of Leonardo DiCaprio. Both the '50s and the '90s could be classified as ideologically conservative times of intense social and economic change, characterized by strong efforts to lead viewers back to an imagined simpler era when men and women's behavior was clearly spelled out, and social class was simply a matter of individual "capabilities." The sensitive antihero served as an antidote to these periods of reaction; an apparent popular rejection of, and release from—therefore a denial or masking of—the dominant macho stereotypes suitable for a society that is growing in its military capacity, production, and use. This very militarization is essential to maintaining and increasing economic global corporate control.

These messages shape us and make us what we are although not necessarily directly. At any rate, we can hardly escape them. One pervasive idea currently popular in Hollywood is that sexual identity is written in our biology, that gender is biologically based and not subject to change (Hubbard and Wald; Gould). The discovery of the so-called gay

gene was front page news. The refutation of the research underlying the "discovery" of this gene as fundamentally flawed was practically ignored. Homosexual attraction is still rather simplistically seen as rooted in our biological makeup. A well-meaning film built on this assumption is *The Twilight of the Golds* (1997), based on a play in which a liberal New York family is torn apart by the daughter's pregnancy. Genetic testing has supposedly discovered that her fetus carries the "gay gene." Her decision to abort the child, even though her own brother is gay, illustrates how deeply homophobia is entrenched while at the same time reinforcing a biologically deterministic view of sexuality itself. The reality of human sexuality is of course more complex. While biological factors must be considered, the social context, socialization, and social structure are more significant. As biological theories and explanations of sexual behavior do not threaten the status quo, they can serve to shield dominant systems of power from scrutiny and thus maintain systems of oppression and class exploitation. Focus on sexual orientation therefore masks serious concern with the production of social inequality. It is in this area that Hollywood fills its most important function: the ideological justification of such an inequitable system.

If human social organization is varied and constantly changing, ideological forces constitute a resistance. The acceptance of the ideology of a "natural" social world has long been a barrier to social change. Treatment accorded to homosexual behavior has varied from culture to culture, according to anthropologists and sociologists (Greenberg; Halperin; Herdt; Weeks); different social systems have different social rules and values. Some theorists have noted that the actual categorization of groups of people as "homosexuals" is a relatively recent phenomenon. The "gay and lesbian community" is a modern creation, and homosexual behavior in itself did not necessarily result in the formation of "homosexuals" as a group. In fact, even in contemporary society there are many who engage in such behavior—spontaneously, momentarily, experimentally, and briefly, or systematically and with commitment—yet never identify themselves as gay or lesbian. And there are even many who do not engage in such behavior but who do place themselves in this social category.

The modern narrative, however—and especially the modern cinematic narrative, aimed at the mass audience—does not offer complex sociological explanations. Gender identity and sexual orientation are

presented as absolutes. And it is this representation of homosexuality as fixed, generic, and organic that has not changed even with the more positive portrayal of homosexuality in some contemporary films. Ironically, both positive and negative gender images can in fact reaffirm the status quo of class inequality; women have been portrayed with affection and charm in imagery that may do nothing to challenge established patterns of behavior—Julia Roberts's role in *Pretty Woman* is one good example. Indeed, positive but unchallenging images can be most powerful, touching deep human emotions.

While much of the material on homosexual representation that followed the groundbreaking book *The Celluloid Closet* focused on the effect of such portrayals on gays' and lesbians' self-image and the reinforcement of scapegoating and discrimination in the social system, little has been written on the relationship between homosexual imagery and the dominant gender roles already operating in the larger social system. It is here that we may begin to understand the real function of stereotypical portrayals and their relation to homophobia in the broader social context.

Both gay and straight media commentators have viewed some recent portrayals of gays and lesbians in film as an improvement over the past while noting that there are still many examples of stereotyping and egregious homophobic portrayals in films such as *Con Air* (1997), *Braveheart* (1995), *No Way Out* (1987), *Pulp Fiction* (1994), *They Live* (1988), *There's Something about Mary* (1998), and other action narratives or in TV comedies such as the syndicated "In Living Color" (1990) or "Cosby" (1996). *Con Air*, for example, is a testosterone-filled prison escape film that takes place in an airplane transporting criminals. While action films need villains by definition, in this film villains are everywhere, and a hierarchy is clearly established among them. Surprisingly, one of the most odious of these is not the serial killer Garland "The Marietta Mangler" Greene (Steve Buscemi), a creature so dangerous he is kept in a steel cage, but the Hispanic gay prisoner "Sally-Can't Dance" (Renoly Santiago); an outrageous drag queen, it is he who is positioned as the target of derision for the audience. *Braveheart* was notorious for its depiction of a prince's gay lover (Stephen Billington) so vile that when he is pitched out a window by the king, audiences almost always cheer. Still-running repeats of the popular show "In Living Color" have a regular segment of two gay queens (David Alan Grier and Damon Wayans) who are portrayed in thoroughly negative terms and are meant to be not just figures of fun, as

in *The Birdcage* (1996), but self-centered, nasty misogynists who have no redeeming qualities. Situation comedies have what is now a standard segment where gay men are mistaken for heterosexual, or vice versa. Depending on the script, these shows can reinforce homophobia ("Cosby") or challenge it ("Murphy Brown" [1988] or "Frasier" [1993]). Even more conventional romantic films sometimes fall back into the old patterns: *You've Got Mail* (1998) is one example, with Jon Lovitz' small and uncredited cameo as a whining and apparently gay shopper who should know better than to be rude to Meg Ryan, of all people.

At the end of the century, it is certainly clear to anyone turning on the television or going to the local multiplex that gays and lesbians are everywhere and that their depiction is varied, interesting, and often positive. The coming out of Ellen DeGeneres on her situation comedy "Ellen" (1994) was a much-publicized and highly-rated success, and many major television shows have at least one openly gay performance from a supporting character or, in the case of the NBC sitcom "Will & Grace" (1998), a lead. Even the news coverage of burgeoning Gay Pride celebrations, typically negative, has made occasional, and surprising, attempts to be fair.

Much of the change from traditional stereotyping can be attributed to an organized counteroffensive by gays and lesbians to their representation in mass media. That political organization can be directly tied to the antiwar, civil rights, and feminist struggles of the 1960s—struggles that are directly related to change in capitalist societies. Gender definitions are undergoing popular challenge in general, and the efforts to change representation of gays and lesbians cannot be separated from that struggle. It also appears that the business sector has discovered the demographically attractive gay market. Unsurprisingly, this seemingly positive change has not been without its backlash. Responses by members of the public at large have been mixed; the television-based religious Right has decried the furthering of the interestingly named "homosexual agenda"; politicians continue to shy away from granting equal rights to gays and lesbians, citing such rights as threats to "the family." Gay bashing is up. In North America, only the courts in Canada have been a vehicle for social change, while in the United States the struggle has had few breakthroughs either in the courts or in state or federal legislatures. Yet even in this climate, many of these "new" gay films have been successful at the box office.

The attack on gays and lesbians from the Right has accused the media of directly contributing to a decline in "family values." While these values tend not to be very precisely articulated, it is clear that they are antigay, anti-abortion, and supportive of strict gender divisions, class divisions, and traditional sex roles. The attack has been successful and has had far-reaching ramifications: the law, education, and the workplace have all been subject to the scrutiny of this organized, and media-based, political pressure group, and much potentially progressive legislation has been blocked.

Attacks on sexual equity by the Right continue to function, as they have historically, by fragmenting the working class. Working-class people are encouraged to oppose equal rights for gays and lesbians because they represent "special interests," while at the same time the abilities of those same working-class people to defend their own economic interests are being eroded. Coupled with the fostering of working-class homophobia is a general absence of working-class homosexuality in film, notwithstanding some notable exceptions such as *My Beautiful Laundrette* (1985), *My Own Private Idaho* (1991), and *The Full Monty* (1997). But in more conventional films, such as *The Damned* (1969), *Death in Venice* (1971), *Deathtrap* (1982), *Another Country* (1984), *The Birdcage, Braveheart, In & Out* (1997), and *Gods and Monsters* (1998), gays are at least middle class if not nouveau riche or aristocratic.

The response of the media establishment has been an ambiguous one: they have reinforced homophobia while at the same time presenting more positive images. The latter trend began with Tom Hanks's portrayal of a gay man dying of HIV and struggling for his rights in *Philadelphia* (1993); continued with *In & Out*, a film about the outing of a gay teacher (Kevin Kline) by his former student (Matt Dillon) on a televised awards ceremony (an idea ironically suggested by Hanks's acceptance speech at the Oscars); *The Object of My Affection* (1998), about the love of a straight woman (Jennifer Aniston) for a gay man (Paul Rudd); and *Bound* (1996), the story of two women, Violet and Corky (Jennifer Tilly, Gina Gershon), who murder Violet's lover, Ceasar (Joe Pantoliano), a brutal mob boss, as they discover their passion for each other. These films are particularly interesting in that, popular with both gay and straight audiences, they represent the "new" Hollywood gay film.

Written by Paul Rudnick, who is gay, Frank Oz's *In & Out* is now widely available on video. Howard Brackett (Kline), a popular school

teacher in a small town in Indiana, is forced to confront his sexual orientation by movie star Cameron Drake's (Dillon) announcement at the Oscars. As the film's publicity notes state, Howard did not even know that he was "in" the closet. The plot of the film is simple and straightforward; Howard Brackett, originally offered as a heterosexual high school teacher who has been mistakenly labeled as gay, gradually comes to see that he is *in fact* gay, a discovery that foils his attempt at marriage to fellow English teacher Emily Montgomery (Joan Cusack). His awakening is precipitated as he receives a much-publicized kiss from a gay TV reporter, Peter (Tom Selleck). Throughout the film, Howard's self-discovery is chronicled in a series of vignettes. At his bizarre bachelor party, his friends celebrate his love of show tunes, in particular Barbra Streisand's. His students point out to him his "gay" characteristics: he is an English teacher, he is smart and well dressed, he is "really clean." And as he goes into the school hallway to greet reporters, the students advise him to watch how he holds his hands. In a moment that clearly shows Rudnick's savvy desire to skewer homophobic attitudes, the reporters are heard shouting in the background, "Should gays be allowed to handle fresh produce?" and, "Do you know Ellen?"

The truth dawns on Howard in one of the film's most hilarious moments, the taped instructions on how to be a "man." The segment, which was no doubt written to be an ironic commentary on male gender roles, was marketed as Howard "doing his frantic best to assert his manliness." The tape begins slowly with instructions on how to dress, how to be in control and take charge. "Stand up and untuck your shirt, adjust yourself"—Howard's lack of understanding is addressed by the omniscient commentator: "The package, sissy man, the family jewels. Grab 'em!" The instructor goes on testing that "most critical aspect of masculine behavior: dancing. Manly men do not dance. . . . Avoid rhythm, grace and pleasure." Of course, Howard cannot resist Gloria Gaynor's disco beat and succumbs to the "demon whispers" by dancing wildly around the room. The tape tells the "pussy boy" he has flunked the test, and at his wedding instead of, "I do," he blurts, "I'm gay." Afterward, Emily shouts at him, "Fuck Barbra Streisand and fuck you!" The denouement of the film is a teasing wedding segment where the audience is led to believe that Howard and Peter are being married, but in fact it is Howard's parents (Debbie Reynolds, Wilfrid Brimley) reaffirming their vows. The credits roll with the wedding

party dancing to "Macho Man" by the Village People. The two male protagonists barely touch, so that even in this gay positive film all remains as it was before, with the system intact, and people fitting neatly into their "proper" categories.

There is no question that Kline's portrayal of Howard is a positive and effective one or that the audience is clearly meant to be on his side and to hope for his ultimate self-actualization and happiness. The climactic graduation scene, where Howard's students, family, and neighbors—including the fire department—stand and proclaim that they are gay to protest his firing, is designed to keep the audience onside in opposing discrimination based on sexual orientation. Yet this very positive portrayal with its liberal sensibilities does not challenge the structure of sexual interrelations in this culture, that men are "men" and women are "women," and we are not all gay and heterosexuality is still intact.

The oddly tepid Selleck-Kline kiss at a pivotal moment in the film in fact illustrates our fundamentally conventional attitudes in an interesting way. One might have expected such a transcendental moment to be passionate, if not on fire. But the filmmakers were anxious about the reaction of an audience to such a kiss. Scenes of men kissing in films have often been greeted with derision by audiences; when Christopher Reeve and Michael Caine kissed in *Deathtrap* audiences jeered. Shooting *Six Degrees of Separation* (1993), Will Smith is reported to have resisted kissing Eric Thal for fear of reaction from his fans. Even Will, the gay lead of "Will & Grace," has yet to physically contact anyone other than his female roommate. The gay kiss in *The Full Monty* was apparently censored on Air Canada flights everywhere in the world, and advertisers withdrew from sponsoring a scene of two men in bed on the 1980s series "thirtysomething." Scenes of men fighting engender no such squeamishness on the part of producers, however. In fact, filmmakers sometimes paradoxically use vicious fighting as a means of demonstrating male intimacy. The final, incredibly brutal fight between David Duchovny and Brad Pitt in *Kalifornia* (1993) and the elaborately staged dust-up between Roddy Piper and Keith David in *They Live* are two such uses. Previews of *In & Out* were carefully watched by production executives for audience response to the kiss, and when the telltale scene was screened, and they heard an explosive titillated cry from the audience, they knew they should leave

it in. Perhaps a militaristic, competitive, class-divided capitalist society necessitates this relentlessly rough relationship between men and film is merely reflecting—while doing nothing to challenge—the need (Gibson). The gender relations supported by rough masculinity and its depiction are ultimately part of a system of class domination. It is that system that is ultimately sacrosanct to the powerful ruling class (Ewen; Parenti; Miedzian).

While mainstream films have avoided erotic tenderness between men, fringe or art house films have explored it: *Beautiful Thing* (1996), *My Beautiful Laundrette, Swoon* (1992), *Another Country, Prick Up Your Ears* (1987), *My Own Private Idaho,* and *The Living End* (1992), for example. Tender passion between women has been more readily portrayed and accepted. The erotic lovemaking scene in *Bound,* a centerpiece of the film, has no male counterpart in the Hollywood pictures I have been addressing, with its full nudity, sensual frankness, and attention to detail. Howard's first kiss in *In & Out* and its public treatment by production personnel make for a useful contrast: his leg briefly curling around Peter's body is the sole indicator of any heat between the two characters; and Selleck, asked about the kiss on a network morning news show, replied to the effect that an actor doesn't have to be a killer to play one.

But why are women allowed screen passion when men aren't? The answer is related to preexisting gender role expectations in North American society. Male socialization has been noted by many (Pronger; Gilmore) to involve very particular values: men are taught to hold their compassion and feelings in, a predictable strategy in a competitive capitalist labor market based on maintaining a labor surplus to keep wages down. Women are treated as though their principal territory is the emotional realm of the home. Though women constitute a major sector of the workforce, they are still paid less than men for similar work (Armstrong and Armstrong). Further, the ghettoization of women's work and the provision of necessary, but unpaid, labor in the home—all supported by our processes of gender socialization—are central to a capitalist economy as well. The objectification of women, moreover, is a central factor in the sale of commodities, another pillar of the competitive system. Gender expectations are reinforced by mainstream corporate media since their interests are tied to the maintenance of this very lucrative system, which continues to primarily benefit the very few. It makes sense, then,

that there would be a different portrayal of gay men and lesbians by the industry, one that displaces screen homosexuality from the rewards of competition, holds screen homosexuality up as an object of (even friendly) ridicule, and reinforces existing institutional structures while at the same time seeming to celebrate the progressive delights of an "alternate lifestyle."

Homosexuality is presented in far more realistic, and precisely controlled, light in Gus Van Sant's *My Own Private Idaho*. This is the story of two young male hustlers, a rich prodigal son, Scott (Keanu Reeves), and a working-class narcoleptic, Mike (River Phoenix). Mike's open profession of love for Scott is ultimately rebuffed because Scott has fallen in love with a charming Italian girl just at the moment he is to come into a major inheritance. Van Sant allows us to experience the story, and the ultimate sense of loss, from a point of view sympathetic to Mike, reversing most traditional treatments of "illicit" love. Compared to *The Children's Hour*, for example, *My Own Private Idaho* is revolutionary. By the end of the film, the viewer feels closeness with the gay character, Mike, and relative alienation from the more heteronormative and calculating Scott.

Van Sant's vision of gender is intertwined with his clear analysis of social class in America, a combination also evident in *Drugstore Cowboy* (1989) and the compelling *Good Will Hunting* (1997). Scott's initial flirtation with Mike has a ring of insincere slumming, and his ability at the film's end to cast off a previous homosexual affiliation is rooted solidly in the power given to him by his newly inherited social position. Mike, however, is both committed to a gay identity and powerless to change it.

Negative stereotyping of homosexuality and the homophobia that is reinforced by it operate to help maintain preexisting class and sex divisions. Homophobic gay bashing is the ultimate form of social control, not only for the victims, but also for the perpetrators. Other forms of harassment—name calling, jokes, and discrimination—also serve the same function. Homophobia keeps us in our proper gendered place, reinforcing the gender/class divisions that are vital to the powers that be. Yet the "new" gay films are clearly gay positive and are the result of a long period of struggle; what is their relationship to homophobia? First, homophobic images have not disappeared from the media, and the majority of society's members has not come to accept such gay marriages

as are implied in *In & Out*. Also, the allure of the traditionally gendered family remains untarnished and dominant in mass media and in our culture in general. Our economic system's demand for a mobile and flexible labor force is fundamentally fragmenting the traditional family while at the same time media holds it up as a universal ideal. If gays and lesbians have been used in film to signify the excitement and allure of social change, they have also been made scapegoats for the social disruption of that economic change.

Howard, then, must be no real threat to the established order in *In & Out*. The qualities he possesses must continue to mark him as "other," significantly different from more powerful straight men in the broader scheme of things. Though he has discovered his true self by the final reel, Howard must remain strangely impotent, dancing alone at the film's conclusion. In this way, the message of *In & Out* is sanitized, and the gendered division of power remains as it had been before. In fact the message is one that reinforces "self-actualization," the central myth of American society in which everyone who tries gets his or her just reward. Similarly, the women of *Bound* are no real threat to the status quo even though the film's main theme appears to be a feminist one. The eroticism that is present in the film has become a mainstay of the pornography industry. The killing of the mobster/lover, while symbolically indicating the liberation of women, leaves no room for an interpretation of sexism that shows the class structure, not males, as a principal beneficiary. Instead it reinforces the idea of gender war.

The potential of same sex love to challenge dominant sexist ideas and structures, including the traditional family, is diverted by the "new" gay films. In fact they, too, like their more obviously homophobic historical counterparts, serve a reinforcing function for traditional sex roles and class divisions. While the "new" gay films do represent a step forward in the advancement of human rights for gays and lesbians, what they do not represent is any significant challenge to traditional sexist ideology.

WORKS CITED

Armstrong, Pat, and Hugh Armstrong. 1994. *The Double Ghetto: Canadian Women and Their Segregated Work*, 3d ed. Toronto: McClelland & Stewart.

Boswell, John. 1980. *Christianity, Social Tolerance, and Homosexuality.* Chicago: University of Chicago Press.

Crisp, Quentin. 1988. *How to Go to the Movies.* New York: St. Martin's Press.

Ewen, Stuart. 1976. *Captains of Consciousness: Advertising and the Social Roots of the Consumer Culture.* New York: McGraw-Hill.

Gibson, James William. 1994. *Warrior Dreams: Paramilitary Culture in Post-Vietnam America.* New York: Hill & Wang.

Gilmore, David D. 1990. *Manhood in the Making: Cultural Concepts of Masculinity.* New Haven: Yale University Press.

Gould, Stephen Jay. 1996. *The Mismeasure of Man.* New York: W. W. Norton and Co.

Greenberg, David F. 1988. *The Construction of Homosexuality.* Chicago: University of Chicago Press.

Hadleigh, Boze. 1993. *The Lavender Screen: The Gay and Lesbian Film: Their Stars, Makers, Characters, and Critics.* New York: Citadel Press.

Halperin, David M. 1990. *One Hundred Years of Homosexuality.* New York: Routledge.

Herdt, Gilbert. 1997. *Same Sex, Different Cultures: Exploring Gay and Lesbian Lives.* Boulder: Westview Press.

Hubbard, Ruth, and Elijah Wald. 1993. *Exploding the Gene Myth: How Genetic Information Is Produced and Manipulated by Scientists, Physicians, Employers, Insurance Companies, Educators and Law Enforcers.* Boston: Beacon Press.

Miedzian, Myriam. 1991. *Boys Will Be Boys: Breaking the Link between Masculinity and Violence.* Garden City: Doubleday Anchor Books.

Parenti, Michael. 1992. *Make-Believe Media: The Politics of Entertainment.* New York: St. Martin's Press.

Pronger, Brian. 1990. *The Arena of Masculinity: Sports, Homosexuality and the Meaning of Sex.* Toronto: Summerhill Press.

Rubinstein, Ruth P. 1995. *Dress Codes, Meanings and Messages in American Culture.* Boulder: Westview Press.

Russo, Vito. 1987. *The Celluloid Closet: Homosexuality in the Movies,* rev. ed. New York: Harper and Row.

Seidman, Steven. 1996. *Queer Theory/Sociology.* Cambridge: Blackwell.

Weeks, Jeffrey. 1985. *Sexuality and Its Discontents: Meanings, Myths & Modern Sexualities.* London: Routledge and Kegan Paul.

FIGURE 13. Francis (François Cluzet, right) collects the records, and the person, of jazz great Dale Turner (Dexter Gordon, left) in Bertrand Tavernier's *Round Midnight* (1986). (frame enlargement)

CHAPTER FOURTEEN

◈

Hipsters and Nerds: Black Jazz Artists and Their White Shadows

KRIN GABBARD

Whether they favor compact discs, LPs, 78s, cassette tapes, or Napster downloads, serious collectors of jazz recordings are not like other collectors. For one thing, they are almost always male. As Susan Stewart has suggested, women collect souvenirs and mementos, while men tend to collect serially. Even if a woman collects records, she is likely to have only those discs to which she is emotionally attached. Male collectors usually seek a complete inventory, often based on some kind of list that gives order to their collecting activities. (I have been a serious collector of jazz recordings since 1964. Several walls in my apartment are covered with LPs, CDs, and tapes. Close by my records I keep my discographies with their complete listings of recordings by specific artists. I have carefully annotated many of my discographies, and I take great pride in those volumes where I have put a little dash next to all of the recordings listed in the book. I am constantly frustrated that the unending flow of new releases on CD quickly makes a discography obsolete. Indeed, collecting any single artist complete is difficult because of so many rare and out-of-print records, not to mention bootleg recordings that circulate among collectors and can be acquired only through elaborate networking. Nevertheless, I have what

can be considered "complete" collections of recordings by Charles Mingus, Clifford Brown, Charlie Parker, Billie Holiday, John Coltrane, Eric Dolphy, Lester Young, Thelonious Monk, Bud Powell, Roy Eldridge, Fletcher Henderson, Betty Carter, Jimmy Lunceford, Johnny Hodges, Woody Shaw, Rahsaan Roland Kirk, Bix Beiderbecke, Ben Webster, and Lee Morgan. For aesthetic and personal reasons, there are artists whose works I have not attempted to collect in their entirety. For example, I have only a handful of Miles Davis records from the years after 1968. I've stopped collecting David Murray CDs because he's still alive and recording so frequently that it's difficult [and expensive] to keep up with it all. Then there is Duke Ellington, the greatest of them all, whose entire works are virtually impossible to acquire since he performed almost every day of his life, and someone was probably running a tape recorder when he played a highschool prom in Jamestown, Pennsylvania, on 16 May 1959, thus presenting the likelihood that sooner or later a tape will turn up in the circle of "advanced" collectors who seek the holy grail of a "complete" Ellington collection.)

A psychoanalytic explanation of the collector's behavior might suggest the persistence of the "anal stage," when the child takes pleasure in holding on to material that should have passed out of his system long ago. A more satisfying explanation of both the collector's pathology and the dominance of men among serial collectors would draw upon Lacanian theories of the body within the Symbolic Order. The man whose collection is complete has no gaps and thus no anxieties about what is not there. The serial collector seeks plenitude, the warding off of castration. In this sense, jazz collectors share some qualities with other serial collectors, such as philatelists and numismatists, who also labor at filling gaps. (My friend Perry has compiled all the releases of certain premodern jazz artists on 78 rpm discs but never listens to them, preserving them in carefully arranged volumes that resemble the albums of stamp and coin collectors.)

Jazz collectors who do not listen to their records are not typical, however. Most immerse themselves in the music in order to acquire expert knowledge of jazz history and the improvisatory styles of canonical masters. When Baudrillard writes that the collector prefers the "formal" aspect of objects to their reality (147–48), he may be right for most collectors but not always for jazz collectors. The fetishist's pleasure in a complete and well-ordered collection is richly available to jazz devotees, but most would say that they are acquiring music that is enjoyed and studied as if it were entirely separate from the vinyl on which it was purchased.

(To those who are puzzled by the way I fill up my apartment with LPs and CDs, I patiently explain that the music is lighter than air and full of moments of transcendence unrelated to the spectacle of shelves groaning under the weight of vinyl.)

Male record collectors seek mastery over a body of music, almost always as a way of establishing a masculine identity. That identity may be subversive, as is often the case with men who collect opera (Koesten-baum); it may be absurdly hypermasculine, as with those who collect heavy metal (Grossberg); or it may be normative with a tinge of masochism, as seems to be the case with men who collect country and western (Ching). The collector makes conscious and unconscious connections to the masculine codes in the music, but he also works at acquiring a commanding knowledge that can be carefully deployed in the right surroundings. The display of authoritative information, especially when it has been acquired outside of "bureaucratized institutions of knowledge," is a well-established sign of masculine power in contemporary American culture (Straw, 7). Nor is it any longer a secret that masculinity is constantly being constructed and reconstructed in that culture, within and across boundaries of race, class, ethnicity, and age, often in contradictory ways. The masculine self-presentation of Arnold Schwarzenegger is different from that of George Bush, Jr., which is different again from that of Charles Barkley. The fact that in the popular imagination Schwarzenegger seems to possess a complete inventory of masculine attributes (mused upon by Goldberg) reveals the success with which the culture industry has concealed the contradictions in familiar constructions of masculinity. But how do we account for the fact that working-class white males are more likely to look to Barkley or some other black athlete for styles of masculinity than to either Bush or Schwarzenegger? Another anomaly is the culture's ability to find a continuing, hypermasculine presence in aging stars, such as Sean Connery in *The Rock* (1996) and Clint Eastwood in *Absolute Power* (1997). As Steven Cohan has written, American masculinity is built upon the great contradiction that it is performative at the same time that, at least for familiar middle-class white versions, it must not present itself as a performance.

But the man who performs his masculinity with the knowledge acquired through record collecting is hardly entitled to mainstream models of masculinity. Like all homosocial activities, a serious devotion to collecting may even hinder a man from acquiring the regular company of a sympathetic woman, and not just because so many record

collectors end up with the unkempt look of the nerd. The collector's conundrum is central to Nick Hornby's novel *High Fidelity*. The connoisseurs of marginal rock who work in the South London store Championship Vinyl feel superior to the many people who do not share their refined tastes in pop music. But as the novel also suggests, this feeling of aesthetic purity coexists with a romantic streak based in a certain credulousness about what Al Green, Neil Young, Solomon Burke, and the rest are saying in their songs. At least for Rob, the protagonist/narrator of *High Fidelity*, real-life romantic encounters never measure up to the fantasies so compellingly inscribed in his favorite records, and, of course, he cannot meet a woman with the same rarefied but crucial attitudes about music that he shares only with his fellow collectors, all of them male. The novel ends with the thirty-five-year-old Rob suddenly realizing that he no longer has contempt for people just because they like Tina Turner, Kate Bush, or Billy Joel. *High Fidelity* associates this transition with a maturation process that also leads to Rob's ability to nest comfortably with a woman for the first time in his life.

Stephen Frears's film of *High Fidelity* (2000) starred John Cusack as Rob and was surprisingly faithful to the novel even though the action took place in Chicago rather than in London. For my purposes, however, the most important difference between novel and film is a shift from black to white music. Rather than fetishizing the recordings of soul artists, John Cusack's Rob listens to avant-garde rock. As many reviewers pointed out, *High Fidelity* looked back to Barry Levinson's debut feature *Diner* (1982), which featured a white collector of black music but was more attentive to his pathological edge. Shrevie (Daniel Stern), one of six young men facing adulthood in the 1950s, would rather participate in the male bonding rituals at the diner than spend time with his wife Beth (Ellen Barkin). Nevertheless, Shrevie reveals a profound romantic streak when he talks about why his record collection is so important to him. In a memorable scene, he becomes enraged when he finds that Beth has filed a James Brown album under "J" rather than "B" and in the rock 'n' roll section instead of in R and B. He then explains to her the logic of his filing system:

> SHREVIE: I mean, you're not going to put Charlie Parker in with the rock 'n' roll, would you? Would you?
>
> BETH: I don't know. Who's Charlie Parker?

SHREVIE: *(In a rage)* JAZZ. JAZZ. He was the greatest jazz saxophone player that ever lived.

BETH: What are you getting so crazy about? It's just music. It's not that big a deal.

SHREVIE: *(Still angry)* It is. Don't you understand? This is important to me.

BETH: *(Near tears)* Shrevie, why do you yell at me? I never hear you yelling at any of your friends.

Shrevie also expresses great regret that Beth never asks him about what is on the flip sides of records.

BETH: Who cares what's on the flip side of a record?

SHREVIE: I do. Everyone of my records means something. The label, the producer, the year it was made. Who was copying whose styles, who was expanding on that. Don't you understand? When I listen to my records, they take me back to certain points in my life, OK?

Like the protagonist of *High Fidelity*, Shrevie associates his music with idealized moments from the past that then frustrate romance in the present. Later in the film Shrevie is very much in his element as he goes for a drive with Tim (Kevin Bacon), who throws out the names of pop tunes so that Shrevie can recall the song on the flip side of the original 45 rpm release. Shrevie glows with delight during an experience that can only be shared with another male. Beth, meanwhile, feels so injured by Shrevie's rage that she is on the verge of beginning an extramarital affair. Unlike *High Fidelity*, however, *Diner* does not show a way out of the record collector's obsessively homosocial behavior. At film's end, little has changed in the lives of the principal characters, including the marriage of Shrevie and Beth. Writer/director Levinson may have been after an ironic view of men permanently trapped in late adolescence, but twenty years later the film seems more like a nostalgic, even admiring view of masculinity in the 1950s.

Although much if not most of the music favored by the collectors in the film *Diner* and the novel *High Fidelity* is performed by African American artists, the race of musicians is never mentioned in either the novel or the film. Serious jazz collectors, by contrast, are richly aware of

race and develop a unique relationship with African American masculinity. As Eric Lott (1993) has shown, white males in the United States have regarded black men as masculine role models at least since the midnineteenth century when minstrelsy was the most popular form of American entertainment. At the same time that working-class white men at the minstrel shows could indulge their contempt for African Americans, they could also take vicarious pleasure in black men's supposed hypersexuality, transgressiveness, and carefree abandon. As in *Diner* and *High Fidelity* (novel and film), in which race and sexuality are never explicitly linked, the importance of black masculinity to white men is seldom ever discussed in contemporary American culture, at least in part because it "is so much a part of most American white men's equipment for living that they remain entirely unaware of their participation in it" (Lott 1993, 53). Today white fascination with black masculinity is more omnipresent than ever. Virtually every gesture with which white athletes and white rock musicians perform their masculinity is rooted in African American culture. White men, especially white working-class men, even seek black masculinity where it seems to be absent, for example when white men imitate Elvis Presley, "as though such performance were a sort of second-order blackface, in which, blackface having for the most part disappeared, the figure of Elvis himself is now the apparently still necessary signifier of white ventures into black culture—a signifier to be adopted bodily if one is to have success in achieving the intimacy with 'blackness' that is crucial to the adequate reproduction of Presley's show" (Lott 1997, 205).

Some jazz collectors may bear a certain resemblance to the Elvis imitator. I'm thinking in particular of men who primarily collect the music of white jazz artists, on one level keeping blackness at arm's length, while embracing the work of white men who have built their careers on appropriating the styles of black musicians. Woody Allen's *Sweet and Lowdown* (1999) creates a white jazz guitarist from the 1930s named Emmett Ray (Sean Penn), who plays in the style of the real-life French gypsy guitarist Django Reinhardt. As in *Zelig* (1983) and *Broadway Danny Rose* (1984), Allen includes talking heads or "witnesses" who speak in the style of documentary realism about the fictional guitarist. As is so often the case in jazz films, the handful of black musicians in *Sweet and Lowdown* are only there to validate the superiority of the white artist (Gabbard 1996, 76–82). And like many of the heroes of jazz films, Emmett Ray is so immersed in his art that he is incapable of making a serious commitment to a woman. On the one hand, Ray is one of the many disguises for

Woody Allen, whose problems with women and whose tireless commitment to the art of filmmaking are well known. On the other hand, as a jazz musician, Ray is the familiar white Negro, drinking to excess and even working as a pimp when he is not playing jazz. Along with Nat Hentoff and Douglas McGrath, Allen appears as himself in the film, very much the nerdish jazz fan, obsessed with the legend of Ray and able to speak with great authority about his career as a recording artist. Although it is hardly fair to characterize Woody Allen as a mere fan, many jazz purists have contempt for fans with the tastes of Allen, who can only appreciate the music of white men who imitate the music—and the perceived lifestyles—of black jazz artists.

Jazz purists often take pride in denouncing successful white musicians such as Paul Whiteman, Glenn Miller, and Dave Brubeck. White artists have made essential contributions throughout jazz history, and some have even made profound impressions on black musicians; the most commonly cited example is the impact of the white saxophonist Frankie Trumbauer on Lester Young (Porter, 33–35). But insisting upon the superiority of "black" styles over "white" ones allows the jazz fan to claim the moral and political high ground in a racist culture. Many jazz purists were delighted when Miles Davis, one of the two or three most influential black jazz trumpeters, denounced Oscar Peterson, a black jazz pianist who grew up in Montreal, for playing like a white person (Lees, 174). Peterson has maintained a large following for several decades, but at least since his authenticity as a black artist was questioned by Davis, he has never regained the full favor of jazz cognoscenti.

Those collectors most devoted to black artists will insist upon the superior musical abilities of African American musicians and repress what is, at base, a problematic relationship to black masculinity. In many ways the white fan of black jazz is a race traitor who turns his back on the mainstreams of Euro-American culture. Both whites and blacks can then charge him with bad taste, snobbery, slumming, colonizing, and/or voyeurism. The white fan can in turn insist that jazz is simply a great art music and that he is sufficiently free of racial and cultural prejudice to be capable of recognizing the achievements of great black artists. The well-established myth of jazz as an autonomous art is especially useful here because it shifts the debate into primarily aesthetic territory (DeVeaux, 542). As long as he stands by these claims, the white jazz fan need not concern himself with the homoerotic and voyeuristic elements of his fascination with black men as they enact their masculinity with saxophones,

trumpets, and other phallic instruments. Nor does the white collector need to consider the inferior self-image he creates by insinuating his pale, relatively talentless body next to the African Americans he admires; although the collector possesses the manly power of extensive knowledge, and although his record collection guarantees his plenitude, none of this can compete with the masculine power of the real live black jazz artist. When white collectors seek to justify their pursuits, they engage in massive acts of repression. (But then any serious fan represses homoeroticism, voyeurism, and much else that is superficially forbidden in mainstream culture, whether he adulates a saxophonist, a baseball player, a poet, or a classical composer. When Franz Schubert was "outed" in the 1990s by musicologists who found evidence that he may have been gay, one devotee was overheard saying, "But I was moved by Schubert's music. How could he be gay?")

Very often, the American cinema is where the repressed returns. A devastating portrait of a white jazz collector, including a dramatization of his masculine crises, appears in *Blackboard Jungle* (1955). One of the first things we learn about the bespectacled mathematics teacher Josh Edwards (Richard Kiley) is that he collects "Swing." After several drinks in a bar with the film's hero, Richard Dadier (Glenn Ford), Edwards listens admiringly to Stan Kenton's 1952 recording of "Invention for Guitar and Trumpet" on the jukebox, referring to Kenton as "Stan the Man." As Maynard Ferguson's hyperphallic trumpet solo builds to its piercing climax, Edwards says that he has decided to play his records for his students. When Richard cautions him that the students may not like his music, Edwards responds, "Why not? Listen. It took me fifteen years to collect those records. Half those records can't even be replaced." The stereotypical nerdish collector, Edwards lets his enthusiasm about acquiring records determine how he conceives the tastes of his students. Later, when he plays Bix Beiderbecke's trumpet solo on "The Jazz Me Blues" for his class, Edwards begins by displaying his mastery of musical knowledge, differentiating Beiderbecke from later stylists such as Harry James. Almost immediately, however, Artie West (Vic Morrow) takes over and throws the records into the air, while Edwards makes pitiful attempts at preventing them from shattering on the floor. Unlike Richard, who ultimately overpowers the most malevolent students and wins the respect of the others, the record collector has control over only his acquisition of musical information. (Like everyone else who spent most of his youth locked in classrooms with mediocre teachers, I found myself identifying with the

hoodlums as they smashed the records. As a young jazz aficionado with contempt for those who collected white artists such as Beiderbecke and Kenton, I forged no identification with Kiley's character when I first saw the film. When Vic Morrow reads off the titles on the discs in the math teacher's collection, one is "Cow Cow Boogie," the 1942 hit for the band of Freddie Slack, a Swing Era musician who seemed to me most devoted to bleaching and rusticating a music associated with urban blacks. *That* was a record that deserved to be smashed.)

The problematic relationship between record collecting and masculinity is even more explicit in *Young Man with a Horn* (1950). The eponymous hero Rick Martin (Kirk Douglas) idolizes Art Hazard (Juano Hernandez), an aging black trumpeter who effectively adopted the orphaned hero as a child and instructed him in the art of the jazz trumpet. The young white acolyte's monkish devotion to Hazard and the discipline of the trumpet keeps him innocent until he marries the socialite Amy North (Lauren Bacall), who neglects Rick and quickly turns him into an alcoholic. On the day that Rick returns from Art Hazard's funeral, he finds Amy in the beginnings of what the film darkly suggests is a lesbian affair. As if this blow to Rick's ego were not sufficient, Amy tells him that she hates the sound of brass and then breaks his records by throwing them on the floor. Rick begins a downward slide that culminates when he falls down in the street and a car flattens his trumpet, a sure sign of castration in the film's phallic discourse of the horn. *Young Man with a Horn* allows Rick Martin to regain his masculinity only by abandoning the jazz life and by forming a liaison with Jo Jordan (Doris Day), a much more submissive and attentive woman than Amy North (Gabbard 1996, 67–75). We can also assume that a remasculinized Rick has no need for his record collection and the access it once gave him to his black mentor and the *jouissance* of the jazz trumpet.

Unlike the Elvis imitator, and unlike Josh Edwards in *Blackboard Jungle*, the Rick Martin of *Young Man with a Horn* pursues black masculinity more directly by acquiring the jazz records of a favored African American artist. So does Francis (François Cluzet) in *Round Midnight* (1986). But whereas the interracial eroticism in *Young Man with a Horn* is moderated by allowing Art Hazard to function as both father and mother to Rick Martin, the romance is more overt in *Round Midnight*, where Francis, a French jazz enthusiast, literally collects the body of the black jazz artist Dale Turner (Dexter Gordon). *Round Midnight* was inspired by the lives of Lester Young and Bud Powell, highly respected

black American jazz artists who were plagued by serious substance abuse problems. Powell spent a great deal of time in Paris where he was looked after by Francis Paudras, the commercial artist and jazz devotee who was clearly the model for the Francis of *Round Midnight*.

In *Round Midnight* Francis first meets saxophonist Dale Turner when he is most interested in drinking himself into oblivion. Francis competes with Turner's black female companion, Buttercup (Sandra Reaves-Phillips), for possession of the lumbering saxophonist, who would spend most of his time in jails and hospitals without the constant interventions of Francis. Eventually Francis wins the struggle with Buttercup and relocates to a larger apartment that can hold both his young daughter and Turner, not to mention his record collection. Once he has moved in with Francis, the jazzman stops drinking and becomes a contented bourgeois, at one point preparing an elaborate dinner for Francis and his daughter. Turner also begins "composing," a familiar trope in jazz films that constructs the jazz musician on a European model as a writer of music rather than as an improviser or conceptualist. Turner slips back into his old drug-taking habits only when he returns to the United States, far away from the watchful eyes of Francis. The Frenchman vocalizes his passion for the black jazz artist in a conversation with his estranged wife midway through the film. Awkwardly asking his wife Sylvie (Christine Pascal) to loan him money so that he can rent the larger apartment to accommodate Turner, Francis says, "If I'm anything today, it's on account of guys like him . . . I would do anything for him. . . . Nobody inspires me like him." The film may grant Sylvie more pathos than it intends when she poses a question that is crucial to *Round Midnight's* interracial male romance: "And I never inspired you?" Francis does not answer.

But Francis has taken his love of the music to unusual extremes by collecting a musician's body. Most jazz collectors are content to fill their lives with only the sounds of black jazz musicians although a few let their collections expand in other directions. (My friend Herbert is one of these. In building what may be one of the world's most extensive Charlie Parker collections, he has filled his study not just with records, CDs, and rare tape recordings of unissued material. He also owns a copy of every known photograph of Parker, including several overlooked photos in which the alto saxophonist is not holding his horn. His vast collection of Parker memorabilia also includes numerous documents such as record contracts with the saxophonist's signature and a giant poster of Forest Whitaker playing Parker in the 1988 film *Bird*. Herbert's goal seems to be to recre-

ate the body of Parker within his study.) And *Round Midnight* is an "art" film by the French auteur/director Bertrand Tavernier, who could take on the subject of interracial male romance without fear of intervention from nervous studio bosses.

In the Hollywood cinema white jazz collectors are more likely to pursue black women than black men. In *Corrina, Corrina*, Manny Singer (Ray Liotta) is a recently widowed advertising man living in the suburbs of Los Angeles in the early 1960s. He hires Corrina (Whoopi Goldberg) to be the caregiver for a young daughter still traumatized by the death of her mother. While the earthy black woman gradually brings both the handsome father and the charming daughter out of their shells, she bonds with the father while listening to jazz and black music, especially Louis Armstrong and Oscar Peterson's 1957 recording of "You Go to My Head." The film suggests that the same open-minded approach to life that made Manny a jazz fan has led him to make the daring but entirely appropriate decision to take the wise and warm Corrina as a lover.

Zack (Michael Rapaport), the teenaged hero of *Zebrahead* (1992), comes from three generations of jazz record collectors. He and his father run a record store established in the 1940s by his grandfather in Detroit. The walls are plastered with the photos of canonical jazz artists, and at one point the grandfather boasts that he "broke bebop in." Although Zack also has a passion for the most popular black music, and although he often speaks in the cadences of a rapper, he reserves jazz for the more important moments in his life, as when he seduces Nicky (N'Bushe Wright) with the sounds of John Coltrane playing "Say It (Over and Over Again)" from the 1962 *Ballads* LP. Nicky is a black teenager at the same high school as Zack, and although their love affair has tragic results, they are closer than ever at the film's end. Like *Corrina, Corrina, Zebrahead* is extremely generous about the white man's intentions, linking his love of black music with feelings for a black woman that are not, as in Spike Lee's 1991 film, simply a case of "jungle fever."

Hollywood's compulsory heterosexuality aside, it would still be simplistic and obtuse to say that white collectors are simply attracted to black masculinity, which is hardly monolithic. Jazz fans tend not to be so interested in black athletes or in the more provocative music of African American youth culture such as rap and hiphop. The favored form of black masculinity for jazz collectors is understated, ironic, instinctual, witty, slightly transgressive, but indisputably powerful. The most admired black artists can be regal like Duke Ellington, ebullient like Roy Eldridge, angry

like Charles Mingus, or sublimely lyrical like Clifford Brown. Like Charlie Parker and John Coltrane, they can display great reserve in their non-musical personae while playing with astounding intensity. By means of short musical quotations, they can make sly references to other musical traditions, always maintaining a poker face so that only the most sophisticated listeners even know that a joke has been made (Gabbard 1991). In short, the revered black jazz artist is hip.

Will Straw has developed a typology for understanding collectors of popular music that is also useful for conceptualizing black jazz artists and the white men who follow their recording careers. Straw differentiates the dandy—who has little substantial knowledge but complete mastery of how to appear poised in public—from the nerd, whose knowledge "stands as the easily diagnosed cause of performative social failure, blatantly indexed in the nerd's chaotic and unmonitored self-presentation" (8). To help theorize these types, Straw adds the figure of the brute, who is all physical, instinctual power but with little knowledge or grace. While the jazz enthusiast may look to the black musician for a certain degree of instinctual, almost brutish energy, the most revered artists are likely to present an image that promises a rich store of knowledge just beneath a seemingly intuitive, even crude exterior. Straw's typology gives us one of those semiological squares with one axis for exteriorized masculinity and another for knowledge. The dandy presents little in the way of either masculinity or knowledge; the brute is all masculine exterior without knowledge; the nerd has so much knowledge that it seems to prevent any conventional masculine display; but the hip jazz musician is able to balance a powerful masculine presentation with solid knowledge of a rich tradition.

Bill Moody's series of detective novels about a jazz pianist named Evan Horne take the idealization of the hip jazz artist to an almost absurd degree. In each of the four books, the police call upon Evan and his insider knowledge of jazz to solve crimes that baffle them. In *Bird Lives!* for example, he tracks down the murderer of commercially successful "jazz-lite" artists for whom both Evan and the killer have nothing but contempt. The killer, a devout fan of canonical jazz musicians, throws out clues that only an obsessive collector of jazz records could decode and eventually begins communicating directly with Evan through haikus constructed from titles of jazz standards. Although we are told that Evan is a fine jazz pianist, during large stretches of each of the four novels he is either injured or preoccupied with chasing crimi-

nals and thus unable to work regularly as a musician. And although women find him attractive, he has difficulty maintaining a stable relationship. He is in effect a jazz nerd made heroic through the fantasy that a vast and obsessive knowledge of jazz can save lives and bring criminals to justice.

Will Straw writes, "Collecting is an important constituent of those male character formations, such as nerdism, which, while offering an alternative to a blatantly patriarchal masculinity, are rarely embraced as subversive challenges to it" (10). Record collecting in the Evan Horne mysteries does not allow for a subversion of patriarchal masculinity so much as it offers an opportunity to one-up the patriarchs on the police force. But at least two American films involving jazz collectors may in fact offer examples of nerdism as subversive challenge. First, there is the rare image of an African American jazz collector, Mr. Moses (James Earl Jones) in *The Meteor Man* (1993), directed by Robert Townsend, the famously resourceful black director who once financed a film by maxing out a stack of credit cards. Costumed throughout *Meteor Man* in nerd mufti, Mr. Moses reflects more than Townsend's desire to create a greater panorama of black culture than Hollywood usually offers; Jones even takes on a heroic quality at a crucial moment when he uses his beloved jazz 78s as weapons against a gang of thugs.

And then there is Terry Zwigoff's 1994 documentary *Crumb*, a portrait of R. Crumb, the brilliant cartoonist and collector of early blues and jazz. The film actually begins with Crumb crouched in front of his records, swaying gently as he listens. Later he worries about moving men handling the crates filled with his records as he and his wife prepare to relocate to France. With his fractured sense of style, his coke bottle glasses, and his lingering attachment to fetishized objects from his childhood, Crumb is the embodiment of nerdism as the challenge to patriarchal masculinity that Straw cannot find in the community of rock music collectors. But Crumb goes about his work with much self-knowledge and irony, suggesting that a person of great wit and sensitivity lies beneath the unkempt exterior. He may thus represent the hipster more than the nerd.

Crumb may even represent an ideal to which the jazz collector aspires. Scrupulously ignoring the most prominent codes of proper attire and grooming (and God knows I have been to jazz concerts where 90 percent of the men would have been thrown out of even a mildly pretentious restaurant), the male jazz collector asserts by his appearance that he has

risen above such superficial concerns. But he is not entirely oblivious to all codes of bodily display. Unlike the headbanger in a mosh pit or the inert bourgeois at the symphony, the jazz fan nods insouciantly with a carefully cultivated balance between detachment and involvement. Thus does the collector make use of the highly refined masculine codes he has learned from the jazz musician. Norman Mailer's *White Negro* apocalyptics and ultimate orgasms notwithstanding, the nerdish collector aspires to become the hip jazz artist's double off the bandstand. The nerd seeks this transcendence in his soul even if the uninitiated cannot possibly decode its exterior manifestations.

And this is why the dominant codes of representation will never be kind to the collector and why Will Straw can find no hope of a subversive challenge in the figure of the nerd. In a culture with a mammoth entertainment industry vigorously promoting spectacular masculinity and jingoistic display, the jazz nerd becomes a marginal figure largely because, like Crumb, he has refused to accept the most entrenched values of that culture. It would be difficult to imagine a Hollywood film endorsing the sentiments of someone like Crumb who did, after all, leave America for France where he believed that people had more respect for black music. The jazz collector may be most hip and subversive when he creates an unrepresentable identity.

(If I am wrong about all this, I still have my record collection.)

WORKS CITED

Baudrillard, Jean. 1968. *Le Système des objets.* Paris: Gallimard.

Ching, Barbara. 1997. "The Possum, the Hag, and the Rhinestone Cowboy: Hard Country Music and the Burlesque Abjection of the White Man." In Mike Hill, ed., *Whiteness: A Critical Reader.* New York: New York University Press, 117–33.

Cohan, Steven. 1997. *Masked Men: Masculinity and the Movies in the Fifties.* Bloomington: Indiana University Press.

DeVeaux, Scott. 1991. "Constructing the Jazz Tradition: Jazz Historiography." *Black American Literature Forum* 25:3, 525–60.

Gabbard, Krin. 1991. "The Quoter and His Culture." In Reginald T. Buckner and Steven Weiland, eds., *Jazz in Mind: Essays on the History and Meanings of Jazz.* Detroit: Wayne State University Press, 92–111.

———. 1996. *Jammin' at the Margins: Jazz and the American Cinema.* Chicago: University of Chicago Press.

Goldberg, Jonathan. 1992. "Recalling Totalities: The Mirrored Stages of Arnold Schwarzenegger." *Differences* 4: 1, 172–204.

Grossberg, Lawrence. 1984. "Another Boring Day in Paradise: Rock and Roll and the Empowerment of Everyday Life." *Popular Music* 4, 225–58.

Hornby, Nick. 1995. *High Fidelity.* New York: Riverhead Books.

Koestenbaum, Wayne. 1993. *The Queen's Throat: Opera, Homosexuality, and the Mystery of Desire.* New York: Poseidon Press.

Lees, Gene. 1988. *Oscar Peterson: The Will to Swing.* Toronto: Lester & Orpen Dennys.

Lott, Eric. 1993. *Love and Theft: Blackface Minstrelsy and the American Working Class.* New York: Oxford University Press.

———. 1997. "All the King's Men: Elvis Impersonators and White Working Class Masculinity." In Harry Stecopoulos and Michael Uebel, eds., *Race and the Subject of Masculinities.* Durham: Duke University Press, 192–227.

Porter, Lewis. 1985. *Lester Young.* Boston: Twayne Publishers.

Stewart, Susan. 1993. *On Longing: Narratives of the Miniature, the Gigantic, the Souvenir, the Collection.* Durham: Duke University Press.

Straw, Will. 1997. "Sizing Up Record Collections: Gender and Connoisseurship in Rock Music Culture." In Sheila Whiteley, ed., *Sexing the Groove: Popular Music and Gender.* New York: Routledge, 3–16.

FIGURE 14. "In the future, when a woman's cryin' like that, she i'nt havin' any fun!" While Thelma (Geena Davis, left) looks on, Louise (Susan Sarandon) teaches a lesson. (*Thelma & Louise*, Ridley Scott, 1991) (frame enlargement)

CHAPTER FIFTEEN

◈

"Let's Keep Goin'!":
On the Road with Louise and Thelma

JANICE R. WELSCH

Thelma & Louise (1991), starring Susan Sarandon and Geena Davis and directed by Ridley Scott, has commanded national attention and stirred passionate debate and discussion not because of its budget or special effects but because of its characters and content, its story. Championed as paragons of feminism and freedom, condemned as social pariahs, Louise and Thelma have been interpreted and reinterpreted, analyzed and psychoanalyzed, with appropriately—given their defiance of social norms—contrary results. My own initial response to *Thelma & Louise* was a feeling of triumph and exhilaration. Repeated viewings and discussions since have not changed that response even though I can see the contradictions and problems the movie and its protagonists pose. What accounts for my and other feminists' positive response? The attractiveness and agency of the characters and the charisma of the actresses but also the fantasy level on which the film functions. As I see it, the film places two women within a carefully delineated and schematized male world that inevitably exaggerates situations and characters in the process of developing a coherent but unrealistic narrative. Acceptance of the film as fantasy is essential and allows us to privilege Louise and Thelma, excusing their illegal behavior,

identifying with them as they move further and further from their conventional and passive roles in society, and responding to them ultimately as strong, resilient, defiant women who refuse to accept a decidedly macho world's definition of women and their place. They become mavericks as they explore a frontier that resonates with the visual iconography and narrative structure of traditional westerns, buddy films, and road movies, while simultaneously defying genre expectations.

Perhaps some of the feminist excitement generated by *Thelma & Louise* results from its appearance within just a few years of *Fatal Attraction*, another movie that sparked controversial and contradictory responses as it captured media attention and worked its way to being the second most successful box-office draw of 1987. Evolving from a James Dearden screenplay "that says you are responsible for your actions" (Faludi, 14F) and that indicts a married man for what he regards as a casual one-night stand, the Adrian Lyne film exonerates the philandering husband, Dan Gallagher (Michael Douglas), by focusing on the increasingly intrusive and destructive behavior of the woman, Alex Forrest (Glenn Close), with whom he has his fling. Lyne sums up the situation very directly: "It wasn't his fault. [Alex] was the bad lady" (Faludi, 14F). As unfair and disturbing as this judgment is, however, that many critics and viewers adopted it isn't surprising given the film's contrasting depictions of Alex as the single, career woman and Beth Gallagher (Anne Archer) as homemaker, wife, and mother, and the film's clear ongoing invitation to adopt Dan's perspective.

The film shows us that Alex initiates the affair and that she prolongs it first by inviting Dan to spend the following day with her and then through the moral blackmail of slitting her wrists. She pursues Dan, despite the return of his wife and daughter (Ellen Hamilton Latzen) and his clear indication that for him the relationship is over. In her pursuit, Alex becomes increasingly irrational and dangerous, resorting to an escalating series of violent assaults on Dan's property and family. Intercut with scenes of Alex's growing obsession and pathology are scenes of Dan at work, with his family (charming, sexy wife; cute endearing daughter; and trusting dog), and with his friends. Once the affair begins, Alex is never again seen working; never in the movie is she seen with friends; and the only mention of family are two references to her father's death, the first in conversation with Dan and the second via a newspaper clipping.

While Dan enjoys dinner or bowling with friends, celebrates family birthdays, and realizes the American Dream of owning his own home in the congenial atmosphere of a small town, Alex is alternately isolated in her sterile apartment, hypnotically indulging in self-pity and junk food, or stalking Dan and his family. Under other circumstances, the high-tech, clean lines of Alex's apartment might be read as chic and connote class, but the white walls and open spaces, as well as the location of the apartment in an area depicted as a virtual inferno (the meat-packing district of lower Manhattan), suggest both the hot, hellish, destructive passion that characterizes much of Alex's activity and the cold, empty, lonely madwoman at the core of her existence. Frequently dressed in white or black (including black leather) and wearing her hair in a style routinely described by critics as Medusalike, Alex moves between siren/witch/femme fatale and helpless child/victim—victim of her own madness and obsession. In contrast to Dan, she is not represented, visually or narratively, as a whole, healthy person. If audiences call for not just her demise, but her violent destruction at the hands of a chastened but righteous husband/father and his steadfast, forgiving wife, they are systematically led to do so by the filmmaker.

Film critic Richard Corliss has suggested that *Fatal Attraction* "is like velcro: any theory can attach itself to the story and take hold," and co-producer Sherry Lansing described it as "A Rorschach test for everyone who sees it" (Corliss, 74). Both comments are directed specifically to diverse audience responses to the film. They suggest that the texts against which audiences read *Fatal Attraction* are those the audience members bring with them to the film. They function on the level of ideology. In the case of *Fatal Attraction*, the ideological assumptions and values seem more overt than usual. AIDS, sexual freedom, the women's movement— each offers a threat on some level to patriarchal power and its values: the nuclear family, the American Dream, the hierarchical order of society. And audiences, identified as 60 percent male (Faludi, 14F), in the age of Reagan and of retrenchment along reactionary lines, responded—most frequently with approval of Lyne's aggrandizement of the family (even though his Gallagher family is flawed through the presence of a weak, fearful, inept head) and annihilation of the single career woman (even though that woman is clearly mentally disturbed and possibly the victim of a tragic childhood, circumstances that allowed earlier femmes fatales some degree of audience sympathy).

Robin Wood, in *Hollywood from Vietnam to Reagan*, suggests that restoration of the Father, the Father "understood in all senses, symbolic, literal, potential," is "the dominant project, ad infinitum and post nauseam, of the contemporary Hollywood cinema, . . . embracing all the available genres and all the current cycles" (172). Under such circumstances, it is not surprising that if a "woman can't accept her subordination, she must be expelled from the narrative altogether" (Wood, 173). The vehemence with which this expulsion is accomplished in *Fatal Attraction* is such that it obliterates concern not only for Alex but also for her (and Dan's) unborn child. Dearden suggests the final scenes depicting Alex's demise are cathartic for audiences. Having vented their anger against Alex, they are ready to relax with the re-formed nuclear family before the Gallaghers' hearth. The final image of the Gallaghers we see is that of a framed family portrait: Dan, Beth, and Ellen irrevocably fixed within their prescribed roles—a small consolation to viewers who read the image as indicative of an ultimately deadening stasis.

Given the success of *Fatal Attraction*, and the absence, undercutting, or destruction of strong, independent women in Hollywood films generally, Louise and Thelma were decidedly a breath of fresh air for many viewers, including feminists. The two friends may begin their journey with just small acts of resistance, of rebellion, as they abandon the roles they've assumed in relation to Thelma's husband, Darryl (Christopher McDonald), and Louise's boyfriend, Jimmy (Michael Madsen), but when they violently challenge Harlan's (Timothy Carhart) predatory physical and verbal assaults, they begin a journey toward growth and self-determination that seriously questions the patriarchal status quo and gives women and allies cause for celebration. As Louise and Thelma take action, even when they act illegally and destructively, audiences are allowed to identify with them, to see events from their perspectives, and to respond empathetically. Just as Alex in *Fatal Attraction* is given short shrift through that film's narrative perspective and *mise-en-scène*, so Louise and Thelma's male antagonists are caricatured through unsympathetic thumbnail sketches that underscore some of the most misogynist facets of patriarchal society (Dargis, 17; Maslin, 16; Schickel, 54).

The male caricatures, despite the seriousness of many of the film's events, actually contribute to its lightness of tone through most of Louise and Thelma's journey. This tone is sustained and supported by the women's irrepressible energy and humor and by their progress toward

more and more predominantly open, well-lit spaces in which to move (Rapping). Like the reversal of points of view and character representation *Thelma & Louise* effects, its tone and ambiance counter the dark, horrific *mise-en-scène* of *Fatal Attraction*. On the one hand, Louise and Thelma, despite their diminishing options as they rush toward Mexico, grow stronger and more self-assured during their flight; on the other hand, Alex, and with her Dan and Beth are themselves increasingly closed in and diminished, their final confrontation taking place at night in the bathroom of the Gallaghers' locked but still penetrable house. With Alex eliminated, *Final Attraction's* final image of the closely cropped and framed Gallagher family portrait contrasts significantly with the dynamic motion of Louise's Thunderbird as it spins out over the Grand Canyon and is frozen in midair, in the last shot of *Thelma & Louise*. Louise and Thelma's fate is sealed, but their integrity and friendship are intact. They may not have been able to fashion successful alternative lives, but they have suggested that access to their bodies can be denied and the rule of the father subverted.

While *Fatal Attraction's* Alex moves from confidence and competence to madness within the structure of a melodrama, Louise and Thelma move from cool detachment (Louise) and naiveté (Thelma) to self-definition and friendship within the linear structure of a road movie. Their personal—or spiritual—growth parallels their physical journey. While stops along the way mark their progress, the pace and setting of the drive itself set the tone of the film and reflect the women's spirit and energy. Just what does take place on the road with Louise and Thelma, two "ordinary" women whose initial intent was simply to get away for a weekend of fun in the mountains?

Louise and Thelma might initially be seen as unlikely friends, though one can also view them as complementary, each giving the other something the other lacks: the intercutting between the two in the film's opening scenes underscores their differences. Louise is older, more serious, more sophisticated, an independent, self-supporting single woman who is deliberate in her actions and as meticulous in her personal appearance as she is in her housekeeping. She is goal oriented and has to work at having fun. Thelma is portrayed as both childlike and childish. She is charming, spontaneous, accommodating, and naive, dependent, easily intimidated, undisciplined, and unorganized. Slipped into these portraits are suggestions of a mother-child relationship. Louise addresses Thelma

affectionately as "little housewife," admonishes her with, "Don't be a child," when Thelma confesses she hasn't yet told Darryl about their proposed trip, and casts a disapproving glance at "Thel-ma!" when Thelma puts her feet on the dashboard of the Thunderbird; Thelma asks Louise for advice about packing, asks her to take care of the gun she packed, and resorts to a childish, "I never get to do stuff like this," to convince Louise to make the first road stop.

The dynamics of the relationship established in these early scenes continue to the point when Louise breaks down after J. D. (Brad Pitt) vanishes with the $6,700 she has counted on for their escape. Up to that point, Louise assumes and exercises control. She tries to temper Thelma's high spirits and naiveté at the Silver Bullet and, failing that, rescues her during Harlan's attempted rape. After she shoots Harlan, the women stop at a motel, so Louise can "get it together" and "figure out what to do." While Louise does this Thelma appears to retreat further into childhood as she curls into a fetal position on the motel bed. It takes Louise's directives to get Thelma moving. A bit later, Thelma both relies on and goes beyond Louise's earlier challenge and question—"Is he your husband or your father?"—in standing up to Darryl when he orders her back home: "Darryl, you're my husband, not my father," adding an invective to punctuate her resolve not to be bullied. Back in the car, she signals Louise that she's ready to escape with her to Mexico.

Thelma is obviously not completely passive with Louise either. She argues with Louise and issues her own challenge when Louise asks her to map their route to Mexico without going through Texas: "The only thing between Oklahoma and Mexico *is* Texas." When Louise insists on avoiding Texas and asks Thelma if she understands this, Thelma's blunt reply is, "No, Louise, I don't," followed by a request for an explanation which Louise ignores. Louise remains in control, directing Thelma to call Darryl—ostensibly to tell him when they will be back but actually to see if the police have linked them to Harlan's death; refusing and then granting J. D. a ride; instructing Thelma and J. D. to say their good-byes while she runs into the Vagabond Motel to pick up the money Jimmy was to wire; and, later, directing Thelma to "guard that money, and if there's *any* problem, you call me." She's clear and to the point—as one needs to be when leaving a child on its own. But like a child, Thelma lets J. D. distract her from this responsibility and loses the money to him.

This sequence is pivotal and filled with irony. It juxtaposes the end of Louise and Jimmy's relationship with Thelma and J. D.'s playful sexual encounter, Louise's self-control with Thelma's spontaneity, and Louise's despair with Thelma's newly discovered energy and enterprise. Louise accomplishes what she hoped to accomplish when she and Thelma set out for the weekend, eliciting a serious commitment from Jimmy. His proposal, of course, comes too late. Thelma also has the fun she was looking for, though, given her unsatisfying relationship with Darryl and the trauma of her interaction with Harlan, the sexual initiation that shapes the fun is a surprise. The fun ends as abruptly as her brief encounter with Harlan, when she and Louise discover J. D. has robbed them. The discovery causes Louise, having run out of resources and ideas, to slip into despair and immobility, while Thelma is energized into action and authority, a clear reversal of roles underscored by the parallels between this and the earlier motel sequence when Thelma retreated into herself while Louise figured out what to do.

Seeing Louise crumble and recognizing her complicity in J. D.'s robbery, but still enlivened by her sexual encounter, Thelma instinctively urges Louise to "Get up!" and "Move!" when they leave the Vagabond Motel. And it is Thelma who is driving when they make their next stop. Louise is listless, Thelma upbeat, confident, and decisive. Adopting J. D.'s style, she pulls off the robbery of a country market with the aplomb and charm J. D. demonstrated when he seduced and robbed her. Her shouted instructions to Louise to "Drive" and "Go! Go-go-go. Go!" define the new Thelma. Louise thinks through situations and figures out what to do; Thelma acts impulsively and instinctively. The women haven't completely escaped the mother-daughter overtones of their relationship as some of their later interaction attests, but they have definitely shifted positions. Thelma assumes more responsibility, while Louise admits greater vulnerability. They begin to forge the deeper friendship that makes it possible for them to cut their ties and attachments to specific men—Darryl, Jimmy, and J. D.—and begin a journey that leads them to reject a society ruled by the father. This patriarchal world is very much present throughout *Thelma & Louise*, most blatantly in the interaction between Thelma and her overbearing, abusive husband, Darryl, and between both women and two particularly predatory males, Harlan and the trucker who harasses them on the road; but it is also evident in Jimmy's and detective Hal Slocombe's (Harvey Keitel) protective stances

toward the women. Just how pervasive this male world is is reflected in a *mise-en-scène* characterized by phallic images such as semitrailers, hoses, and oil derricks, as well as in an iconography and a linear narrative structure defined primarily by westerns, road movies, and buddy films (Roberts, 61; Shapiro, 63).

How far Louise and Thelma travel in their journey of transformation is apparent when we remember that immediately after Harlan was killed, they independently turned for help to Jimmy and Darryl (neither of whom was home when called). With the notable exception of Louise's request that Jimmy wire her the equivalent of her life savings, neither she nor Thelma asks men for further help, but they do adopt male modi operandi as these are typically portrayed in the genres in which they operate. When Thelma, for example, robs the country store, she doesn't hesitate at drawing a gun even though earlier she had not wanted to touch the .38 pistol. Louise pulls that gun on Harlan to stop his attempt at rape and kills him with it, but then, moments after, she looks at it in apparent disbelief as she holds it in her lap. Later, when they are pulled over for speeding, Thelma seems comfortable using the gun to effect their release and force the officer into the trunk of his car, shooting holes in the trunk— "air holes"—before he crawls in. Louise seems to waiver between confusion and awe as she watches Thelma and follows her instructions to take the officer's gun and shoot the radio. Though close to panic when they first notice the police car pursuing them and extremely apologetic as they disarm and confine the officer, once back in Louise's Thunderbird, they expertly reload the guns while Thelma comments that she thinks she has a "knack for this shit." Louise readily concurs.

Both Louise and Thelma display a knack for wielding guns in their encounter with the trucker who repeatedly harasses them. After inviting him to join them at a deserted roadside stop, they demand an apology for his disgusting behavior. When he refuses, Louise flattens three of his tires with three expertly aimed shots and gives him another chance to apologize. Following his second vehement, even hysterical refusal, she and Thelma calmly fire several more shots into his oil tanker. As it explodes, they drive victoriously around the still recalcitrant trucker, Thelma snatching his hat from the ground, and the women drive off savoring their triumph and congratulating each other for their marksmanship. Marks*man*ship seems to be the right word here because of their identification with guns and with the male roles associated with many

buddy films and westerns. Their absorption of a male mode is signaled not only by their growing ease with guns, but also by their dress, particularly the hats they wear in several scenes. Well worn and grimy, both were previously owned by men. Louise traded her jewelry, including Jimmy's engagement ring, for hers, and Thelma picked up the trucker's as a trophy.

The women appear to be moving more deeply into male territory, adapting themselves to that world as they go, without ceasing to be nice, polite, and agreeable in ways that women are acculturated to be. They have discarded their makeup and with it their concern for their image. They have moved from reacting to acting. When Louise shot Harlan she was responding to his attempted rape of Thelma and to her own painful Texas experience. Thelma's robbery, modeled after J. D.'s, was a reaction to his betrayal and their need for money. The kidnapping of the state trooper was "forced" by his imminent discovery of who they are. With the trucker, they engineer the confrontation specifically to challenge his assumption of male prerogative. Their next encounter, however, is again with the law: they are pursued in what becomes a typical—except that the pursued are women—adventure-film car chase. Though pressed once more into reacting to male power, they actually manage to elude the police temporarily and enjoy a brief respite before they are finally, and literally, trapped by the law at the edge of the Grand Canyon.

The chase is very much in the male mold and calls for "good drivin'" by Louise as she runs police barricades, crashes through fences, and steers her convertible under a low viaduct while being pursued by over a dozen cops. She and Thelma even wear the men's hats they acquired earlier. By the time they reach the edge of the canyon and are pinned down by the police, a wind stirred up by the blades of a police helicopter has blown the hats away. The cops—far more than needed under the circumstances—point high-powered rifles at them, and Louise reaches for a gun, asserting that she's not giving up. But Thelma has another idea: "Let's keep goin'!" When Louise asks what she means, she looks out over the canyon, points with her chin, and says simply, "Go." They do. Exchanging a kiss and a smile and clasping hands high, they choose friendship, freedom—and death—rather than punishment and reabsorption into a world of male privilege.

Ultimately, Louise and Thelma reject the male world, its methods and solutions. They are not, therefore, Butch Cassidy and the Sundance

Kid going out in a blaze of gunfire (Roberts, 66); rather, they choose to reaffirm their bond of female friendship, the one thing that they are unwilling to relinquish. Just before Louise very deliberately floors the accelerator and sends them over the canyon, a shot of the backseat of the Thunderbird focuses on an ammunition belt, a necklace, and a jacket. Louise and Thelma have discarded both the traditional male and female worlds represented by the trooper's stolen belt and by the necklace. The jacket—owned by Louise, worn by Thelma—suggests their friendship, but even the jacket is no longer needed since they've moved beyond the material world to another plane where neither "men with guns" (Sayles) nor the most solicitous of fathers can reach them.

Detective Hal Slocombe seems to be a most solicitous father, but he "turns out to be the most dangerous" of the men with whom Louise and Thelma interact. He asserts a "sympathetic but paternalistic authority" that tempts Louise to confide in him, but his concern works as a snare and gives the FBI the women's location (Griggers, 129; Grundmann, 35). He protests the excessive firepower the law assembles to bring Louise and Thelma in, but his protests are as ineffectual as his last desperate run to stop them when they defy all male authority once and for all by heading for the canyon. Jimmy also is solicitous and anxious to help Louise in particular. Not clear about what she needs and not willing simply to wire the money she requests, he appears in Oklahoma City with the money, an engagement ring, and an assumption that that will solve Louise's problem. His presence complicates the situation instead, because it interrupts Louise and Thelma's escape, holding them in place while Louise tries to ease Jimmy's anxiety. Like Slocombe, he wants to help, but he's so much a part of the patriarchy, he can't get beyond it.

Louise and Thelma themselves can't escape except through self-destruction because they are hostages of the genres in which they exist (Roberts; Stringer). A hybrid of westerns, road films, and buddy movies, *Thelma & Louise* follows the masculine trajectory of accelerating a linear journey. Male cultural and cinematic codes determine its *mise-en-scène*, as well as its narrative structure and pace. This is particularly evident as Louise and Thelma get caught up in the chase and a final confrontation with the law. Previously, the robbery and their subsequent escape and then their destruction of the semitrailer had excited and energized them. With the chase, speed is coupled with the challenge of outdistancing the law to create an exhilarating momentum that

captivates Louise and Thelma. They are enlivened and emboldened when they go or do, when they become agents, but their agency, within the parameters of a male adventure, leads inexorably to a showdown. The film "does not provide, or even allow for, a female space for escape or revitalization" (Roberts, 66). Because they refuse the showdown and have no "female space for escape," their choice is death, a choice at once inevitable and deliberate given the conflicting demands of character and structure in *Thelma & Louise*. By making the choice they do, Louise and Thelma personify unusual integrity and independence. How do they reach this point?

Having been an integral part of the patriarchy, and having learned their roles well, Louise and Thelma turn to male partners to get them out of trouble after Harlan is shot. That doesn't work, and Louise focuses on "tryin' to figure out what to do." She assesses the situation and comes up with a plan. When that plan goes awry, largely due to Jimmy's concern and inability to trust Louise's judgment but also because of J. D.'s treachery and skill, Louise and Thelma set out for Mexico anyway. Thelma's readiness to go is prompted as much by Darryl's domineering stance as by J. D.'s theft. As indicated above, the trip is characterized by Louise and Thelma's acceptance, enjoyment, and increasingly skillful use of male strategies of survival, but they ultimately abandon these because the process of transformation they are going through involves more than survival. It encompasses how they see the world, how they see themselves, and what they gain through their interaction with each other and through the action they take once they end their relationships with Darryl, Jimmy, and J. D.

Louise and Thelma initially view the world differently from one another. For Louise, the defining experience occurred in Texas, and though it is never explicitly described, repeated allusions to the event suggest not only that she was sexually assaulted but that her report of the assault was dismissed. Every reference to Texas alludes to this event, even Louise's comment that she hasn't seen a place like the Silver Bullet since she left Texas, which in retrospect foreshadows Harlan's attempted rape of Thelma. After she stops Harlan and he asserts he and Thelma were "just havin' fun," Louise, with an intensity that suggests direct experience, tells him, "When a woman's cryin' like that, she i'nt havin' any fun!" She begins to follow as Thelma leaves, but Harlan, arrogant and contemptuous, won't quit. "Suck my cock," he says. She turns back and silences him

with a bullet. When Thelma wants to go to the police for help and sup-
port, Louise angrily retorts that they "don't live in a world like that." She
understands that neither her Texas experience nor Harlan's assault is an
isolated incident and that in a male-dominated society, the police cannot
be counted on to share a woman's perspective on sexual assault. Under-
standing this relationship between her personal experience and the larger
world has made her careful, even cynical.

Thelma has not had a defining experience comparable to Louise's,
and, given her temperament, she does not analyze situations or reflect
on their broader meaning. She began dating Darryl when she was four-
teen years old, married him at eighteen, settled into the role of house-
wife, and accepted his domination. She was afraid to ask his permission
to take a weekend vacation with Louise because she was not willing to
risk refusal. She was willing to risk his wrath, however, and opted to
escape with Louise, a small act of rebellion signaling her dissatisfaction
with her marriage. Despite this dissatisfaction and some suspicion about
Darryl's late hours at work, she is unusually trusting and completely
unsophisticated in relations with men, especially strangers. Unlike
Louise, Thelma has not made the connection between Darryl's excessive
control and the larger world. Even a succession of negative encounters
with various men, including Harlan's assault, further verbal abuse from
Darryl, and J. D.'s theft, isn't enough to bring Thelma to see a connec-
tion between her experiences and the patriarchal society in which she
lives. Her response to J. D.'s theft is, "I've never been lucky"—the pat-
tern she sees revolves around herself. It's only after she begins to take
charge and to exert power herself that she begins to understand the
dynamics and the pervasiveness of male power, specifically male power
over women.

Thelma's advice to the state trooper as she forces him into the trunk
of his car is to "be sweet" to his wife and children, especially his wife
because "My husband wasn't sweet to me. Look how I turned out." She
seems to be moving toward a recognition that her situation vis-à-vis Dar-
ryl is not unique and needs to change. Conversations with Louise help
bring her to this broader view since Louise continually cautions her
against being too open, too trusting; and it becomes increasingly clear,
through her own experience as well as her growing understanding of the
trauma of Louise's Texas experience, that Louise has good reason for giv-
ing this advice. Exercise of her own power, the cumulative effects of mas-

culine power on her and on Louise, and her friendship with Louise bring Thelma to the point where she realizes, more through instinct than reflection, that "somethin's crossed over in me" and "everything looks different." She can't go back to what or where she was; she is too awake, too aware. Her perception of herself changes as her understanding of the world changes.

Initially, though, Thelma shows little self-awareness. She does know she wants to have fun, and with Darryl that isn't an option. While on the road with Louise, Thelma begins to reflect more on who she is and what is important to her. Even when Louise comments that the situation they're in might get them killed, Thelma still sees "havin' some fun" as a priority. What she defines as fun has changed from the kind of good time the Silver Bullet offers to taking charge in a crisis or speeding purposefully through a beautiful part of the country, unconcerned about appearance, focused in the present with wind and motion contributing to a sense of freedom and possibility. She comes to value her friendship with Louise more than her marriage or a heterosexual relationship; though she does learn to enjoy sex when J. D. shows her "what the fuss is all about." She realizes she "just couldn't live" the way she had before, and it's this realization that enables her to suggest she and Louise "keep goin'" even when that means plunging to their deaths.

Louise doesn't change as dramatically as Thelma does in her view of either the world or herself. What happened to her in Texas informs both and causes her to distrust men in general, to be cautious in her relationships and circumscribed in her body language. Always reflective and usually serious, once Thelma starts taking responsibility, Louise lightens up on occasion. Thelma's assertiveness takes Louise by surprise when she robs the store, and leaves Louise momentarily speechless when she pulls a gun on the state police officer. Louise's respect for Thelma grows in proportion to Thelma's acceptance of responsibility and her derring-do. Thelma's bold action stirs Louise to greater daring, and she finds their joint ventures satisfying. Like Thelma, despite their fugitive status, she enjoys both their camaraderie and the beauty of the Southwest as they rush toward Mexico. She becomes noticeably more animated and relaxed when she and Thelma take on various representatives of the patriarchal world, but she never reaches the point where she can talk about the Texas experience, the experience that subsequently shaped every aspect of her life.

Thelma annoys Louise when she tries to pry an explanation of the Texas trauma from Louise, but as Thelma matures, she intuits what happened and learns to respect Louise's unwillingness to talk about it. Their last exchange on the subject is prompted by Thelma's memory of Harlan's assault, and she asks Louise, "It happened to you, didn't it?" When Louise stops the car, turns to Thelma, and reiterates her intent not to talk about it, Thelma responds reassuringly with, "It's okay," and, more softly as they resume their journey, "It's okay." She is far more understanding and supportive because of her own development and the deepening of their friendship. Other indications of the growth of their friendship, as suggested above, include Louise's greater respect for Thelma, their increased interdependence as they sever relationships with the men they relied on previously, and their shared pleasure in simultaneously adopting and challenging male prerogatives. Further indications are the serious discussions and easy banter that gradually replace the thinly disguised accusations and arguments they had directed at each other earlier. Their final agreement, kiss, clasped hands, and action—proposed by Thelma, executed by Louise—seal their commitment to one another.

Ridley Scott does not give audiences time to dwell on Louise and Thelma's leap into the Grand Canyon beyond the affirmation and expansiveness of the gesture. Scott freezes the frame while they are still in midair, fades to white—not black—and begins a revue of Louise and Thelma's odyssey through a series of close shots that continues under the credits. All of the clips show the two friends laughing, smiling, "havin' fun." With this ending, Scott turns attention away from the western and road movie dynamics that bring Louise and Thelma to the edge of the world and refocuses the film on the fantasy elements that have helped determine its overriding tone of optimism—and that have amused, delighted, aggravated, or frustrated viewers.

I am among the amused and delighted and have included in my analysis a great deal of descriptive detail to support my interpretation, but I am aware that another critic could, or already has, used some of the same detail to support an opposing perspective and will not be swayed by mine. Like *Fatal Attraction, Thelma & Louise* seems to serve as a Rorschach test (Corliss) for viewers, one that film journalists and scholars have not hesitated to take, judging from the amount of discussion sparked by the film. The earliest reviews were quickly followed by "reviews of the reviews" (Carlson; Maslin; Pincus and Trojan; Schickel; Shapiro) that

usually illustrated how widely varied and passionate the first responses had been before vigorously attacking or defending the film themselves. Film scholars joined the discussion, most notably in *Cineaste* (1991) and *Film Quarterly* (1991–92) forums. Though for the most part relying on less fiery rhetoric, they too expressed multiple, sometimes contrary, perspectives. Book chapters have followed and though not always exclusively focused on *Thelma & Louise* (Griggers; Hollinger; Keating; Roberts; Stringer; Willis 1993; 1997a; 1997b), they have broadened the contextual and theoretical frames used to explore the film.

Virtually all of the analyses of *Thelma & Louise*, like mine, foreground the movie's ideological significance and meaning emphasizing the presence of women in roles traditionally reserved for men in genres identified first and foremost with men. Because Louise and Thelma, female characters in a hybrid male genre, are translated by viewers into women in a man's world, their gender becomes the pivot around which all of the film's meanings revolve (Willis 1997a, 287). Given the impact of the women's movement and of feminism over the past quarter century, this should not be surprising. Women have been redefining and sampling an array of ways to be in the world, pressing men to adjust and rethink their positions as well. *Thelma & Louise* suggests how difficult this process is, given the patriarchal restraints still in place. The responses to *Thelma & Louise* suggest how wide the gulf is between those who deeply resent and resist changes in the status quo and those who welcome and applaud any progress, no matter how limited, toward gender equality.

WORKS CITED

Carlson, Margaret. 1991. "Is This What Feminism Is All About?" *Time*. 24 June, 57.

Cohan, Steven, and Ina Rae Hark. 1997. "Introduction." In *The Road Movie Book*. New York: Routledge.

Corliss, Richard. 1987. "Killer!" *Time*. 16 November, 72–81.

Dargis, Manohla. 1991. "Roads to Freedom." *Sight and Sound* 1 (July), 15–18.

Faludi, Susan. 1987. "Attraction Is Fatal: Movie's New Villain Is the Single Woman." *St. Louis Post-Dispatch*. 29 November, 3F, 14F.

Griggers, Cathy. 1993. "*Thelma and Louise* and the Cultural Generation of the New Butch-Femme." In Jim Collins et al., eds., *Film Goes to the Movies.* New York: Routledge.

Grundmann, Roy. 1991. "Hollywood Sets the Terms of the Debate." *Cineaste* 18: 4, 35–36.

Hollinger, Karen. 1998. *In the Company of Women.* Minneapolis: University of Minnesota Press.

Kamins, Toni, and Cynthia Lucia. 1991. "Should We Go Along for the Ride? A Critical Symposium on *Thelma & Louise.*" *Cineaste* 18: 4, 28–36.

Keating, Nicole Marie. 1999. "If Looks Could Kill: Female Gazes as Guns in *Thelma and Louise.*" In Murray Pomerance and John Sakeris, eds., *Bang Bang, Shoot Shoot! Essays on Guns and Popular Culture.* Needham Heights: Simon and Schuster.

Martin, Ann, ed. 1991–1992. "The Many Faces of *Thelma & Louise.*" *Film Quarterly* 45: 2 (Winter), 20–31.

Maslin, Janet. 1991. "Lay Off *Thelma and Louise.*" *The New York Times.* 16 June, 11, 16.

Murphy, Kathleen. 1991. "Only Angels Have Wings." *Film Comment* 27 (July–August), 26–29.

Pincus, Elizabeth, and Judith Trojan. 1991. "At Odds over *Thelma and Louise.*" *New Directions for Women* (September–October), 16.

Rapping, Elayne. 1991. "Feminism Gets the Hollywood Treatment." *Cineaste* 18: 4, 30–32.

Roberts, Shari. 1997. "Western Meets Eastwood: Genre and Gender on the Road." In Steven Cohan and Ina Rae Hark, eds., *The Road Movie Book.* New York: Routledge.

Sayles, John. 1997. *Men with Guns.* Columbia TriStar Films.

Schickel, Richard. 1991. "Gender Bender." *Time.* 24 June, 52–56.

Shapiro, Laura. 1991. "Women Who Kill Too Much." *Newsweek.* 17 June, 63.

Stringer, Julian. 1997. "Exposing Intimacy in Russ Meyer's *Motopsycho!* and *Faster Pussycat! Kill! Kill!*" In Steven Cohan and Ina Rae Hark, eds., *The Road Movie Book.* New York: Routledge.

Willis, Sharon. 1993. "Hardware and Hardbodies, What Do Women Want? A Reading of *Thelma and Louise.*" In Jim Collins et al., eds., *Film Goes to the Movies.* New York: Routledge.

———. 1997a. "Race on the Road: Crossover Dreams." In Steven Cohan and Ina Rae Hark, eds., *The Road Movie Book.* New York: Routledge.

———. 1997b. *High Contrast.* Durham: Duke University Press.

Wood, Robin. 1986. *Hollywood from Vietnam to Reagan.* New York: Columbia University Press.

FIGURE 15. The association of books with men, and men with books, in *Yentl* (Barbra Streisand, 1983): an ultimate expression of the sexiness of Jewish men, in this case "men." (frame enlargement)

CHAPTER SIXTEEN

◈

Jews in Space:
The "Ordeal of Masculinity" in Contemporary American Film and Television

DAVID DESSER

At the end of *History of the World—Part I* (1981), Mel Brooks's sometimes hilarious, sometimes juvenile look at the high and low points of the development of human history from the Stone Age to the French Revolution, the director offers us a putative preview for the never-made *History of the World—Part II*. In it he includes a number of scenes from this would-be sequel, including a sequence entitled "Hitler on Ice," nothing other than a look-alike performing some rudimentary figure-skating routines. Perhaps this is simply Brooks continuing his obsession with Germans, Hitler, and the Nazis—he finds room for some World War I-era German soldiers in his "western," *Blazing Saddles* (1974), and has made films such as *The Producers* (1968) and *To Be or Not To Be* (1983) focusing significantly or centrally on the Nazis. Following the preview, "Hitler on Ice," Brooks offers up another sequence in this alleged sequel, "Jews in Space," a sci-fi spectacular featuring Star-of-David-shaped spaceships, flown by obviously Orthodox Jews, singing of the glories of "defending the Hebrew race." What is the source of the intended humor of these two

267

scenes? In both we may understand that the comedy derives from the use of nonsequitur, an unlikely or surreal combination of images. That Hitler might simply appear as a graceful figure skater and that Orthodox Jews might be fearsome fighter pilots are both, ipso facto, intended as impossible images.

A quick look at *Independence Day*, the 1996 summertime Hollywood blockbuster, might seem to indicate that the American cinema has come a long way since the days when all men were staunchly WASP and strictly heterosexual. Though the United States president (Bill Pullman) is still lily white, the intrepid heroes who here save the day include a black fighter pilot (Will Smith) and a Jewish scientist (Jeff Goldblum) bravely trekking into outer space to meet the enemy and destroy the alien threat, while on the ground a gay scientist (Harvey Fierstein) helps solve the riddle of the aliens' intentions. One could easily imagine that just a few years previously this fighter pilot would be as white as the stars of *Top Gun* (1986), Tom Cruise and Anthony Edwards, and that the Jewish scientist would remain strictly on the ground and behind the scenes while the gay character would belong only in another type of film.

Certainly, Will Smith, as the tough-talking, fast-acting fighter pilot, demonstrates how much has surely changed for African American movie stars in the '90s. With crossover blockbuster hits such as *Men in Black* (1997), *Enemy of the State* (1998), and *Wild Wild West* (1999), Smith shows that in the action cinema skin color may no longer be a barrier to leading-man status. Stars such as Denzel Washington, Wesley Snipes, and Eddie Murphy perhaps demonstrate that as well, as do Danny Glover and Morgan Freeman. But is the situation quite so sanguine for Jewish stars? What about openly gay male stars? And do black actors still labor under other kinds of stereotypical images? Could we, for instance, imagine *Independence Day* with a Jewish fighter pilot and a black scientist? As Will Smith appears as an action star opposite a Jewish actor in *Wild Wild West*, could we similarly imagine Kevin Kline as James West and Will Smith as Artemus Gordon? While the situation for African American actors and openly gay characters is well worthy of intensive analysis, this chapter will focus on the lingering stereotypes of Jewish characters prevalent in the American mass media and on efforts by Jewish writers, directors, and performers not necessarily to rewrite images of Jews, but, more interestingly, to rewrite larger cultural conventions that have an impact upon the images of Jews.

Unlike many, even most, minority groups within the United States, Jews have been unique in their ability to control their own media images.

Nevertheless, a variety of forces have contributed to an ongoing media stereotyping of Jewish men as, on the one hand, physically small, weak, urban dwellers ill at ease on the farm and in the country; or, on the other, clever, cunning, fast-talking city slickers. These images of frail urbanites, more verbal than physical, more devious than brave, in short, more brainy than brawny, have adhered to Jewish men ever since the encounter of the *Ostjuden* with modernity, the shtetl or city-dwelling Eastern European Jews butting up against the forces of the Enlightenment and their Western European brethren. For Jewish intellectuals and community leaders in Europe and the United States in the latter half of the nineteenth and first half of the twentieth centuries, this close encounter with modernity meant a sometimes embarrassing struggle to attain mainstream ideals of behavior patterns and actions. Many intellectuals reacted with feelings of embarrassment and shame, producing for them what John Murray Cuddihy has called "The Ordeal of Civility." Many social or cultural movements grew out of the tensions between Jews and Gentiles, between Yiddishkeit and the Protestant Ethic. The formation of Reform Jewry, for instance, a kind of "Episcopalianization" of Jewish religious observance and ritual, was one response. Others ranged from the formation of Jewish fencing societies in Germany (literally to out-duel the antisemitic images plaguing Jews), to "muscle Jewry" movements in the United States and the United Kingdom, and attempts in the United States explicitly to relocate Jews from the Northeast to the farmlands of the Midwest.

Yet I suspect that for Cuddihy, something more devious may also be found in the Jewish struggle with modernity, in the Jewish confrontation with not only the Protestant Ethic but also what he calls the "Protestant Esthetic and the Protestant Etiquette" (4). From out of this ordeal, Jewish intellectuals and thinkers, like Marx, Freud and Lévi-Strauss, questioned the foundations of the culture from which these tensions arose, rewriting the codes of the very civilization with which they struggled. I am hypothesizing here, if not an ordeal of civility on the part of Jewish media artists, then an "ordeal of masculinity." This ordeal of masculinity may take two forms: creating counterimages of Jewish men more in conformity with "traditional" images of American masculinity or rejecting traditional definitions of masculinity entirely, in either case rewriting, as it were, what it means to be a man—and in this rewriting reconfiguring issues of sexuality, of sexual desirability, across gender lines.

For most of the modern era, Jewish writers, artists, and filmmakers labored within the paradigm of muscular masculinity, the traditional

image of masculinity of the Euro-American experience, an image in which the Jew (i.e., the Jewish man) quite literally came up short. Thus in order to prove their masculinity, to prove they were men, Jews had to become soldiers, fighters, and sports figures and thus, the Jewish domination of boxing in the first half of the twentieth century; the prominence of many Jewish baseball and football stars (Hank Greenberg, Sid Luckman); and the near-universal military service of American Jewish men. Images of Jews interspersed throughout much of the American mass media of the twentieth century have similarly tried to situate Jews within these hypermasculine contexts: the Jewish boxer (from *His People* [1925] to *Body and Soul* [1947]); the Jew as heroic soldier (the ubiquitous New York Jew is in every platoon of every World War II combat film); the Jew as freedom fighter (*Exodus* [1960], *Cast a Giant Shadow* [1966]). More recently, the Israeli Jew has emerged as a kind of superman, ruthless, competent, and heartless, in films such as *Eyewitness* (1981) or *Homicide* (David Mamet, 1991) to name only two.

Alternately, Jewish comics, in particular, have engaged in a kind of self-denigration sometimes verging problematically on self-hatred in portraying themselves as classically unmasculine—thus Woody Allen's perpetual neuroses and lack of confidence in films such as *Take the Money and Run* (1969), *Bananas* (1971), *Play It Again, Sam* (1972, directed by Herbert Ross from Allen's own play), and *Sleeper* (1973), or Albert Brooks's often quite subtle understandings of the Jewish man's ordeal of masculinity in films such as *Modern Romance* (1981), *Lost in America* (1985), and *Defending Your Life* (1991).

But whether imaging men as "tough Jews" (Breines) or as insufficiently masculine, such films as these (and literally hundreds of others one could name) have coalesced around an unproblematic and untroubled image of masculinity. Whether Jews veered away from it or aspired toward it, this masculinist image—and ideology—was a constant.

But in media and discourses, we may see an alternative to this masculinist bind, a way not of defining Jewish men according to these mainstream modes of masculinity, but of rejecting these mainstream images as defining "masculinity." In other words, if Freud, Marx, and Lévi-Strauss rewrote the foundations of Western civilization, Jewish artists, writers, and cultural critics may be seen to be rewriting the foundations of masculinity.

Daniel Boyarin, perhaps one of the most interesting cultural critics writing on, and working in and through, a Jewish perspective, writes the following: "As I reflect on my coming of age in New Jersey, I realize that

I had always been in some sense more of a 'girl' than a 'boy.' A sissy who did not like sports, whose mother used to urge me, stop reading and go out and play" (xiii). But instead of doing that, instead, that is, of sub-scribing, as his mother wished, to the masculinist fantasy of mainstream culture, he rejects that approach: "Rather than producing in me a desire to 'pass' and to become a 'man,' this sensibility resulted in my desire to remain a Jew, where being a sissy was all right" (xiii). Two important rhetorical advances are made via this stance: the first is that the Jewish man, Boyarin, does not deny the idea widespread throughout the culture that being Jewish renders a boy effeminate; the second is that being "Jew-ish" provides an alternative image of masculinity. That is, the effeminate Jewish man of antisemitic rhetoric is, in fact, a sissy, but a sissy is, in turn, the "real man."

> He whom a past dominant culture . . . considers contemptible, the feminized Jewish . . . male, may be useful today, for "he" may help us precisely today in our attempts to construct an alternative masculine subjectivity, one that will not have to rediscover such cultural archetypes as Iron John, knights, hairy men, and warriors within. (xiv)

I would like to consider this image of an "alternative masculinity" within a strictly heteronormative context by demonstrating that the image of the Jewish man has not necessarily significantly shifted from the traditional portrayal of the Jew as urban, weak, frail, and intellectual, but rather has itself, to some extent, been transformed and transposed into one of desir-ability. The Jewish male continues to exhibit many of the characteristics antisemitic culture has traditionally ascribed to him, but these very char-acteristics are now to be seen as desirable masculine traits within the spec-trum of heteronormative sexuality. Even more simply: Jewish men are sexy precisely when they exhibit the very cultural traits ascribed to Jews.

I want to demonstrate this newfound potency in the image of the Jewish man along two axes: (1) I want to show that, for the most part, Jewish men are still assigned the sorts of roles and images they have tra-ditionally inhabited, but (2) in inhabiting these roles they now become sexually desirable and potent, not only heterosexually, but along inter-racial, interethnic lines as well. Playing off the most notorious antisemitic imagery of all—that the Jewish man is the despoiler of the Aryan woman—contemporary images find the Jewish man as a desirable partner for non-Jewish women.

Interestingly, the most revealing site of analysis to demonstrate how these parallel axes play out may be found on American television as much as, or more than, in the cinema. Precisely because of television's "normative" qualities—residing in the house, on at all times, a member of the family—and precisely because it is the most strictly commercial medium ever known—no ratings, no show—both a prevalence of Jews there and a conformity to a constrained series of images and roles reveal a sociohistorical moment in great relief. First, I want to demonstrate a prevalence of overtly Jewish characters on American television; then I want to describe the sorts of roles they inhabit and contrast these to the sorts of roles assigned to non-Jews. Then I want to show how the very "Jewishness" of the male roles gives rise to a new counterimage of masculinity. In turn, this counterimage of masculinity extends to the cinema where, in the '80s and '90s, Jewish men inhabit the sorts of leading-man romantic roles previously reserved for only the nonethnic, traditional male.

Anyone watching American network and cable television between 1986 and 1996 or so would have seen a wide array of Jewish characters, especially men, in leading and major supporting roles. In the long-form drama, but most particularly in the sitcom, Jews appeared in virtually unprecedented numbers; so much so that their lack of appearance in earlier televisual programming finally became noticeable. In specific, within this ten-year period, programs such as "L.A. Law" (1986–94), "thirtysomething" (1987–91), "Murphy Brown" (1988–98), "Northern Exposure" (1990–95), "Seinfeld" (1990–98), "Love and War" (1992–95), and "Mad About You" (1992–99) featured Jewish men engaged in particularly—indeed, stereotypically—Jewish pursuits. These were all primetime network programs. The HBO program "Dream On" (1990–96) might also be mentioned in this context. Moreover, programs such as "Murphy Brown," "Mad About You," "Seinfeld," "Northern Exposure," "L.A. Law," and "Love and War" consistently ranked in the top twenty (and in the case of the sitcoms, the top ten) programs for season after season of their runs. "Seinfeld," of course, was for years among the most popular programs on television; in the 1993–94 season it was number 3; in 1994–95, it reached number 1, a position it held virtually until its self-motivated finale.

Both the ubiquity of Jews on American prime time (there are other programs in this period one could mention as well, by way of further demonstration: "Law & Order"; "Homicide: Life on the Street"; "Cybill," all containing major Jewish characters) and the popularity of the shows in

which they are featured, are in marked contrast to much of the televisual past. Though Jews have been present in American television from its start after World War II, both behind and in front of the camera (the Jewish influence on American television is consonant with the influence on American cinema), few, if any, identifiably Jewish characters appeared onscreen. With the exception of "The Goldbergs" (a popular program carried over from radio, which ran on network television from 1949 through 1954), Jews were to be found virtually nowhere. Though one could find the likes of Milton Berle (star of the most popular program of its era), Jack Benny (star of a show that ran for fifteen seasons), George Burns (whose show with wife Gracie Allen ran almost the entire decade of the '50s) and Sid Caesar (host, star and co-writer of "Your Show of Shows," which featured an all-Jewish writing crew), their characters, their personae, were not particularly coded as Jewish. Few of the most popular sitcoms of the '60s or '70s contained Jewish characters, especially leads. In what seems in retrospect a bizarre retreat from the increasingly urban, polyglot society America had surely become by the 1960s, we find programs such as "The Andy Griffith Show" (1960–68), "The Beverly Hillbillies" (1962–71), "Petticoat Junction" (1963–70), "Gomer Pyle, USMC" (1964–70), and "Green Acres" (1965–71). These shows created something like a closed universe, both within themselves and in relation to other shows like them. "Gomer Pyle" was a spin-off of "Andy Griffith"; "Green Acres" a spin-off of "Petticoat Junction." In any case, Jewish characters, not to mention African or Asian or Latino Americans, were simply nowhere to be found. Perhaps that most notorious of '60s shows, "Gilligan's Island" (1964–67), demonstrates this concept of a retreat from urban, multicultural woes with its limited, all-white cast.

Was there some sort of conspiracy at work to "de-semiticize" the televisual landscape? Consistently popular westerns such as "Gunsmoke" (1955–75), "Bonanza" (1959–73), and "The Virginian" (1962–71) certainly precluded a space for Jews in their universes (though both "Bonanza" and "The Virginian" had stars who were Jewish [Lorne Greene, Michael Landon, and Lee J. Cobb]), but look what happened when Carl Reiner turned to his television experiences to make a sitcom about writing a comedy television series. Reiner created "The Dick Van Dyke Show" (1961–66) based obviously on his behind-the-scenes and in-front-of-the-camera experiences working with Sid Caesar, Mel Brooks, Imogen Coca, and others on "Your Show of Shows." While Reiner's own character, Alan Brady, star of the eponymous "The Alan Brady Show"

within the show, may well have been Jewish, the leads of "The Dick Van Dyke Show" (Dick Van Dyke and Mary Tyler Moore) and the characters they played were most emphatically not.

Given the ethnically and racially monochromatic landscape of the American televisual universe of the 60s, it is perhaps no surprise to see the upsurge of ethnic and racial consciousness within the culture at large at the time, in particular the rise of the Black Power movement and its famous slogan, "Black Is Beautiful." Other racial and ethnic groups took their cue from this assertion of difference. Within the cinematic realm, we see the careers of Mel Brooks, Woody Allen, and Paul Mazursky beginning to coalesce around a more overt presentation of a distinctly and distinctively Jewish self, regardless of how stereotypical it might have been in retrospect or even at the time. Similarly, the short-lived but highly influential "Blaxploitation" cycle of films (e.g. *Shaft* [1971]) allowed a greater appearance—if not a particularly wide range—of black actors and actresses. In any case, we can clearly date the appearance of a greater sense of ethnic and racial consciousness and difference to the turbulent times of the late '60s. Television, too, would take up this cause.

A new generation of sitcoms in the early '70s, from Jewish producers such as Norman Lear, Bud Yorkin, and Saul Turtletaub, and the quality television from MTM Productions, brought what we might call a "Jewish sensibility" to television, though not quite yet actual Jewish characters. With settings in big cities, shows such as "The Mary Tyler Moore Show" (1970–77), "All in the Family" (1971–79), "Maude" (1972–78), and "The Bob Newhart Show" (1972–78) had, in retrospect, a surprising lack of Jewish characters, especially considering the sorts of social and geographic milieux in which they were set: a Queens, New York, blue-collar worker with a hippie/radical son-in-law; a Chicago psychologist in a professional building; a television station. Expressed in this way, it is the lack of Jewish characters, not their presence, that is notable. It was clear that Rhoda (Valerie Harper) on "The Mary Tyler Moore Show" was Jewish, alone in her ethnicity among the rest of the cast, while Maude (Bea Arthur) was Jewish in everything but script. ("Maude" was a spin-off of "All in the Family"; the character was initially introduced as a cousin of Edith Bunker.) These Jewish producers also brought out shows with all-black (or nearly so) casts such as "Sanford and Son" (1972–77), "Good Times" (1974–79), and "The Jeffersons" (1975–85), thus finally widening the ethnic and racial range of television. Most important, the attitudes expressed both on and behind the camera clearly came from new sensi-

bilities that, one would argue, derive from the particularities of the Jewish American experience (Desser and Friedman, 5–33).

It was perhaps with "Bridget Loves Bernie," an only moderately successful show that ran from 1972 until the following year, that TV turned to Jewish comedy, introducing therein what would later become one of the hallmarks of the structure of Jewish-themed sitcoms: Jewish/non-Jewish romance. Yet surely "Bridget Loves Bernie" was nothing but a throwback to the early days of movies when the Jews and the Irish were everybody's favorite lovable ethnic types. (*Abie's Irish Rose* might as well have been the title of "Bridget Loves Bernie.") More tentative steps were taken to introduce Jews to the televisual landscape in two urban (specifically New York) programs that debuted in 1975: "Barney Miller" (1975–82) and "Welcome Back, Kotter" (1975–79). Stars Hal Linden of the former and Gabe Kaplan of the latter were both Jewish, and though their characters didn't necessarily flaunt it, neither did the programs particularly hide the characters' religio-ethnicity. Both shows were ensemble pieces featuring an increasingly common television strategy: the racially mixed group. "Barney Miller"'s precinct house was New York City's ethnic mixture writ small: Jewish, Polish, Hispanic, black, and Asian. The same was largely true of "Welcome Back, Kotter," with Robert Hegyes's Epstein doing double duty as Jewish and Latino. (It was of course John Travolta's Vinnie Barbarino who stole this show out from under its likable lead.) The point here is that however tentative the introduction of Jewish characters might have been in the latter half of the 1970s, following on the heels of the more challenging if less overtly Jewish programs from Norman Lear and MTM, the particular settings of the shows begin to allow the coalescence of Jewish characters. In the 1980s, Jewish characters would appear more overtly, more dominantly, and more desirably.

The increased Jewish presence on network television began with the popular successes of "L.A. Law" and "thirtysomething" in the 1980s. The characterization of Stuart Markowitz (Michael Tucker) and Michael Steadman (Ken Olin), respectively, found Jews on two prestigious hour-long night-time serials; found them at the center of the dramas (in particular "thirtysomething"); found them in major urban centers (Los Angeles and Philadelphia); and found them in traditionally, even stereotypically, Jewish pursuits: law and advertising. Yet with all of that it also found them married to dynamic, accomplished—and non-Jewish—women. This set the tone for the sitcoms to follow, wherein the urban settings, the traditionally Jewish pursuits, and the Jew-shiksa relationship

would predominate. To be blunt: the Jewish characters in these shows would flaunt their Jewishness through stereotypical Jewish locations, lifestyles, and behaviors.

"Mad About You," "Love and War," "Seinfeld," and "Dream On" all take place in New York City, the most archetypically Jewish city in the world, subject of many an antisemitic joke and many a Jewish comedian's retort. Star character Paul Buchman is a filmmaker; Jack Stein a newspaper writer; Jerry Seinfeld a comedian, and Martin Tupper an editor at a publishing house. The world of show business, of intellectual pursuits, of verbal dexterity and repartee characterizes both the careers and the behaviors of all these characters. As for "Murphy Brown," the setting is Washington D.C., but the immediate locale is a television station where main character Murphy Brown is a newswoman and Miles Silverberg is her executive producer. Only "Northern Exposure" breaks the pattern of virtually every Jewish-starred, Jewish-themed television show with its setting in (an idealized) rural Alaska. But it doesn't break the pattern of the stereotypically Jewish pursuit of its Jewish male lead: Joel Fleischman is a doctor. Need one say more? Similarly, hour-long shows of the '90s that feature prominent Jewish characters, such as "Chicago Hope," "Homicide," and "Law & Order," take place in urban settings (Chicago, Baltimore, and New York) and revolve around doctors or Jewish policemen (the latter a departure from much of previous television, but not from the reality of multicultural urban police forces).

Let me reiterate: these shows contain overtly Jewish characters, sometimes portrayed, in fact, by Jewish stars, such as Paul Reiser, Jerry Seinfeld, and Jerry Orbach. They are set in the archetypal locale for Jewish figures: large cities, in particular New York; and the characters engage in traditionally Jewish pursuits revolving around show business, medicine, publishing, and so on. That is to say, Jewish men remain locked into an image prevalent now for well over one hundred years, that of urban intellectuals, possessing mental dexterity, a sense of humor, and the like, but ill at ease or not at all at home outside of this environment or in other sorts of pursuits (e.g., Joel Fleischman in "Northern Exposure"). Let us contrast this briefly with the settings and lifestyles of contemporaneous shows that do not feature Jewish characters. Craig T. Nelson in "Coach" is a college football coach at a fictional midwestern university; Tim Allen's tool man on "Home Improvement" has a home repair, do-it-yourself cable-TV show; "Roseanne"'s Dan Connor was a construction worker and motorcycle repairman. (Interestingly, though Roseanne is herself Jewish,

neither her comedy nor her persona are coded as such.) On the black character comedy "Family Matters," the father is a policeman; on another black-oriented show, "Hangin' with Mr. Cooper," the male lead is a basketball coach; on "Step by Step," the male lead is a construction worker. Even in the more Jewish-themed "Cybill" we find two ex-husbands, one of whom is a movie stuntman, the other a writer. Is it any surprise that if one of the husbands is Jewish, it turns out to be the writer, and not the stuntman? Jewish men, then, continue to pursue the sorts of things that Jewish men have stereotypically pursued; the difference now is that they are themselves now pursued: by sexy shiksas.

We might note, first of all, the romantic couplings in some of these shows: in "Mad About You" Paul Buchman, the Jewish man, married to Jamie Stemple (Helen Hunt), his non-Jewish wife; in "Love and War," Jack Stein (Jay Thomas) pursuing and being pursued by Dana Paladino (Annie Potts), again the Jew/shiksa structure. In "Northern Exposure," it's Joel Fleischman (Rob Morrow) and Maggie O'Connell (Janine Turner); in "Murphy Brown" it was Miles Silverberg (Grant Shaud) and, eventually, Corky Sherwood-Forest (Faith Ford). On one hand, there is a troubling commonality in virtually all shows with Jewish leading characters: the Jewish man involved with or married to the non-Jewish woman. (The reversal is also true: in "The Nanny," a Jewish-woman show, we note the desire on the part of the woman for the non-Jewish man and their eventual nuptials in the show's closing season.) Finally, in the case of "Murphy Brown," in addition to the character of Miles Silverberg we may note Murphy's three romantic relationships on the series, two with Jewish men. One was played by Jay Thomas before he got the lead in "Love and War"; and the other was a character, Jake (Robin Thomas), who was Murphy's ex-husband of many years back and who, when they temporarily rekindle their romance, becomes the father of her child.

Of particular importance, then, in noting the desirability of the Jewish male lead or supporting character in these shows is the fact that he is desirable at least partly for the things he does, for the values incarnated by his work and his persona. In other words, intellectual or artistic achievement, a facility with words, and, above all, a sense of humor, are precisely the qualities that women find attractive in the Jewish man, and these are precisely the qualities stereotypically and often antisemitically assigned to him.

In other words, the Jewish man is desirable, and is masculine, insofar as he expresses attitudes, beliefs, traditions, and behaviors that have

historically been associated with Jewishness but that have not, until recently, been associated with desirability. The Jewish man's associations with bookishness, education, literature, the arts, entertainment, and the like have been historically more associated with racialism and anti-semitism than with desirability and sex appeal.

One may account for this apparent sea change in attitude by recall-ing that the majority of the aforementioned television shows were the products of Jewish producers, writers, and/or stars. Thus, images of the Jewish man's sex appeal and of his desirability to women, especially non-Jewish women, are either figures of fantasy or, alternately, accurate reflec-tions of the rates of Jewish out-marriages (over 50 percent). Indeed, the very popularity of the shows indicates a willingness on the part of (mas-sive) television audiences to accept these images as part and parcel of the universe the shows create and inhabit, a universe, in the case of most of these shows, that is particularly Jewish.

Let us return to the world of the cinema, with which we began. Here, too, a number of texts might be marshaled in evidence to demon-strate a kind of Jewish alternative masculinity, an alternative arising in the 1980s precisely when the hypermasculinity of the likes of Arnold Schwarzenegger and Sylvester Stallone began to predominate (Tasker, 73–90). Though there are numerous films to choose from, I'd like to look briefly at four. These films introduce and deal with some of the tensions arising from this new masculinity and bring forth interesting questions not only of sexuality, but also of race and gender.

The question, precisely, of an image of masculinity shows up sub-tly in *The Fly*, directed by a Canadian Jew—David Cronenberg—and starring an American one—Jeff Goldblum. Though not necessarily coded as Jewish, Goldblum's Seth Brundle is certainly, save for his height, the very image of the Jewish nerd or nebbish—a scientist with poor social skills, all of whose suits are the same color, so he won't have to bother with mundane concerns like fashion and color coordination. Geena Davis (at one time married to Goldblum), as Veronica, is initially attracted to Seth for those very qualities. Yet as Seth unknowingly becomes Brundle-fly, more traditional masculine traits, such as increased physical strength and aggressiveness, begin to emerge, and they quite lit-erally horrify Veronica ("Be afraid, be very afraid" is her famous tag-line in response to him). Though critics rightly note Cronenberg's ongoing fascination (repulsion) with physical change and decay as structuring this film, it is the use of Jeff Goldblum as a kind of liminal figure between

the feminized Jew and the hypermasculinized WASP (okay, WASP fly) that is particularly appropriate to note in this context.

In *A Stranger among Us* (1992), Sidney Lumet directs a film set in the world of New York City and its police. In a gender reversal well worthy of note, it is the woman, Melanie Griffith, who is the cop, and the man, Eric Thal, who occupies a traditionally female role: a teacher. Thal's Ariel is introduced in a strikingly feminized manner, as well: teaching a group of small children in a room awash with golden light and filmed in soft focus. It is as if Thal is the object of desire, for both the heroine, Griffith, and the audience. And indeed, a romance develops between the Jewish man, a school teacher in a *cheder*, and the very sexy non-Jewish police woman. And it is precisely the fact that Ariel is a man of intellect and learning, a teacher and scholar, and precisely not a man of action, of street smarts, or of violence that she finds most appealing. When he tells her that he likes her for her mind, she finds him completely refreshing and desirable. Yet even here, the film seems torn between the need for Ariel as an alternative image of masculine desirability and the need to situate him within the more traditional world of violence. It is Ariel who eventually saves the detective's life, rather improbably, by killing a would-be assailant with a hand-gun (Desser and Friedman, 184–86). That the Jewish man *not* still somehow be physically adept, violently capable, or capably violent, remains a source of tension in the script.

Corrina, Corrina (1994) represents yet another cinematic treatment of the Jewish man as sex symbol in a mainstream film. Of course, the film is actually trying to build the image of Whoopi Goldberg, a black woman, as a sex symbol. *Corrina, Corrina,* by means of a plot that derives greatly from an earlier film of hers, *Clara's Heart,* adds the motif of romance as the nanny (Corrina) falls for her boss, and vice versa. Yet in trying to continue to build Whoopi up as a sex symbol (a continuation of her role in *Made in America* [1993] and her highly publicized, ultimately controversial offscreen romance with that film's co-star, Ted Danson), this film makes the object of her affections a Jewish man (played sympathetically and without his usual bravado and neopsychosis by Ray Liotta—best known for films such as *Something Wild* [1986] and *Goodfellas* [1990]). In making him a songwriter, the film provides him with a characteristically Jewish job and continues the association of the Jew with show business and the arts; and in making him an outright grieving man, it shows him as sensitive and emotional. *Corrina, Corrina* also returns us to the late 1950s, a more difficult time for such an interracial romance to thrive, but

also a more optimistic time, a time when the Jews, almost unique among white ethnic groups, were highly active in civil rights, when the black-Jewish coalition was as strong as it is weak today, and when the values incarnated by the Jewish man were not held in so high esteem as they apparently are today.

The film is also autobiographical of its writer-director, Jessie Nelson, whose sympathies and autobiographical affiliations are with Tina Majorino as the grieving young daughter of a widower-father. Yet it is interesting that Liotta's character, Manny Singer, should be Jewish; and neither does the film shy away from highlighting his Jewish (albeit non-religiously Jewish) background. Most mainstream reviews of the film mention the (obvious) interracial romance on view here, but very few note that Liotta's character is Jewish. One might want to claim, though without evidence, that precisely the woman writer-director is sympathetic to the appeal of this distinctively Jewish version of masculine desirability.

We can see this yet again from a woman's, perhaps even a feminist, perspective, in an even more memorable image of the Jewish man's desirability stemming less from physical attributes of power, strength, or hyper-muscularity than from his well-developed mental faculties and talents: *Yentl* (1983), directed by and starring Barbra Streisand. In this film we may find one of the most important (and underrated) cinematic statements of the attractiveness of Jewish values. Although something like a Jewish-feminist tract, the film sets the world of the *yeshiva*, of books, study, the Torah, and the Talmud, to occupy pride of place. The introduction of Avigdor (Mandy Patinkin, better known now for his Jewish doctor role on "Chicago Hope"), finds him rescuing Yentl (Streisand) from physical threat, which makes him something of a "manly man," but his primary association is with learning. They first banter about a quote from the Talmud. Later, in a musical sequence, the world of books represents the spiritual fulfillment of Yentl's life thus far, but we notice, too, how often Avigdor is highlighted. The association of books with him, and he with books, in what is a characteristically musical moment of heightened emotions associated with romance, is the ultimate expression of the sexiness of Jewish men and their values.

Yet the image of the Jewish man as feminized is taken one step further in this film, literalized in the figure of Yentl, who is, after all, a woman cross-dressing as a man. This woman-man becomes, in turn, the object of desire of Hadass (Amy Irving), who falls in love with Yentl, little knowing "his" true gender but attracted precisely to his sensitive (girl-

ish) looks and his bookish learning. As Daniel Boyarin has it: "[T]here is something correct—although seriously misvalued—in the persistent European representation of the Jewish man as a sort of woman. More than just an antisemitic stereotype, the Jewish ideal male as countertype to 'manliness' is an assertive historical product of Jewish culture" (3–4). In *Yentl* manliness is doubly female: Avigdor is bookish; and the "masculinity" that attracts Hadass is a mask worn secretly by a woman. No film has ever so clearly presented these traditional Jewish values, emanating from the long-gone world of nineteenth-century Eastern European Jewry, with more romance than this film—no surprise perhaps that it took a woman to show this to the world, that it took a woman to show the masculinity of the feminized Jewish male.

WORKS CITED

Boyarin, Daniel. 1997. *Unheroic Conduct: The Rise of Heterosexuality and the Invention of the Jewish Man.* Berkeley, Los Angeles: University of California Press.

Breines, Paul. 1990. *Tough Jews: Political Fantasies and the Moral Dilemma of American Jewry.* New York: Basic Books.

Cuddihy, John Murray. 1974. *The Ordeal of Civility: Freud, Marx, Lévi-Strauss and the Jewish Struggle with Modernity.* New York: Basic Books.

Desser, David, and Lester D. Friedman. 1993. *American-Jewish Filmmakers: Traditions and Trends.* Urbana and Chicago: University of Illinois Press.

Tasker, Yvonne. 1993. *Spectacular Bodies: Gender, Genre and the Action Cinema.* New York: Routledge.

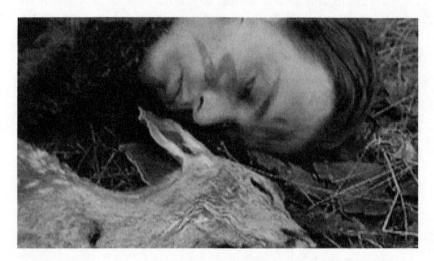

FIGURE 16. On the verge of death throughout the film, William Blake (Johnny Depp) discovers a great deal about life. (*Dead Man*, Jim Jarmusch, 1995) (frame enlargement)

CHAPTER SEVENTEEN

◆

Gender and Other Transcendences:
William Blake as Johnny Depp

MICHAEL DeANGELIS

"Although set in the 1870s and filled with creepy period details," J. Hoberman explains, "*Dead Man* equally suggests an imaginary post-apocalyptic 1970s, a wilderness populated by degenerate hippies and acid-ripped loners forever pulling guns on each other or else asking for tobacco" (1996, 65). Yet by assigning the name of *William Blake* to the central protagonist of this 1996 black-and-white western, director Jim Jarmusch begins to extend the historical references and resonance both forward and backward, to a century before the plot unfolds. Beyond the initial associations generated by the English Romantic poet's name, *Dead Man* (1995) develops a sense of historical progression through the concepts of cycle and revolution—concepts integral to Blake's complex mythological vision of individual and social redemption in a culture dominated by corrupt and tyrannical forces. And if, for the historical and poetical William Blake, redemption is intimately connected to transcendence, the choice of Johnny Depp for the mirror role of the heroic Blake figure helps to illuminate not only the central themes of Jarmusch's narrative, but also the construction of a version of heroic masculinity defined by a nurtured respect for human difference.

283

BLAKE, REVOLUTION, AND THE NEW AMERICA

The formative years of William Blake, born in 1757 and apprenticed in the art of engraving, coincided with major political and social upheavals in Europe and abroad. Opposing the tyrannical practices of King George III and his parliament, Blake was openly critical of the British monarchy in the wake of the American Revolution. In the closing decades of the eighteenth century, Blake allied himself with societies and groups opposing the monarchy. In 1804, the poet was charged with (and later acquitted of) sedition and treason. Both America and France come to assume central places within the mythological system that the poet was in the process of developing by the late 1700s: the French Revolution provides Blake with a model that might inspire England to overcome its own corrupt rule, while the American Revolution offers a model of successful political resistance. In Blake's *America* (written and engraved in 1793), revolutionary forces are emblematized by the fiery figure of Orc, who, according to Northrop Frye, "represents the return of the dawn and the spring and all the human analogies of their return" but also "the periodic overthrow of social tyranny" (1947, 207). Although the "periodicity" or cyclically recurring nature of revolution is integral to Blake's use of the concept, Orc simultaneously serves as a generative force, one destined to inspire, thrive, die out, and be reborn in a yet more powerful form in another era:

> Every advance of truth forces error to consolidate itself in a more obviously erroneous form, and every advance of freedom has the same effect on tyranny. . . . The evolution comes in the fact that the opposition grows sharper each time, and will one day present a clear-cut alternative of eternal life or extermination. (Frye 1947, 260)

In Blake's mythological system, the independence to be gained by revolution surpasses matters of political and governmental autonomy; more expansively, liberty also suggests a radical perceptual enlightenment and transcendence that reveals both the social and psychological effects of tyranny and offers a course of action that might enable the human subject to disrupt these effects. For Blake as well as other English poets of the Romantic tradition, such as Shelley (especially in *Prometheus*

Unbound and *The Cenci*), oppressive power relationships taint individual psychologies, as well as social bodies, and these two forms of oppression are inseparable. This is so because the workings of tyranny insidiously impose a singular, specific perspective of human experience and, through strategies that might be described in the present day as "hegemonic," this institutionally sanctioned perspective is passed off as the only possible perception. Tyrants thus define perceptual limits, solidifying them into laws and religious tenets that inevitably force the oppressed into involuntary submission.

For Blake, among the most despicable of these enforced perceptual limits emerges through the defense of the practice of slavery. Yet the poet extends the metaphor of enslavement so that social and political tyranny also imply sexual corruption. As Jean Hagstrum explains, "Blake never relinquished the idea that what poisoned sexuality is not the body itself, desire per se, but debilitations of the mind and spirit coming from psychological *and* institutional tyranny" (1985, 121; emphasis added). Nowhere is this extension more evident than in his powerful plea for sexual liberation, *Visions of the Daughters of Albion* (written and engraved in 1793). From the beginning of the poem, the heroine and slave Oothoon is associated with "the bound and struggling imagination of America" (Frye 1947, 240–41). Oothoon, whom David Erdman identifies from the engravings as Native American (1954, 221), seeks to be reunited with her lover Theotormon, but en route she is brutally raped by the thunderous Bromion. While the selfish Theotormon remains jealous and unmoved even when Oothoon takes the drastic step of having eagles tear at her breast to obliterate the stain of the encounter, Oothoon becomes yet more resolved to enact her own redemption, experiencing a series of perceptual shifts that awaken her to the "logic" of the oppressive forces that enslave her body and her psyche.

Indeed, Oothoon's enlightenment in *Visions* constitutes an empowering "perceptual transcendence" that, in its myriad forms, predicts the response of other oppressed figures in Blake's poetry. First, transcendence is signaled by an epiphany of sexual freedom in which the heroine denounces the moral and religious constraints that have bound her. In the course of her argument, both Bromion and Theotormon are themselves revealed as slaves of a set of constraints designed to protect the powerful while tainting the disavowed perceptions of the victimized. In the process of sexual liberation, Oothoon connects faulty moral codes with corrupt

religious codes that would label the rape victim a "whore" in a system that rewards duplicity and that celebrates only the "self enjoyings of self denial" (7:8). In terms of sexuality, religion becomes for Oothoon a solipsistic and masturbatory practice antithetical to the joys of "happy copulation" (Erdman 1970, 7:1): "Why dost thou seek religion? / Is it because acts are not lovely, that thou seekest solitude, / Where the horrible darkness is impressed with reflections of desire" (7:8–10).

More expansively, Oothoon's transcendence takes the form of a celebration of difference. Learning to respect the diverse perceptions of all living creatures, she also develops a deep suspicion toward tyrants who unquestioningly presume their authority to dictate what others should feel. Counteracting the workings of tyranny, she quickly learns to distinguish her own perception from that of her oppressors, from whom she distances herself by referencing them as an indefinite and generalized "they" whose interpretations are gradually revealed to be apart from her own.

Oothoon's process of enlightenment begins with a realization that the realm of the senses is inadequate to account for the multiplicities of experience:

> They told me that the night & day were all that I could see;
> They told me I had five senses to inclose me up.
> And they inclos'd my infinite brain into a narrow circle.
> (Erdman 1970, 2:30–32)

With the knowledge that sense perception can be used by the powerful as a means of enslavement, Oothoon continues the process of transcendence with a series of rhetorical questions that transform this knowledge into a celebration of diversity—a concept of perception that moves beyond the confining enclosure of the five senses. Extrapolating from the observation in Blake's earlier work *The Marriage of Heaven and Hell* that "One Law for the Lion & Ox is Oppression" (Erdman 1954, plate 24), Oothoon's interrogation reveals the absurdity of the assumption that unlike beings act according to like principles: "and wilt thou take the ape / For thy councellor? Or the dog, for a schoolmaster to thy children?" (Erdman 1970, 5:8–9). Perhaps the clearest indication of the heroine's transcendence comes with the fact that in the closing section of the poem, Oothoon's rhetorical method shifts from interrogation to indication. The

answers to her questions are now self-evident, and she respects her own perceptions. Oothoon is able to distinguish the value systems of oppressor and oppressed.

Despite her considerable efforts, Oothoon's enlightenment fails to effect any change in the jealous Theotormon, who at the end of the poem still "sits / Upon the margind ocean conversing with shadows dire" (Erdman 1970, 8:11–12). Both Theotormon's self-isolation and Bromion's sustained adherence to the principles of tyranny resonate historically in Blake's later poetry and foresee the outcomes of the two major revolutions of the late eighteenth century.

DEAD MEN: REVOLUTIONARY CYCLES AND CATALYSTS

While the perceptual transcendence of Blake and Oothoon certainly constitutes a triumph of the imaginative faculties, it falls short of disrupting the oppressive social and consequent psychological conditions of tyranny. If Blake perceived "the American Revolution as a sort of mass resurrection or secular apocalypse that would overthrow poverty and cruelty and establish a new Eden" (Erdman 1954, 48), the desired transformation never took place in his native land. And neither of the historical revolutions lived up to the vision set forth in the poet's prophecy. As Frye explains, "Within the next few years [after he engraved *America*] Blake watched the American and French revolutions gradually subside again into the fallen world. The Americans kept owning slaves, and the statue of the wrong kind of Reason was set up in Paris" (1947, 216). Set in the postrevolutionary frontier America of the 1870s, Jarmusch's *Dead Man* attests at every juncture both to the failure of a past revolutionary spirit and the promise of a new prophet who might renew the transformative possibilities revealed to the new land one hundred years earlier.

A brief plot synopsis will be useful here as a context for exploring the connections between Blake and Jarmusch's concepts of transcendence. After the death of his parents, the Cleveland-born accountant William Blake (Johnny Depp) spends all of his savings on a train ride west to the small frontier town of Machine, where he has been promised a position at Dickinson Metal Works. Upon his arrival, however, Blake discovers that the position has already been filled. He then befriends and spends the night with Thel (Mili Avatal), a reformed prostitute who now

dedicates herself to making and selling paper roses. When her former lover, Charlie (Gabriel Byrne), returns unexpectedly to find Thel and Blake together, Charlie shoots and mortally wounds Thel; Blake returns fire and kills Charlie in self-defense. Suffering a chest wound from the bullet that killed Thel, Blake manages to escape from Machine and is soon discovered by the Native American "Nobody" (Gary Farmer), who unsuccessfully attempts to extract the bullet. When William reveals his surname, Nobody is convinced that this "stupid white man" is actually the poet William Blake (despite Blake's protestations that he knows nothing of his namesake) and that it is this prophet's mission to become a "killer of white men." The murdered Charlie is revealed to have been the son of John Dickinson (Robert Mitchum), who hires a posse of three professional (yet inept) killers to hunt Blake down and later posts a reward to the general public for the capture of his son's murderer. Realizing that he is now a hunted criminal, and with his friend Nobody as guide, Blake proceeds to elude his hunters and to kill off those whom he cannot escape. Meanwhile, Nobody makes preparations for Blake's death and spiritual journey to a place "where this world will no longer concern you," and the closing scenes reveal the expiring Blake on a canoe headed out to sea, barely able to perceive the fatal exchange of gunfire between Nobody and Cole Wilson (Lance Henriksen), the sole remaining hired killer, on the shore.

With its close attention to authentic historical details, *Dead Man* relentlessly demonstrates that revolutionary promises of liberty and mutual respect continue to be undermined one hundred years after the "birth" of the nation. Most notably, the undermining corruption correlates commercial enterprise with oppressive power relationships and social stratification resulting from the Industrial Revolution—a historical development that the poet Blake had long before associated with the perpetuation of tyranny. Far from suggesting a land of promise, the landscape of Jarmusch's "end-of-the-line" town of Machine is a dark, dismal wasteland of animal skeletons, saloons, and tired, blank faces. Inside the huge, noisy metal works factory whose belching smoke pours over the barren landscape, the machinists appear as mechanized creatures whose disaffected and deadened stares rival those of the factory workers in Lang's *Metropolis* (1927). Yet those "privileged" enough to gain a position in administration find no better working conditions: the momentary, bitter laughter echoing through the dusty business office upon Blake's insistence that he

must speak with Mr. Dickinson is abruptly curtailed when the supervisor, John Scholfield (John Hurt), snaps at the accountant Olafsen (John North) and the other employees, "Back to work!" Blake and the hired killers tolerate John Dickinson's arrogance and intransigence not out of respect but because they have no choice—Dickinson is, after all, the wealthiest citizen in a town that would have no identity or reason for being without him.

Dickinson's tyranny is shown to be both infectious and symptomatic of a wider range of disgraces emerging in a world that continues to define the polarities of oppressor and oppressed in legal terms that gain conviction through commercial enterprise. Here, gender stratification is strictly maintained as a function of commodity relations: the world of the frontier is a man's world, in which the role of the white woman is reduced to providing as-needed sexual service to men in dank alleys away from Machine's main thoroughfare. Indeed, even when women attempt to sustain an identity as something other than prostitutes, they are still defined as such: outside the town saloon on the evening of Blake's arrival, a drunken man pushes Thel into the mud while mumbling the designation, "whore." Unlike her poetical counterpart in Blake's *Book of Thel* (written and engraved in 1789), who resists being born to avoid the perils and transience of human experience, Jarmusch's Thel shares more with rebellious Oothoon, resisting the definitions that men impose upon her. Yet despite her ambitious attempt at self-sustenance by making and selling the white paper roses (and the prospect of eventually using silk with "a drop of French perfume" on each flower), Thel is murdered for her attempts at resistance, "guilty" as she is of the practices of free love in the eyes of her long-absent fiancé.

Yet the most pervasive injustices in the film victimize the Native American population, whom the white men treat as a scourge to be eradicated in the interests of God and country. In one scene, Blake and Nobody stumble upon three vagabonds cooking dinner at a forest campfire. After relating the story of "Goldilocks and the Three Bears," Salvatore "Sally" Jenko (Iggy Pop in drag) entertains his companions, Big George Drakoulious (Billy Bob Thornton) and Benmont Trench (Jared Harris), with stories of Roman tyrants feeding criminals to the lions. The three men in the party agree that such practices are "horrible" and "terrible," yet the crimes committed against Native Americans in the film's frontier era certainly do not pale by comparison. On the train to

Machine, Blake looks out at scorched and smoldering tepees, and the train riders open fire at a herd of buffalo, a practice that was "encouraged by the government as a means of wiping out Indians by eliminating one of their staples; in 1875, over a million buffalo were slaughtered" (Rosenbaum 1996a). Later in the film, as Blake and Nobody approach a trading post, Nobody explains that such establishments regularly engage in the practice of selling the Native Americans blankets infected with malaria, an effective means of biological warfare and racial cleansing that quickly spreads a fatal disease throughout a community; after they enter the post, the missionary-manager (Alfred Molina) denies Nobody's request for tobacco, instead maliciously proposing the sale of a blanket.

Throughout the narrative, the figure of William Blake maintains an "outsider" status that sets him apart from the prevailing corrupt practices sanctioned by white men. The image of the outsider emerges as early as the opening train sequence, in which Blake's tailored, checkered suit, proper hat, and eyeglasses contrast sharply with the attire of his fellow riders, who persistently stare at him. Blake also assumes a marginal gender status at several points in the film: in the campfire scene referenced above, after Nobody prompts Blake to interact with his fellow white men, the band of three perceives William as an object of curiosity, which they feel free to fondle and caress. The interchange between Blake and the three men soon takes the form of an exchange of beauty secrets, with Big George Drakoulious admiring and commenting upon Blake's fine and well-kept hair; shortly after, the three men argue over which one of them will "have" their uninvited but welcome visitor.

Blake finds more of a common ground with Nobody than with any other male figure in the narrative. Both men lack a sense of place in the world. A cross-breed ostracized from both of his ancestral groups, Nobody was abducted by white men and transported across the United States on display in a cage. Subsequently taken to Britain where he learned many of the social and cultural attributes of his white oppressors (and where he also first encountered Blake's poetry), Nobody later returned to the United States only to experience an even greater alienation from his ancestors, who renamed him "He who talks loudly and says nothing." From the outset, Blake is also a displaced and alienated figure. He remains apart from any traditional or institutional attachments: on the train, he tells the train fireman (Crispin Glover) that he once had a fiancée but that "she changed her mind" (although the fireman insists that "she

found somebody else"). Of his heritage or his former life in Cleveland, the narrative reveals only that Blake's parents have recently died. Maintaining no ties to his past, Blake's prospects for the future are quickly nullified when he learns that the mail-order job promised to him in Machine has been given to someone else.

It is precisely this ahistoricity of character that makes Blake so susceptible to inscriptions or projections of his identity from the outside. Unlike Oothoon, however, William Blake's response to the strategies of such inscriptions is to accept and rework them rather than struggle against them. "You were a poet, and a painter, and now you are a killer of white men," Nobody proclaims, and given what the Native American has learned about the poet Blake's revolutionary status and *this* Blake's recent experience with Thel and Charlie, his proclamation holds just enough feasibility to resonate as prophetically true—first for Nobody, and eventually for Blake himself.

From the start, John Dickinson entertains no other possibility than that Blake is a "murderer," and his claim gains authority not through his discerning, objective judgment but because the law is always on the side of the powerful. Yet if Blake eventually adjusts to his affiliation with a Romantic poet, he is also not resistant to the notion of adopting the status of outlaw, a designation that others have imposed upon him. As the film progresses, Blake does indeed become a murderer, yet in assuming this role he entirely reconfigures the social and political significance of the act of killing. If Blake's initial act of self-defense is legally deemed as "murder" only because it was committed against a rich and powerful man's son, and if in the process this murder induces an act of revenge in order to balance the scales of social justice and order, Blake's killing spree in the second half of the film constitutes the protagonist's own retributive agency and empowerment. Blake commits murder with a revengeful eye intent upon righting past wrongs, but the wrongs are now those of the white oppressors guilty of decimating the Native American population.

Certainly, the component of violence is essential to Blake's method of effecting revolutionary change. Jacob Levich argues that "Jarmusch's Blake is not just a harmless dreamer: he's the fiery poet who championed revolution and purifying violence, who assailed willful ignorance and hypocrisy, who furiously denounced slavery, poverty, commerce, and the Church" (1996, 41). In accordance with Nobody's proclamation that

"your poetry will now be written in blood," Blake aims his fatal instrument of poetic inscription at religious hypocrites (the missionary) and the upholders of the law (marshals), both of whom hold a financial stake in the revolutionary's capture and in maintaining the structure of the social arrangements that give power to men like Dickinson. He even earns the respect of those hired to kill him, including the legendary Conway Twill (Michael Wincott), who exclaims, "That there Blake fellow keeps shooting marshals, I might end up liking the bastard."

But if Jarmusch's revolutionary hero is characterized by a capacity for violence, the heroism of this version of Blake just as essentially depends upon nurtured human compassion and empathy, along with an acute sense of the injustices that mankind inflicts and suffers. Blake is the only man in the film who treats white women with respect: after Thel is shoved to the ground outside the saloon, William apologizes for staring, helps her up, gathers her mud-stained paper roses, and walks her back to her apartment. And in a poignant scene later in the film, the revolutionary/poet, who has been fasting in order to induce visions of the infinite, embraces and cuddles a dead fawn alone in the middle of the woods, bearing the traces of unjust human acts upon his own flesh by smearing the animal blood down from his forehead, to his nose, to his chin.

"Some are Born to sweet delight / Some are Born to Endless Night," recites William after the killing of the marshals, quoting from his namesake's *Auguries of Innocence* (Erdman 1954, 124–25). The recurrence of this passage points to the fact that in the postrevolutionary world of *Dead Man*, revolutionary action is intimately connected to, and in conflict with, the concept of transcendence. At once, Blake perceives the sorrows of indifference to human suffering, the necessity of acting in a way that will cause such suffering to cease, and ultimately, the centrality of death in moving beyond a world in which the suffering is permitted to exist. Without any attempt at reconciliation, the narrative constructs death as both tragic and perfect, as an act that generates inspiration by creating role models such as the historical or revolutionary William Blake, and also legends. The legendary status of the film's professional killers is quite precarious while they remain alive: Cole Wilson is plagued by a nagging toothache, and young Johnny "The Kid" Pickett (Eugene Byrd) grasps in the night for the teddy bear that Conway Twill holds tightly to his breast. And as Blake is about to die, Nobody rightly proclaims that "William Blake is a legend now" since legends are born out of death and sustained

out of mystery, depending as much upon how little we verifiably know about the legendary figure as upon how we interpret his actions. But if death regularly serves to idealize and redeem the western hero in the eyes of those who survive him, Blake's feature-length death is distinctive in that it also transforms the process of redemption into a quest for personal salvation and self-perfection.

MASCULINITY AND THE TRANSCENDENT STAR

In its emphasis upon transcendence, its construction of the rebellious and revolutionary hero, and its focus upon the status of the outsider, *Dead Man* and the central character of William Blake provide an insightful commentary on the career of Johnny Depp and the appeal of the actor's version of masculinity. Suggesting an indifference to the resolution of polar opposites, transcendence takes on a curious form of gender and sexual appeal for Depp—an appeal that depends upon the star persona's maintenance of ambiguities, contradictions, and mystery in an attempt to reach a wide variety of audiences. In relation to Depp, "transcendence" implies, among other things, a movement beyond the sorts of traditional and stereotypical definitions of masculinity that might constrain virile young males to surmount the vicissitudes of woundings and maimings in order to preserve the impression that they are invulnerable. Depp, indeed, was apparently attracted to Jarmusch's project precisely because of its "idea of a central character wounded early in the piece, with a bullet resting so closely to his heart—on the verge of death throughout the film. . . . In that condition Billy Blake discovers much more about life" (Colbert). Indeed, for both Oothoon and Jarmusch's Blake, the process of self-discovery is initiated by a violent and life-threatening act, and in both cases the perceptual enlightenment that follows this act transforms the heroic figure into an outsider, one who sees more clearly for having established a distance from mortal concerns.

But the sort of "outsider" status maintained by the character of William Blake has been an essential component of Johnny Depp's star persona for more than a decade. The actor is often portrayed as an unanchored figure who belongs nowhere and is therefore wholly accessible to his audience: "I was not the most popular kid at school. I always felt like an absolute and total freak. Edward Scissorhands. That feeling

of wanting to be accepted but not knowing how to be accepted as you are, honestly. Wanting to hold a girl but thinking I'll screw it up" (Ryan 1994, 543). Alienation and lack of connection become a function of spatial displacement: Depp's family moved a number of times during his childhood and adolescence. The motif of homelessness continues even after Depp moves to California: a 1989 article written while the actor was still appearing as an undercover cop in the hit Fox series "21 Jump Street" (1987) explains that Depp "still doesn't have an apartment; nor does he own a house. And while he once lived in his best friend's car when they were teenagers, that option isn't open to him today because—you guessed it—he doesn't own a car (his vintage Harley-Davidson sits idle in Vancouver, British Columbia)" (Pond 1989, 152). The actor's placelessness and outsider status were also played out for some time in his tenuous connection to the institution of marriage: he maintained commitments and engagements to actresses Jennifer Grey, Sherilyn Fenn, and Winona Ryder, as well as supermodel Kate Moss, yet the relationships were always broken off before the exchange of wedding vows. Conditions may well have changed for Depp now, but star biographies often linked the star's "unattached" status to an insecurity whose "roots" can be traced to his lack of grounding in the traditional family unit: Brian Robb has suggested that Depp's "lack of security stems from his childhood, and primarily the divorce of his parents during his teenage years" (1996, 11). And yet this sense of disconnectedness often anticipates a desire for belonging and grounding. Popular press articles emphasize that Depp maintains a very close connection to his mother and that at one point in his life, he bore the traces of his own split racial heritage (Caucasian and Native American) in the two tattoos on his arms: one a heart inscribed with the name of his mother, the other an Indian head.

Press articles also correlate Depp's outsider image with the figure of the rebel, tracing the historical "roots" of the actor's rebellion to James Dean and Marlon Brando. In some cases, the connection is solely based upon physical appearance: Elaine Warren suggests that "with his angelic punk face and his hair cascading James Dean-style into his eyes, he looks the perfect teenage rebel" (1988, 10). Yet the connection is also established in terms of like, if seemingly opposed, emotional attributes, as when Steve Pond explains that Depp "has been compared to James Dean, Marlon Brando, all those tough-but-sensitive outsider guys" (151).

But the connection to legendary rebels such as Dean and Brando is also articulated as a sign of Depp's integrity, and the actor is often praised for distancing himself from Hollywood's institutional system of star image construction, for being willing and able to make his own career choices. Indeed, Depp's integrity and acuity in selecting (very often eponymous) screen roles is juxtaposed with the vulnerability of the unanchored outsider, reinforcing a masculine identity that is both strong and sensitive. "Seen by some as a modern rebel in the James Dean mould," Robb explains, "Depp has pursued a relentlessly uncommercial series of films" (1996, 7), among which very few qualify as financial successes. Depp also seems more concerned with disrupting any coherent reading of his persona than in establishing or maintaining consistency across roles. He often turns down offers for parts in films that become blockbuster hits, electing deeper characterizations and more emotionally complex roles in projects by directors with whom he has established trust and friendships. Indeed, his "strategy" in accepting the role of a rebel rock singer in John Waters's *Cry-Baby* (1990) was to disrupt the teen heartthrob stereotype that had been developing against his wishes through four seasons of work on "21 Jump Street." And while the sheer treachery of his 1999 part as an alien-infected astronaut who schemingly sets out to sire a master race in *The Astronaut's Wife* certainly reinforces the star's alienated rebel persona, Depp's first experiment with the role of villain overturns any suspicion that the actor is convincing only when he plays empathetic figures. His rebellion also takes the form of a lack of devotion to institutional authority, as evidenced by his reputation for being difficult or demanding on the set of "21 Jump Street": "According to reports, Depp has set fire to his underwear, been deliberately belligerent to his producers, and even thrown a punch or two" (Rebello 1990). He has also been uncooperative and hostile with nosy reporters. Indeed, his capacity for violent reactions has received press attention, such as that devoted to his heavily publicized arrest after he "trashed" the presidential suite of a New York hotel.

Counterposed with his often violent temper, the actor consistently demonstrates a politically correct sense of perceptual enlightenment and attentiveness to the needs of others both onscreen and off. An interviewer for *Gentleman's Quarterly* explains that Depp "wears work boots and befriends fringe people and gives money to sick children" (Schneller 1993, 224); shortly before an interview with *Newsweek*, as Depp watches a bug landing in the reporter's glass of water, he expresses "concern—*for*

the bug" (Schoemer 1997, 69). Many of the actor's roles have sustained a construction of the star persona as sensitive, compassionate, sincere, and inherently "decent." The rebel figure he portrays in *Cry-Baby* is, as the title suggests, prone to displays of emotion that are anything but violent. He is exceptionally devoted to, and protective of, his family in *What's Eating Gilbert Grape?* (1993), and when his girlfriend (Juliette Lewis) asks Gilbert (Depp), "What do you want—just for you?" his only response is that "I want to be a good person." In the title role of *Edward Scissorhands* (1990), the "unfinished" Depp steals the affections of Kim (Winona Ryder) from her insensitive, tough-guy boyfriend, Jim (Anthony Michael Hall), not through any matched display of macho bravado, but by behaving as the compassionate, well-mannered, and virtuous creature whom his inventor (Vincent Price) designed him to be.

Edward Scissorhands holds an essential place in the construction of Depp's star persona, especially in relation to his role in *Dead Man* and his affiliation with William Blake. Edward is initially perceived as a product of his deceased inventor, but as the narrative progresses, his identity becomes a projection of the needs, desires, and fears of the society into which he is released. The community accepts Edward as long as he continues to serve its needs as either a harmless and docile curiosity or a potentially "profitable" agent, sculpting its bushes and creatively designing the hair of its human and canine inhabitants. But after he refuses to respond sexually to one of the town's notable citizens, and after others discover how easy it is to use the innocent Edward as a moral and ethical scapegoat, he is quickly transformed into a monster that must be eliminated from the community. Through a similar process of inscription, the identity of William Blake is transformed from innocuous accountant, to infamous outlaw, to prophetic savior, one identity yielding to another according to the various social settings into which the hero wanders.

Given Johnny Depp's ability to assume a variety of roles, it is not surprising that the press has debated the matter of his place in the sensitive and resonant categories of gender and sexuality. Within this debate, the most visible aspects of the star's identity lead to speculations upon what resides more deeply, and less visibly, beneath the surface. Unlike the racial divisions plainly exposed by the tattoos burnt into the actor's skin, the "deeper" sexual ambiguities of Depp's persona remain more susceptible to press speculations and inferences that sometimes appear to be con-

tradictory—even when expressed by the same reporter. Noting, for example, that Depp's fans include "millions of teenage girls and gay men," one biographer describes the actor as "almost asexual in most of his films," then reverses himself to suggest that the actor's characterizations "rely as much on their feminine attributes for their success as they do on Depp's high cheekbones and classic good looks" (Robb 1996, 7–8).

Certainly, racial and gender ambiguities are visible and *visualized* in Depp's persona, rendering sexual ambiguity more opaque. But rather than constructing the actor's sexuality as conflicted or unresolved—Is he straight or is he gay?—this less visible ambiguity neutralizes any possibility of meaningful opposition between "straight" and "gay" so that sexuality assumes a status as a fluid, elusive, and indeterminate aspect of human identity. The relationship between the visible and the invisible is elucidated in Depp's discussion of his title role of *Ed Wood* (1994), a figure who is perfectly comfortable with (and comforted by) wearing women's clothes. Here, the "appearance" of gender difference becomes sufficient ground for an interview with *The Advocate* to discuss the actor's sexuality. Although in the interview Depp mentions that he has never had sex with a man, the actor seems much more intent upon dispelling heterosexuality as a definitive and limiting aspect of his identity: he outwardly denies accusations of his homophobia and admits that he would be reticent neither to portray a gay character nor to do a gay love scene. What resonates most strongly in the interview is the actor's sensitivity to the social alienation that gays face and his location of a social space common to all outsiders: "Depp says that like many homosexuals he has experienced the anxiety of not belonging. 'We all have our fears of being different . . . whether you're gay and afraid to come out or you just feel like you don't fit in any place in society'" (Galvin 1994, 51).

And it is this matter of "difference" that helps to distinguish the version of masculinity harbored by Depp's persona. The act of perceiving himself as different from others—as one who does not "fit in"—is a kind of epiphany that effects the practice of respecting difference in others. Depp's difference constructs him as a "sensitive" man whose inherent vulnerability has made him stronger, more discerning, and more attentive to a variety of human perceptions and perspectives. The actor's difference also reinforces a view of his identity as both individual and unique, at the same time that the qualities comprising this individuality seem to escape

any clear definition. Like the characters he portrays onscreen, the off-screen "version" of Johnny Depp harbors a malleable identity. Jim Jarmusch describes his William Blake as a "blank piece of paper that everyone wants to write all over, which is why I like Johnny so much for that character, because he has that quality" (Rosenbaum 1996b, 23). This "blank slate" persona comprises a variety of seemingly opposed attributes: Caucasian and Native American, violent and tender, impulsive and wise, soft and hard. Instead of registering as contradictions that must be resolved, however, these oppositions gather evidence of depth, complexity, and mystery that transcend any need for reconciliation.

WORKS CITED

Colbert, Mary. 1996. "Dead Original." *The Sydney Morning Herald.* 19 April. www.smh.com.au/metro/content/960419/cover.html.

Erdman, David V. 1954. *Blake: Prophet Against Empire.* Princeton: Princeton University Press.

———. 1970. *The Poetry and Prose of William Blake.* Garden City: Doubleday Press.

Frye, Northrop. 1947. *Fearful Symmetry: A Study of William Blake.* Princeton: Princeton University Press.

Galvin, Peter. 1994. "Johnny Depp: Drag Superstar." *The Advocate.* 1 November, 48–53.

Hagstrum, Jean H. 1985. *The Romantic Body: Love and Sexuality in Keats, Wordsworth, and Blake.* Knoxville: University of Tennessee Press.

Hoberman, J. 1996. "Promised Lands." *Village Voice.* 14 May, 65.

Levich, Jacob. "Western Auguries: Jim Jarmusch's *Dead Man.*" *Film Comment* 32:3, 39–41.

Pond, Steve. 1989. "Depp Perception." *US.* 26 June.

Rebello, Steven. 1990. "Johnny Handsome." *Movieline* (May).

Robb, Brian J. 1996. *Johnny Depp: A Modern Rebel.* London: Plexus Publishing Limited.

Rosenbaum, Jonathan. 1996a. "Acid Western." *Chicago Reader.* 28 June.

————. 1996b. "A Gun Up Your Ass: An Interview with Jim Jarmusch." *Cineaste* 22:2, 20–23.

Ryan, James. 1994. "Depp Gets Deeper." *Vogue* (September), 542–45+.

Schneller, Johanna. 1993. "Johnny Angel." *Gentleman's Quarterly* (October), 224–29.

Schoemer, Karen. 1997. "A Little Respect Please." *Newsweek*. 3 March, 68–69.

Warren, Elaine. 1988. "Bad Boy to Role Model." *TV Guide*. 23 January, 10–12.

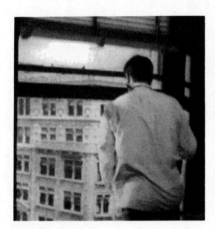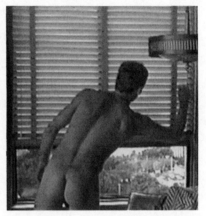

FIGURE 17. How sensuous does Gus Van Sant's Sam Chalmers (Viggo Mortensen) seem (right), with Hitchcock's Sam Chalmers (John Gavin, left) having gone "prudishly" before him. (*Psycho*, 1960; 1998) (frame enlargements)

CHAPTER EIGHTEEN

❖

Marion Crane Dies Twice

MURRAY POMERANCE

Interdit a ceux qui n'ont pas encore vu *Psycho.*

—Douchet, *Cahiers du cinéma*

"Gender identity" in film differs in style and consequence from its model in everyday life, if only because our everyday gender careers constitute what Vivian Sobchack might call "embodied narratives." While lived gender has medical, political, linguistic, emotional and navigational facets, filmed gender is constituted as a set of signals *about* rather than instantiations *of* and is therefore an index: of motive, alignment, history, probability, and piety (Burke; Goffman 1976). Screened gender, an attribute of and code for experience-as-represented, may come to function in the everyday world indexically, referentially, played out or recounted as what Goffman (1974) would have called a "keying." Though screened gender may metaphorize and point, it has less to do—in its structure— with the nature and social organization of gender in everyday life than with the history of, and conventions for, exploiting and depicting gender, more generally, pictorially, and more precisely, filmically.

That representational art is not an unframed window upon the world, and that our ability to learn about life by studying pictures

301

depends upon our knowledge of the techniques and strategies of representation used by an artist, was proposed by Gombrich. The pictorial arts, he argued, rely upon informed *schemata* of depiction:

> The most illustrious instance of this natural union between knowledge and art is of course Leonardo da Vinci . . . Leonardo was obviously dissatisfied with the current method of drawing trees. He knew a better way. "Remember," he taught, "that wherever a branch divides, the stem grows correspondingly thinner, so that, if you draw a circle round the crown of the tree, the sections of every twig must add up to the thickness of the trunk." I do not know if this law holds. I do not think it quite does. But as a hint on "how to draw trees," Leonardo's observation is invaluable. (154)

The technique of representation continually evolves, through what Gombrich referred to as a process of "schema and correction" (Miller, 218–21). Works of art are manifested through modifications to the conventions and principles by means of which it has been agreed upon by artists to depict things and by viewers to see things depicted. In film, it has been suggested (Carey), the conventions according to which certain narrative elements are both placed in and developed through history are themselves negotiated with viewing audiences, so that the history of conventions for representation is accessible as a history of such deals.

In that they give further play and schematic modification to the representational conventions established earlier in the medium; and in that their elements can best be understood as making reference to those conventions rather than to the modeling world, all films are "remakes." But a fascinating limiting case can be found in those infrequent, narratively bounded, and stylistically resplendent works *that openly claim to be remakes of earlier films.* Douglas Sirk's 1959 reconstruction of John M. Stahl's 1934 *Imitation of Life* exemplifies. In the officially declared *remake,* taken as genre itself (one that turns the lens most directly upon the filmic process), we see, without the masking purport of "originality," transformations and transpositions, borrowings and developments, reiterations and poesies, evidences, in short, for a theory of historical change as posited by a filmmaker by means of the pointing and accentuating idiosyncrasies of his representational style. As a way of picturing gender, the remake assumes, negotiates, and plays upon new interpretations of,

understandings and recognitions presumably already resident in the locus of the audience's attention and involvement.

What is significant in an explicit remake is not that it stands objectively to report some renovated aspect of the social world, but that viewers can be expected to believe it does by the sheath of progressivity within which it presents itself. Such nostalgic, but also purposive, viewers can be addressed by filmmakers as though they have a live present memory for "historical" conditions that may have been depicted once through a helplessly immediate, unselfconscious process of representational fidelity in the past version, yet are now superceded by notable forthcomings as obscure to earlier prediction as they are lambent to current hindsight. How quaint and old-fashioned, then, do Janet Leigh and John Gavin *now* seem making out *only half-naked* at the beginning of *Psycho* (1960). Gus Van Sant's 1998 retelling of Alfred Hitchcock's film is not seen as a mere ineffectual mechanical repetition of Hitchcock's complex narrative, then, but as unmanipulated evidence of inevitable historical development in mores and sexual etiquette and of the passage of time; it possesses and worries a progressive subtext, situating itself in turn-of-the-century filmmaking as a nostalgic reflection and a "presence" and causing the earlier thematic statement—even, in this case, one filmed by an acknowledged master of the medium—to recede in meaning into an "antiquity" that can be set nostalgically in an outmoded "past." How hot, even provocative, then, must Anne Heche and Viggo Mortensen seem (he without a stitch on, gazing out the window), and especially because Leigh and Gavin were there so "prudishly"—if also more selfconsciously and with a tamer animality—before them.

Without here attempting to dichotomize the cultural and economic differences of present and past societies, it can be useful to examine the two *Psychos* in some detail regarding the presentation of gender as itself a commodity whose value is grounded in social currencies; for with each film, however bizarrely expressive or putatively representational it is of the social context in which it was filmed, gender had to be ultimately readable to the audience. While I do not here wish to entertain the claim that our social treatment of gender at the end of the twentieth century shows a step in a particular direction, nevertheless, I hope to show that at least in respect of certain key scenes in this one film—remade in 1998 with some attempt to replicate not only dialogue and scenic construction but also exact shots—the social codings of the past are in some ways illegible in the light of present expectation.

Waylaid exegetically by Hitchcock's brilliant and foxy titling prac-
tices, many sincere critics have treated *Psycho*, a film in which what pop-
ular thought configures as psychosis plays a major role, as a film *about*
mentality—or at least psychological derangement; and have sought
urgently throughout the exposition for symptoms of psychological trou-
ble or justifications for the assuring, even nourishing, application of psy-
chiatry which is its finale (see Douchet 1999). That the film takes its gross
narrative form and its name from Robert Bloch's novel (1959), which is
in fact told from a set of interior positions all indicating one degree or
another of emotional and psychological discomfort, does not diminish
the fact that Hitchcock chose books such as *Psycho* not on the basis of
their own fictional qualities but because they were ready-built narrative
frameworks that would support his own subtler and philosophically
denser designs (Truffaut, 268). Notwithstanding the psychiatrically
tainted observations of Greenberg—"[*Psycho*] represents the extremity of
Hitchcock's black vision of human vulnerability and corruptibility"
(118)—or of other psychologically influenced critics he cites—including
Rothman, Modleski, Naremore, Braudy, and Wood—generally to the
effect that mentality is the central motive in *Psycho*, Hitchcock's film can
be seen as a construct, employing psychological and emotional language
merely as a means of audience engagement, while its design explores two
fascinating and related—but not implicitly psychological—issues, the
structure of gender, and the shape of narrative unfolding.

Gender play is central to *Psycho*. All of the dramatic action—the
theft, the trysting, the killing, the housekeeping, the flight—is gender-
focused. In the very introduction of the 1960 film Sam and Marion are
served up in a state of half-nudity as, after a lunch hour's petting in a
Phoenix hotel room, they dress themselves in garments, statuses, and
moral arguments. The topic of their discussion is marriage, that fusion of
gender and political economy. Marion has been reserving herself sexually
for an idealized future, though Sam's hopes have been threatened by the
impoverishing pressures of a divorce. In prim white underwear, her hair
severely cropped, and her lips tidily painted to demarcate her demand
that Sam make an "honest woman" of her, Marion is personified by Leigh
as the paragon of Friedan's "feminine mystique" (1959), eager, because
powerless, to succumb to the dictate of a male-controlled society that she
subordinate her sexual hunger to conjugal pieties. Soon afterward, in the
real estate office where she works, blatant evidence of male power and
control of women is offered by the millionaire Cassidy, who for forty

thousand dollars, and apparently on the spur of the moment, is buying a house for his "little girl," who has never known a day of pain in her life. Handed to Marion's boss Lowery over scotch and locker room banter in the back office, this male money is the treasure entrusted to her safekeeping and that she decides to divert to produce that "decent" marital bliss. Since it is still in underwear (now serious and black) that Marion fashions her plan to leave town with the propulsive male element—the MacGuffin—of this tale, the rectangular wad of bills, it is in sexual availability that she takes action.

Escaping northward, Marion encounters dominating men, a nosey highway patrolman and a manipulative used car salesman, both of whom use gendered aggressiveness to increase her selfconsciousness about her social position as a woman. Chafing in vulnerability and powerlessness, then, and shaken by a sudden heavy rainstorm, she is prepared for the hospitable friendship of a young man with a distinct lack of brashness and a reassuringly hesitant, stammering manner. Norman Bates is not only a mother's boy, but a boy who seems in some ways like a mother. His shyness of posture; his fascination with the dexterous hobby of taxidermy; his linguistic fluency; the extreme measure of his nursely devotion to the sick old matriarch in the "castle" on the hill; the dainty domestication of his cooking—all suggest he is a very different kind of man than Marion has met before, or than most of the other men in this story who reflect dominating, heterosexist masculinity (Corber; Cohan and Hark).

In Norman's little parlor adjacent the motel office, where he and Marion spin a conversation about being trapped—

NORMAN: Do you know what I think? I think that we're all in our private traps. Clamped in them. And none of us can ever get out. We scratch and claw, but only at the air, only at each other. And for all of it, we never budge an inch.

MARION: Sometimes we deliberately step into those traps.

NORMAN: I was born in mine; I don't mind it any more.

MARION: Oh, but you should . . .

NORMAN: Oh, I do. But I say I don't.

—as she nibbles the delicate chicken sandwich he has made her (for a more conventional "masculine" version of such catering we may watch

Cornel Wilde's efforts for Gene Tierney in *Leave Her to Heaven* [1946]), we have opportunity to detect his genteel identification with her femininity in his confiding tone and fastidious diction. Though he is referring to birds, words such as *clamped, scratch,* and *claw* and the notion of being *born in* a trap all suggest the debilitating confinement by ascription that fell to women in Western society of the late 1950s. Where a woman's future is marriage to an eligible man; where brutalizing patrolmen can provoke female drivers even as they seek to ensure their safety; it is women, not just people, who are trapped. So it is women, not just people, Norman invokes in his attempt at confidence. Behind a framed picture in this somber little room, he has poked a peephole and can watch Marion, later, preparing for her shower—a withdrawn, timidly preadolescent, inexperienced male. Spying, he feels for his target a sense of wonderment and associative curiosity, not the latent aggression of Powell's *Peeping Tom* (1960).

The slaughtering of Marion Crane—Rothman suggests eagerly that the famous shower scene is "the most celebrated sequence in all of Hitchcock's work" (292); Sterritt says more precisely that it constitutes "the most celebrated montage of Hitchcock's career" (108)—is a gender study, not simple violence; a choreography of unprotected female modesty, the victim twisting and vocalizing, pointlessly covering her ventrum with splaying fingers against the swift, inescapable knife thrusts. It is femininity, not thievery, addressed and undressed by this (unmistakably male) blade slashing through the shower (and prefigured moments earlier by Hitchcock's shot of the wiper blade slashing across the window of Marion's car in the rain). Gender play features, too, in the legend of Norman's mother and the "man from the East" who married her and died by her side, and in the presumptuousness of Arbogast, a man on the trail of not only crime but *female crime*. Here is a second questionable male, Norman's echo—too verbal, too cerebral, much too intuitive—whose interrogation of Norman is a flaccid echo of the brutalizing capitalist male bonding of Lowery and Cassidy. And the gender of motherhood—Norman's mother's replete closet, her dressing table; her modalities of voice; her symphony of motives; indeed, her very *perdurability* as a character, given the nature of her history—is a central and unifying riddle, fusing essence and appearance, intent and claim, sincerity and performance.

As a clue to that riddle, let us examine Norman's illuminating statement about having been born in his trap yet not minding it anymore.

Chided by Marion that he should mind, he makes bold to explicate that in fact he does but *says* he doesn't. His character is an open travesty, constructed artfully of sayings and silences—all coverings. His masculinity is worn upon a sleeve, slid into and drawn out of a jacket pocket. In the broadest sense, this sartorial view of gender—that it is dramaturgic, situational, performed—suggests that it does not inhere in biological fact, but resides in social application, an idea commonplace enough now but unspoken in these terms in 1959 (Oakley). Norman and Marion's "gender trap" is built of regulations and preferences, legal treatments, shaped condescensions and probable outcomes, *layers* permitting that they might appear and thus socially "be." As what we see covers what we cannot, we may suspect that under the soft masculinity of Norman Bates there lurks an essence that is hard. And the form of Marion's victimization becomes a peel (under running water), an attempt to disclose (wash off) the being inside her. In the climactic vision of *Psycho*—in the fruit cellar—we see in one swift intoxicating shot not only the innermost nature of Norman's mother, but most important, the layers of integument and intelligibility that have covered it. Interestingly, Van Sant vitiates the shock of this moment, placing a busy aviary in the background and then having Mrs. Bates, in her throne, swivel oh so slowly into view for Lila Crane. We have so much time to estimate her essence (the shot becomes an anatomy lesson) that only a spider crawling out of her maw can revive in us the flashing shudder produced in 1960.

Gender in the late 1950s is shown by Hitchcock to have been an affair of coverings and portrayals. So: Norman's peephole, by means of which he performs a purely gendered relation to Marion, is an apparatus of gender, a pathway for what Mulvey could call the empowered male gaze (see Keating) but what can also be seen as an associating fixation of vision. Similarly, Mrs. Bates's closet, Bates's careful performance of language, the membranous shower curtain, the swamp, the newspaper secreting the money that Marion has taken are all appurtenances of gender dedicated to the central role of covering as an organizing feature of social display. All are intimations of what is beyond themselves, wrappings of what is wrapped. One could add the coverlet on Mrs. Bates's bed, Marion's helpless hands in the shower, the highway patrolman's sunglasses, Marion's claim to migraine, Arbogast's deflective style of questioning. These elements shape the engenderings put in play in this film, principally by offering to viewers hints as to the nature of a hidden and inner, presumably truthful and deeply sexed, personal world.

Perhaps most central of all gender teases is architectural structure, the setting of sexual and financial interplay designed to be held off from the public eye. Jean Douchet begins his critique (1960, 7) with filmic architecture in view, proclaiming, "This article is forbidden to those who have not yet seen *Psycho*. . . . It is impossible to study this film without revealing its secret" but then proceeds to actual edifices, suggesting the opening scene is a play on our desire to penetrate the sorts of boundaries to perception offered by the Phoenix hotel:

> Let's suggest that Stewart has come down off the screen of *Rear Window* to take a seat in the theater, that he's become one of us, a spectator. His appetite for voyeurism finds nourishment right at the beginning of *Psycho*. In effect, the camera rather indiscreetly slips into a room with lowered blinds, in the middle of the afternoon, and in this room, a couple on a bed are kissing, clinching, showing a great carnal attraction.

The hotel is another gender façade, then, as is the Bates Motel a façade for the gender play that takes place in its rooms. Norman's office is a façade for his parlor; his parlor is a façade for Marion's room; her room is a façade for her bathroom; the bathroom is a façade for the shower stall; the stall is a façade for what lies beyond the drain. Gender is face; and sex is the end of gender.

But what has happened to all of this *pudeur* and pretense by 1998, at a time when "women's liberation," "gender equality," "male domination," and "female modesty" are treated as slogans of a vanished, even antiquated, past, a forgotten and irrelevant campaign, by a Hollywood power structure squeamish to portray social conflict and eager to claim, on women's behalf, political progress in order to ease its own sense of obligation? I want to suggest that Van Sant's film extracts sex from its cache, exteriorizes and diffuses it onto the gendered surface of consciousness, making of it less a romantic secret to be penetrated through shadowy hints and cloaks of anxious ambiguity and more a uniform topography of social fact, presence, utility, and kinesis. All is now surface; more, surface is now all. If gender was earlier a catafalque and chrysalis for desire, it is now a banality, like weather. The rainstorm, once pathetic fallacy, is here, then, a realistic setting and nothing more (and the wiper blade is no longer lit to be slashing). There is realism, too, as Marion packs to run out of town in underwear that is money green, bringing to the surface of

awareness and attention a stash that was earlier, in a black and white universe, a guilty secret. And the behaviors that constitute Van Sant's gender stylings, as we shall see, call up the real more than the imagined, as though we have celebrated the death of imagination; they would have been unreadably brazen in the context of the gender assumptions made by Hitchcock's generation.

But in order to effect these stylings, which I shall discuss, Van Sant had to overcome some difficulties. He had cast in the female lead a talented, yet hardly famous, young actress—no contemporary reflection of the Janet Leigh who had already, by the time she contracted with Hitchcock, shot *Little Women* (1949), *The Forsyte Saga* (1949), *Angels in the Outfield* (1951), *It's a Big Country* (1951), *The Naked Spur* (1953), *Houdini* (1953), *Prince Valiant* (1954), *Living It Up* (1954), *Pete Kelly's Blues* (1955), *My Sister Eileen* (1955), *Safari* (1956), and the resonant *Touch of Evil* (1958). Because Leigh had a huge name at the box office, Hitchcock knew his viewers would be stupefied and confused to see her killed off in the first third of the film and contracted arrangements with distributors, here for the first time in the history of modern film distribution, to forbid entrance to the theater after the screenings had commenced. However, for a contemporary audience, most of whom would be familiar with at least the publicity blurb of the story of *Psycho* and many of whom would have no particular associations with the name of Anne Heche, the shock of the shower killing would be reduced. A technical address to this problem through color cinematography is made by Van Sant as an attempt to re-elevate the shower scene since at least the aura of legend and publicity surrounding the Hitchcock film for a contemporary audience required that this scene be powerful.

Shooting in color in the white bathroom provided for blatant splashes of red blood. While the tonal contrast between the blood and the tiles and tub is not greater here than it was in the black and white original, there is added an intense *color contrast*, in which the frenzied and intimate emotional associations with the redness of the blood are pronounced within the screen space. Blood shot in black and white appears very dark gray, and it falls to the viewer to imagine the redness implicit in—that is, phenomenologically *beneath*—the gray. The imagistic tones in the original *Psycho*, then, comprise another construction, another mask to cover some deeper, more direct and more passionate substance. In the Van Sant *Psycho*, this deeper and dirtier layer of meaning is surfaced and openly articulated, cleaned up, in a process analogous

to the "erasure of nineteenth-century squalor" Anthony Vidler attributes to modernist architecture (63). So, paradoxically, the shower scene is less ambiguous, less erotic, less troubling, yet more newsworthy because less covert and more reported/reportable. In the original, Norman's voice is out of control, and therefore acoustically emphatic, when he stumbles into the motel room and discovers what is in the bath: "Mother! Oh God! Mother! Blood! Blood!" But that mantra, trilogizing lifegiving fluid, deity, and maternal presence, is now reduced to a photo caption.

Hitchcock is reported by his writer, Joseph Stefano (Lucas), to have produced and then withdrawn from the final cut so that the film would not be denied a rating, a startling shot that Van Sant was at liberty not only to reproduce but also to leave in. From high above, just as Marion tears away the shower curtain in her final living gesture, we see her body fall across the lip of the tub, the head dropping to the floor, and the legs splaying apart so that the dark perineal area is visible under the pouring water. Certainly, if it is true that Hitchcock made this shot, it offers to the viewer the Leigh-Crane that had been withheld from the potential bridegroom, the prize that had been promised to Loomis and that was never to be delivered; just as for Van Sant it presents the Heche-Crane Loomis has had many times over, what we may have been eager enough to share with him (his is the flesh to which we are given access most in the film), a public truth, a known topography. It may be worth noting, however, that the shot we do actually find in the earlier film leaves Leigh positioned facing along the length of the tub—when she falls (but we won't see it) she will not quite fall over the lip; whereas Van Sant's requires Heche to fall across the width. Since Leigh's orientation in the tub does not precisely match Heche's, if Van Sant duplicated a Hitchcock shot precisely (and there is little but publicity to suggest he did), the Hitchcock shot he duplicated— and that was cut—would not have been a longer version of the one we see but a second shot taken on-set, probably at the same time. If Hitchcock doubled this shot, it was an act untypical of his working style. But either way, it is clear that Hitchcock was operating with a keen sense of what social propriety would deem it honorable and respectable to show. Not simply was less gendered reality to be seen onscreen in 1960 than may be seen today, but the sense of propriety and impropriety, of revelation and hiding, was denser and more palpable in the social world of that time where theaters, filmgoing, and spectatorship were situated.

Color activates a system of openness, flatness, and anti-ocular-centrism (Jay) in the 1998 *Psycho,* then, producing all objects and all

space equally for the eye and therefore eliminating the privileging *frisson* of visual allure and organization. Similarly overt and matter-of-fact in Van Sant's film—that is, satisfying to a new appetite without prurience and hungry for "reality"—and indeed even promiscuous, is Heche-Crane, whose tawny bra and underpants melt into her flesh in the opening hotel sequence and are metamorphosed as green as leprechauns as she prepares to skip town; whose lover (Viggo Mortensen) displays in her presence a casual and full male nudity with which she is blasé, thereby implicating her sexual experience and capacity; whose gestures and expressions utterly lack the strict moral containment and painful repression of Leigh-Crane. The formula of Heche-Crane's sexual knowledge reduces Loomis from motive to accomplice. And Marion, for her part, becomes capacitated in her relation with the patrolman, controlling in her relation with her boss, canny and agile in her banter with the millionaire Cassidy (the puissant Chad Everett), savvy in her relation with the used car salesman (James LeGros). "You can do anything you have a mind to. Being a woman, you will," he smirks. In 1960 we knew he (John Anderson) was being superior and coy, really speaking about himself. Now we know he is telling the blunt truth.

If the contemporization of *Psycho* has taken the female protagonist off the knifepoint adjustment to a world of perduring and extenuating disempowerment and resuscitated her in a flat topography where desire, capacity, effort, achievement, and expression are both everywhere and at a minimum, if it has brought her pensivity and anxiety to a multicolored—that is, conflict-free—surface where skin is indistinguishable from underwear and the fabrics from which her dresses are cut are like the landscapes through which she drives, its transformation of male engenderedness is similarly radical and exteriorizing, a pretext for at least two startling developments. Against the performance of Vince Vaughn, that of Anthony Perkins now stands out in the nudity of its denial and the starkness of its fear. In his gaunt face, the darting avian eyes, often photographed in high key lighting that emphasized patches of darkness from which they could glow, are both a signal and a mystery, indicative of a frenzy in residence utterly beyond our vision. Vaughn, however, has a full-frame athletic body and a fleshy face with pouting, expressive lips. His facial expression is self-sufficient and projective, implying its target but not its source, an open and incontestable marker of male aggression and achievement orientation; it is a teleological face, a purposive face, appropriate for the demands of our

multinational economy, where the forty-thousand-dollar fortune Marion Crane took in 1960 is become a puff in the wind and a house for a little girl who's never known a day of pain costs ten times as much, profit and success being valorized as critical at every instant regardless of the banality of the frame of reference in which they are achieved. Vaughn-Bates's mother is only a projection worn by a violent and ambitious man; while Perkins-Bates was a mask worn, and ultimately eaten, by a violent and hungry mother.

The inability of Vaughn-Bates to restrain himself from projective expression toward a situated end is conveyed by Van Sant in an astonishing modification of the peephole scene. Perkins-Bates was shown in medium close-shot profile peering through the hole into Marion's room. Then we saw what he saw: Marion undressing. As she performed the final gestures we jumped to a macro-close shot of his glowing, mystified, impotent eye swollen to occupy (be trapped by) the entire screen. This shot is witty, Rothman shows: "While we were viewing this eye, it was viewing . . . a view of which we were deprived" (289). Vaughn-Bates's eye is shown in a duplicate macro-close shot, but the medium profile shot is extended as he peers through the wall, then looks down, reaches below the frame edge, presumably withdraws his penis in shadow, and masturbates to the display that is unavailable to us. Where Hitchcock used the image of seeing to hide the object of sight—reflecting the devotion to the lens that is implicit in his filmmaking technique: while the lens sees the director does not see what it sees—Van Sant shows Bates's orgasm as signal of the power to look and the new male who possesses it. Vaughn-Bates evidences such a surfeit of looking power, indeed, there remains no thing-being-looked-at. We are given his doing, but not a vision composed through it. Hitchcock had a frame; Van Sant, with post-Mulveyan correctness, has a viewer framing. Consequently Vaughn-Bates secretes his male power; Perkins-Bates made a secret of it. And the peephole itself, that earlier reflection of the shady world of gay clubs and porn theaters, has in Van Sant's film become a central site of contemporary sexual life. From a society in which male sexuality was desire invested and denied, converted into kinesis, violence, wit, posture, or charm and in which such desire unavoidably configured a dominable other, we have moved into public, and independent, male expression, the other traced only as a pretext, not a visible aphrodisiac. Domination is doubled since the figure of Marion, once a passive and unresponding stimulant, is now only an

excuse for him; and since Bates's self-absorption, an object of fascination for us, utterly evaporates her for us as even an imaginary social interactant. Domination now implies definition and control, not rights to exploration by (even violently) probing boundaries. At the edge of the swamp, waiting to see whether Marion's car will *go in*, Vaughn-Bates is not standing in eerie trepidation as Perkins-Bates was. Instead he smirks with knowledge of his own technical capacity to produce the event (like Van Sant, who learned from Hitchcock that it could be done), willing the vehicle down in a demonic inversion of the ceremony of enlightenment in *The Empire Strikes Back* (1980), where Luke Skywalker raises his X-Wing from the swamps of Dagobah.

A concluding point about narrative structure. Hitchcock's *Psycho* was altogether a film about packaging, the essential process in the maintenance and outplaying of gender identity at a time of cold war internationally and civil war between the genders at home (Leibman; Marling). Indeed, the film is a package of packages, and the Bates who does mind about being born in a trap (package) but says he doesn't is therefore a model for it, an entrapment by suits and trappings. With forty thousand dollars illicitly packaged in her vehicle (it is presumed to be licitly packaged at her home, waiting to be packaged in a bank account), Marion finds a concealed (packaged) back road (in a concealing rainstorm) and thence the obscure Bates Motel. She repackages the cash in the *Los Angeles Times* (itself a packaging of accounts), then packages herself in a final(izing) shower. Dead, Marion is packaged in the shower curtain, this package itself being packaged in the trunk of the car along with the money packaged in the newspaper. The car is packaged in the swamp. Then the entire case of Marion Crane, packaged in the consciousness of Milton Arbogast, is repackaged when he is killed and packaged in his car in the swamp. The swamping is ostensibly done self-protectively by Mrs. Bates herself, packaged inside her son Norman for long years until she emerges (was the monster of *Alien* [1979] a homage?), to package him and everything he has done inside a perfect silence—the ultimate package.

Forty years later, however, entropy and publicity have triumphed. Gender is now configured in a pansexual—or at least panerotic—universe where the potentials of performance, staging, camouflage, concealment, and anxiety are no longer keynotes. Gender identities are only rationales on the basis of which to take specific action toward specific success, roads to boredom and tranquillity at once. Dying a second

death, Marion Crane is not a protagonist packaged in guilt or gender, but only and pathetically a passer-by in the wrong place at the wrong time. The chilling "psycho" has become a mere psycho, certifiable, to be sure, but not so strange. For him, gender and brutality are mundane facts of late-twentieth-century life, not moral mysteries.

Mrs. Bates had been buried, we learn from a sheriff's gossipy wife, in a dress that was *periwinkle blue*. As we watch *Psycho* in black and white, this is a profound, entrancing, almost debilitating vision of desire and unattainability, one that perfectly embodies Norman's visionary debility and romantic wound. In color, however, it is a perfunctory datum. Periwinkle blue, persimmon pink, any color—every color—will do. In such a sensible consumerist world as Van Sant depicts, the radical tale of camouflage and revelation is itself suspect, pure cheese. So now, as we are regaled by the attending psychiatrist with a history of Norman's possession, even consumption, by his dominating mother, we come in this post-Freudian posterotic posttheatrical era *not to believe him at all*—another empty theory touting to claim truth. He may not be Norman, to be sure, but this killer is surely not his own mother. At worst the diagnosis is a scriptwriter's failure, a false closure, a dead end, a pathetic masculinism incanting to redeem itself. At best it illuminates a fabulous—and theatrical—scam. Instead of suffering a lingering chill of mixed terror and delight, we are suspended in readiness for the next banality as we step homeward to watch the evening news.

WORKS CITED

Bloch, Robert. 1989, © 1959. *Psycho*. New York: Tor.

Braudy, Leo. 1972. "Hitchcock, Truffaut, and the Irresponsible Audience." In Albert J. LaValley, ed., *Focus on Hitchcock*. Englewood Cliffs, NJ: Prentice-Hall.

Burke, Kenneth. 1969. *A Grammar of Motives*. Berkeley: University of California Press.

Carey, John. 1974. "Spatial and Temporal Transitions in American Fiction Films." *Studies in the Anthropology of Visual Communication* 1:1 (Fall).

Cohan, Steve, and Ina Rae Hark. 1993. *Screening the Male: Exploring Masculinities in Hollywood Cinema*. New York: Routledge.

Corber, Robert J. 1993. *In the Name of National Security: Hitchcock, Homophobia, and the Political Construction of Gender in Postwar America*. Durham: Duke University Press.

Douchet, Jean. 1960. "Hitch et son public." *Cahiers du cinéma* 113.

———. 1999. *Hitchcock*. Paris: Cahiers du cinéma.

Friedan, Betty. 1959. *The Feminine Mystique*. New York: W. W. Norton and Co.

Goffman, Erving. 1974. *Frame Analysis: An Essay on the Organization of Experience*. Cambridge: Harvard University Press.

———. 1976. *Gender Advertisements*. *Studies in the Anthropology of Visual Communication* 3: 2 (Fall).

Gombrich, Ernst. 1960. *Art and Illusion*. Princeton: Princeton University Press.

Greenberg, Harvey Roy. 1993. *Screen Memories: Hollywood Cinema on the Psychoanalytic Couch*. New York: Columbia University Press.

Jay, Martin. 1993. *Downcast Eyes: The Denigration of Vision in Twentieth-Century French Thought*. Berkeley: University of California Press.

Keating, Nicole Marie. 1999. "If Looks Could Kill: Female Gazes as Guns in *Thelma and Louise*." In Murray Pomerance and John Sakeris, eds., *Bang Bang, Shoot Shoot! Essays on Guns and Popular Culture*. Needham Heights: Simon and Schuster.

Leibman, Nina C. 1995. *Living Room Lectures: The Fifties Family in Film and Television*. Austin: University of Texas Press.

Lucas, Nicole. 1999. *Dial H for Hitchcock: The Genius behind the Showman*. Universal TV Entertainment.

Marling, Karal Ann. 1994. *As Seen on TV: The Visual Culture of Everyday Life in the 1950s*. Cambridge: Harvard University Press.

Miller, Jonathan. 1983. *States of Mind*. New York: Pantheon.

Modleski, Tania. 1988. *The Women Who Knew Too Much: Hitchcock and Feminist Theory*. New York: Methuen.

Naremore, James. 1973. *Filmguide to* Psycho. Bloomington: Indiana University Press.

Oakley, Ann. 1972. *Sex, Gender, and Society*. New York: Harper and Row.

Rothman, William. 1982. *Hitchcock: The Murderous Gaze*. Cambridge: Harvard University Press.

Sobchack, Vivian. 1995. "'Surge and Splendor': A Phenomenology of the Hollywood Historical Epic." In Barry Keith Grant, ed., *Film Genre Reader II*. Austin: University of Texas Press.

Sterritt, David. 1993. *The Films of Alfred Hitchcock*. New York: Cambridge University Press.

Truffaut, François. 1985. *Hitchcock*. New York: Simon and Schuster.

Vidler, Anthony. 1992. *The Architectural Uncanny: Essays in the Modern Unhomely*. Cambridge: MIT Press.

Wood, Robin. 1989. *Hitchcock's Films Revisited*. New York: Columbia University Press.

CONTRIBUTORS

◈

Rebecca Bell-Metereau wrote *Hollywood Androgyny* (2nd edition, Columbia 1993) and co-authored with Christopher Frost *Simone Weil on Politics, Religion and Society* (Sage 1998). She has chapters in *Writing With* (State University of New York Press, 1994), *Deciding Our Future: Technological Imperatives for Education* (University of Texas, 1994), and *Cultural Conflicts in Contemporary Literature* (University of Puerto Rico, 1993). She directs Media Studies at Southwest Texas State University and was a Fulbright Scholar at the University of Saint Louis in Senegal, Africa.

Michael DeAngelis is an assistant professor and director of the undergraduate program at DePaul University's School for New Learning. His study of fantasy, male sexuality, and crossover stardom, *Moments of Desire*, is forthcoming in 2001 from Duke University Press, and his current book project is a history of art cinema exhibition in the 1960s and 1970s. His work has also appeared in *Cultural Critique, Spectator,* and the anthology *Pictures of a Generation on Hold: Selected Papers* (Media Studies Working Group, 1996).

David Desser is a professor of cinema studies at the University of Illinois, Urbana. He has authored, co-authored, edited, and co-edited nine books, including *The Samurai Films of Akira Kurosawa* (UMI, 1983), *Eros Plus Massacre: An Introduction to the Japanese New Wave Cinema* (Indiana, 1988), *American Jewish Filmmakers: Traditions and Trends* (University of Illinois Press, 1993), *Ozu's Tokyo Story* (Cambridge University Press, 1997), and *The Cinema of Hong Kong: History, Arts, Identity* (Cambridge University Press, 2000).

317

Murray Forman has done research and writing on popular music, urban youth subcultures, and media representations of minorities and has lectured in communications and cultural studies. He teaches at Queens College of the City University of New York. His book, *"The Hood Comes First": Race, Space, and Place in Rap Music and Hip Hop* is forthcoming from Wesleyan University Press.

Krin Gabbard is a professor and chair of the Department of Comparative Literature, State University of New York at Stony Brook. He is the co-author of *Psychiatry and the Cinema* (Chicago, 1987) and the author of *Jammin' at the Margins: Jazz and the American Cinema* (Chicago, 1996). He has edited *Jazz among the Discourses* and *Representing Jazz* (both Duke University Press, 1995). He is currently writing a book on the construction of masculinity in American film and music.

Frances Gateward is an assistant professor in the Center for African and Afro American Studies and the Program in Film and Video at the University of Michigan. She is co-editor of *Sugar, Spice, and Everything Nice: Contemporary Cinemas of Girlhood* (forthcoming, Wayne State University Press), and is currently doing research on Korean cinema as well as writing a book, with Gloria Gibson, on the history of African American cinema.

Lenuta Giukin has a master's in French literature from the University of Illinois, Chicago, and is pursuing her doctoral studies in French and film at the University of Illinois, Urbana-Champaign. Her essay, "La Mère Afri(que)(caine): Tradition et continuité d'un discours politique dans le cinéma africain francophone" will appear in *The Mother in/and French Literature*, FLS vol. 27 (University of South Carolina, 2000).

Barry Keith Grant is a professor of film studies and popular culture at Brock University in St. Catharines. His books include *Voyages of Discovery: The Cinema of Frederick Wiseman* (University of Illinois Press, 1992) and *Near Death* (Flicks Books, 1999), and as editor or co-editor, *Film Genre Reader* (University of Texas Press, 1986, 1995), *The Dread of Difference: Gender and the Horror Film* (1996) and *Documenting the Documentary: Close Readings of Documentary Film and Video* (Wayne State University Press, 1998). Grant's writing has also appeared in numerous journals and anthologies. Currently he is edi-

tor of the Contemporary Film and Television series for Wayne State University Press and the Genres in American Cinema series for Cambridge University Press.

Garth Jowett is a professor and director in the School of Communication, University of Houston. He is the author of *Film: The Democratic Art* (Little, Brown, 1976), *Movies as Mass Communication* (Sage, 1986, with James Linton), *Children and the Movies: Media Power and the Payne Fund Controversy* (Cambridge, 1996, with Ian Jarvie and Kathryn Fuller), and *Propaganda and Persuasion* (3rd ed., Sage, 1999, with Victoria O'Donnell). He is currently at work on a totally revised new edition of *Film: The Democratic Art* and his new book, *Television and America: A Social History*.

Gina Marchetti is an associate professor in the Cinema and Photography Department, Roy H. Park School of Communication, Ithaca College, Ithaca NY. She is author of *Romance and the "Yellow Peril":Race, Sex, and Discursive Strategies in Hollywood Fiction* (University of California Press, 1993).

Hamid Naficy is an associate professor of film and media studies, Rice University, Houston. He has published extensively about theories of exile and diaspora cultures and media and about Iranian, Middle Eastern, and Third World cinemas. His latest English language books include *Home, Exile, Homeland: Film, Media, and the Politics of Place* (Routledge 1999), *The Making of Exile Cultures: Iranian Television in Los Angeles* (University of Minnesota Press, 1993), and *Otherness and the Media: The Ethnography of the Imagined and the Imaged,* co-edited with Teshome Gabriel (Harwood Academic Publishing, 1993). His forthcoming book is *An Accented Cinema: Exilic and Diasporic Filmmaking* (Princeton University Press).

Murray Pomerance is a professor and chair of the Department of Sociology at Ryerson Polytechnic University, Toronto. His fiction has appeared in *The Paris Review, New Directions, The Kenyon Review,* and elsewhere and he is the author, editor, or co-editor of *Ludwig Bemelmans: A Bibliography* (Heineman, 1993), *The Complete Partitas* (Les trois O, 1992–1995), *Magia d'Amore* (Sun & Moon, 1999), *Pictures of a Generation on Hold: Selected Papers* (Media Studies Working Group, 1996), *Bang Bang, Shoot Shoot! Essays on Guns and Popular Culture* (Simon and

Schuster, 1999; Pearson Educational, 2000), *Closely Watched Brains* (Pearson Educational, 2001) and, with Frances Gateward, *Sugar, Spice, and Everything Nice: Contemporary Cinemas of Girlhood* (Wayne State University Press, forthcoming).

John Sakeris is a professor in the Department of Sociology at Ryerson Polytechnic University, Toronto, and is co-editor of *Pictures of a Generation on Hold: Selected Papers* (Media Studies Working Group, 1996), *Bang Bang, Shoot Shoot! Essays on Guns and Popular Culture* (Simon and Schuster, 1999; Pearson Educational, 2000), and *Closely Watched Brains* (Pearson Educational, 2001).

Kevin S. Sandler is a visiting assistant professor of film and video studies at the University of Michigan, Ann Arbor. He is the editor of *Reading the Rabbit: Explorations in Warner Bros. Animation* (Rutgers, 1998) and, with Gaylyn Studlar, the co-editor of *Titanic: Anatomy of a Blockbuster* (Rutgers University Press, 1999). He is working on a book about the Motion Picture Association of America's rating system.

Gaylyn Studlar is Rudolf Arnheim Collegiate Professor of Film Studies at the University of Michigan, Ann Arbor. She is the author or editor of a number of books and articles. Her most recent publication, with Kevin S. Sandler, is *Titanic: Anatomy of a Blockbuster* (Rutgers University Press, 1999). She is currently working on a social history of women and the American cinema. With Matthew Bernstein she has edited *John Ford Made Westerns* (Indiana University Press, 2000).

Janice R. Welsch is a professor in the Department of English and Journalism at Western Illinois University, where she teaches courses in film, women's studies, and cultural diversity. She is past-president of the Society for Cinema Studies and a co-editor of *Multiple Voices in Feminist Film Criticism* (University of Minnesota Press, 1994) and of *Cultural Diversity: Curriculum, Classroom, and Climate Issues* (1999, a grant-sponsored publication).

Steven Woodward has wide-ranging interests in literature and film and is currently pursuing studies of gender and genre and of the relationship between fear and the acquisition of language. He has contributed film essays to *Pictures of a Generation on Hold: Selected Papers* (Media Studies Working Group, 1996) and *Bang Bang, Shoot Shoot! Essays on Guns and*

Popular Culture (Simon and Schuster, 1999; Pearson Educational, 2000) and is currently working on a study of killer girls for *Sugar, Spice, and Everything Nice: Contemporary Cinemas of Girlhood* (forthcoming). He teaches children's literature at Nipissing University in North Bay, Canada.

INDEX

Malan, Adolphus G. ("Sailor"), 153
Malinowski, Bronislaw, 162
male gaze, the, 41, 58, 61, 163, 182, 192,
	193, 196, 307, 312:
	unawareness of female subjected to in
		Western film, 42–43
Maleknasr, Yasmin, 46
Man Hei-Lin, Hayley, 74
Man Who Knew Too Much, The (Alfred
	Hitchcock, 1956), 6
Man Who Shot Liberty Valance, The (John
	Ford, 1962), 191
Mansfield, Jayne, 165
Mao Ying, Angela, 210
Marjan (Shahla Riahi, 1956), 46
marketing, *see* gender, marketing of
Marnie (Alfred Hitchcock, 1964), 6
Marriage of Heaven and Hell, The
	(William Blake), 286
martial arts:
	movies, *see* film genres
	technique, difficulty of filming, 57
Marx, Karl, 269, 270
"Mary Tyler Moore Show, The"
	(1970–73), 274
masculinity:
	African American, 238–240, 243:
		and white men's performance, 238
	alternative, 278
	assertive, 114
	"authentic," 175, 176
	beauty and, 290
	black, image of, 138
	and cars, 114
	and collisions, 114
	and competition, 111
	counterimage of, 272
	Cronenberg's analysis and depiction of,
		119; *see also* Cronenberg
	cultural and cinematic codes of, 258
	and dance, 149–167
	deconstruction of, 67
	and dominance in the workplace, 115
	and driving, 114
	effeminate, 271
	embodied, 119, 172

exhibitionism and, 181
Father, the, 252
gaze and, *see* male gaze
heroic, 283
heterosexist, 149, 305
and homoeroticism, 204
homosocial, 235, 237
and hypervirility, 124, 235
ideal figure of, 156
identity and, 120–127, 235
image of, 110, 120
influential figures of, 161
and Jewishness, 12, 267–293:
	antisemitism and, 278
	bookishness and, 278
	as feminized, 280
	with non-Jewish women, 271
	and out-marriage, 278
and labor capital, 116; *see also*
	capitalism
and macho physicality, 173–174
through male body, 171–172,
	175–176, 177:
	masculinist ideology and, 270
	masquerade of, 67, 68, 175
	"new," 220
	"ordeal" of, 269
	performative, 174–175, 176, 235
	phallicism and, 62, 181, 239–240,
		241; *see also* phallicism
	postfeminist, 83
	representation of, 113
	rough, 227
	spectacular, 246
	stardom and, 173
	symbolized by motorcycles, 203
	"tough guy" image of, 124
	transformative, 120
	working-class, 220, 227
and musical codes, 235
nerd type of, 244–245, 278; *see also*
	nebbish, nerd
as object of polymorphous gaze, 174
record collecting and, 235
and serial collection, 233
sissy type of, 271